A Community of Many Worlds

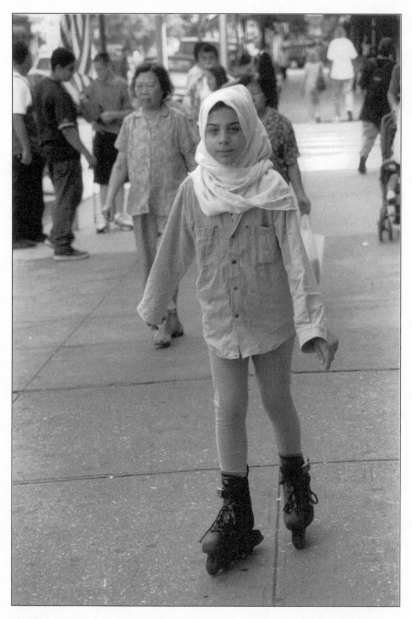

Palestinian American girl rollerblading in front of her father's electronics store, Bay Ridge, Brooklyn, 1998. Photograph by Mel Rosenthal.

A Community of Many Worlds

Arab Americans in New York City

◆ ◆ ◆

Museum of the City of New York

Edited by Kathleen Benson and Philip M. Kayal

Museum of the City of New York/Syracuse University Press

First Edition 2002
02 03 04 05 06 07 6 5 4 3 2 1

The paper used in this publication meets the minimum
requirements of American National Standard for Information
Sciences—Permanence of Paper for Printed Library Materials,
ANSI Z39.48–1984.∞™

Library of Congress Cataloging-in-Publication Data
A community of many worlds : Arab Americans in New York City.— 1st ed.
p. cm.
Papers originally presented at conference initiating the project "A
Community of Many Worlds: Arab Americans in New York City" organized by
the Museum of the City of New York.
Includes bibliographical references and index.
ISBN 0–8156–0739–3 (cl. : alk. paper)
1. Arab Americans—New York (State)—New York—History—Congresses.
2. Arab Americans—New York (State)—New York—Social
conditions—Congresses. 3. Immigrants—New York (State)—New
York—History—Congresses. 4. Immigrants—New York (State)—New
York—Social conditions—Congresses. 5. Arab countries—Emigration and
immigration—History—Congresses. 6. New York (N.Y.)—Emigration and
immigration—History—Congresses. 7. New York (N.Y.)—Ethnic
relations—Congresses. I. Museum of the City of New York.
F128.9.A65 C66 2002
974.7'1004927—dc21
2002004312

Manufactured in the United States of America

Contents

 Stanley Rashid 74

7. Being Arab American in New York: *A Personal Story*
 Peter J. Awn 83

8. So, Who Are We? Who Am I?
 Philip M. Kayal 90

PART TWO | **Arab New Yorkers in the Late Twentieth Century**

9. Inventing and Re-inventing the Arab American Identity
 Yvonne Yazbeck Haddad 109

10. The Changing Arab New York Community
 Louis Abdellatif Cristillo and **Lorraine C. Minnite** 124

11. Arab Families in New York Public Schools
 Paula Hajar 140

12. The Syrian Jews of Brooklyn
 Walter P. Zenner 156

13. NY-MASJID: *The Mosques of New York*
 Jerrilynn Dodds 170

14. Arab Americans: *Their Arts and New York City, 1970–2000*
 Inea Bushnaq 178

15. Hollywood's Muslim Arabs
 Jack G. Shaheen 191

16. Lebanese Women: *The Beirut–New York Connection*
 Evelyn Shakir 213

17. Being Arab American in New York: *A Personal Story*
 Abdeen Jabara 226

 Afterword
 Kathleen Benson 237

Illustrations

Foreword

Robert R. Macdonald, Director

In 2000 the Museum of the City of New York completed a major step in the project *A Community of Many Worlds: Arab Americans in New York City* by holding a scholarly conference designed to begin an exploration of the history of Arabs as part of the New York story. The papers in this book are a result of that conference and they provide the intellectual context for an exhibition on the subject that was to open in November 2001.

The tragic events of September 11, 2001, transformed what was a worthy project to one of vital significance to the people of New York City. The Museum of the City of New York has a long tradition of undertaking projects that study and celebrate the diversity that has defined New York from the days of seventeenth-century New Amsterdam to the present. Over the years the museum has presented programs on New York's Irish, African American, Jewish, Latino, and other communities and neighborhoods. We have undertaken these projects with the belief that the knowledge of our individual and shared past undercuts the ignorance that leads to intolerance. By appreciating the people who have made New York, New York, we can share in those cultural traditions that form the rich fabric of our community.

Within a few days of the tragedy of September 11 the museum convened a meeting of its Community of Many Worlds advisory committee to discuss the future of the project. Drawing on the recommendations of our advisers and others, the museum decided to reshape the project by enlarging the exhibition and increasing its accompanying public and educational programming. The project's expansion required us to reschedule the opening of the exhibition to March 2, 2002. With this book and the enhanced ex-

hibition and programming, the museum is advancing its mission to chronicle the stories of New Yorkers during the past four hundred years. By doing so we offer new perspectives on our history as a community of diversity. We believe that with this understanding we will have a greater appreciation of our neighbors and ourselves.

I would like to extend the museum's gratitude to all those who have made A Community of Many Worlds possible. I congratulate the contributors to this book; its editors, Kathleen Benson and Philip Kayal; and Kassy Wilson, manager of published media. The Arab New York Project team provided invaluable advice and assistance. The museum continues to be indebted to the New York Council for the Humanities, a program of the National Endowment for the Humanities, for its support of the conference on which this volume is based. Special thanks to the Near East Foundation, the Arab American Institute Foundation, the Middle East Institute at Columbia University, Inea Bushnaq, and Charles Sahadi for their generous financial assistance. Together you have made a significant contribution to our understanding and appreciation of what makes New York, New York.

Preface

Kathleen Benson

In the fall of 1997, the Museum of the City of New York responded to overtures from ACCESS (Arab Community Center for Economic and Social Services) in Dearborn, Michigan, to undertake an investigation of New York City's Arab Americans. The museum had not worked with these groups before and is always interested in reaching out to the city's diverse communities. For these simple reasons the museum began what was to become a multidimensional, multiyear project.

Sally Howell of ACCESS provided names and contact information for several Arab American scholars, educators, and activists in the New York area. In March 1998 Inea Bushnaq, a member of that group, and I were guests of ACCESS at a weekend conference on Arabs in Detroit at the Detroit Historical Society, where an exhibition created by ACCESS entitled Arab Americans in Greater Detroit: A Community Between Two Worlds was on display. In the course of discussing the museum's project, Anan Ameri and Dawn Ramey of ACCESS suggested that we partner with a local university. Back in New York, I placed a call to the Middle East Institute at Columbia University and learned that the MEI had just received a grant from the Ford Foundation to conduct a three-year study of Muslims in New York City. There were many areas of shared focus, and the MEI agreed to an informal partnership.

An "Arab New York team" began planning for an exhibition about New York's Arab communities. In addition to Inea Bushnaq, Mary Ann Haick DiNapoli, Paula Hajar, Ed.D., and Philip Kayal, Ph.D., whose papers are contained in this volume, the exhibition project team included Reeva Simon, Ph.D., assistant director of Columbia's Middle East Institute;

Michael Hindi, co-director of foreign student services at New School University; Souhad Rafey, collections manager at the American Academy of Arts and Letters; Jack Salzman, Ph.D., then a visiting scholar at both the museum and the Taub Urban Research Center of New York University; and Thomas Kessner, Ph.D., professor of history at the Graduate Center of the City University of New York. Mel Rosenthal, director of the photography program at Empire State College of the State University of New York, who had already begun working in the Bay Ridge Arab community for his exhibition, titled Refuge, was brought on as project photographer. Later important additions to the team were Debbie Almontaser, educator and activist, Ralph Coury, Ph.D., professor of history at Fairfield University, and his wife, Melissa, artist, appraiser, and librarian.

One of our first challenges was encompassing the great heterogeneity of "Arab New York." There was really no Arab community as such, and to reflect that reality, Paula Hajar suggested the title that we have since used for both the overall Arab New York project and each of its parts: *A Community of Many Worlds: Arab Americans in New York City.* An even greater challenge was finding information about all these communities. I was astonished to learn how little scholarship had been done on New York's Arabs. By comparison to Detroit/Dearborn and Los Angeles, Arab New York was practically undocumented. Granted, those two other metropolitan areas have larger Arab populations. But New York City is the third largest in the nation. Moreover, to quote from the title of Dr. Alixa Naff's lead paper in this volume, New York City was the "Mother Colony" of Arab Americans!

It would be difficult to mount an exhibition without some baseline scholarship. To address this paucity of information and to inform the script for the exhibition, we decided to hold a symposium. We invited scholars who had done work on New York to present their findings, encouraged others to focus on New York, and provided the Middle East Institute at Columbia with a forum for sharing some of the initial findings from its Muslim New York study. Just before the conference, Annemarie Jacir, a poet, photographer, and film student at Columbia University, came on to assist with the project and subsequently became a member of the team.

The conference was the first such event to take place in New York City. At times, it had the flavor of a large family reunion. Presenters did not simply show up to read their papers and then leave; those who did not have other pressing commitments arrived early and stayed late. I quote two of the presenters, who wrote to thank us:

"I stayed longer than I expected to take in more of the presentations."—Gregory Orfalea

"The sessions were simply outstanding, in that one left with so much more than expected; most gatherings do not stimulate thought, nor do they provide fresh, important information."—Jack Shaheen

They listened to other speakers, asked questions, made comments, and listened and responded to audience members who approached them between sessions and during other breaks.

Paula Hajar expressed how we all felt when she said, "It felt like a flower, opening." We hope readers of this volume of essays based on the conference presentations will appreciate and share the sense of wonder and excitement at the flowering of an Arab New York community.

Contributors

Peter Awn is dean of the School of General Studies and professor of Islamic religion and comparative religion at Columbia University. He was the first recipient of the Phillip and Ruth Hettleman Award for distinguished teaching and research and in 1995 was awarded the Great Teacher Award from the Society of Columbia Graduates.

Inea Bushnaq is a writer and translator and a part-time teacher in New York City public schools. She received her M.A. in classics from Cambridge University. A new edition of her book *Arab Folktales* will be published in 2002.

Louis Abdellatif Cristillo is director of field research, Muslims in New York Project, Middle East Institute, Columbia University.

Mary Ann Haick DiNapoli, freelance researcher and founder of the Arab-American Heritage Association, has served on the project team for *A Community of Many Worlds: Arab Americans in New York City* since its inception in 1997. Mrs. DiNapoli received her M.A. in urban studies from Long Island University; her thesis topic was "The Syrian-Lebanese Community of South Ferry, 1900–1977."

Jerrilynn Dodds is professor of architectural history and theory at the School of Architecture of the City College of the City University of New York. She has also taught at Harvard and Columbia Universities. A distinguished author, curator, and filmmaker, her work has centered on issues of artistic interchange and identity and the problems surrounding art and minorities in pluralistic societies. Her book *New York Masjid/Mosques of New York* will be published in 2002.

Jonathan Friedlander is assistant director of the Center for Near Eastern Studies and director of Outreach for International Studies and Overseas Programs at UCLA. He is coeditor of *Irangeles: Iranians in Los Angeles* (1993) and *Transitions: Russians, Ethiopians and Bedouins in Israel's Negev Desert* (1989), and editor of *Sojourners and Settlers: The Yemeni Immigrant Experience* (1988). In the 1970s, he produced the seminal television documentary *Arabs in America*.

Yvonne Yazbeck Haddad is professor of Christian-Muslim relations at the Center for Muslim-Christian Understanding at Georgetown University. She has served as both president of the Middle East Studies Association of America and editor of the quarterly journal *Muslim World*. Among her recent books are *Muslims on the American Path* with John Esposito (1998) and *Christian-Muslim Encounters* (1995), which she edited with Wadi Haddad.

Paula Hajar is supervisor of elementary education in Englewood, New Jersey. Dr. Hajar, who received her doctorate from Harvard University, wrote her dissertation on "Arab Immigrants and American Schoolpeople: An Ethnography of a Cross-Cultural Relationship." She wrote all eleven entries on Arab groups in New York for *The Encyclopedia of New York City* (1995).

Abdeen Jabara, attorney and activist, was born in Michigan and practiced law in that state for twenty years. A member of the New York and Washington, D.C. bars as well as that of his native state, he currently practices law in New York City. He was one of the founders of the Association of Arab American University Graduates, the Palestine Human Rights Campaign, and the American-Arab Anti-Discrimination Committee.

Philip M. Kayal is chairman of the Department of Sociology/Anthropology at Seton Hall University. He edited *The Coming of the Arabic-speaking People to America* by Adele Younis (1995) and co-authored, with Joseph Kayal, the seminal work *The Syrian-Lebanese in America: A Study in Religion and Assimilation* (1975).

Lorraine C. Minnite is associate director of the Center for Urban Research at Columbia University and assistant professor of political science at Barnard College.

Alixa Naff published the first in-depth study of Arab Americans, *Becoming American: The Early Arab Immigrant Experience, 1880–1950* (1985), as well as *The Arab Americans* (1998), an illustrated history for young adults. She is also the donor of the unique collection of Arab immigrant artifacts and archival materials to the Smithsonian Institution's National Museum of American History.

Gregory Orfalea is a poet and author whose books include *Messengers of the Lost Battalion: The Heroic 551st and the Turning of the Tide at the Battle of the Bulge* (1997); *Before the Flames* (1998), a history of Arab Americans; and *Grape Leaves* (1998), an anthology of Arab American poetry co-edited with Sharif Elmusa. He is currently publishing a series of memoirs of growing up in Los Angeles for the *L.A. Times Magazine*. Orfalea teaches creative writing in the Center of Talented Youth Program at Stanford University; he also works as an editor at the Center for Substance Abuse Prevention and lives with his wife and three sons in Washington, D.C.

Stanley Rashid was born in Detroit, Michigan, and received his master's degree in education from Fairfield University. Since 1965 he has worked in the family business, Rashid Sales Company (established 1934), importing, distributing, and presenting Arabic films and recorded music.

Jack G. Shaheen, author of *The TV Arab* (1984) and *Reel Bad Arabs: How Hollywood Vilifies a People* (2001), is professor emeritus in the department of Mass Communications at Southern Illinois University. An internationally acclaimed author, lecturer, and media critic, he serves as a consultant to motion picture and television production companies and has consulted with the United Nations, the United States Information Service, and the New York City Commission on Civil Rights.

Evelyn Shakir, associate professor in the department of English at Bentley College, is the author of *Bint Arab: Arab and Arab American Women in the United States* (1997). She has also published short fiction, served as a news writer and reader on the "Arabic Hour" television program in Boston, and was a producer of a two-part documentary on the Lebanese and Syrians in Massachusetts for WGBH, Boston.

Michael W. Suleiman is University Distinguished Professor of Political Science at Kansas State University. Publications he has edited include *Arabs*

in America: Building a New Future (1999) and *Arab Americans: Continuity and Change* (1989). He is the author of *The Arabs in the Mind of America* (1988) and *Political Parties in Lebanon* (1976). His *Arab-Americans: An Annotated Bibliography* will be published in 2002.

Walter P. Zenner is professor of anthropology at the State University of New York at Albany. He received his doctoral degree from Columbia University and has devoted most of his professional research to the study of ethnic identity among Jews and Arabs in the United States and Israel. His forthcoming book, *A Global Community: The Jews from Aleppo, Syria,* will be published in 2002.

Introduction

Philip Kayal

The papers presented here were first delivered on February 5 and 6, 2000, at a symposium sponsored by the Museum of the City of New York as part of its long-term commitment to represent and preserve New York's multicultural history. This conference was the first to determinedly reach out to Arab New Yorkers, seeking their help in putting together both this symposium and an exhibition identifying the history and contributions of Arab Americans to the life and commerce of New York City.

Two years in the planning, the year-2000 conference was intended as a precursor for an exhibit on the contributions of the diverse Arabic-speaking communities living here to the economic, social, and religious diversity of New York City. Appropriately titled "A Community of Many Worlds: Arab Americans in New York City," it made clear that diversity was the keystone to understanding the Arab American experience in New York. Hundreds of people attended the conference. In addition to academicians, there were Jordanian and Palestinian students from the city and from Yonkers, Syrian-Lebanese adults from Brooklyn (the children of the older Christian Arab immigrants), and newer Muslim Arabs living in Manhattan from diverse Middle Eastern backgrounds. And, of course, interested members of the general public.

As the articles that follow indicate, bringing such a range of generations, religions, and nationalities together to study and discuss their common immigration and assimilation experiences was no easy task. What made it successful was the community's common sense of being underappreciated in the city and the desire to share its heritage with other New Yorkers. Not only did the planners learn a lot about their own ethnic histo-

ries, but they learned from one another across all sorts of socially constructed barriers. Both attendees and presenters discovered what they had in common: their immigration and assimilation stories, why they came, how New York responded to their presence, where they established communities and institutions, and how they wished to be seen, identified, and remembered.

There were tales of stereotyping and discrimination and stories of religious traditions and economic successes. The thrust, however, was on how and why an Arab American identity evolved in the city. It is this one hundred-year-old story that is being told here for the first time in an organized fashion. Just like the conference itself, some papers are vignettes and others are documented studies. Some tell individual though highly representative stories, while other papers supply the historical context for understanding these stories. Some papers are "scholarly" and footnoted, others are personal and informal. But all are insightful, reinforcing and complementing one another. In any case, the reader will have an up-to-date and accurate review of Arab New York over time that will make sense and help to put an end to the stereotypes of Arabs that some New Yorkers harbor. Better still will be the information garnered about Arab New Yorkers and their history and contributions to the life of the city.

Both the conference and this book open with the description of the "mother colony" of all American Arab communities at the turn of the last century in lower Manhattan on Washington Street. Alixa Naff, a specialist on Arab American peddling traditions, takes us through the community's early years and establishes New York as the primary Arab community in America. Her concentration is on commerce, which is, in fact, what New York is all about. She outlines the background for Arab American entrepreneurial development, a facet of life that coincides so well with the nature of this great city.

The second paper, by Mary Ann Haick DiNapoli, is an outstanding historical piece describing the movement of the community from Manhattan to South Ferry (downtown) in Brooklyn. Her extensive research documents the establishment of the Arab American press; the primacy of Atlantic Avenue as a commercial and cultural center; and the beginnings of numerous social, cultural, and religious institutions in Brooklyn that survive to this day. While it is not her central focus, DiNapoli identifies the shift from peddling to manufacturing, merchandising, and store ownership just as the Lower Manhattan community was dissolving and relocating itself in Brooklyn.

If trading (importing and exporting) and manufacturing are what made America great, then it is no wonder that the Syrians' first view of New York was as an entrepreneur's paradise. Professor Michael Suleiman's paper presents impressions that early Arab immigrants had of New York and, by extension, the United States. Without intending to do so, he also explains why the Syrian-Lebanese at the turn of the century were so successful here. Being merchants "by nature," they generally thrived in New York. What they noticed was that commerce is an American obsession, as it was with them; for the most part they intended to fit right in. Yet many of the immigrants were not so sanguine on selling their souls for the sake of profits. Professor Suleiman's analysis compares and contrasts those who were impressed and challenged by New York and those who were not so favorably inclined. His wonderful paper offers a rare glimpse of life in this emerging metropolis and discusses how cultural expectations were both challenged and reinforced by the emphasis on moneymaking and economic prosperity. The reader is treated to what is good and bad about capitalism and American culture from the perspective of the immigrants.

A similar theme, though in a different medium, is presented by Gregory Orfalea in his paper titled "My Mother's Zither." This personal, but very representative, story traces the development of the arts in New York's Arab American Community. The emphasis here is on literature and poetry, the founding of the Pen Bond, and the emergence of Kahlil Gibran, Mikhail Naimy, and Elia Abu Madi as poets and writers onto the American scene. Long before it became fashionable, these poets and writers "sang" and wrote of alienation in American society and the general lack of "feelings" in human relationships. Orfalea then brings us up to the present with a review of the contributions to the arts that Arab New Yorkers are now making. He offers a political context for understanding their creativity and contributions. But, as Stanley Rashid reminds us in his paper on the musical traditions of early Arab immigrants, not all was gloom and doom or even political. Arab New Yorkers loved to sing, dance, and party—not just contemplate and analyze. Music was their life source and the Rashids were central players in preserving the legacy of Arab music and film in this country.

In her paper on contemporary Arab American arts and Arab Americans in the arts, Inea Bushnaq goes beyond music and traces the community's literary, artistic, and poetic history. The arts were a vehicle for preserving ethnicity and identity and for relating the community to the broader society. Along with growing Arab New York representation in the professions,

she describes beautifully the production and scope of the *Mahrajan al-Fan* held at the Brooklyn Museum of Art. The reader understands how the older *mahrajans* (outdoor picnics) of music, dance, and food evolved at this event into a festival of Arab arts and history. Because of its range and scope, Bushnaq's paper is both historical and sociological.

Given their diverse origins and the length of time that Arabs have been coming to the United States, my own paper attempts to link the early Arab Christian migration to that of the modern Muslim movement. My basic thesis is that to know where you (individually and collectively) are going you need to know where you have been. I compare and contrast the social context or setting of the early migration and the identities of those immigrants with those coming here today. The question addressed is how a group that is culturally united—but socially divided by generations, religion, identities, and historical circumstances— can transform itself into an ethnic group in a society that is generally hostile toward their interests. What it meant to be a Syrian in New York one hundred years ago and how that loyalty has changed into an Arab consciousness are important questions because Arab ethnogenesis is an ongoing and contemporary American phenomenon with broad implications for the American political landscape. The major focus of my paper is religious divisions, not only between Christians and Muslims but also within the Christian population itself, and how these distinctions affected group identity and integration.

This theme of growing up Arab in New York is personalized in the paper by Peter Awn, a Lebanese Maronite Catholic scholar of Islam. Professor Awn tells how he became conscious of his Maronite roots in Irish New York and later became a Muslim specialist. He notes how his experiences as a Maronite in Latin Catholic schools parallels those of Muslim students today in the city's public schools, complete with all the stereotypes and their effects on identity formation and ethnic pride. In searching out his own roots, he realized that becoming a "good Arab-American" meant that he had to know about Islam. This led him down a journey of discovery and rebirth in his own religious and cultural traditions.

Complementing both Kayal's and Awn's papers is the presentation by Professor Yvonne Haddad, who identifies the historical forces that shape and reshape the development of Arab American identities. National, religious, sectarian, and generational issues abound for emerging ethnic groups. In Haddad's view, the main problems or difficulties facing Arab American identity formation are in the political relationship of the United States to the Arab countries over time and in the negative stereotypes re-

garding Muslims and Arabs in general that dominate our news media. Haddad compares the early Christian migration with that of the modern era, noting that a stable ethnic community and identity are thwarted by sociopolitical contexts, the location of settlements, the reception given Arabs or Muslims, and the institutional autonomy of the community itself. She notes that the process of Americanization is impeded for Arab Americans by a profound awareness of an American double standard that dismisses Arab sentiment and rights. Haddad emphasizes the diversity of Arab American populations, with differences existing both between Christians and Muslims and within Islamic groups themselves, and how Arab nationalist sentiments affect these populations and their ability to cooperate with one another. In some ways Arab Muslim accommodations to American society have mirrored those of Arab Christians, but Haddad also highlights their unique characteristics, particular problems and issues, and the types of accommodations they have made. She ends with an important review of Arab American institutional development.

Christians and Muslims were not the only emigrants from the Arab East. As historian Walter Zenner reminds us, thousands of Syrian Jews, mostly from Aleppo, came to New York as well. Zenner gives us an important and rare glimpse into the life of this Brooklyn Sephardic community. Issues of identity and loyalty in the group mirror those of other groups divided by culture, origins, and religious practices. The author successfully reviews "the problem of numbers." Just how many Syrian Jews are there in Brooklyn? What does it mean to them to be Syrian and Jewish at the same time or how do they actually fuse these two identities with that of being Sephardic? How are they similar and different from their Ashkenazy co-religionists and what exactly binds them to their community are just some of the questions he raises. This paper is important because Zenner offers insight on the assimilation experiences of an often-ignored ethnoreligion, one that is economically affluent yet socially isolated. New York's Syrian Jews have been intimately involved with trade and commerce for decades, yet maintain distinct cultural nuances that differentiate them from other Jewish and Syrian communities.

Religious differences are not the only ones that exist between Arab New Yorkers and American society. Paula Hajar's ethnographic study of Arab students in city schools offers a glimpse of culture conflicts that exist between parental and school expectations. Her research on education is important because, of all the institutions that affect both acculturation and eventual assimilation, the schools are primary. Her focus is on how the or-

ganization and ideology of public schools impact Arab students' self-esteem and identity. Arab parents, teachers, and administrators often have conflicting views on what is good for the students and what the proper goals of education should be. Professor Hajar raises an interesting question when she wonders how her life would have been different if her own ethnicity was affirmed at the schools she attended. When the author was a student the prevailing societal ideology was assimilationist; now it is multiculturalist. Despite positive effects on the students themselves, her findings on Arab parents' reactions to this new ideology were surprising and should be of great interest to the reader and to educators.

If the earlier Christian immigrants from the Middle East had to establish their unique churches here to sustain their communities, so do today's Muslim immigrants. Reproducing Byzantine-style churches in New York was not easy. Today, authentically building or establishing mosques that capture the culture of the community is an equally daunting task. Dr. Jerrilynn Dodds's analysis of several New York mosques gives insight into the relationship of culture, theology, architecture, and community integration. As Dodds indicates, there is no singular Muslim architecture. The domed mosque is emerging as a unique American form of Islamic architecture, but theologically, it is not a central pillar of faith. Dodds surveys several small Muslim communities and observes how the architecture of their mosques changes with assimilation, ethnic group, and generation using them. Many of the same problems that the Christian Syrians faced are repeated today among Muslim Arabs. Is the mosque to be an ethnic or religious center or some combination of both? Should it be English oriented or ethnically committed? Arabic, of course, is the *lingua franca* of Islam, but is language enough to unite a community of believers? These are some of the questions raised.

The theme of a rising Arab Muslim community in the city is presented, indeed documented, by Louis Abdellatif Cristillo and Lorraine Minnite. In an intensive demographic survey of every New York City neighborhood, these authors document several trends. Not only is Arab migration no longer overwhelmingly Christian, it is no longer Syrian or Lebanese. It is Egyptian, Palestinian, Jordanian, Yemenite, etc. The variations differ by nationality and sect and by location. No longer limited to Brooklyn, Arab Muslims are found in every borough and have established numerous, flourishing mosques throughout the city. The authors' focus is on how culture and faith are maintained in a new country and city known for both its tolerance and its assimilationist tendencies. Their data compare the old and

new Arab migrations to the city and the relationship of Arab Muslims to those of other non-Arab ethnic groups.

Well-known political activist and lawyer Abdeen Jabara gives a personal account of his discovery of "Arab New York." His story is important because it focuses on the central issue of this conference: How can there be so many institutions and Arab communities yet no real integrated and representative political structures? Jabara highlights his often-accidental discoveries of Arab cultural centers and venues with stories about his role as a lawyer representing disenfranchised Muslims in the New York metropolitan region. He observes the reluctance of Arab New Yorkers to identify high-profile "crimes" by newer immigrants and the effects of these cases on community building. But just as he discovered his identity again in New York (through the arts), he is optimistic that Arab New Yorkers will bear witness to one another and become a functioning political force in the city.

Picking up where Michael Suleiman's paper left off, Evelyn Shakir's study of contemporary "bicoastal" Lebanese women offers impressions of New York from these modern, educated Protestant women émigrés here during the recent civil war in Lebanon. Her perspective is unique in that she examines how cultural conflict affects life for these migrants in New York and then again when they return to Lebanon, mainly Beirut. In this rich ethnographic study, these women represent cultural diffusion and identity changes. Coming from communal societies into the world of radical individualism, their impressions and survival strategies are recounted in first-person interviews. The women also act as agents of social change, returning to Lebanon more Americanized than they imagined while remaining loyal, with some difficulty, to their origins. Although their opinions of New York vary and reflect those of the early immigrants, they thrived in the cosmopolitanism the city offered them and struggled to reproduce the same in Lebanon.

One of the major themes alluded to in many papers and highlighted in the presentation by Professor Jack Shaheen is the reality of multimedia "Arab bashing." One of the few remaining groups that is continuously stereotyped negatively and without sanctions is Arabs and Muslims (the terms being used interchangeably). Professor Shaheen gives clear documentation to this phenomenon throughout the industry. He begins with a history of Hollywood films, moves on to television, and ends with a survey of children's comic books and comic strips. The paper is important because the author discusses the effects of such depictions on Arab American psychology and the ways such negative portrayals impact on community

building and integration. Part of the problem is the lack of a strong lobbying or interest group defending Arab interests. Shaheen offers some hope that change is in the making, citing the fact that media follows politics. As relations with the Arab world improve, so will the depiction of Arabs and Muslims. He credits change to the activities of many Arab American organizations.

Illustrating this volume is a selection of images, both archival and contemporary, of Arab New York. Six of those images form the basis for Jonathan Friedlander's graceful essay on the first immigration period. Such early images are all too rare (as indicated in the essay title), but those he has identified tell a compelling story: the first Arab immigrant, the first Arab immigrant family, the earliest view of Syrians on Washington Street, an early image of a Syrian peddler, the bustling Washington Street colony, and one of the last vestiges of the colony that remains. Together with maps created for the Muslims in New York City project at Columbia University, photographs of contemporary Arab New Yorkers by Mel Rosenthal, and other illustrations, these images further demystify the city's Arab communities and underscore, as do the symposium papers, their history, accomplishments, and contributions to the dynamism of New York City during the past one hundred-plus years.

PART ONE

Early Arab Immigration to New York

1

New York

The Mother Colony

Alixa Naff

New York City was the primary port of entry for the flood of immigrants who sought American shores. They came for a variety of reasons in the last quarter of the nineteenth century. Among the immigrants were Arabic-speaking sojourners who before World War I arrived from the Ottoman province of Syria, which included the administrative district of Mount Lebanon. It was from Mount Lebanon that 90 to 95 percent of the Arabic-speaking migrants originated, of whom about 90 percent were Christians. They called themselves Syrians. Even those relatively few who came from Palestine referred to themselves as Syrians. This ethnic reference was cultural rather than nationalistic, because before World War I there was no political entity that would justify a nationalistic identity.

Unlike millions of immigrants who were recruited in Europe by agents of industry and steamship companies, among other groups, Syrians were recruited, on the whole, by fellow countrymen, some of whom had attended the American Centennial Exposition of 1876 in Philadelphia. A few were encouraged to emigrate by the Presbyterian missionaries in Syria, who had established several American schools in Mount Lebanon and dispensed charity and health care. Syrians, like the large majority of other immigrants, entered through Castle Garden, the primary immigrant-processing center in New York Harbor that preceded Ellis Island, which opened in 1892.

When immigrants cleared customs, they generally were directed to the railroad room to be labeled for their respective destinations. Those heading

3

for the city were directed to a door marked "New York." Beyond that door, there might be relatives and friends to greet them. There certainly would be agents recruiting workers for industry or agriculture as well as unscrupulous men waiting to steal their baggage or cheat them out of their newly exchanged American money. Faris N., one of my informants, knew about them from the cousins who had recruited him and thus was able to outwit them.

The pioneer Syrians were not, on the whole, interested in industry or agriculture. They had come on a two- or three-year sojourn to get rich quick and return to their villages wealthier and prouder than when they left. They even talked about picking gold from the trees or off the streets. However, the majority stayed and drew family and friends, and before long they began to acknowledge that the gold they found was opportunity.

It is uncertain when or by whom the New York Syrian colony was founded. But it is quite possible that the founders were a few courageous and shrewd entrepreneurs among the Syrian merchants and artisans who had shown their wares at the Centennial Exposition in Philadelphia and were impressed by what they saw. Perhaps they went back to Syria, mulled over what they had experienced, and in a few years decided to return to America as immigrants.

After they cleared customs at Castle Garden, newly arrived immigrants boarded a ferry that brought them to the First Ward at the tip of Manhattan. A few blocks north, at Washington and Rector Streets, they found Washington Market, a bustling commercial center. The neighborhood appealed to them as a good location to establish the business ventures they undoubtedly had in mind. They rented a couple of brownstone houses at the tip of Manhattan and, stocking them with merchandise, used them as shops. They probably planned to wholesale this merchandise to pack peddlers, who would roam the residential neighborhoods of New York and beyond and, when their packs were empty, would return to fill them. For this venture a coterie of peddlers was needed. They probably wrote to relatives and friends in their own and nearby villages inviting them to come over and get rich quick. Some, like members of the Jabbour and Gorra families from Damascus and the Awn family from Lebanon, did come and did, in time, get rich—richer than they could have imagined. Then from among these early peddlers the founders sent recruiters back to villages in the homeland. Thus from an idea there developed a settlement and then a community that would become known as the Syrian "Mother Colony" for most subsequent

Syrian colonies that spread around the country. The dates of this pioneer or pack-peddling period are acknowledged to be about 1880 to 1910.

Pack peddling would become the magnet that drew Syrian immigrants. It was a lucrative trade, supplied and directed initially by a handful of astute entrepreneurs in the First Ward of the city, where the nascent settlement of Arabic-speaking immigrants was taking root. Syrians say that they learned the trade from Jews at the Centennial Exposition. Jews, in fact, had dominated the trade for most of the nineteenth century until the Syrians replaced them at the end of the century.

The above scenario, based on small and fragmentary data, is speculative. Yet this scenario is plausible and is accepted as fact by subsequent generations of Syrians and Syrian Americans as revealed in interviews and some published sources.

Hope of quick wealth spread like wildfire throughout the villages of Mount Lebanon and ultimately Syria and Palestine. Asked how he had learned about America, one informant said that while selling his wares in villages some distance from his home, he heard some of his customers discussing America and their plans to travel. Moreover, the once-a-week postmen's visits to villages were usually attended by fellow villagers anxious to learn what was included in the envelopes. It was not so much what as how much! Letters from America describing undreamed-of wealth and containing remittances were better recruiters than the swaggering, well-dressed men sent by the New York entrepreneurs.

And the Syrians did come. In the eighties, they trickled in. Their annual numbers were counted in double digits. From the 1890s they began leaving their villages in ever-increasing groups. Faris N. left his village in 1895 with thirty-one other men and one woman. Mike H. traveled that same year with seventy-one men and women from his village because they learned that one of the poorest villagers had sent $800 in remittances to his family. It was said that as many as 200 people left some villages. By the late nineties the immigrants were counted in the thousands. The United States Department of Commerce and Labor estimated that between 1899 and 1907 some 41,404 Syrians were admitted. By 1910 the figure swelled to 56,909, a veritable exodus from the homeland.

Although most Syrian arrivals during this period were young, unmarried men, many wives and other female relatives came as well. The women, as anxious as the men were to help their families, proved to be valuable assets in the manufacturing and peddling trades. On the whole, these immi-

grants were poor and unschooled village farmers or artisans, but they were not destitute or ill mannered. About 10 percent were educated professional men who would play important leadership roles. They all knew about New York (or "Nay Yark," as they called it) and why they were going there.

The majority of Syrian immigrants who reached the New York colony were transient. Many used it as a way station on their journey to relatives and friends in settlements patterned after the "Mother Colony," which were, by 1910, found in every state and territory in the country, proving historian Philip K. Hitti correct when he noted that "trade takes a man far."

By 1890 the growing numbers of immigrants spurred the Bureau of Immigration to hire Najib Arbeely as interpreter and facilitator. He served the bureau and the colony in several ways. For example, he directed immigrants with no specific destination to the colony, thus sparing them a sense of anxiety, fear, or loss while adding to the peddling population of the colony. Later, he directed them to settlements further afield to connect them with people of their own village and faith. As in the homeland, Syrians in settlements congregated by place of origin and religion.

By the time a *New York Tribune* reporter described the New York colony in 1892, it was brimming with success and the shopkeepers were casting about for more business. "It was," the reporter wrote, "a buzzing trading center and middle eastern bazaar transplanted to the first ward where the North and East rivers meet. Bounded by Rector, Greenwich, Morris, and Washington Streets, it was the wellspring of Syrian peddling in America." "The wholesale dealers," he continued, "are of great help to their poorer countrymen, often advancing to them not only goods but money with which to trade, and although there are large sums outstanding at times, the Syrian colony has yet to furnish a case of bankruptcy, and the credit of the tradesmen is first class." The reporter also commented on housing in the colony. "The houses, especially on the Washington side of the block are old, weather beaten, dingy and sometimes dirty cellars are devoted to trade and packed full of everything which a peddler can carry in his pack or find a market for in his wanderings, and the first or ground floor is generally used as a display-room and office where the goods are sorted out and bargains made—these sojourners from the east are sharp traders." He went on to enumerate a myriad of products. "And in the midst of all this riot of the beautiful and odd, stands the dealer, the natural gravity of his features, relaxed into a smile of satisfaction."

Lucius Hopkins Miller, in a 1904 study of the Syrian communities of greater New York, characterized the colony as the dumping ground for new

arrivals. Other accounts of the colony recall a multitude of transient and resident peddlers crowding the morning streets, stuffing their suitcases from suppliers, ambling along as they selected items from the many basements and living-room shops, and finally moving out in groups in all directions—veterans with newcomers in tow.

There are several other picturesque descriptions of the early colony. One is by W. Bengough, whose 1895 drawing depicts the colony's quaintness. He was impressed by what he called the "color" given to little Syria by its alien tongue and colorful appearance. "There's a queer mingling of American and Syrian costumes," Bengough wrote. "Women cooked the traditional dishes from ingredients imported from the homeland and visited in airless rooms of boarding houses, for at least sixty percent of the men either have no families or have left them behind in Syria. The boarding house was necessary for at home life . . . there is little in this colony. The Population is constantly shifting and the families who are here find their homes utilized as headquarters by those who are not yet settled."

Ameen Rihani, an eminent Arab writer, created two fictional characters who peddled from a rented cellar and reflect that a peddler is superior to a merchant. "We travel and earn money; our compatriots, the merchants, rust in their cellars and lose it," the peddlers assert. "To be sure, peddling in the good old days was most attractive. For the exercise, the gain, the experience, these are the rich requirements." Many of the real-life peddlers who experienced the hardships and hazards of being on the road would heartily disagree.

Abraham Mitrie Rihbany, a religious student, found the colony's single-minded infatuation with the peddling trade repulsive. "Call it pride, vanity, or whatever you please, whenever I thought of peddling jewelry and notions, death lost its terror for me," he recalled.

The overwhelming majority of Syrian immigrants took up pack peddling as a trade. The reason it was so appealing was that it required no large investment of money and no proficiency in English. The most expedient characteristic of peddling was its itinerancy. That is, peddlers could abruptly leave the trade to return to their home village on family business then return to America and pick up peddling where they had left off if they chose. The job's most attractive aspect was the income it yielded. Despite the hardships, the average peddler's annual income was about $1,000 while industrial laborers earned about $650 at the turn of the twentieth century.

Many Syrians took their earnings and returned to the homeland. Some acquired property or improved their homes. The visibility of red tile roofs in the villages advertised to neighbors and friends that the owners had been

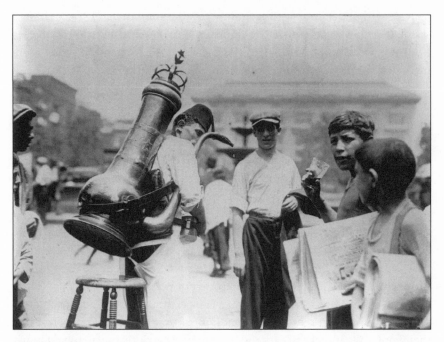

A Syrian selling cold drinks in New York about 1910. The beverage in the copper vessel was probably water flavored with licorice, a traditional Syrian drink. Photograph by Bain, courtesy of the Library of Congress.

to America and enjoyed a higher status. They may also have fathered children before returning to the United States. The extent of the two-way traffic across the seas was surprising.

Out of this hectic atmosphere a number of leaders emerged to lend the colony some sense of order. They gained a grip on the economic potential that was fermenting around them and turned what had been a colony into a community. No group poured more high hopes and energy into the minds of their people than did the great merchants, especially the colony founders and spokesmen: the editors and publishers of the Christian Arabic newspapers. One of the most consistent advocates of entrepreneurship and success through hard work was Salloum Mokarzel, the younger brother of the publisher of *Al-Hoda*, one of the oldest and most influential Arabic newspapers published in the colony. He contributed several articles to English newspapers promoting the merchants and manufacturers of the colony. Mokarzel

also published articles and books in Arabic. He urged his people to engage in trade, and he tied success in it to Americanization.

The Syrian Press, which Mokarzel owned, published his books as well as those written by members of the community. The types of business endeavors that sprouted and expanded in the New York colony are too numerous to include here. They are, however, listed and described in the *Syrian Business Directory 1908–1909*, published in New York by Salloum Mokarzel and a colleague. The directory lists the number and kinds of Syrian-owned businesses in the growing colony, which by 1908 had expanded to Brooklyn. The directory also records Syrian businesses in every city, town, and hamlet in every state of the union.

Salloum Mokarzel had two major obsessions: publishing and commerce. He combined these concerns and put them to practical use in the interest of Syrian trade in America. In addition to the directory, in 1909 he published a short-lived monthly on trade called the *Courier of America*. In 1918 his *Syrian American Trade Magazine* appeared and was followed in 1920–21 by the *History of Syrian Trade in the United States*, illustrated with photographs of the establishments of the great merchants.

Before the nineteenth century was out, several successful Syrian manufacturers, importers, and wholesalers had arisen. Some manufacturers produced kimonos; others turned out shirtwaists, lingerie, and laces utilizing the labor of immigrant women. There was also a large trade in oriental rugs as well as in imported linens and laces.

Nazha H., who with her husband made the transition from selling dry goods to selling oriental rugs and imported linens, said in an interview, "Many peddlers started carrying linens several years before World War I. They were supplied by importers in New York who specialized in importing goods to supply peddlers." These import houses would send salesmen from New York to the widely dispersed Syrian communities. The salesmen would bring their trunks full of such prestigious goods as imported linens, laces, and oriental rugs, and the peddlers (now calling themselves "traveling salesmen") would buy their stock on consignment. "The importing house would give them credit up to $2,500," Nazha H. recalled. "Listen, the importers in New York had agents who would buy from manufacturers in Italy, China, France, etc. They got laces from France and *madeiras* from Brussels. They got the cutwork from Italy. The Syrians had people make goods for them in China and the Philippines long before it became fashionable to do so. They would pay people to make laces and embroidery in their

houses—a cottage industry." Joe D. of Grand Rapids, Michigan, and some of his colleagues echoed this description.

I must confess that I was surprised to see the sophistication and extent of advertising used by the merchants, bankers, manufacturers, and other tradesmen in Arabic and English newspapers as well as in the *Syrian Business Directory*. The New York merchants did not only import merchandise to be sold to peddlers; they imported ingredients for Syrian recipes and kitchen utensils for preparing Syrian food as well as other cultural artifacts for the pleasure and comfort of immigrants. Syrian communities as distant as Texas and California simply ordered what they wanted in bulk and it was sent to them by rail. There is no doubt that this kind of endeavor was much appreciated by the immigrants and quite lucrative for the merchants.

The Syrian population in the colony expanded and more women and families arrived, especially in the 1890s. The character of the colony began to change into that of a nascent community with its native institutions. Between 1890 and 1895, three of the Eastern-rite (Catholic) faiths—Maronite, Melkite, and Eastern Orthodox—had established churches in Manhattan. There is a cornerstone in what is now a trendy bistro on Washington Street that reads "The Syrian Church," a remnant of the first Melkite church. The small group of Protestants was able to meet in the home of its leader. Eventually all moved to Brooklyn.

Kawkab Amerika, published by the Arbeely family in 1892, was the first Arabic newspaper in the country. It was quickly followed by several other dailies, weeklies, and monthlies, most notably *Al-Hoda* and *Al-Naar*. That same year the Syrian Society was organized by Dr. Ameen Haddad, the prominent leader of the small Protestant community, "for the purpose of providing an educational and industrial institution for natives of that [the Syrian] race, by which they shall be taught the English language and such branches of learning and industry as may assist them to support themselves, and to become intelligent American citizens." This evolution is what Louise Houghton meant when she wrote in her series of articles in 1911, "Very early in its development, the colony began organizing around ethnic institutions, creating a small society of rich and poor, educated and unschooled." The colony served the Syrian immigrants not only economically (the primary reason for its existence) but also socially and culturally. By priority, complexity, and prosperity, the New York community was the model some early pioneers tried to recreate in other parts of the vast American market.

It was, in every respect, worthy of the title of "Mother Colony."

2

The Syrian-Lebanese Community
of South Ferry from Its Origin to 1977

Mary Ann Haick DiNapoli

Since the beginning of the twentieth century, Atlantic Avenue and its surrounding communities of Brooklyn Heights and Cobble Hill have been home to countless numbers of Arab Americans, especially Syrian and Lebanese Americans. This area has been a cultural and commercial center for the entire metropolitan area as well. The focus of this essay is the South Ferry community from its origin to 1977.

From Syria and Lebanon, then part of Greater Syria, and from an earlier colony on the Lower West Side of Manhattan, they came to Brooklyn, especially to what was then known as the South Ferry area. Researcher Lucius Hopkins Miller, who surveyed the Syrian communities in New York in 1903, defined South Ferry as that part of Brooklyn bounded by the East River on the west, Joralemon Street on the north, Boerum Place on the east, and Warren Street on the south.[1]

The colony's early period—from the community's origin around the turn of the century through 1909—was an era of beginnings. Churches and societies were organized, businesses were started, and the population of Syrians in the area grew. The second phase of the South Ferry community's development was from 1910 to 1923. This was a time of transition and, in spite of some immigration-limiting legislation, a time of multifaceted growth. The "Golden Age" of the community occurred between 1924 and 1950, when it was a nearly self-sufficient ethnic community that was both residential and commercial. Between 1950 and the late 1970s, the Arab American community of South Ferry lost its residential population but maintained its commercial integrity.

As early as 1895 there were said to be thirty Syrian families living in Brooklyn.[2] The U.S. census of 1900 records 102 persons in South Ferry listing Syria or Turkey as their birthplace.[3] The number of Syrian immigrants had increased to 442 by 1905.[4] In 1904 South Ferry had more than twice as many Syrian inhabitants as did the South Brooklyn community.[5] On the other hand, South Ferry was small compared to the 1,300-plus population of the Manhattan colony.[6]

During this time, Syrians whose businesses were in Manhattan were "attracted socially by the Brooklynites and naturally by the quiet and healthy atmosphere of Brooklyn." The South Ferry area was recognized early as a Syrian colony.[7] The majority of Syrians there at that time lived in rented apartments.[8]

Transportation links between the Washington Street colony and South Ferry in Brooklyn included the ferry after which the Brooklyn community was named. It ran from the foot of Atlantic Avenue in Brooklyn to Manhattan's South and Whitehall Streets. The latter adjoined New York's "Little Syria" on the south.[9] By 1910 the two areas were also linked by the Interborough subway.[10]

The Syrian population of greater New York and of South Ferry in particular was overwhelmingly Christian.[11] The transition from a people without a church to a religious community followed a pattern and often took years to complete. When Syrian Catholics, for example, "reached a sizable proportion of the population they would try to retain the services of a priest of their faith and preferably of their rite. . . . Services would first be held in the halls and basements of the Latin parishes until funds, permission and property could be obtained."[12]

The Maronite Catholics were the first to establish a church in the South Ferry area. The parish of Our Lady of Lebanon was founded in March of 1903. A house and grounds at 295–297 Hicks Street was the initial location of the parish center.[13] The Melkites, or Greek Catholics, worshiped in the basement of St. Peter's Church on Barclay Street in Manhattan until their own church of St. George was established nearby.[14] The Syrian Orthodox parish purchased 301–303 Pacific Street for its congregation, and in 1904 St. Nicholas Church was named a cathedral.[15] The church is not strictly within the boundaries of the South Ferry area, but it was not considered distant from where the churchgoers resided; thus South Ferry Orthodox were no doubt members of its congregation. By 1907 the Syrian Protestants were using the Second Unitarian Church on Clinton and Congress Streets for meetings on Sunday evenings.[16]

Other religious groups, some of which might be expected to exist in a community of Syrians, were noticeably absent. Miller found no Jewish families in his survey of South Ferry. Nor were Muslims or Druse noted in South Ferry in 1903.[17]

Philanthropic activity at this time was largely sectarian.[18] An early and important nondenominational self-help group was the Syrian Ladies Aid Society of Brooklyn. Founded in 1907, this organization had as its chief purpose the care of immigrant Syrian women.[19] The Syrian American Club was founded in 1908 and for at least part of its existence was headquartered on Amity Street in South Ferry.[20] In the same year the Syrians formed their own Masonic chapter, the Damascus Lodge. Their meeting place was the Masonic Temple at Lafayette and Clermont Avenues in Brooklyn.[21]

Even during this early period, the Syrian press flourished. In their 1975 book, *The Syrian-Lebanese in America*, Philip Kayal and Joseph Kayal identified "the creation of a viable Arabic press" as a primary concern of Syrian and Lebanese immigrants. An article in the *Brooklyn Daily Eagle* in

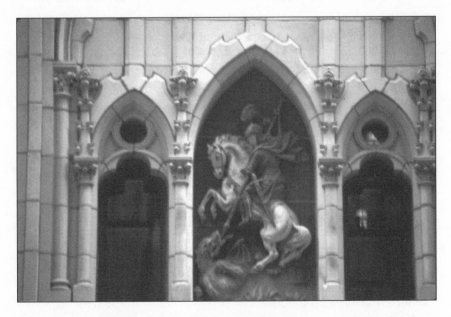

Site of St. George Syrian Catholic Church, Washington Street. While the church building, complete with its colorful statue of Saint George, still stands on Washington Street, it is now occupied by a restaurant. No original church elements remain in the interior. Courtesy of Mary Ann Haick DiNapoli.

1907 verified the publication of eight newspapers and two magazines by Syrians in New York City. Two of the earliest such newspapers were *Kawkab Amerika* and *Al-Hoda*.[22] It was said of *Al-Hoda*, the longest-lived and most prestigious of the newspapers, that through it "newly arrived immigrants of Arabic-speaking origin were helped . . . to a better understanding of American citizenship."[23]

With the exception of peddlers, nearly all of the South Ferry working population around 1903 and 1904 worked in Manhattan, "almost exclusively within the borders of the Syrian quarter there."[24] A random sampling of contemporary newspapers showed that all New York City advertisements were for Manhattan businesses.[25] Some Syrians did work in non-Syrian-owned stores and factories in Brooklyn.[26] The South Ferry colony, primarily a residential area, housed little, if any, industry at this time.

Whether they were peddlers or store-owning merchants, Syrians, as a group, were very much involved in commerce. The largest number of Syrian household heads in South Ferry in 1900 was engaged in sales.[27] South Ferry Syrians in 1904 had stores (33.6 percent), worked in factories (21.8 percent), peddled (18.2 percent), and were involved in needle trades (12.9 percent). In addition, 7.7 percent were clerks and 5.8 percent were professionals. Among those who were classified under the headings of "factory" and "store" were wealthier Syrians who were probably owners of these establishments.[28] The majority of clerks worked for other Syrians; a few, however, were with American firms.[29] Child labor existed only to an imperceptible degree in South Ferry.[30] The 1905 New York State Census statistics show that the greatest number of Syrian heads of household were merchants. These represented 20 percent of the total of employed heads of household.[31]

"Successful peddling became the base industry through which the [Syrian] community entered the American mainstream," observed the Kayals.[32] Peddling was a means of earning a livelihood that required no training, bound no one for any length of time, and was an attractive alternative when no other jobs could be found.[33]

Miller found that peddlers most frequently lived near the ferry on Furman Street, Columbia Place, Columbia Street, Emmett Street, and Atlantic Avenue.[34] In 1905 all peddlers who were heads of household lived either between Hicks Street and the waterfront or on Atlantic Avenue. As the peddlers prospered, they would move away from the waterfront and commercial streets.[35]

Miller also found that the stores maintained by Syrians generally

served one of three purposes. The first type ministered "to the immediate needs of the community" and were mostly "grocery and provision stores." The second type included wholesale and retail dry goods and notion stores. In the third category were wholesale and retail stores carrying oriental goods.[36] During the period 1907 through 1910 there existed more than a dozen Syrian-owned groceries.[37] The Syrians also maintained two bakeries, a drug store, a shoemaker, a tailor, two barbers, and a glazier.[38] South Ferry could boast an Egyptian and Turkish cigarette manufacturer and an importer of rugs.[39]

The federal census of 1900 and state census of 1905 show the prevalence of the needle trades. Miller noted that many Syrian women were kimono home-workers. Most of their work was supplied by Syrian kimono-factory owners.[40] Embroidery, shirtwaist, and lace manufacturers as well as a knitting factory were located on Atlantic Avenue by 1910.[41]

The South Ferry community was the residence of the small professional class of Syrians in New York City in the early years of the twentieth century.[42] Two dentists and five physicians were practicing in South Ferry by the end of the first decade.[43]

One of those Syrian doctors would become a beloved figure in the community and the inspiration for a foundation to help finance Syrian American students pursuing higher education. Risq G. Haddad was a founder of the United Syrian Society and "distinguished himself for his leadership among his people." The Risq G. Haddad Educational Foundation was established in 1943 after his death.[44]

Some Syrians in South Ferry held rather unusual jobs. One was a midwife who gave "scientific and best treatment."[45] Also in the community were an engineer, a surveyor, and the artist A. T. Ghosn.[46]

In a 1911 article Louise Seymour Houghton quoted an unnamed New York newspaper known for its generally unfavorable coverage of the Syrian immigrants as admitting, "there is not a more industrious or capable representative of the East than the Syrians. He generally brings money, lives at peace."[47] According to the Syrian American writer K. A. Bishara, the Syrians' home life was "fortified by very strong filial-parental ties, buttressed by extremely intense affection." The *Brooklyn Eagle* in 1907 reported the Syrians' eagerness to become Americans and their speed in doing so.[48]

As was true on the national level, Syrians in New York did not escape discrimination. Houghton cited another unidentified newspaper's statement that "numberless" unreported "shootings and stabbings" took place

among the Syrians, but countered the report by stating that there were no police records that confirmed the tabloid's claim.[49]

It is to be expected that the displacement of one immigrant group by another would create some disturbances. In both the early Manhattan and Brooklyn colonies, the Syrians moved into areas hitherto occupied by Irish immigrants. With the subsequent displacement of the old by the new, "hostility between the two groups was frequently in evidence."[50]

Considerable change occurred in the second (1910–23) period of the South Ferry community. Houghton wrote that it had become "both a residence and an industrial colony."[51] The importance of South Ferry as a Syrian-Lebanese settlement is obvious in that by 1915 more than two thousand Syrians lived there.[52] The Syrian-born population of the city of New York numbered 4,485 in 1921, with more than half of all Syrians in the United States living there.[53] The BMT subway line, which by 1920 connected the Washington Street colony with Brooklyn Heights, helped bring more Syrians to Brooklyn.[54]

This era was one of not only comparatively large-scale immigration but also perhaps the strongest anti-immigration feeling in the history of the nation. The general nativist mood of Americans resulted in a series of legislative acts that restricted the flow of immigrants. A 1917 Congressional measure imposed a literacy test on immigrants. Much more restrictive was the Quota Limit Act of 1921, which set Syria's annual quota at 882.[55]

In the religious sphere, this period was a time of transition and of new beginnings. The Melkites first rented church facilities in Brooklyn, holding services in the basement chapels of two Latin-rite churches in the area from 1910 until 1924. During this time work began on their own church building. The Syrian Orthodox St. Nicholas Cathedral moved to its present location at 355 State Street in 1920.[56]

South Ferry was becoming a full-fledged ethnic community in other ways. By 1923 the area could boast its own newspaper. The *Syrian Daily Eagle*, established in 1914, had its offices at 181 Atlantic Avenue.[57] Another Brooklyn newspaper, *Al-Bayan*, at 391 Fulton Street, had the distinction of being the only Muslim newspaper being published in America.[58] Syrians in Brooklyn also subscribed to *The Syrian Review*. This New York-based English-language magazine was founded in 1917 "to interpret the best and highest in American civilization to the Syrians and the Syrian civilization to the Americans."[59]

One example of philanthropic activity at this time was the creation in 1916 of the Syrian Education Society, headquartered at 153 Clinton Street.

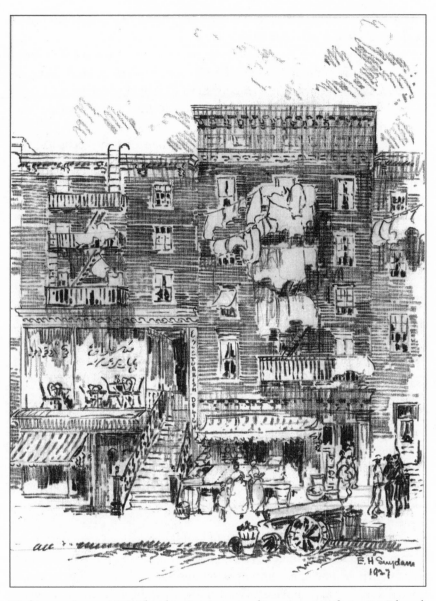

Washington Street, 1927. This drawing was one of twenty-seven that artist Edward H. Suydam (1885–1940) created for Will Irwin's book, *Highlights of Manhattan* (New York, 1927). All are in the collection of the Museum of the City of New York. MCNY J. Clarence Davies Collection 29.100.2233.

The society awarded fifteen scholarships between 1916 and 1920 to students of "Arabic-speaking origin."[60]

Syrians responded to the challenge of World War I in various ways. Even before the United States entered the war, the Syrian American Club wired President Wilson that its members would enlist to defend the United States, "our beloved country."[61] Syrians also formed their own Boy Scout troops and Red Cross chapters.[62]

The period from 1911 to 1923 marked a change in the occupations of South Ferry's Syrians. By the beginning of this second era it could be reported that "Syrians had entered every branch of commerce from banking and importing expensive oriental commodities to small trading."[63] Cigarette factories helped some Syrians make their fortunes. Just as important to the economic well-being of the entire Syrian community in New York were the city's "Syrian manufactories of kimonos, embroideries, suspenders and the like."[64]

Habib Katibah, a Near East correspondent for the *Brooklyn Daily Eagle* and other American newspapers, wrote that "peddling gradually lost its primacy as a peculiarly Syrian occupation. Many Syrians became owners of wholesale houses in New York . . . selling goods to other peddlers of Arabic-speaking stock and other nationalities. They also sold goods to department stores, thus shifting the volume of goods to be disposed to the public from the peripatetic vendor to a stationery [sic] store."[65]

This statement was supported by the findings of the 1915 New York State Census. For employed Syrian persons who were heads of households, peddling no longer ranked as one of the top five areas of employment. By this time, peddling was superceded by jobs in retail or wholesale firms and by occupations in the needle trades.[66] Commercially, Court Street attracted some Syrian businesses, including the Malouf Phonograph Company and Saleeby's Drug Store.[67]

The decrease in peddling and a slight difference in geographical distribution in the area are indicative of the growing prosperity of the community as a whole. In comparing where Syrians lived in 1905 and in 1915, one finds that there was a move eastward and southward, away from the waterfront and from peddling and toward greater prosperity and the mainstream of American life.

The years from 1924 to 1950 were the "Golden Age" of the Syrian-Lebanese community of South Ferry. Habib Katibah called these years "the period of diversification" for Syrians, a time when they entered "completely into the American heritage, branching out into all the economic

and social activities of the country, being represented in practically every industry and profession open to all Americans and becoming American citizens."[68] Yet it was also during this period that expressions of Syrian-Lebanese ethnicity were most vigorous.

South Ferry was an important residential area through the 1930s, although Syrians had already begun moving to Park Slope, Bay Ridge, or "wherever living is comfortable."[69] South Ferry's primacy as a Syrian center, however, was reinforced in the 1940s, when construction of the Brooklyn Battery Tunnel forced the relocation of most Washington Street Syrians and their businesses. While the Washington Street area would not be completely abandoned until 1947, in 1933 one writer noted that "it is now Atlantic Avenue and not Washington Street that is the principal habitat of the species Syrianica."[70]

In 1925 the Syrian South Ferry population numbered 1,745.[71] A 1930 directory noted nearly 2,200 Syrian and Lebanese households in Brooklyn, of which 33 percent were in South Ferry.[72] By the end of this era, greater numbers of Syrians were living in the Park Slope and Bay Ridge sections of Brooklyn.[73] Margaret Mara wrote in 1949 that, "although Bay Ridge is the home of the largest section of the borough's Syrian population, you will find more evidence of the Syrians in the downtown sections where their churches, restaurants and food stores are centered."[74]

In 1924 a survey made by the Syrian American Club showed that half of the Syrians in Brooklyn who were eligible for citizenship were actually citizens.[75] By the late twenties the Syrian American press was urging readers to go to the polls, to become politically active, and to be less concerned about politics in the homeland.[76] At least 75 percent of Syrian immigrants were naturalized Americans by 1929.[77]

The general climate of the country, however, continued the restriction on immigration begun in 1921. The flood of Syrians to the United States was held in check by the National Origins Act, passed in 1924 but not actually effective until 1929.[78] The legislation set each country's quota at "two percent of the number of foreign-born individuals of such nationality resident in the continental United States as determined by the census of 1890, the minimum quota being fixed at one hundred." Syria's quota was thus reduced to one hundred.[79]

Nevertheless, growing political clout on the local scene was evidenced in the 1930 election of Syrian American George C. Dagher to the Republican leadership of the First Assembly District in Brooklyn. South Ferry comprised a part of that district. At the time Dagher was "the only Ameri-

can of Syrian extraction to be a leader and executive of a political organization in the state of New York, if not in the United States." [80] In 1933 Dagher brought out the Syrian vote for Fiorello La Guardia, who ran for mayor on a Republican Fusion ticket and won. Dagher proudly noted that this election marked the first time that "we Americans of Syrian extraction united for a political cause not prompted by any motive save that of good citizenship and the welfare of the whole community." [81]

Syrians had largely entered the mainstream American economy by this time. In 1925 one-third of the working immigrant household heads in South Ferry were involved in the needle trades. Only one wage earner claimed to be a peddler and other occupations ranged from engineer to woodworker. [82] Abdo Elkholy found that in the Syrian American community during the depressed, pre-war thirties, "grocery stores, restaurants, bars and itinerant peddling helped the Arab-American family to exceed the average income of all American families." [83]

Certain businesses appeared to be prominent among South Ferry Syrian Americans in 1930. The lingerie business flourished on both Court Street and Atlantic Avenue. [84] One of the most successful New York houses in the field, Kiamie Brothers, was located in Brooklyn at 164 Atlantic Avenue. [85] Several embroiderers were to be found in the area, as were fourteen tailors. [86] Numerous Syrian Americans rented out furnished rooms and at least one-third of these people were women. [87] Fifteen Syrian Americans were listed as grocers in the 1930 *Syrian American Directory* and at least two of them, Kirshy Brothers and Sam Arbeeny, would be community fixtures for many years. [88]

Also during this time, nearly one-half dozen Syrian physicians were located on Clinton Street, including Fuad I. Shatara, a surgeon and instructor in the School of Medicine at Long Island College Hospital. Najib Barbour, also a physician, was another prominent South Ferry Syrian. [89]

The Syrian American community in South Ferry in 1930 also boasted a lawyer, a shoe manufacturer, and even a fragrance house, the Lebanon Perfume Company, the latter on Atlantic Avenue. [90] The Syrians also maintained a financial association in South Ferry: the Damascus Industrial and Financial Corporation, housed at 201 Clinton Street. [91] The Oriental Mercantile Co., selling "pastries, groceries and confections," opened at 151 Atlantic Avenue in 1926. Alexander Alwatan established a bakery at 150 Atlantic Avenue in 1928. [92]

The South Ferry community had grown not only commercially but also in other ways. It contained within its borders several houses of worship

Advertisement for Atlantic Avenue businesses that appeared in the *Syrian American Directory 1930*. Courtesy of Mike Homsey.

by the 1930s. In 1939 the Islamic Mission of America Mosque opened at 143 State Street.[93] Our Lady of Lebanon remained on Hicks Street until 1944 when it moved to a sanctuary on Remsen and Henry Streets that had been the Congregational Church of the Pilgrims.[94] The Melkites opened a basement Church of the Virgin Mary at Amity and Clinton Streets in 1924.[95] The St. Mary Antiochian Syrian Orthodox Cathedral was on State Street and Boerum Place until 1951.[96] In 1952 St. Mary's Church relocated to Ridge Boulevard in the Bay Ridge section of Brooklyn from its previous property at 201–203 Clinton Street.[97] The borough in 1924 had the unique distinction of being among the three urban areas in this country that had Syrian Protestant congregations with their own buildings. In addition to these major sects, there were a small number of Syrian Russellites (antecedents of today's Jehovah's Witnesses) who met several times a week at 131 Pacific Street.[98]

Beginning in this period, Syrian organizations were no longer based almost solely on religion. Organizations varied in their purposes; some were formed on the basis of town of origin, such as the Damascus Fraternity, the Beyrouth Young Men's Society, and the Aleppo Social Club. Some were educationally oriented, like the Syrian Educational Society of New York and the Book Club. Still others, such as the Junior League, were charitable in nature.[99] During the Depression, the Syrian Ladies Aid Society did much for the relief of needy Syrians.[100] The American-Syrian Federation, which met for a time at 153 Clinton Street and later on Schermerhorn Street, was interested in "everything Syrian, encouraging Americanization while preserving the worthwhile traditions of the old country."[101] The Syrian Young Men's Association (SYMA), first organized with fifteen members in 1935, would be among the most long-lasting and well-known of Syrian American clubs.[102] Other clubs included the Arab Music Club and the Syrian American Club.[103]

Although some Syrian clubs had their own facilities, numerous Syrian fetes and activities were held at local hotels and at the Brooklyn Academy of Music. Dances and dinners were frequently given at the then-luxurious Hotel St. George on Henry and Clark Streets.[104] In 1929 the Brooklyn Academy of Music was the site of an Arabic play performed by the St. Nicholas Young Men's Society.[105] In the spring of the same year, an Amity Street resident, Fedora Kurban, known as "the Syrian nightingale," gave her first concert in New York.[106]

At one time, *Al-Hoda*, perhaps the most important Arabic newspaper in the Americas, was literally part of the South Ferry community. Its publication plant was moved from 55 Washington Street in Manhattan to 169

Court Street in Brooklyn in 1930.[107] This move preceded a relocation back to Manhattan. Salloum Mokarzel, brother of Naoum Mokarzel, who published *Al-Hoda*, published *Al-Majallah Al-Tijariyeh (The Business Review)* to report the business activities of the Syrian community. He also published the English-language journal *Syrian World*, which first appeared in 1926 as a monthly devoted to "literature, history, sociology and the arts."[108] This magazine was the only Syrian publication in English around 1930. The *Syrian World* was published until 1932, by which time its format had changed to that of a weekly newspaper. In 1933 Salloum Mokarzel took charge of the family-owned *Al-Hoda*.[109]

Other newspapers and magazines serving the Syrian American community at this time included the *Syrian Daily Eagle* and *Miraat-al-Gharb*. The latter began publishing a page in English in 1927.[110] The *Syrian Daily Eagle* continued to originate from Atlantic Avenue through at least 1930.[111] Syrians also became active in the local American press. Habib Katibah and Joseph Abbott both wrote for the *Brooklyn Daily Eagle*.[112]

Syrian Americans enjoyed films from Middle Eastern countries during this period. Beginning around 1939 Arabic films were shown regularly at the Brooklyn Academy of Music.[113] Brooklyn radio station WBBC was just one source of Arabic music programs in the 1930s.[114]

During this time Syrians were contending not only with the pressure to conform but also with the badge of being different. "Race prejudice" was cited as a problem facing Syrian American youth in the late 1920s.[115] As a result, the second-generation Syrian American may have been "prone to look with contempt upon the language and queer customs of his parents."[116] The general Syrian American view of the community's future seemed to be a compromise: one should be more concerned about American than Syrian politics and problems and yet still be aware and proud of one's ancestral heritage.[117]

While coping with being new in a strange society, Syrian and Lebanese Americans rejoiced in the opportunities the United States provided. Although there was already a realization that cherished culture and customs might be lost in time, the stark reality of that loss was not evident until the latter part of this period. At that time the community would also witness the great residential change marking the end of South Ferry's importance as a Syrian-Lebanese residential center.

In the quarter century between 1950 and 1977, South Ferry maintained its status as a metropolitan Middle Eastern center. Atlantic Avenue in 1950 was considered the "main thoroughfare" of Syrian and Lebanese

Americans, although by that time the local Arabic newspapers and some restaurants had moved to mid-Manhattan.[118] By 1960 Atlantic Avenue was called New York's "principal Arabic-speaking area."[119] Its appeal reached farther than the immediate South Ferry area. Atlantic Avenue and its environs were "the Syrian shopping center of Brooklyn, Manhattan and New Jersey."[120]

By the 1970s Atlantic Avenue was located in the middle of a declining neighborhood, as indicated by the designation of Cobble Hill in 1961 as "suitable for urban renewal treatment." The Syrian Young Men's Association protested that urban renewal would invite the local Syrian-Lebanese community "to commit ethnic suicide."[121] Although urban renewal did not occur, the population shifted nonetheless. The Syrian-Lebanese population moved to Park Slope and Bay Ridge, after brownstones were turned into rooming houses and poorer Puerto Rican immigrants moved into the area. Later, when the nineteenth-century houses of Cobble Hill appealed to professionals who could not afford to buy in Brooklyn Heights, many Syrians and Lebanese were forced out of the neighborhood by increased rents.[122]

The period from 1950 to 1977 in South Ferry marked the transformation of the area from a residential and commercial Syrian-Lebanese community to a largely commercial one. Syrian and Lebanese Americans continued to live in Brooklyn Heights and Cobble Hill, although Bay Ridge, especially exclusive Shore Road, became their primary residential area. Syrians and Lebanese from the "downtown" area began trickling into Bay Ridge as early as 1950. Correlated with this movement was the building of 3,400 new dwelling units in Bay Ridge by 1959.[123]

Commercially, however, South Ferry maintained its importance. The grouping of merchants on Atlantic Avenue selling "Syrian bread" (commonly known as "pita"), pastries, and groceries formed what various writers have called "an Arab quarter second to none in the country," "the crossroads of the Arab-speaking communities of the New World," and "the principal Middle Eastern commercial area on the East Coast."[124]

The Atlantic Avenue of the 1970s, symbolic of the commercial importance of South Ferry, was the result not only of decades of Syrian-Lebanese settlement but also of the invigorating influx of newer immigrants (following the repeal in 1965 of the 1924 National Origins Act) and appreciative "brownstoners." There was, for example, a dramatic increase between 1972 and 1974 in the number of Middle Eastern restaurants on and near Atlantic Avenue.[125] These were often established and patronized in part by local Middle Easterners, who now included Palestinians and Yemenites.

The recent Muslim immigrants formed men's social clubs in South Ferry, including the Red Crescent Society at 91 Atlantic Avenue and the Yemen-American Benevolent Association at 205 Court Street.[126]

Although the coffeehouses and ethnic butchers of the old Syrian Atlantic Avenue were gone, restaurants, grocery stores, bakeries, and a music store remained in the neighborhood. One of the oldest stores on Atlantic Avenue is Sahadi Importing Company at 187 Atlantic Avenue. The Damascus Bakery at 195 Atlantic Avenue serves the local area and also sends its bread to retail outlets. Another venerable establishment, Rashid Sales Company, once at 191 Atlantic Avenue and now on Court Street, has been the purveyor of Arabic music and films since 1934.

While the commercial establishments of the Syrian-Lebanese vicinity of Atlantic Avenue remained fairly stable, the fates of the churches reflected the movement of their congregations to other areas of Brooklyn. In 1954 the Syrian Protestant Church buildings at 201–203 Clinton Street were sold.[127] The minister of the church at that time, the Reverend Edward Jurji, subsequently was appointed to the Fourth Avenue Presbyterian Church in Bay Ridge.

The Melkite congregation established another church during this period under the same name as the first, Clinton Street Church. In this case, too, the church was following the southward movement of its congregation. The second Church of the Virgin Mary, which occupies a former Protestant church building at Eighth Avenue and Second Street in Park Slope, was dedicated in 1952. Services continued to be held at the South Ferry Church of the Virgin Mary until 1970.[128]

Unlike the Syrian Protestant Church and the Church of the Virgin Mary, St. Nicholas Antiochian Orthodox Cathedral and Our Lady of Lebanon have remained in their respective locations and draw their congregations from many parts of Brooklyn and beyond. In August 1977 Our Lady of Lebanon was honored as the new seat of the nationwide Maronite Diocese, thus becoming a cathedral.[129]

The Syrian Ladies Aid Society and the Syrian Young Men's Association continued into this period and the latter exists to this day.[130] The social clubs started in the 1960s and the 1970s were generally organized by the newer Muslim immigrants.

Arabic radio and films continued to be part of the neighborhood social and cultural life. Joseph Beylouni was a popular radio announcer on WWRL.[131] Egyptian and other Middle Eastern films were distributed around 1950 by the Sunset Film Corporation at 155 Court Street.[132] Rashid

Sales Company later would present films at the Brooklyn Academy of Music.

The heyday of the Syrian American press had largely preceded 1950. By that year, only *Miraat-al-Gharb*, a six-day daily, remained of the Arabic press in South Ferry per se, at 139 Atlantic Avenue.[133] The *Caravan*, an English-language newspaper serving the community, was published from 1953 to 1961 on nearby Hoyt Street.[134] *Al-Hoda* and the *Lebanese American Journal*, an English-language paper published by *Al-Hoda*, ceased being published by the Mokarzel family in 1971.[135]

The politics of the period, especially regarding Palestine, evoked a reaction from Syrian Americans, including letters of concern to President Truman from the National Association of Syrian and Lebanese Federations.[136] When Marines landed in Lebanon several years later, "the Lebanese American Association of the United States adopted a resolution . . . commending the United States for intervening in Lebanon."[137] Around the time of the Middle Eastern conflict of 1972, and partially as a result of past experience, Syrian and Lebanese Americans complained "that the Arab side of the Mid-East conflict is unfairly presented" in the American media.[138] The Lebanese civil war, which erupted in early April 1975, elicited a strong reaction from Lebanese Americans, many of whom had relatives living in Lebanon. The situation was universally lamented for the death and destruction it brought. In New York the Lebanon Emergency Committee was established "to assist victims of the civil fighting in Lebanon."[139]

Syrian and Lebanese New Yorkers have never been a vocal minority and as a result have been "lost in the shuffle, ignored or indirectly discriminated against."[140] Because of the scattered nature of their settlements, Syrians were not highly visible as a group.[141] In addition, the group as a whole did not work or think as a single unit.[142] While each religious group faced assimilative pressures, their differences "interfered with the development of 'pan-Arabic' institutions and caused each sect to act as if it were a different 'nationality group.' "[143] Institutions that could maintain homogeneity and promote solidarity did not develop.[144] This lack of unity is evidenced on many levels. In Syrian American political life it is reflected in the paucity of elected officials of this background.[145] It can also be seen in the fact that for many years citywide ethnic festivals were held without the participation of the Syrian and Lebanese.[146]

Nonetheless, Syrians and Lebanese adapted; for some, life in America was a tale of "rags to riches." Elias Sayour, for example, was an immigrant from Damascus who began the nationally known Saybury Housecoats

business in New York.[147] In later generations in New York, a number of "the sons of successful manufacturers and distributors, in spite of professional and college training, seem to have taken their fathers' business."[148]

Syrians and Lebanese also adapted to religious practices in America. Rather than establishing their own schools, Melkite and Maronite Catholics sent their children to the Latin-rite Catholic schools. The majority of these children have responded by "negating their ethnic past and preferring the services of the Latin Catholic church."[149] What American-born Syrian and Lebanese Catholics knew about their rites was what was taught them by their parents and grandparents, usually in connection with particular holy days and feast days. Surprisingly, though, religious institutions have acted as the most binding ethnic forces, "preserving the ethnic cultural heritage."[150]

While Syrians professed a desire to see their traditional language, culture, and customs preserved, there were practically no organized efforts to do so.[151] Part and parcel of the imported Syrian and Lebanese culture was the Arabic language. Because of a failure to nurture and maintain the Arabic language, 20 percent of the second generation and 71 percent of the third generation were not able to read or understand Arabic.[152]

Perhaps the best description of Syrian-Lebanese ethnicity was given by Mary Bosworth Treudley: "'Syrianism' had a simple meaning: food habits, crafts, music and dancing, the rites of hospitality, authoritarian family patterns, the closeness and warmth of family ties."[153]

While many forces contributed to the absorption of the Syrian-Lebanese into the American mainstream, some conscious efforts have been made to preserve the heritage of Middle Eastern forebears. One example is that of religious education programs for children in the different sects.

For the South Ferry community, the era from 1950 to the late 1970s was a time of both gain and loss. It was a period in which Syrian and Lebanese Americans became more cognizant of their heritage. This time, however, also marked the end of the area's precedence as the main residential center of Syrians and Lebanese in New York City. Rather, the commercial side of South Ferry became invigorated by those both inside and outside this ethnic group.

While the South Ferry area has not been a major residential destination of Arab immigrants since 1980, some have come to neighboring Boerum Hill and Carroll Gardens. The continuing influx of immigrants to New York City from numerous Arabic-speaking nations has helped to re-ethnicize Atlantic Avenue more than a century after Syrians and Lebanese first settled there.

3

Impressions of New York City
by Early Arab Immigrants

Michael W. Suleiman

There is no question that, from the start of Arab immigration to the United States, New York City had the biggest and most diversified Arab colony. It was known as "Little Syria" since at that time Arabic-speaking immigrants called themselves and were known as "Syrians" after the geographic region in the Middle East from which they came. New York City was the first place of arrival for most, as well as the main source of Arab American trade.[1] It was also in New York City that most Arab American intellectuals resided and where most, if not all, of their important newspapers were published. Also, the main Arab American organizations and churches had their headquarters in that city. It was there that the first Arab bank (owned by the Faour brothers) was set up and where the first Arab Democratic and Arab Republican clubs were formed. The biggest slums along with the best housing of Arab Americans were to be found in New York City. Finally, the New York City Arab colony was the basis of the often negative views Americans formed of the Arabs in their midst. At the same time New York City was the setting for the first and perhaps the only play about Arab Americans (*Anna Ascends*) that was written by a non-Arab and performed in a mainstream context.[2]

Even though this chapter records the impressions of New York City and New Yorkers by the early Arab immigrants, at least one important caveat and two general observations need to be made. The caveat is that the

I wish to thank Lisa Suhair Majaj for her careful reading of an earlier draft of this essay, and for her valuable comments.

overwhelming majority of Arab Americans never recorded their views in writing. Most were, in fact, illiterate. Nevertheless, letters were sent to relatives in the old country describing the new land and the experience of these Arab immigrants. Unfortunately, hardly any such letters are available to us today. While oral history interviews may be seen as a substitute, they are often less than reliable since impressions of a distant past are often marred by memory lapses as well as by selective memory. Presented in this report, therefore, are accounts by a very small number of individuals, almost all male. They are culled from newspapers and magazine articles as well as from full-length memoirs.

The first observation to make is that, to most Arab immigrants, New York City represented America. In fact, as Mikhail Naimy states, to early Arab immigrants all countries of emigration were "Merka." "If they made any distinctions, they said 'Nayirk,' meaning the United States."[3] Therefore, when writing about New York, these immigrants often generalized to the United States as a whole. The second observation is that, in their writings, these Arab immigrants did not just address New York and New Yorkers but rather often made a comparison between the host society—America—and the situation in their former homeland. Their favorite contrast was between Easterners and Westerners.

Preconceptions

Obviously, long before Arabs came to America they had definite ideas about what the country was like. Indeed, they mainly came to America because of those preconceptions. The dominant view of late-nineteenth-century America was that of a Utopia or Promised Land,[4] "a land of plenty—a land of progress—a land of money—a land of education for everyone."[5] That, in fact, is what Arabs learned at the missionary schools. The letters and word-of-mouth accounts from returning immigrants emphasized the wealth of America and the ease with which wealth could be amassed.[6] Perhaps the most idealistic view of America was conveyed to Salom Rizk by his teacher in Lebanon in the 1890s. As he reported it many years later, he was told that America "is a country—but not like Syria. It is really a country like heaven."[7] He goes on to describe that heaven: "So many wonderful, unbelievable things my school-master told me . . . the land of hope . . . the land of peace . . . the land of contentment . . . the land of liberty . . . the land of brotherhood . . . the land of plenty . . . where God has poured out wealth . . . where the dreams of men come true . . . where

Scene from *Anna Ascends*, 1921. (Alice Brady, center, as Anna; Gustave Rolland as her father.) Photograph by White Studio. This play was the only sympathetic portrayal of Syrians ever to appear on the Broadway stage. A Hollywood film of the same title was based on this Broadway play, but it has been lost. MCNY Theater Collection 51.329.154.

everything is bigger and grander and more beautiful than it has ever been anywhere else in the world . . . where wheat grows waist high, shoulder high, sky high, and as thick as the hair on your head . . . where mountains press their snowy heads against the sky . . . where forests teem with trees as plentiful as the sands of the sea . . . where men do the deeds of giants, and think the thoughts of God . . . where they harness rivers of water to turn great machines, and drench the land with light . . . where merely the push of a button does the work of thousands of horses, and donkeys, and camels, and men . . . and schools . . . schools everywhere, in cities, in towns, in villages, and even where there are no villages . . . where everybody has a chance to learn, even the humblest child of the humblest Syrian immigrant . . . where there are medals, and honors, and prizes waiting to be won . . . where every boy and girl can learn to be what he or she wants to be."[8]

This ideal picture of America was greatly changed after immigrants arrived in the New World, especially as they settled in big cities like New York. The changed picture was much more realistic. However, reality was different for different immigrants, especially concerning which aspect of the new environment and way of life they favored or found objectionable. I have sorted through the views of Arab American immigrants and will present them according to three categories: favorable, critical, and mixed.

Favorable Views of New York City

The first things that dazzled these early-twentieth-century visitors were the tall buildings, the tramways on every street, the many and large ships in the harbor, and the great bridges, especially the Brooklyn Bridge, which was a wonder and a great engineering feat over which cars, carriages, trains, and people passed.[9] "New York City," wrote Rizk, "was overwhelming, an unbelievable jumble of swiftness, and bigness—millions of people, millions of cars, buildings, windows, lights, noises . . . too wonderful and dazzling for me to see in part or understand as a whole."[10] Other immigrants just referred to the fact that New York City was one of the most important cities in the world and went on to enumerate all the wonderful aspects of the city: gardens, commerce, museums, theaters, clubs, electric lights, statues, churches, meeting halls, public squares, and so on.[11]

Among the most detailed descriptions of New York and New Yorkers was that provided by Fuad Sarruf, who referred to the city as the "New

Babylon."[12] Sarruf first compared Paris and New York City. To him, Paris was the pride of European civilization, based on beauty and the arts, museums, philosophy, literature, and poetry. New York City, on the other hand, was seen as the pride of American civilization, based on a strong foundation of wealth, people, and order. Sarruf greatly admired its commercial establishments and its engineering wonders. New York City appeared to him as a giant in the form of a human in constant motion, farsighted, hopeful and optimistic, confident of success: "New York manifests all the amazing characteristics which, within a century and a half, have produced a lively American civilization and a vigorous American public out of a virgin land of great expanse and a mixed population of people of different desires, sects, and religions."[13] He then used a series of superlatives to describe the city: "Greater New York is the largest city in the world in area, and the most populous, and the most crowded, and the greatest in wealth. It has the tallest buildings, the longest and largest hanging bridges, and the best, most spacious, and most luxurious hotels. Its transportation facilities are the glory and triumph of practical science. They run underground, under water, on the ground, and in the air, transporting thousands of millions of people every year. Also, New York's wealthy are the wealthiest in the world and the most influential in money markets."[14]

Nothing, it seems, escaped Sarruf's notice. He gave rather detailed descriptions of some of the main buildings in New York, including the Woolworth, the Equitable, and the Singer buildings, as well as the Hudson terminal and the Municipal building. According to Sarruf, "Building tall buildings is an American art whose practical principles the Americans invented. . . . Indeed, the architecture of a people represents the desires, and objectives of its people. Undoubtedly, naming their high buildings skyscrapers indicates that the Americans accept their Philosopher Emerson's saying: 'Hitch your wagon to a star.' "[15]

In the 1940s an Egyptian immigrant poet waxed eloquent in praise of New York City, which he said made him forget paradise and poetry's muse. New York City, he wrote, was the capital of competition for what is eternal, the capital of skyscrapers and aspiration. Even though its walls were black (dark), its people's conscience was white. There was a place for religion here, even though some claimed wealth was the measure of its greatness. He gloried in the city's advancements in science, medicine, art, entertainment, museums, churches, educational institutions, factories, and theaters. He was enthralled by all this, and offered a prayer of gratitude.[16]

Critical Views of New York City

Among even the most enthusiastic Arab American admirers of New York, a certain awe of and concern about the city's bigness, speed, and noise was evident. Critics could point to these and several other deficiencies and problems to highlight the negative aspects of the city.[17] An early critic was Khalil Sakakini, who in 1908 came to New York to make his fortune—but instead faced a life of penury and humiliation. He despised having to peddle or to work in a factory where the job was, literally, backbreaking. To him, life in New York, and in America generally, was neither pleasant nor worthwhile. Life in the fast lane was not his cup of tea. In America, however, speed was critical and the value of an individual was measured by his hard work and productivity, not by who he was or what family he came from. As he wrote, "The American walks fast, talks fast and eats fast. . . . They [Americans] are so fast that they have restaurants called 'Fast Food,' where you do not see chairs, as customers eat standing up. A person might even leave the restaurant with a bite still in his mouth!"[18]

Sakakini compared the situation he saw in New York with life back home, very much preferring what he had in the old country. For instance, in the Arab world the peddlers were happy and sang their wares. In America, however, peddlers hardly smiled and their voices were disturbing when they called for customers. They went to bed worried and anxious, and woke up the same way; such was not the case in the *Levant*. In comparing "our crazies, and theirs," Sakakini reported that, of two madmen he knew back home, one walked day and night, the other locked himself up in a closet. In America, he found that everybody was that kind of crazy, either in constant motion or behind a counter (closet). In America, people worked all the time. There was no pleasure in work. Their only pleasure was in making money and more money. In America, electricity was used to dispel cold and fog and to light up buildings and streets—yet still there was fog and there was cold. Back home, however, "electricity" came from the sun and moon, and people's way was clear and the weather was great.[19] Sakakini was also horrified that American women left their homes and entered the workforce, becoming like men. He claimed that they were no longer the respected, beautiful, well-bred women found in the Arab world. Consequently, he thought that they should be pitied and their condition lamented.[20]

In the first decade of the twentieth century, an Arab American wrote a

poem that referred to all that was considered great in New York City but found that such greatness hid an ugly side that was destructive of people and the environment. Here are a few representative stanzas of the poem, titled "New York," written by an unnamed poet:

> The fields are your birthplace
> but filled with your boa constrictors.
> The mines are your cradle
> But filled with their poison.
> The mountains of richness are your throne,
> but surrounded by their wild animals.
> Woe to your sons and lovers.
>
> Your drink is silver and your food is gold
> Your dress is the most valuable of silk and
> the rarest of jewels.
> Your sandals are the wings of knowledge
> But your heart is of tar set on fire.
> Woe to your sons and lovers.
>
> The daughter of richness and monopoly
> In your stores are the productions of the world
> In your safes the immense heaps of money and jewels
> In your castles the wonders of civilization
> And in your dark cottages—poverty, hunger and sighs.
> Woe to your sons and daughters.
>
> Highness, and immensity in the womb of commerce, called
> greatness, and splendor by your merchants, and
> this is your beauty.
> But woe to them and thee because they are liars.
> The beauty of their idols like a dollar, minted
> in the night and gilded in the day.
> Woe to this beauty [21]

In 1908 the U.S. economy suffered from a severe recession. This apparently hit New Yorkers hard, leaving a large number of people out of work and penniless. There were no welfare or social services or unemployment insurance to help them out. One night during that period, Niqula Haddad

saw some 150 impoverished, hungry, and homeless men following an evangelist preacher, who was begging for money to buy bread and to feed and shelter them. It was a scene repeated daily in New York and other big cities. It was a sight that horrified Haddad. He was astonished that the United States, a rich country with fertile and productive land, could not or would not provide food for these wretched people. He was told that workers were paid only when there was work; otherwise they had no food and no shelter. Haddad thought that was a source of shame for the United States. He expected a revolt by the unemployed but realized that the law was extremely harsh against such activity. Haddad could not understand how unemployment, poverty, and homelessness could exist in the richest country in the world. He finally concluded that the main culprit was the "system," which favored the rich who controlled when work was provided and who would be allowed to work, without any concern for the workers. Another reason for that sad situation was that the rich resources of America were not distributed on the basis of merit but on the basis of greed and cheating.[22] As Haddad wrote, "The lack of fairness in the distribution of wealth in America is its worst calamity, and it is worse here than anywhere else in the world."[23] A third contributing factor, according to Haddad, was that charity was not intended to help the poor but to glorify the donors. Thus, Andrew Carnegie built public libraries to show that he cared for education and culture when he should have built affordable housing and restaurants for the poor.

In another scathing article,[24] Haddad ruminated over the lives, hopes, and dreams of the millions of people who crossed the Brooklyn Bridge every day: "They say we seek after happiness, and happiness is personified in wealth. Wealth comes through work. Therefore we work hard to achieve happiness. They work and collect dollar after dollar and wealth on top of wealth and figures added to figures. Life ends without achieving happiness since so long as there are zeros to be added to the right, numbers are endless—and wealth is limitless, yet happiness is not a trusted partner but unattainable."[25]

According to Haddad, few in New York City understood why they were in constant motion. He wondered whether they were machines. "Yes we are machines, or rather parts of machines, in the human building factory."[26] What bound people to that machine, according to Haddad, was law or social order. Thus, law was not there to provide justice and fairness but to reward the wealthy. When a person failed to do his job because of illness or old age, he was discarded like a machine part and replaced by another. Where was the equality before the law, Haddad asked? Where was freedom?

According to Haddad, rules, laws, and mores were not there to provide justice but to enforce the rules that benefited the wealthy—and to keep workers, like parts of a machine, working. That was why Haddad saw millions crowding the Brooklyn Bridge daily.

One of the most important figures in twentieth-century Arabic literature was an immigrant who was in America for a number of years, serving in the United States armed forces during World War I. Mikhail Naimy, who graduated from the University of Washington, Seattle, went to New York City to help a small number of Arab literati who formed an influential group they called *al-Rabita al-qalamiyya,* or the Pen League.[27] New York City, however, was the last place on earth Naimy wanted to be.[28] In fact, the whole notion of "progress" as represented in the great inventions and the material advancement known as civilization was anathema to him. He was not shy about expressing these views, both in writing and in talks with his brothers, who were successful businessmen.[29]

Naimy did not see that machines were instruments of progress. Ac-

Members of al-Rabita (Pen League), ca. 1921. Top row, from left: Abdul Massih Haddad, William Catzeflis, Ameen Rihani, Wadi Bahout, Nudra Haddad; bottom row, from left: Nasib Arida, Raschid Ayoub, Mikhail Naimy, Elia Madi, and Kahlil Gibran. From *Kahlil Gibran: His Life and World,* by Jean and Kahlil Gibran (Interlink, 1998). Collection of Kahlil and Jean Gibran.

cording to him, machines merely meant faster movement, increased production, and increased consumption. On the other hand, the machine did not make people happier or less miserable. Indeed, the machine made them slaves to it without alleviating people's greed, fear, suspicion, and anxiety.[30]

To Naimy, this so-called progress meant that machines were now needed to monitor people's conscience. Thus, people were no longer trusted to pay for a newspaper when they took it from a stack in a public place. Now a box was invented in which the customer put in his penny before he could open the box and take his newspaper. Similarly, in the New York subway human interaction was eliminated as people placed their money in machines to get their ticket and the turnstile was invented to check on the validity of the ticket. Trust among people was gone and research was in progress "to invent a machine which would discover people's innermost thoughts. . . . What can you expect, therefore, from a civilization which surrendered its hands, legs, brain, conscience, justice, and honor to money and money turned it over to the machine? Indeed, what can you expect from it—except bankruptcy?"[31] Naimy called New York City the twentieth-century Babylon and described life in the city as residence in a horrible vortex "where five million people have gathered from five continents. Among them are blacks, whites, yellows, and reds, giants, and dwarfs, the emaciated and the overweight, the believer and the atheist. The robber, the killer and the dissolute sit side by side with those who comply with the commandments: Do not steal, do not kill, do not covet your neighbor's wife. Among them, you find the imbecile as well as the genius, the despicable and the notable, the sluggish and the self-made. All of them are sentenced to live in dens inside dens inside dens. Some of these are caves, barns, and basements, and some are palaces which shame those of the nobility, the princes, and the kings. They are all sentenced to incessant motion, day and night. In return for every smile and every hour of happiness, and joy they are able to garner, they are forced to pay dearly through their blood, tears, brains, and muscles, as well as their hearts, and well-being. As for their languages, they are a mixture of all the languages of the world, all combined in one language, namely the language of the dollar. They all seek their livelihood anyway they can—and some get their livelihood through ways even the devil has not thought of. That is the New York I entered for the second time in the autumn of 1916. Rather, that is the horrible vortex into which I willingly threw myself."[32]

Needless to say, Naimy preferred a return to natural settings, and he eventually did just that. In a later article he compared two scenes, one in

Madison Square Garden in New York, the other on Mount Sannin in Lebanon. In New York City, the scene was of crowds from all parts of the world, including people one did not like—impoverished people working for spoiled wealthy residents, rowdy children moving about in unenthusiastic play—all sweaty and hot in the sun, a sun obscured somewhat by the smog from pollution and factory smoke, which looked as if it came from a dragon. On Mount Sannin, however, there was quiet, a beautiful environment, a blue sky, singing birds, a strong young man farming his fertile land on which the fields and trees were healthy and verdant. Shepherds and their flocks passed by singing joyously in this idyllic scene.[33]

Mixed Views of New York City

It is, I believe, correct to state that for most Arabs in New York City the picture was a mixed one, with many favorable orientations and some negative views. For businessmen, the wonderful economic opportunities afforded them in the big metropolis and beyond were the source of great satisfaction and often brought them much wealth. If they had complaints at all, they pertained to social mores and conduct unbecoming a moral people. Abraham Mitrie Rihbany, a man of some education when he came to America, provided an excellent description of New York City as he first saw it and wrote about it to his family in the old homeland: "New York is three cities on top of one another. The one city is in the air—in the elevated railway trains, which roar overhead like thunder, and in the amazingly lofty buildings, the windows of whose upper stories look to one on the ground only a little bigger than human eyes. I cannot think of those living so far away from the ground as being human beings; they seem to me more like the *jinnee.* The second city is on the ground, where huge armies of men and women live and move and work. The third is underground, where I find stores, dwellings, machine shops, and railroad trains. The inside of the earth here is alive with human beings; I hope they will go upward when they die. There are so many big policemen who don't seem to be doing anything. The women walk on the streets freely, dressed like queens. They wear very thin veils, for the purpose, I believe, of showing rather than hiding their beauty, for they look magical. But they don't speak to anybody. The other day, while in the great garden called Central Park with a Syrian friend, we needed to know where the animals were (the Zoological Garden), and, seeing a lady sitting on a bench, we thought we should ask her to direct

us. After our more sociable Oriental custom, I ventured to greet her, with a 'Good morning.' She neither answered nor even looked at me. I was struck with dumbness. But my wise companion asked her where the animals were without saying 'Good-morning,' and she immediately pointed us in the right direction. They have strange ways here. And you never saw such drinking of intoxicants as there is in this city. We Oriental wine-drinkers do not know what real *effrenj* drunkenness is. I have seen even drunken women raving in the streets, but I am told they are not real Americans." [34]

To intellectuals, however, ambivalence about almost all aspects of life in New York City was more often the norm. This is beautifully illustrated in a poem titled "New York," by Nasib Arida, an active member of the Pen League. [35] In it, the poet addresses the immigrant passengers in a ship as it approached the New York harbor in the following terms, presented here in summary fashion: Glory and wealth are here—enjoy; catastrophe and hardships are here—suffer pain. Be cautious as you approach potential disasters. Here purity dies a virgin, here chastity is stoned; here happiness is lost; here goodness is shackled and evil wears the robe of blasphemy. Oh, passenger, turn back. Here, for wealth and beauty, if you want them, you will sell your soul. If you seek love, it is not platonic. Taste it; it is bitter. There are many places for love, but there is hardly a marriage without a poisoned heart. And, as people plunge into pleasures, they forget the laws of Moses and Jesus. What is forbidden is given the highest status, and traitors flourish. "This is a *ka'ba* where pilgrims come every day, where nothing is forbidden. If you succeed, others will conspire against you; if you fail, no one will show you mercy." [36] Here, time is everything, along with speed. Years pass in gathering wealth, and you destroy your body in the process. You regret when it is too late to do anything about it. "The paradise you seek from a distance is enveloped with hell." [37] You are a prisoner, a slave—and we have many slaves who come willingly. You seek wealth and happy evenings, thinking they are easy to secure; happy evenings are often followed by long, unhappy years of disaster.

A different voice, however, addresses the passengers as follows: "Oh, newcomer take courage, look at your promised land. This is the *ka'ba* of ambition, where you get what you seek. Have you seen the high towers? These are the work of inspired individuals; they are palaces of success prepared for inexperienced masters; greatness here is an incentive to whoever seeks even greater greatness. We have prestige, wealth, glory and beauty— but this is not all. We have ideal freedom, gained with blood and sacrifice, its statue is high, lighting the darkness. We believe in equality, and broth-

erly love." [38] When morning comes the passenger sees glorious New York smiling at him—and that it is full of promise. He realizes that he is there to capture that promise.

One of the first and most important Arab American writers was Ameen Rihani, a truly bilingual and bicultural individual who cared deeply about the welfare of both the Arab world and the United States and worked hard to reconcile their differences. Ameen Rihani, perhaps more than any other Arab American intellectual, belonged to both East and West. He greatly admired the material wealth and great scientific advances in the West/United States but he also reveled in the spiritual and moral contributions of the East. He, therefore, was a major advocate of combining and synthesizing the great contributions of both civilizations. [39] These notions were reflected in two articles he wrote in and about New York City.

The setting for the first article was the roof of a twenty-five-story building where Rihani stood and surveyed the surroundings. [40] Seeing the smokestacks, he imagined them to be the hands of coal miners raised in protest, asking for reprieve from their constant labor and mercy for their deplorable conditions. He "saw" the bull of Wall Street killing the small goats, then killing itself; he "saw" a snake spewing poison (smoke) in society. The smoke came from the burning coal, which also burned the lives of men and children working in the mines in the killing darkness—a slavery like no other. "A society," he wrote, "which can only exist on the misery of a section of its people is cruel and unhealthy." [41] The new civilization brought with it a new slavery. Reflecting on a news item that reported that prices on Wall Street fell $50 million in one hour, Rihani questioned a "civilization" in which millions of dollars were lost in a short time, while miners worked ten hours a day and risked their lives and the lives of their children for a mere dollar or two.

In another article, Rihani expressed his admiration for the Brooklyn Bridge and stated that he preferred walking on it to riding the crowded train. [42] Walking on Brooklyn Bridge every day, Rihani wrote, a person would not need a doctor, a priest, or a lawyer; a doctor would not be needed because of the clear air, a priest because one would contemplate and create a bond with the Creator, a lawyer because such an atmosphere made one want to avoid conflict.

Rihani expressed pity for those who, like cattle, rode the crowded trains. Their time was seen as precious but their lives were cheap. They feared rain but not the germs of malaria and tuberculosis. "They run away from the pure air and from under God's wide sky because that is what com-

merce dictates."[43] Rihani saw the Statue of Liberty lit by the moon and wondered when freedom would be exported to all parts of the world, including the Arab world.

Three scenes fascinated Rihani: the Lebanese coast from Mount Sannin, Paris from the Eiffel Tower, and New York City from the Brooklyn Bridge. The first is a symbol of nature and natural beauty, the second is a symbol of fine arts, and the third is a symbol of struggle and hard work. These, to Rihani, are the three bases of spiritual life.

Another mixed view of New York City was expressed in an anonymous prose poem in *al-Samir*, a prominent Arab American journal.[44] In it, the poet complained about being made dumb, being destroyed by the iron feet of New York City. He said he was going to leave the city to seek the peace and beauty of the countryside. However, the poet also wrote that he was bound to return "to search for milk and honey in the iron and stone."[45] People cannot escape New York City, he wrote, even when they try. She is always victorious over them.

Generalized Views: America as New York City Writ Large

Many Arab visitors to, or residents in, New York began by describing the New York City scene and analyzing the situation there only to end up generalizing about life in the United States. For instance, Fuad Sarruf, after providing an extensive and detailed description of New York's monuments and of the *New York Times*, expanded his remarks to include much praise for the American press in general.[46] He followed the same practice in discussing the system of transportation. He then provided his assessment of the sources of America's (not just New York's) greatness, namely the American people's respect for and love of work—work that ended only when people died.[47] The same observation was made by Philip Hitti, who wrote that everyone in America worked: men, women, and children, rich and poor. If they did not work, they were not happy. Besides, wrote Hitti, they needed to work to survive, since no one, not even relatives or neighbors, would come to their aid.

Hitti went on to use a favorite tactic to describe life in America by comparing it to life in Arab lands.[48] As he wrote, "The Easterner is an idealist and a visionary, concerned about the hereafter and how to be saved. The Westerner is a materialist and pragmatic, concerned about this world and how to improve it. Because of this difference, the Easterner has become the world's teacher of good manners, and its spiritual guide/law-

giver. The Westerner has become the master of land and sea and their administrator."[49]

According to Hitti, if a Westerner stands by the shore of the waters separating Brooklyn and New York, he thinks of building a connecting bridge; in the same situation an Easterner would compose a poem.

Americans are efficient, wrote Hitti. They do not engage much in courtesies or flattery because there is no time for that. Americans work hard not because there is a law to do so but because they are anxious to produce and create. They enjoy overcoming obstacles. According to Hitti, Americans are not in search of wealth for the purpose of gaining the almighty dollar but for the purpose of being productive and useful. Thus, even the wealthy continue to work hard, and they generously make donations to worthy projects.

In Hitti's view, Americans are optimistic. They are tolerant and caring. Americans are individualistic but cooperative, participating in many interest groups. They are cooperative but also competitive. They are orderly people and law-abiding. Americans are greatly talented, quick-witted, and creative. They seek what is new and apply their knowledge to produce new practical products.

To Hitti, Americans are democratic not only in public life but also at home, in the marketplace, and at church. Furthermore, they believe in fairness, including the way they treat children and women. Women are respected. They seek their own development and compete with others, but do so in a spirit of cooperation and equality.[50]

To Farah Antun, the sophisticated editor/publisher of Al-Jami'ah, a person's view of America depends on one's perspective and background. Some Europeans, for instance, praised American material progress but condemned the lack of art and culture. Antun himself admired the great progress in trade, farming, and industry. He saw many faults, however, especially in discourtesy, ceaseless work, rudeness to others, laxity of morals, drinking and drunkenness, and prostitution. He was particularly shocked because the Americans he met in Arab lands were the epitome of goodness. Then he realized that New York City did not represent America, and that the people of the interior were decent, hardworking, and courteous. He attributed these good qualities, especially in the New England states, to the nation's Puritan founders.[51]

After some description of the greatness of New York City, Antun explored the source of American power and glory. He said it was not commerce, agriculture, industry, or freedom. Rather, he identified the sources

as a strong, just government; representative councils; political opposition; press freedom; and most importantly, the school system, especially elementary schools that are mandatory for all children, where they learn to be part of one great nation and where their creativity and practical knowledge are advanced. He noticed that these factors were true also among Arabs in America. Therefore Antun advocated that Arabs study in American schools rather than establishing their own schools, where the "Eastern" mentality might be perpetuated.[52]

Factors Influencing Arab Views of New York City

Several factors influenced the views of early Arab visitors to New York City. These included the writers' preconceived ideas of America; their educational level and whether or not they had attended missionary schools; the time of their arrival in the United States and whether they were first— or second-generation immigrants; whether they were tourists, sojourners, or immigrants; whether their immigration was voluntary or forced; what political and social values they held; and, importantly, how the host society viewed and treated them.

To begin with, almost all of these Arab immigrants came with preconceived ideas about "Nayirk," as they often pronounced the name of the big city that stood for America in their minds. For most of them (those with little or no education) New York/America was a place like no other on earth, where anyone from anywhere could go to make a fortune in a short time. That was their main focus, although they were also somewhat aware of the great inventions, the skyscrapers, the suspended bridges, the speed of transportation, and the different way of life of Americans, especially the "liberation" of women. Those who succeeded in business lavished great praise on the host society even as they sought ways to shield their families from the potential harm of the excesses of freedom, especially in the behavior of women.

For those who attended missionary schools, Americans "were rich and religious, and little else. Every one of its [America's] citizens told the truth, and nothing but the truth, went to church every single Sunday, and lived the life of non-resistance."[53] Upon arrival, the majority were greatly impressed by America's wealth but were surprised that they had to work so hard to make the fortune they sought. For the educated few, America (and New York City in particular), with its great extremes of wealth and poverty, civilization and immorality, freedom and enslavement to ma-

chines, offered something less than the ideal conditions they anticipated. While the uneducated and the sojourners could, and did, ignore the condescending and sometimes racist attitudes of the host society toward them and concentrate on their own struggle for survival, the educated were less sanguine about such matters.[54] Thus, Rihbany and Rihani, in particular, responded by glorifying Easterners' high civilization as reflected in their great spiritual contributions.[55]

Those who came as tourists were greatly impressed by the high civilization of the New World. Most of the time, New York City was their main focus. After providing detailed descriptions of the wonders of the city, they wrote about the sources of this greatness, especially in comparison to conditions back home. Two factors they often singled out were hard work and the equality of treatment accorded women, which they wished their countrymen would emulate.

For those who came as immigrants or even as sojourners, the emphasis was on the contrast between what they expected and the reality they faced. Furthermore, they wrote about how life in New York City affected them personally. The variety of views may be attributed primarily to their ideological commitments or philosophies of life. To traditionalists, such as Khalil Sakakini, life in a huge American metropolis like New York City was the epitome of all that was uncivilized. There was no leisure time, as everybody rushed everywhere in search of wealth that did not provide the happiness they craved. Furthermore, their domestic tranquility was destroyed, as women abandoned their "natural" family-nurturing functions and joined men in the workplace, thus humiliating themselves as well as their menfolk.

In contrast, socialists and humanists like Al Akl and Haddad were horrified to see poverty and homelessness in the midst of great wealth. They condemned the economic and social system that both caused such horrible conditions for part of the population and condoned such misery. Mikhail Naimy, a person who loved nature and idealized natural settings, saw the whole concept of "civilization," especially as it reached its highest flowering in New York City, as unnatural and an assault on man's humanity. He, therefore, returned to his homeland and sought the serenity and beauty of Mount Sannin.

To reiterate, Arab views of America at the turn of the last century were much more varied than is generally realized. While it is true that the vast majority were enthralled by the great material wealth and fabulous inventions of American civilization, the more discerning and educated Arab im-

migrants presented a far more nuanced picture, which praised progress but was not blind to the costs involved. Those critics, in a very real sense, anticipated the social and political reformers whose writings and activism on behalf of the poor and the lower classes eventually succeeded in implementing the social-welfare safety net, especially in the 1930s under the Franklin Delano Roosevelt administration.

4

Rare Sights

Images of Early Arab Immigration to New York City

Jonathan Friedlander

The "First" Arab Immigrant in America

Most ethnic groups have a defining image that represents their immigration to the United States, like the wide-eyed Eastern European Jewish girl staring into Lewis Hine's camera, or the young Scandinavian resting on a bench in a perfect photographic composition. The Arabs, too, have such an iconic touchstone: an 1878 studio portrait of Joseph Arbeely with his six sons and a niece, posing stern-faced in the custom of the day. Professor Arbeely holds a placard with a message in Arabic, "Here we are enjoying freedom," affirming to kin in Lebanon and Syria the success of his family's quest in the new homeland.

Another defining image that comes to my mind is a portrait of Antonio Bishallany, a young missionary in his mid-twenties, originally from the Mount Lebanon region. The image is taken from the Reverend Charles Whitehead's account of the short life of the young man who died of tuberculosis in 1856, two years after his arrival in New York. The story of his demise and the possibility that he may have been the first Arab immigrant to the United States drew Professor Phillip Hitti, an early historian of the period, to Brooklyn's Greenwood Cemetery in search of Bishallany's lone grave, a journey vividly recounted in *Syrians in America*, one of the first and most important works on the formative years of Arab settlement in the United States.

Some seventy-five years later, I too paid homage to Bishallany's grave

Dr. Joseph Arbeely, sons, and niece, 1878. Courtesy of Jonathan Friedlander.

during the course of my own field research on the early Arab community of New York. Overlooking the Manhattan skyline across the East River, Bishallany's weathered marble tombstone stands at the edge of a serene meadow where cypresses and worn statues of grieving angels intermingle with strikingly carved granite headstones bearing Arab family names in re-lief: Mallouk, Lutfey, Kaydouh, Hossan, Samara, Atiyeh, Kirsheh, Kiamie, Saad, and many others. Bishallany's name and the dates of his life are now almost illegible, ravaged by time and the elements. Still clearly visible above the epitaph and just below the chiseled turban are the figures of a lion, a serpent, and a lamb, symbolizing the courage, wisdom, and inno-cence of the deceased.

It is debatable whether or not Antonio Bishallany was the first Arab immigrant. Some say he was neither the first nor an immigrant; after all, his intention was to gain religious education and missionary experience in America and then return home to spread the word of God in the manner of the American-inspired Protestant missionary movement that was partly responsible for the growing awareness of the United States in Lebanon. That awareness and the perceived economic opportunities prompted many

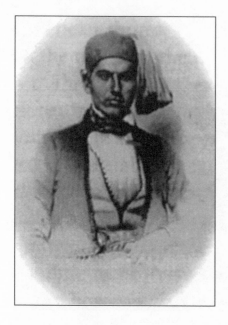

Antonio Bishallany. Courtesy of
Jonathan Friedlander.

Lebanese villagers to emigrate to the eastern seaboard of the United States.
But Bishallany's brief life is a milestone in the annals of Arab American history, and his struggle foreshadowed the sacrifice and hardships that others
would encounter and endure.

The Notions Peddler

While the hardships back home and the quest for religious freedom drove
many to American shores, the prospect of work and prosperity was paramount in the minds of the newcomers. It was also a central theme in the
realm of the visual arts, exemplified by Diego Rivera's River Rouge murals
celebrating the strength of American industry and the working class, including the many European immigrants and the handful of Arabs who
manned the assembly lines. Photographers also took an interest in the subject of work, as evidenced by the ample documentation to be found in the
visual archives of the city of New York portraying the many ways in which
immigrants earned their livelihood. Unfortunately, it is rare to find in the
public record visual documentation of Arabs at work. Some images do
exist, however, in family albums and other private sources, and in the remarkable Naff Collection at the Smithsonian Institution. These shed light

on the primary occupation of the early Arab immigrants, which was peddling. Embracing the entrepreneurial spirit, they set out alone and in groups to peddle their wares throughout the Northeast and the Midwest, some even venturing as far as Colorado to supply the mining communities with a variety of goods, from essential household items to religious fetishes imported from Jerusalem. Numerous photographs depict men with the horse-drawn wagons that carried vital supplies to America's large rural population.

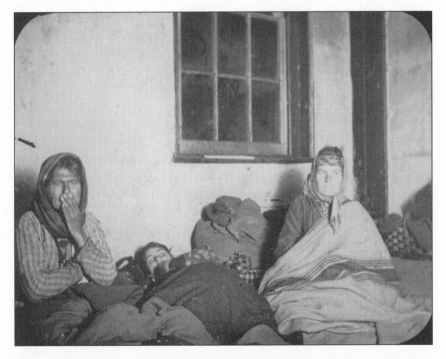

Arab women, Washington Street, 1887. Photograph of lantern slide, probably by Richard Hoe Laurence. Startled by the intrusion of journalist Jacob Riis and his amateur photographer associate, who were armed with a flash powder that enabled night photography and were bent on documenting conditions in Lower Manhattan's immigrant neighborhoods, these three women were among perhaps two hundred Syrian immigrants to the city in 1887. Although to contemporary eyes— and no doubt to Riis's as well—the women appear to be living in woeful circumstances without even beds to sleep on, it is likely that they were simply following the custom of their native land, where they slept on the floor on bedding unrolled at night from a niche in the wall. MCNY Jacob Riis Collection 25.448.196.

Peddling was a mainstay in the urban centers as well. In the neighborhood of Little Syria, the primary residence of the Arab immigrant community in New York, home basements served as depots supplying the networks of door-to-door peddlers who sold their wares throughout New York and other large American cities. The significant participation of women in this trade is little known or appreciated, a fact which makes the following photograph a rare treasure. I discovered it in the visual archives of the Library of Congress, identified simply as "Syrian Woman, Washington Street." The lack of information about the photographer or the date, let alone the subject herself, further adds to its mystique. For me, the proud stance and gaze of this anonymous Arab woman encapsulates the strength and vitality that urban peddlers contributed to the economic, social, and cultural fabric of the United States.

Little Syria and the Last House on Washington Street

At the turn of the century, New York's ethnic enclaves were the subject of visual explorations by scholars, journalists, and documentary photographers who sought to shed light on the living conditions of the immigrant populations and communities that continued to swell in numbers until the outbreak of World War I. *How the Other Half Lives,* (1890) a poignant exposé by Jacob Riis, was commissioned and published to underscore the plight of the poor as well as the need for public housing and other social issues of the time. Considerable ethnographic work was carried out by photographers documenting life in the Jewish Lower East Side, in Chinatown, and in Little Italy, their rooftop shots revealing the fabric of life in these teeming neighborhoods of people, horses, and automobiles jumbled together in an organic configuration against the backdrop of the built environment.

The image on page 52 is, to my knowledge, the earliest depiction of Washington Street, the heart of the formative Arab community in New York known as Little Syria. This street-level panorama, sketched in 1895 by W. Bengough and titled "The Foreign Element in New York—The Syrian Colony," reveals many details of life in the community: storefronts bearing signage in Arabic script, an elderly man smoking a water pipe, a female peddler resting her basket on a stoop, food vendors, children at play, and smartly dressed men and women. There is an interesting mix of Old and New World styles, with several *tarboosh* defining the neighborhood as Little Syria. In the words of Fred Koury, once a resident of the community, "In the early part of the century, and up to the early twenties, these streets were

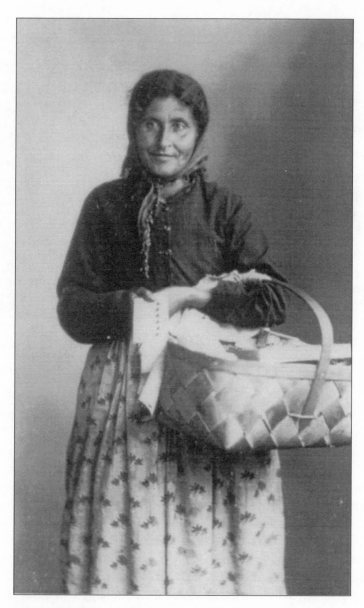

Syrian woman, Washington Street (also known as "The Notions
Peddler"). Courtesy of the Library of Congress.

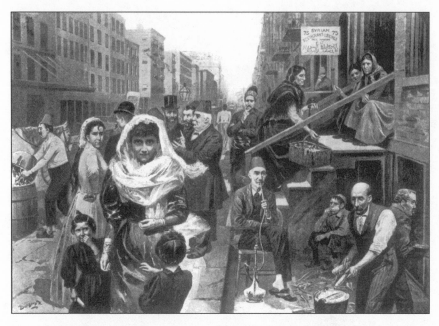

"The Foreign Element in New York—The Syrian Colony," Drawing by
W. Bengough, 1895. Courtesy of Jonathan Friedlander.

almost exclusively Arab, with Arabic signs and Arab stores, Arab restau-
rants and wholesale houses. Besides being a very important trade center, it
was also an intellectual and cultural center. It was even covered in papers
abroad, and I used to read about Washington Street in Beirut."

Nowadays the area is still quite busy, its narrow streets jammed with
pedestrian traffic from Wall Street and Battery Park and trucks delivering
goods to local stores and restaurants. But the Arab life and presence of the
once-thriving ethnic enclave are all but extinct—with one exception. Early
one Sunday morning, Fred Koury guided me through the nearly deserted
neighborhood to the intersection of Greenwich and Rector Streets. On the
northwest corner stands an old two-story brick building. This, according to
Koury, is the last vestige of Little Syria, a building now surrounded by tall
office buildings and skyscrapers.

Other than this structure, only a few landmarks erected by the city of
New York commemorate the religious, social, educational, and intellectual
institutions that were founded and built here by the first generation of Arab
immigrants. With the advent of transportation lines, and as the immigrants

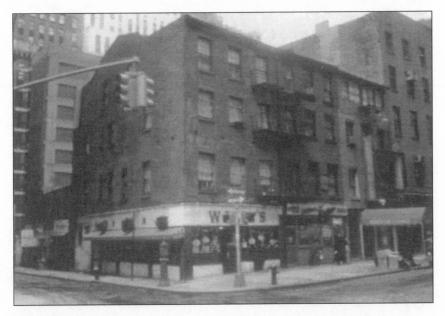

The last house on Washington Street. Courtesy of Jonathan Friedlander.

achieved relative success, they migrated to the Atlantic Avenue and Bay Ridge neighborhoods of Brooklyn, where many are now buried in the shadow of the mother community across the river in Manhattan.

I hope that the minimalist approach I have taken in this short sketch will serve to underscore the need to further seek out and unearth images that will increase the historic value and understanding of early Arab immigration in the broader context of the development and heritage of this nation.

5

My Mother's Zither

Gregory Orfalea

For Evelyn Faris

My mother's zither was New York City. I am being literal. She never played the zither, but she played New York. Or rather in New York or on New York—Brooklyn, specifically—sidewalks and playgrounds around 126 Pacific Street in downtown Brooklyn (she was born on 293 Henry Street) and later above a funeral home on 76th Street and 3rd Avenue in Bay Ridge. She became a stunning sparkle-eyed, olive-complected, onyx-haired beauty who strummed her hand along the piping of the Brooklyn Bridge, the real zither of this piece, and in that she was not too different from Ameen Rihani, the first poet in the United States of Arab extraction, who wrote a rather bad poem with an intriguing image of a boy in the rain "reading what the Shower / Was publishing upon the Bridge."

My mother always loved the rain and the fall and books, so it would not surprise me if she were caught by some wayward poet reading on the Brooklyn Bridge in the rain and inspired him. Not Rihani, mind you, who was already fifty-one when Mother was born in 1927, but perhaps Dick Trabulsi, who was a budding poet at Ft. Hamilton High School and in love with my mother. Dick was a blue-eyed, blond Syrian. As I am the standard darker version, it is true that Dick did not become my father. My own father only wrote one poem in his life as far as I know, but it was a whale of a lyric, the kind you would give your whole life to write, which he did, but that is another story.

I am going to examine here some of the effects New York City has had on Arab American literature. It will do well to begin with four Syrian im-

migrant authors—Ameen Rihani, Kahlil Gibran, Mikhail Naimy, and Elia Abu Madi—the use they made of New York City in their work, and the effects they had on American culture and Arab literary traditions (those effects were nothing short of revolutionary) as well as on us spoiled brats of the future, native-born American poets of the suburbs, drive-in movies, and grape leaves taken out of the freezer. I will then take up more recent interactions between the Big Apple and Arab American writers. These took place almost entirely since World War II, with most production occurring in the past two decades.

If you see Rose Arbeely Awad Orfalea flicker through my words here, it is not entirely fanciful. My mother won a poetry contest as a girl—in 1936, at the age of nine—sponsored by the *Brooklyn Daily Eagle,* which published her elegy about the Spanish Civil War titled, "Prayer for Peace," which goes, in part,

> I pray to God the war will end
> that peace will be restored again
> Peace and happiness
> is all we pray for
> for that is all the world was made for.

Not bad for nine. Mother was, and still is, a voracious reader (she put away Milan Kundera before I did) and to this day can recite from memory Louis Untermeyer's "Caliban in the Coal Mines."

About the time of Mother's poetry prize in Walt Whitman's old newspaper, Ameen Rihani was packing up for Lebanon after a bitter divorce from his wife, the American artist Bertha Case. But for the first three decades of this century, he cut quite a figure in New York City, publishing the first pieces on the Middle East by a native writer in the *New York Times, Atlantic Monthly,* and *Harper's.* In 1911 Rihani wrote the first novel published in English by an Arab American, *The Book of Khalid,* about a Syrian peddler in Battery Park. It is unabashedly imitative of Whitman's "Song of Myself," especially of Whitman's lines, "I loafe and invite my soul, / I lean and loafe at my ease observing a spear of summer grass." One can say that if you are loafing in your teens and lolling in the grass, you are merely being a teenager. If you do so in your twenties, you are a wanderer, but there is nothing to be alarmed about. But if you loll on the grass as Whitman at thirty-seven or Rihani at thirty-five, you are completely lost—to poetry, of course. You are hopeless, pension unbound. Rihani says in *Khalid,* "A man

who conceives a great book, my friend, has done more work than all the helots that laboured on these pyramidical futilities . . . For when Khalid loafs, he loafs in earnest."

Perhaps it is not entirely unexpected that when Khalid loafs he is not inspecting a blade of grass like Whitman but rather the ankles of the ladies. He falls asleep and dreams that

> a goblin taller than the tallest poplar . . . carries me
> upon his neck to the Park in far New York.
> Here women, light-heeled, heavy-haunched, pace up and down the
> flags in graceful gait.
> My roses, these, I cry, and my orange blossoms.
> But the goblin placed his hand upon my mouth, and I was dumb.
> The cyclamens, the anemones, the daisies, I saw them, but I could not
> speak to them.

In short, Khalid cannot ask the girls to lunch because he does not know the lingo. Khalid's poetic dream may begin in Whitmanesque exuberance, but it ends in an old Arab lament:

> I cannot even like the noon-day bulbul
> whisper with my wings, salaam!
> I sit me on a bench and weep.
> And in my heart I sing
> O, let me be a burro-boy again;
> O, let me sleep among the cyclamens
> Of my own land.

As a novel, *Khalid* is overblown, using ten-cent words the way someone might who pulls carelessly from a thesaurus. But this Arab version of *Pilgrim's Progress* has satiric wisdom that celebrates and rebukes the immigrant's fanciful hope, to good effect. For Rihani, Khalid's path to the New World is a virtual "Via Dolorosa"—the three stations of this Way of the Cross being Beirut, Marseilles, and Ellis Island. Khalid moves through the realms of commerce, philosophy, law, and sex, trying to find his niche. Although he is aware of the three evils of the Islamic *hadith*—the tongue *(laklaka)*, the stomach *(kabkaba)*, and sex *(zabzaba)*—he tumbles like an Arab Augie March into New York's barrooms, comparing certain women to whiskey, others to seltzer water, but preferring for himself, "the highball."

After a stint as "Tammany's agent for Syria" in the smoking rooms of Irish pols, unable to sell even his own neighboring Syrians his oranges, Khalid swings over from the Lower West Side to the Lower East Side, with sad results:

Only for a month could he suffer what the Jew has suffered for centuries.

"To trade or not to trade"—thus the Hamlet/Khaled mulls. He concludes the ethos of both Syrians and Americans owes everything to profits. What thrusts him home to Lebanon? In a word, "the pandemonium of civilization" that has overwhelmed him in New York. Rihani is said to have invented the prose poem in Arabic (which Kahlil Gibran took to great pecuniary heights in a kind of Biblical English). Rihani and Gibran conducted the first experiments in free verse from American shores, freeing Arabic poetry of the requirement of monorhyme, in which each line in an Arab *qasida* had to end in the same sound. The two writers were wary friends for a while, dating the same young woman at different times. It did not last long for either of them. Gibran was even less committed to marriage, or any material ties, than was Rihani. Rihani wrote about Gibran in a prose poem, "in the shadow of the skyscraper which substitutes electricity for sun; in the city of iron and gold, where men live by the watch and the scale, the city which tallies and weighs and measures everything; in New York City lived one who was poor at counting, who revered neither scales nor standards."

By 1911 Gibran had moved from Boston to New York and a studio at 51 West Tenth Street. It was here that he began his first book in English, *The Madman*, certainly influenced by a monastery of the demented he lived near in Lebanon as a boy and possibly by the Bowery bums who swayed and yelled out their blasphemous visions in front of his New York studio.[1] *The Madman* also appears, according to Gibran's best biographer, his namesake cousin Kahlil Gibran, to have been the result of an early confrontation with the poems of Stephen Crane (*The Black Riders*), one of which describes a crazed hermit eating his heart in the desert; he calls it "bitter, but I like it—because it is bitter—and because it is my heart."

The Madman, published in 1918 just after World War I, is a powerful book, troubling and meant to be so, in a way the incredibly successful (ten million copies in print) *Prophet* is not. There is a striking and confident rebellion in *The Madman*, particularly evident in the poem, "Defeat," that

could have been read as a cautionary tale to the first President Bush before he launched the inconclusive Gulf War:

> Defeat, my defeat, my solitude and my aloofness;
> You are dearer to me than a thousand triumphs,
> And sweeter to my heart than all world glory.

Although Gibran was writing the poem during World War I to cheer the Serbian rebels at Kosovo against the Ottoman Turks, the strength taken by being outnumbered, the stiffening of the underdog, is an undercurrent in Arab culture and certainly one that was appropriated by the tyrant Saddam Hussein.

The point is, "Defeat" speaks of Gibran's growing self-mastery, the important mystery of being a self (as he says, "to be understood is to be leveled down") as much as it speaks of anger at tyrants. And the publication of *The Madman*, along with his Blakian art shows, catapulted Gibran into the forefront of New York literary and artistic society. He published alongside Eugene O'Neill, D. H. Lawrence, Sherwood Anderson, and Robert Frost in the pacifist journal *Seven Arts*. Although 'Abdu'l-Bahá, the founder of the Bahá'í faith, sat for a portrait by Gibran, the painter wondered if it were all too airy: "Was it not the Peace disease that crept into the Oriental nations and caused their downfall?" Some of Gibran's best work, completed during this early stage in New York, was the result of good old American rebelliousness, lauded so by critics long forgotten, who later turned on him for the quasi-mystical *The Prophet*.

Gibran's fixation with liberty was lifelong. Part of this was the steep solitude the New World thrust him into—his mother, sister, and brother died of tuberculosis not long after arriving in Boston, and his father, an alcoholic, was long gone in Lebanon. New York's self-absorption coupled with Gibran's native love of solitude to produce the striking dramatic monologues of *Jesus The Son of Man* as well as the weaker visions of *The Prophet*.

Otherwise the steel girders and cement towers of the city hardly entered his work. In fact, they may have pushed him entirely the other way—to the spirit, to what withstood time, to the air, and to a phony self. Gibran, like some other New York artists, liked to blur the facts of his biography—one publication said he was born in Bombay, India. An early Knopf flyer had Auguste Rodin calling Kahlil "the William Blake of the Twentieth Century"—almost certainly a ruse, although Gibran had rubbed up against the

Kahlil Gibran, ca. 1920. Collection of Kahlil and Jean Gibran.

Great Sculptor twice in Paris as a youth. He used New York as his base of operations, yes. He set up a Relief Committee to raise money for those starving in Lebanon during World War I; he hid those wanted by the Turks in his apartment. He formed a Pen League of ten Syrian émigré poets, beckoning Mikhail Naimy all the way from Walla Walla, Washington, to New York to be the League's critical standard-bearer. (Naimy had called for an "all-out war on hypocrisy in literature.") Gibran even took refuge on occasion in the Catskills—also a hideout of my mother's Syrian family—where he once blurted to Naimy, wine bottle in hand swaying by a mountain stream, "Mischa, I'm a false alarm!"

Booed off the stage as he read his poems to the Poetry Society of America, destined to be more widely read than any American poet outside of Whitman and Eliot, Gibran's alienation was extreme. He often said he felt at home neither in Syria nor in America. At the height of the Great Depression, Gibran died of cirrhosis of the liver at the age of forty-eight, haunted by the fact that "people are so lonely." He was also aware that the artistic pretensions of his adopted city may have seduced him, too: "And you, the real poets, forgive us. We belong in the New World where men run after worldly goods; and poetry, too, is a commodity today, and not a breath of immortality."

That would be disputed by such people as the Nobel Prize-winning Chilean poet Gabriela Mistral, who adored Gibran, and the millions of others down to this time who have found spiritual sustenance in his work. Some of his aphorisms ring false, but others true: "Work is love made visible"; "We live only to discover beauty; all else is a form of waiting"; "Do not the spirits who dwell in the ether envy man his pain?"

Gibran's influence on present-day Arab American poets is interesting to chart. Sharif Elmusa, my Palestinian American friend and poet, chides Gibran for telling newlyweds to drink from different cups. Says Elmusa, "Drink from the same cup, and dream on the same mattress!" Eugene Paul Nassar takes him to task concerning the aphorism, "Your children are not your children"—in effect saying, "If you'd only had a child, Gibran, you'd know better!" Elmaz Abinader wonders about Gibran's call for a balance between reason and passion, preferring full-fledged passion herself; yet she ends up, wryly, in Gibran's camp, "Follow your impulse / Within reason."

New York plays a big role in the work of Mikhail Naimy, the friend who was at Gibran's bedside when he died. It is the backdrop of most of his short stories and his Dostoevskian novel, *Memoirs of a Vagrant Soul*.

An Orthodox who had spent some time studying to be a priest in Rus-

sia, Naimy ended up as a translator in a New York bomb factory that was supplying ordnance for the White Russians at war with the Bolsheviks. It was not a pleasant time; his autobiography includes a chapter on this New York period, "In the Terrible Whirlpool." Partly to escape making—or at least labeling—bombs, in 1918 Naimy enlisted in the U.S. Army and was sent overseas. There he saw enough of what bombs do to write one of the truly great antiwar poems in modern history, "Akhi," or "My Brother." Here is the opening stanza:

> Brother, if on the heels of war Western man celebrates his deeds,
> Consecrates the memory of the fallen and builds monuments for heroes,
> Do not yourself sing for the victors nor rejoice over those trampled by victorious wheels;
> Rather kneel as I do, wounded, for the end of our dead.

Conjuring up the famine that cut Lebanon's population by half in World War I, Naimy writes, "The foes have left no seedling except the scattered corpses."

But it is with the first Arab short story collection in the realist Chekhovian model, *Once Upon a Time,* that Naimy vaulted himself into the realm of world literature. The effect on him of his New York years is a constant obsession. The Sheik restaurant, once on Washington Street and later on Atlantic Avenue, is a favored setting, and at The Sheik we meet Abu Assaf, the *Bey,* in a classic tale of the haughtiness and pretension in Arab society, "His Grace." For all his ordering around of waiters, the *Bey's* clothes are threadbare; he is a man living on a lost reputation.

The Sheik is also the setting for Naimy's darker look at the immigrant impulse, his novel *Memoirs of a Vagrant Soul.* A dutiful waiter, whom we only know as Pitted Face, is struggling back from amnesia to understand his past and the terrible withdrawal from society that grips him, in spite of his job. Only at the end do we find out Pitted Face has fled to America after killing his wife in their nuptial bed. Ultimately, even America cannot blot that stain. It is a searing story, a Syrian version of *Crime and Punishment,* and its publication in 1949 in Arabic thrust Naimy onto many short lists for the Nobel Prize in Literature. He lived to be ninety-nine, with the stature of a Gandhi in Lebanon; sadly, Lebanon did not listen.

The last of the early *Mahjar* (emigrant) poets was a man my mother watched play poker and whist at her Uncle Mike Malouf's place on 85th

Street in Bay Ridge, a diminutive, balding fellow named Elia Abu Madi. He could not have been more different from the ascetic Naimy or solitudinous Gibran. Yet Abu Madi was considered by Kahlil Gibran and his fellow *Mahjar* poets the cream of their crop in New York in the 1920s. He was virtually unknown to his fellow Americans for a simple reason: Abu Madi wrote only in Arabic. His wife, though of Arab extraction, was born in New York; knowing no Arabic herself, she never read her famed husband's work until it appeared in English thirty-three years after his death.

I say "famed" about Abu Madi because his poetry is as commonplace and memorized in the Arab world as that of Robert Frost is in ours. Of the four poets in question here, Abu Madi's work is the least influenced—at least in its metaphors and images—by the city of New York. Yet that native-born skepticism of New Yorkers, who assert almost nothing without a pull from the side of the mouth or knitted brow, is present in Abu Madi's most famous poem, "Al-Talasim" ("The Mysteries"). It begins,

> I came—whence, I know not—but here I am.
> I saw a road before me, so I walked
> And shall continue, whether I will or not.
> How did I come? How did I see my road?
> I know not.

> Am I new in this existence? Am I old?
> Am I truly free, or bound in chains?
> So I lead myself through life, or am I led?
> I wish to know, and yet
> I know not.

Although Abu Madi was surrounded by his people toiling in the garment industry in New York—half the sweaters in New York were made by the early Syrians, for example—there is no embroidery whatsoever in "The Mysteries." It has none of the flowery imagery for which Arab poetry is commonly known; in fact, it has almost no imagery at all. This is a radical departure from the classic Arab *qasida* in form and content (although there is a hint of the emptiness one finds in the laments for abandoned desert encampments in pre-Islamic Beduoin verse). It is also a stylistic departure from the larded strains of English Romanticism that influenced Gibran and Rihani, although it retains something of Shelley's disdain of prideful cultures.

It may be the soaring towers of New York's Wall Street that moved Abu Madi to write his ironic entreaty, "Eat and Drink!" in which he exhorts the rich to teach the poor "how death devastates" while he rebukes the poor (with a thick tongue in cheek) for not being satisfied that their kingdom is in heaven:

Do you not believe what the Book says?
Woe to you!
You are unbelievers!

Unlike Gibran, who lived the poet's role to the hilt in a garret in Manhattan, or Rihani, who was photographed in 1905 sitting on a bench in Central Park in cutaway coat and walking stick looking like a first-class Arab dandy, or, for that matter, Mikhail Naimy, who fled from America finally to a hermit's shack high in the Lebanon mountains, Abu Madi was thoroughly middle class, taking over the editorship of *Miraat-al-Gharb* (Mirror of the West), the first Arabic newspaper in America, and living in Brooklyn from 1936 until his death in 1957. His two sons skipped the poetic stars for the literal ones; one directed nuclear and space science programs at Grumman and the other chaired the Physics Department at Kent State University.

Unlike the studiously avant garde Gibran and Rihani, Abu Madi had come to America with a price on his head. A Lebanese émigré to Egypt, he had been forced out by the Ottoman Turkish authorities, who deemed his first book, published in 1911, too provocative. Early on, it seems, he had spoken out for the downtrodden and subjugated and became a champion of liberty in his newfound land, although his English-reading neighbors would hardly know it.

Yet it was a neighbor's moan in the middle of the night that produced what is to my mind Abu Madi's best poem, "The Silent Tear." It begins,

She heard the mourners wailing one night
in the neighborhood, awakening grief,
crying in the darkness over a young girl.

The "she" is probably his wife, Dora, whose bitter reaction to the young girl's death stuns Elia: "The summer was blowing its heat around us / and yet I felt as if I were suffering from cold." He tries, successfully as it turns out, to sooth his wife with thoughts of the hereafter or even reincar-

nation, "You will return as a fragrant thicket." But later, although she is cured of doubt, he is not:

> When I went to sleep
> my bed felt rough to me, though it was smooth . . .
> By mounting sorrow
> my heart was robbed of its dream.

Abu Madi ends watching the pavement sweat, full of the sound not of a zither, but of an oud, a youth gone too soon:

> Oh night! I have lost my way.
> Let there be light, if it exists!
> Is this how we die,
> how our dreams disappear in an instant,
> and to dust we return?
> More fortunate than us,
> then, are those who were not born,
> and better than men are stones and rocks.

It was not until after World War II that Arab American writing resurfaced and expanded from the early immigrant experience of the *Mahjar* Syrians in New York City. Most of the new writers were born in the United States and far more representative of its challenges than the world of their fathers in the Middle East. This holds true whether they were born in or later settled in New York.

A far cry from Rihani's writerly rain on the Brooklyn Bridge at the turn of the nineteenth century is the work of two contemporary Arab American poets of singular achievement in New York, Lawrence Joseph and D. H. Melhem. Both are acutely aware of (one might say, in the case of Joseph, burdened by) their heritage and both are active and imaginative pedestrians on the streets of the city by the Hudson, which has so magnetized poets from Walt Whitman to Frederico Garcia Lorca.

Lawrence Joseph is a native of Detroit who transferred the violence and dread of the 1960s race riots in that motor city into a powerful poetry of empathy and anger. Joseph's father was shot during the 1967 riots in his small grocery store, presumably by the rioters venting their frustrations on anyone connected to the power structures of their neighborhood, even someone as dark and apparently understanding as a Lebanese immigrant grocer.

The poet Joseph's voice rises from these violent, ironic encounters in the poem "Then":

> You wouldn't have known
> that soon Joseph Joseph would stumble,
> his body paralyzed an instant
> from neck to groin.
> You would simply have shaken your head
> at the tenement named "Barbara" in flames
> or the Guardsman with an M-16
> looking in the window of Dave's Playboy Barbershop,
> then closed your eyes
> and murmured, This can't be.
> You wouldn't have known
> it would take nine years
> before you'd realize the voice howling in you
> was born then.

The son Joseph finds communion with the downtrodden Lopez, who tells him, with

> rotten teeth
> behind a maze of welding guns,
> you're colored, like me.

His acute sense of the bitterness of the poor and feeling for injustice welds with his own calling in the law (Joseph teaches at St. John's School of Law) to make for a poetry of witness. Righteous, even threatening, truth is his mission:

> I don't want
> the angel inside me, sword in hand,
> to be silent.
> Not yet.
> ("Not Yet")

Joseph's most jarring poem explores a term of degradation, "Sand Nigger," as it has been applied to Arabs:

I am
the light-skinned nigger
with black eyes and the look
difficult to figure—a look
of indifference, a look to kill—
a Levantine nigger
in the city on the strait
between the great lakes Erie and St. Clair
which has a reputation
for violence, an enthusiastically
bad-tempered sand nigger
who waves his hands, nice enough
to pass, Lebanese enough
to be against his brother,
with his brother against his cousin,
with cousin and brother
against the stranger.

This is a shocking poem, not just because of the language, but also because Joseph interjects the criticism. The poetry world is strewn with the lather and confetti of the victim; there is plenty of martyrdom literature around, much of it exaggerated and self-pitying. But Lawrence Joseph wrote this poem in the worst days of the interminable, horrifying Lebanese civil war. It plays on a Lebanese proverb, a rather xenophobic one, and it reveals the utter futility of blood bonds taken to extreme. It is, for that reason, a brave piece of writing. No one can mistake the connection Joseph is making between the Arab and the black man, but some might not sense his searing indictment of the violent devastation brought by the Arab world on itself through absurd pride and its companion, emptiness.

Lawrence Joseph wrote this poem long before the 1993 bombing of the World Trade Center and United States embassies in Africa by various Muslim fundamentalist groups lashing out at U.S. political and military dominance in the Middle East.

I say, along with Lawrence Joseph, and with no small sadness, that the violence in the Arab world —Arab against Arab—has contributed severely to stereotyping. It must also be said in no uncertain terms that violence against civilians is always reprehensible, if not horrifying, and leaves anyone of good will, especially those of Arab extraction, utterly sick at heart.

One has no doubt that the poet Joseph would contemplate the chronic

killing of civilians by both Israelis and Palestinians, especially since the unraveling of the Oslo peace process (whatever its flaws), with great sorrow. The lawyer in him, however, might face three imponderables with grim knowledge: Israelis are not negatively stereotyped in our literature, and, more to the point, it continues to be a universal human right to resist military occupation. If it isn't, what do we say about the French resistance in World War II? How do we assess Algerians who threw off the French occupation of their land? Indeed, what of our own American Revolution? It wasn't all tea parties.

The final nub: the longer a military occupation lasts, the more inured it is to the logic of peace (you don't found settlements while discussing rapprochement). The more desperate Palestinians of the West Bank and Gaza become, the more terrorism rears its ugly head. In this grim equation, suicide bombers and helicopter gunships strafing neighborhoods wade into each other. Where does this madness end? A replay of 1948, with a whole Arab population fleeing in fear or skirted off in "civilized" trucks? Children in Israel afraid to enter a public square or see a movie for fear of losing their lives, or a friend's? There has to be another way. For a poet such as Lawrence Joseph, political consciousness is never far from his aesthetic.

It may be part of his survival as someone so attuned to violence against his people and by his people that Lawrence Joseph buries himself in work and the imagination. He hides, not just as the hard-to-identify Levantine, but as another melted down persona, an American. He says in "That's All":

> I work and I remember. I conceive a river of cracked hands about
> Manhattan . . . I don't meditate on hope and despair.
> I don't deny the court that rules
> my race is Jewish or Abyssinian.
> In good times, I transform myself
> into the sun's great weight, in bad times
> I make myself like smoke on flat wastes.
> I don't know why I choose who I am:
> I work and I remember that's all.

D. H. Melhem is a less caustic observer than is Joseph, but she has a similar sense of injustice, which she takes to urban gentrification on her "longtime Muse, the multiethnic West Side" of Manhattan. As she puts it,

rich building
woe unto you if you rise here
this critical space will cave you
into the cave of its cries
"lamentation after jeremiah to exorcise high rental
high rise building scheduled for construction with public funds"

Like Gibran before her, Melhem has that Arab internationalism of reaching across boundaries to the poor of other lands, as she does so well in "To an Ethiopian Child": "Can you eat your heritage down to the stones / Can you eat those stones down to bedrock?" She speaks of a "porridge of mud." She brings a Gibranian vision of the noumenal to her poem, "by the hudson":

I see the gray gull
above him an eagle I cannot see
limns brilliant passage
gull hovers hopes fish but
I am watching the sky behind him
wing distances dust me with light
the wind lives

Melhem's best work is a long poem about her immigrant mother, who herself wrote a poem in 1922 called "Ellis Island" that has a refrain, "Shall thy heart be stone?" It seems a subliminal theme in much Arab American literature, the fight to keep from being insensate, the struggle to keep an active, sensitive heart and not be bludgeoned by the headlines, the indignities from afar or up close. Melhem's mother was questioning whether she would make it through anger when she was detained eighty years ago on Ellis Island for some reason, probably trachoma.

Two current Arab American novelists have lived in New York for long stretches and drawn inspiration from the city: Consuelo Saah Baehr and Mona Simpson. A resident of Long Island, Baehr is descended from a distinguished Washington, D.C., Palestinian family that she chronicles imaginatively in *Daughters*. Simpson now lives in Los Angeles, but her two novels, *Anywhere But Here* and *The Lost Father*, are skewered with that peculiar American longing for a place in the sun (and a lost Arab father), which can give the soul purpose or at least rest. Both books are filled with journeys back and forth across the American landscape—classic road fiction.

As she searches for her absent father, Simpson's heroine, Mayan Atassi, runs into Salimiddin Atassi from Cairo near the United Nations building: "I looked at his face for some resemblance to me. He had a gourd-shaped head, full and round at the bottom, narrower at the top. Maybe that was Egyptian." Mayan undercuts her own urge to know the meaning of her biologic origins: "Relative seekers always seemed to me the unendowed, the ugly, tirelessly searching for superior cousins and aunts and nieces to prove that traces of beauty lived hidden in their bloodlines. And why? So what? What good did it do them? Better to spend the time and work on yourself." Her very American conclusion to "work on yourself" aside, obsessed with origin she is, not so much to identify herself but to know why she was abandoned.

Salimiddin knew her father, it appears, and remembers him working in a tie shop: "I imagined my father a young man in New York City. I saw him in a hat and a suit, hard shoes, maybe even a cane. It would have been a different kind of life . . . I stood waiting, the high lit flags important and foolish behind running water. Egypt might have felt less foreign to me than these three blocks of the East Side." No more vivifying than Rihani's "skyscraper substituting electricity for the sun," Mona Simpson's Mayan Atassi speaks of the East River blowing "a mouthful of rivertaste into me, dirty and with a black gag in it."

Simpson's lost soul in *The Lost Father* is really Mayan herself, who tries to pin that lostness on the father who left her as a child even as she struggles to understand what it means to believe in life at all. She muses at one point, "Maybe he was a terrorist. Yasser Arafat was at least compelling," but a friend tells her pointedly, "He doesn't sound reliable enough to be a terrorist . . . Or committed enough." That stabs: "Why you are unwanted: the endless, secret question." Mayan is often unforgiving of herself and others, a harsh judge of motive, someone who is as ready to recoil on a pinprick as a sea anemone; yet her search (for want of a better word) is relational, and in that, Simpson has carved a compelling fictional heroine not entirely without the wanderlust for the central fire one might find in the desert or in desert culture.

I would like to conclude by taking a quick jaunt through a few younger New York poets of Arab heritage: Suheir Hammad, Nathalie Handal, Annemarie Jacir, and Sekeena Shaben. It is the singular fortune of these poets that none of them was born in New York and most have lived, quite literally, all over the world, if not these states, to come to an unquiet rest in Manhattan.

Born in the midst of the October 1973 Arab-Israeli war to Palestinian refugee parents, Suheir Hammad came here in 1995 with her family. She has published two books, one of essays and one of poems, and is at work on a third whose title is evocative of her youth and the brash tones of recent Arab American poetry: "Zaatar Diva!" (Her first published book, *born Palestinian, born Black*, (1996) expresses blatantly what Lawrence Joseph suggests—a joining with the African American fate on these shores.)

Hammad's is an insistent, no-holds-barred, feminist voice. It has the monotone drumbeat of a rap song, but with more flair than the usual in that sorry genre. She lunges to connect the political and the sexual:

> in this world of
> men and molotovs
> family pride laid
> between her thighs
> honor in her panties
> and no oslo accord
> or camp david signing
> could free her sex
> from its binding

Her outrage at the Lebanese civil war has more than a tinge of self-hatred in it (curiously akin to Lawrence Joseph's), and although the poem "broken and beirut" has too much of the oxymoronic bent of that title, as well as the gratuitous violence one often sees in the art of those comfortably removed from such scenes, it also has an unmistakable power and honesty:

> don't know what to do with visions
> of blown up babies so we
> lame nails and lame tongues
> which should protest
> love those who cannot
> love us
> hate ourselves and become
> obsessed with puzzles.

The family-all-hail in Arab poetry is not here—the soothing family of Melhem or Naomi Shihab Nye, for example. Hammad calls her father "the

only dynamic I knew / more hurtful" than a bad lover. Having grown up in the Los Angeles community, I do not remember an absent father; I recall only one divorce. But in Simpson's novels and Hammad's poems, male absence is the least of it; there is male blankness, if not outright cruelty. It is a jarring shift from traditional Arab parental warmth and love, and one wonders what part Palestinian disenfranchisement (in the case of Hammad) or loveless and rootless America (in the case of Simpson) might have to do with it.

My favorite of Hammad's lines deals with the nagging urge for an alternate self, "we should all have been other people / with other people," referring to four girlfriends trying to make their way to their thirties. As for New York, the most we can say of its presence here is that the poem "Manifest Destiny" is set in a Cuban diner!

There is little more of New York in Nathalie Handal's ethereal, yet erotic, poetry. She once e-mailed me, "Maybe I will never belong to one city."

Life is so multiple for Handal that it is hard to conceive of her belonging to one of anything. Handal is slightly older than Hammad at thirty-two; her muse is beauty and love, which she transforms into a spiritual yearning. Handal has a confidence and Keatsian virtuosity with the language. Her book of poetry, *The Never Field*, is a lovely series of meditations on the wiles and yearnings of love as well as on existence itself. There is a terra incognita feel about it, an austere sensuality reminiscent of the poets of the Greek anthology. Handal's literary roots are wide. Born in a Palestinian family that has migrated from Palestine to Europe, the Caribbean, then New York, Handal has often traveled to Eastern Europe and London. She is a tireless scholar and champion of the work of our Arab writers in her landmark anthology, *The Poetry of Arab Women*.

"I am not afraid of loving, I am afraid of forgetting I loved," Handal asserts in a poem, putting the possessive on notice even as it takes to Whitmanesque wing, "so I leave my naked body to the evenings, to the / breeze of a September night not too far away from winter." To Handal,

love smiles but is never satisfied
is happy but never for too long, like the stranger
in your bed who speaks to you as if he knew you, loved you
knowing he will never see you.

This would all seem rather bleak, but she has a playfulness with language that rescues the restlessness: "Nothing crowds us but to see and the sea / as

it sighs and sighs in the mouth of will." That from a poem called "The Sigh."

Sekeena Shaben writes poetry and fiction and came to New York City by way of Canada and Colorado. Her book is called *Regular Joe*. It is spare, imagistic, a salute to William Carlos Williams, H. D., and other imagists, as well as to Beat poets with whom she studied, it seems. There is an insomnia to Shaben's work—"all night the creaking / of a loose window pane / and now this / unbearable stillness"—that could be seen as peculiarly New York, with its lofts and studio apartments of singles among the millions of singles. She knows it is 4 A.M. by the garbage trucks rolling outside her window. But of course that is any big city and any lonely soul in it, from New York to New Caledonia. It is hard to say what of the Arab world is here, except that I have found a soul by itself in Arab and Arab American poetry is particularly elegiac, as if it were not quite itself as one. Tribal longing, one might say. Certainly the opposite of Emersonian self-reliance.

Shaben's thoughts echo those of Elmaz Abinader, who taught for some time in New York before her current work at Mills College in California. Abinader speaks from that squeezed space that urges longing:

> We who sit in small apartments have no room for birth
> We do not break the cold air to walk from the book, chair, or quiet phone . . .
> We close our shutters in silence
> with one slot open and a secret wish ("Dar a Luz").

And what of Annemarie Jacir, poet, filmmaker, activist of Palestinian origin, who comes to Manhattan via the Arab world, Texas and California—plenty of heat to store between the Hudson and Long Island Sound? In "Pistachio Ice Cream" (there is no "31 Flavors" in the Middle East—only pistachio), she is informed by the vendor that "we fought / with our hearts and / not our heads—therefore we would never win." The poet is cut off, "dead to my tribe," as she gazes at stars with Arabic nomenclature. My suggestion—try a little chocolate, even a few American walnuts, on that pistachio.

My Mother's zither was New York. The zither, the great bridge of promise that still stands, teeming life of immigrant millions who touched liberty's flame and were burned or warmed—these live on in our American literature. Their struggles to join this dear land, to literally be its people,

still beckon the mind to soar with grief or joy above the tallest buildings. They do not countenance hatred. They do not accept the tyrant of terror. They will look to their writers—from Hart Crane to Lawrence Joseph—to strum that zither of tolerance and listen to the music of the ages between the Hudson and East Rivers, long after mother is gone and I am gone, and everyone here.

6

Cultural Traditions of Early Arab Immigrants to New York

Stanley Rashid

I want a better life for my children." These were the words of my grand-mother, Ajia Rashid, when she sent her first sons, Mojelly and Mitchell, to join their sister Alya and her husband, Elias Rashid. They immigrated from Merdjayoun, Lebanon, to Iowa at the turn of the century. These spoken words were the aspiration of most Arab immigrants to North America. They were trying to escape their Ottoman rulers, who harshly taxed landowners to subsidize the Turkish occupational forces. Many Arabs were impressed into the Turkish army, usually for life, and they migrated to avoid being conscripted.

Our grandparents and parents landed first in New York, bringing with them their customs and their music. Many moved on to New England or to the Midwest. In the early part of the twentieth century most of the Arab immigrants came from what was then known as Greater Syria, which was divided in the early 1940s into Lebanon, Syria, and Palestine. As noted, they were predominantly Christians: Maronites, Syrian Orthodox, and Melkite Catholics. The new immigrants tried to live close to their respective churches. The first Maronite church was located on Cedar Street near the Washington Market, which was the first commercial center for Arab Americans in New York. It was there one could find fresh Syrian bread (now called pita), foods, spices, and records of Arabic music on such labels as HMV, Odeon, RCA, and Columbia. The Washington Market finally succumbed to the building of the Brooklyn Battery Tunnel in the mid-forties. The new retail center arose on Atlantic Avenue in Brooklyn, which already had a growing Arab residential population and several churches. Our Lady

of Lebanon, now a cathedral, is still located on Henry Street; St. Nicholas Antiochian Cathedral is still located on State Street, and the original Melkite Church was located on Amity Street. The Melkite Church has since been demolished, the congregation having moved to Park Slope in the 1950s and eventually to Bay Ridge.

During the first half of the twentieth century many professional musicians followed their countrymen to America also with hopes of finding a better life. An equal number of immigrants and their children learned to sing Arab songs and play traditional instruments here in the United States. They learned in the traditional manner of apprenticeship. For the most part, there was no formal musical education in the Middle East. Egypt was the one exception. Most Arab musicians played "by ear" in the same tradition as many American jazz and pop musicians. As Cab Calloway once said, "If it sounds good, it IS good." They memorized the Arab music scales and the popular melodies. Later, many of the children of the Arabic-speaking immigrants studied Western-style music and were able to adapt that discipline to playing Arab music. These pioneers faced the perennial problems of all immigrants: language barriers, hostility of intolerant neighbors, and fear of the unknown that lay ahead. They found strength in their churches, which were also their primary social and recreational centers. Music was a big part of their social fulfillment. They carried on the traditions of their folk dances such as the *dabke* (an excitingly rhythmic and pulsating line dance in which men and women could clasp hands and dance away all of their anxieties and frustrations accumulated over the weeks of scratching out a living).

Their music was first enjoyed at informal evening gatherings called *sahras*. These were usually parties at someone's home—probably on a Saturday night. Family and close friends were invited to share the food, fraternity, and especially enjoy the songs and the dances. New York was a melting pot of immigrants, and New York Arab Americans did not have the inhibitions of their cousins in the Midwest or South. Song and dance went on through the night, often to the chagrin of the neighbors living in the apartment below. They would share folk songs they brought with them from "the old country." (My Uncle Mitchell played the concertina. He knew five or six different songs, which he would play at all family gatherings and picnics for more than fifty years.)

As the community grew the need for more organized social gatherings became apparent. This led to the *hafla*—which was a large social gathering—usually held in a church or other social hall such as a Masonic Lodge

Construction old and new, 38 Greenwich Street from 37 Wash-
ington Street, August 12, 1936. Photograph by Berenice Abbott.
The neighborhood into which the first Arab immigrants moved
encompassed several blocks of tenements built shortly after the
Civil War. They contained three- and four-room apartments with
a lavatory in the hall and without steam or heat. Abbott captured
the "new" construction behind the old—three office buildings
erected in the 1920s, with main entrances on Broadway. The
tenements depicted here were demolished in 1946 for construction
of the Brooklyn Battery Tunnel, opened in 1950; the three office
buildings on Broadway still stand. MCNY Abbott File 166.

or Knights of Columbus hall. Eventually, they moved into the grand ball-rooms of local hotels like the St. George in Brooklyn Heights. The *hafla* was the first of two major sources for music and entertainment of the Arab Americans. Arab radio programs did not really gain any influence until after World War II and are still heard in New York City, broadcast from Fordham University in the Bronx and Seton Hall University in New Jersey. Arab films had their debut in 1935.

So, the *hafla* was really the first organized form of entertainment for Arab Americans in the new land. A singer would be hired. It was this artist's responsibility to organize the ensemble that would accompany him or her. Among the early professional singers and musicians who settled and performed in the New York area were vocalists Elia Baida and Najeebe Morad, and violinist Na'eem Karakan, All of them came from Greater Syria. *Qanoon* virtuoso Mohammed El Akkad and Mohammed El Bakkar were stars in Egypt before landing in New York. The Arab divas of Brooklyn, Hanan and Kahraman, emigrated from Lebanon to Brooklyn in the late forties and enjoyed long successful careers singing and entertaining thousands in their lifetimes. There were also many talented amateurs who learned to play in the traditional method as apprentices.

One of my favorite musicians in Brooklyn was Eddie "The Sheik" Kochak. Eddie was born and raised in Brooklyn. His father ran a coffeehouse on Atlantic Avenue. Eddie said he learned to play the drums beating on his mother's pots and pans. Eddie learned to play *durbakee,* which is the traditional Arab drum (goblet shaped with a single head). He also learned to play the American snare drums and later formed his own band. His comedic as well as musical talents led him to compose many parodies using both Arabic and English expressions, which appealed to the younger generation of Arab Americans. He was just as comfortable playing mambos as he was the *dabke.* Because of his versatility, Eddie was often hired to play at weddings and church socials. Some of his memorable parodies were "Sahara Sue" and "Shish Kabob Rock." He literally created an Arab American art form called Ameraba (a fusion of Arab music and American pop).

The second, and probably the most significant context of Arabic entertainment, was the *mahrajan,* or festival. The churches, often several in conjunction with one another, organized the *mahrajan.* The festivals ran for two or three days during the warm summer months and were often held outdoors. The most popular time for a *mahrajan* was either Labor Day or the Fourth of July. *Mahrajans* would attract thousands of people from the entire region. Families would pack up sleeping bags in case all of the motels

were full, and bring food. A *mahrajan* in Danbury, Connecticut, or Paterson, New Jersey, would attract people from New York and Connecticut. Churches would pool their manpower and finances to handle such a grand affair.

The venues for these events were fair grounds or municipal parks that offered ample parking as well as facilities for families to barbecue and bring their own chairs or spread their blankets. Food had to be prepared; inclement weather contingencies had to be made; entertainment had to be booked; and a grand stage would be set up with the early sound systems of that era. A *mahrajan* would require many singers and several ensembles, as the music went on all day and late into the evening. The parishioners usually prepared the food, the sale of which helped to pay for the expenses. *Mahrajans* also gave opportunities to young new artists who would showcase their talent at such affairs in order to gain recognition. The *mahrajan* was the one arena in which the Syrian-Lebanese were willing to cross sectarian lines to preserve their collective heritage. It was social, apolitical, and often functioned as a marriage market. So, attendance was encouraged. After all, marrying a "Syrian" was a major concern.

Young Arab Americans such as Emil Kassis, Eddie Kochak and his *Ameraba* sound, and violin virtuoso Fred Elias all had their debuts at *mahrajans*. These *mahrajans* were an integral part of retaining the Arab culture and music within the Arab American community, especially for the American born. It was an opportunity for the children of the immigrants to stay in touch with their heritage, to meet new friends and, in some cases, find a spouse. You could find the young teens off in a remote part of the fair grounds learning how to play the *durbakee* and holding marathon *dabkee*. *Mahrajans* also included other cultural opportunities such as poetry recitals and speeches by local community and religious leaders. Many famous poets and authors made New York their home. Kahlil Gibran, Mikhail Naimy, and Elia Abu Madi were prominent in the New York community. Many cultural and fraternal organizations sprang up such as the Salaam Club, the SYMA Club (Syrian Young Men's Association), the Kiserwan Club, the Aleppian Fraternity, and SOYO (Syrian Orthodox Youth Organization).

In the early part of the twentieth century, between 1900 and 1920, major American record labels recognized the importance of the ethnic markets in the United States. They signed recording artists from Egypt and other Arab countries as well as those artists residing in the United States. They released hundreds of recordings during this period. These recording

companies understood the market for ethnic music, and Arab music was one of their strongest selling repertoires. The advent of recordings on 78-rpm discs also created some problems for Arab music. The maximum playing time of a record was approximately three and a half minutes per side. The average Arab song could last twenty minutes. Arab songs were often poems that had been set to music. These poems are called *qasidas.* If the poem or *qasida* was longer than the time allowed for a 78-rpm record, it would have to be cut down. This meant a considerable amount of editing of the song to fit the format. Another problem was that the relatively poor quality of recording technology affected the style of the music. In many of the early pre-war recordings of the great singer, composer, and actor Abdel Wahab, you can hear him clearing his throat before beginning to sing. It wasn't until after World War II that the "cough button" reached the recording studios and eliminated such problems.

In the 1930s the Great Depression slowed down new production and Arab Americans took control of the Arab music recording industry. Labels such as Macsoud, Malouf, Maarouf, Ash Shark, and Alamphone flourished. Alexander Malouf, the founder and owner of Malouf Records, was a composer and musician. Malouf was a pioneer in the publishing of Arab musical arrangements for the piano as well as traditional instruments. Both the Malouf and Macsoud Companies also produced piano rolls for player pianos, which were popular in their day. The advent of Arab American producers created a wonderful opportunity for young Arab American entertainers to make records in this country. Alamphone Records and Ash Shark Records were both located in Brooklyn. The competition that arose between these two entrepreneurships led to some of the most entertaining and popular recordings made in this country. Sana and Amer Khaddaj—a husband and wife duet—recorded many hit songs on the Alamphone label. Ash Shark touted such artists as Mohammed El Bakkar, Little Sami, and Jalil Azouz. Many humorous songs were recorded and became great successes such as "Khaleek Azab" (loosely translated—"Don't Get Married") and "Sabaq El Kheil" ("Playing the Horses"). These subjects were relevant to the Arab American culture and would never have found an appreciative audience in an Arab country. This was one of the early developments of Arab American music.

Arab films first made the scene in New York in 1934. My father, Albert Rashid, presented the first Egyptian films at the Brooklyn Academy of Music every month. His first film was the epic *Ward El Bayda (The White Rose)* starring Mohamed Abdel Wahab. The novelty of seeing a motion pic-

ture film in their own language created a stir in the New York Arab community that was unprecedented. The film contained over ten songs. The demand for these songs on records was so great that Rashid began to import records from The Baidaphone Recording Company of Cairo, Egypt. The actual records were made in Germany at the Odeon pressing plant. He continued to import these records until the beginning of World War II, when all importation from Germany came to a halt. The Allied bombing subsequently destroyed the pressing plants in Germany, which literally put an end to all Egyptian production for several years. During the war years, Alamphone Records continued to press records in the United States.

When the Allied forces, including American soldiers, landed in North Africa, the State Department, which had started the Voice of America, was looking for sources of Arab music in North Africa to play on their radio broadcasts. Because of the destruction of the German plants there were no records to be found. The State Department then conducted a search. They located and contacted Alamphone Records, which was able to supply them with records throughout the entire campaign.

In 1946 the Egyptian record industry resumed production in Great Britain and France. New films began to find their way to the United States. In addition, the great Abdel Wahab and other recording artists made their debut on the silver screen. The Egyptian Diva, Umm Kulthum, made several films, which were all great successes. Asmahan and her brother, Farid al-Atrash, became megastars and their recordings grew more popular with the success of their films.

In 1944 Albert Rashid opened a retail store and office on East 28th Street in the Manhattan offices of *Al-Hoda*, an Arabic language daily that boasted the first Arabic linotype in the United States. This location was well chosen since the *Al-Hoda* Press was also a cultural center in New York. Rashid started to rent films to other cities in the United States such as Detroit, Cleveland, Boston, Providence, and Paterson, New Jersey. The films created a demand for the records of these films. Seeing a new market, he started the earliest Arab mail order business. He could ship small orders by Parcel Post and larger orders by Railway Express. In 1947 Rashid moved his store from Manhattan to Atlantic Avenue in Brooklyn. During the early 1940s many Arab Americans worked late hours in quilting factories and other garment manufacturing enterprises. Their only day off was Sunday. Rashid would rent a small theater in downtown Brooklyn such as the Boro Hall or the Metro on Court Street for a screening after the end of the regular American feature. Several hundred people would attend this late show, as it

Albert Rashid at Rashid Sales Co., Atlantic Avenue, 1947.
Albert Rashid opened his first business in Detroit. After
the outbreak of World War II it was difficult to import mer-
chandise from the Arab world, so he closed his business and
worked in a Ford defense plant. In 1944, he and his wife,
Josephine, moved to New York and established a business on
East 28th Street in Manhattan. Three years later, following
the migration pattern of New York's Arabs, he relocated to
Brooklyn, opening Rashid Sales at 151 Atlantic Avenue.
Rashid Sales continues to operate just around the corner from
the "Main Street" of Arab New York, at 155 Court Street.
Courtesy of Stanley Rashid.

was the only time they had to see an Arab film. Admission was fifty cents. Eventually, films were shown at the Brooklyn Academy of Music (BAM).

In the mid-forties Arabic-language radio programs gained a foothold in New York. The early programs were on the end of the dial, the location of the weakest stations such as WWRL (1600). Two of the pioneers of Arabic-language radio were Sabree Andrea and Joseph Beylouni. They hosted a weekly program that ran for nearly twenty years. It served the New York community with local and international news and personals such as marriages and births. It reached nearly every Arab American home in New York.

Today, Arab immigration not only continues, but also has accelerated at an unparalleled pace. Travel and new technology, such as the Internet, have increased communications among Arabs throughout the world. Today in Brooklyn there are two Arab Muslim parochial schools and several centers of culture and Islamic studies. Arab restaurants flourish throughout all parts of this great metropolis. The Arabic Channel, an all-Arabic cable TV channel, is part of the Time Warner package. The Dish Network offers four channels from Lebanon and Dubai twenty-four hours a day. And, the odds of finding a cab driver who speaks Arabic are three to one!

7

Being Arab American in New York

A Personal Story

Peter J. Awn

There is a story told about the sixth-century pre-Islamic poet/hero, Shanfara, which captures in a particularly vivid way the spirit of the heroic age in the Arabian Peninsula. It is said that, as a small child, Shanfara was seized by members of a rival tribe and raised as one of their own. When he grew up he found out the truth and was so outraged that he vowed to seek vengeance on the tribe who stole him by killing one hundred of their number. Over the years he killed ninety-eight members of the rival group. Eventually, however, Shanfara found himself surrounded by enemy troops. He fought valiantly, at one point even using his severed arm as a weapon to kill his ninety-ninth man, but the odds were too great and Shanfara was killed.

Time passed; a lone Arab was walking through the desert and absent-mindedly kicked a skull he found lying on the sand. The skull splintered and a sliver of bone entered the Arab's foot. The wound festered, became gangrenous, and the Arab died. Shanfara had finally killed his hundredth man.

Brooklyn is not the Arabian Peninsula, nor was I raised to be a heroic poet like Shanfara. But, growing up in an Arab American family in the forties and fifties, I found that much of my link to the Arab world was based on vibrant cultural myths that helped me create my hyphenated identity of Arab American and negotiate life in this great, multiethnic metropolis. As a Lebanese American from a Maronite Catholic family, I reveled in the stories of our Arab and Phoenician cultural and political history and in the history of our unique brand of Christianity.

Cultural myths in my family helped us keep focused on the positive dimensions of our family's history, despite the painful realities that brought about my parents' families' migration from Lebanon. The end of World War I and the collapse of the Ottoman Empire wreaked havoc on the lives of millions in the Middle East. Famine, political unrest, random violence, economic collapse—all precipitated a major migration of Syrians and Lebanese to the United States, Europe, Australia, Africa, and Latin America.

My father was the second youngest of ten children, eight of whom sailed with their parents from Beirut to Marseilles and then on to New York in the bottom of a dilapidated passenger ship. To say that they traveled steerage does not quite capture the horror of the trip. To compound the situation, at Ellis Island my father, then seven years old, and my grandfather were denied entry for health reasons. My grandmother and the other children moved in with relatives in New York to wait for news of my father and grandfather. The men were able to leave Ellis Island by securing passage on a ship headed for Montreal, from where they eventually were able to arrange entry to the United States.

The memories of war mixed freely with my father's childhood memories of his family's home in Damour, outside of Beirut. He would wax eloquent in later years when he described to us how fat the birds were in Damour, how lush the gardens and fruit trees, and how amazing the sound of thousands of silk worms munching away on mulberry leaves in the sheds built to cultivate them for the Lebanese and European silk industry.

Although I was born in the Arab enclave of Brooklyn Heights (formerly known as Downtown Brooklyn), when I was about seven years old we moved to an equally vibrant Arab community in Bay Ridge. One of my father's sisters and her family lived next door; one uncle and his family were up the street; and several uncles, aunts, and their families were within a five-minute walk from our house. The traditional extended family that was so much a part of life in the Arab world was duplicated here. Sunday dinners were massive affairs. The cooking began on Thursday with my grandmother, mother, and perhaps an aunt or two preparing dinner for fifteen or twenty members of the family who would assemble almost weekly.

As important as cultural pride and family was my family's commitment to their religious faith. The Eastern-rite Christian churches in New York served as important community centers in which Christian Arabs built bonds of friendship, socialized, and sometimes found spouses.

Particularly helpful to immigrant families like mine was the close link to the parochial school system. In the same way that in Lebanon my par-

Mar Nasrallah Boutros Sfeir, Patriarch of Antioch and All the East, Our Lady of Lebanon Antiochian Syriac Maronite Church, Brooklyn, March 11, 2001. Photograph by Mel Rosenthal.

ents and their families had been trained by French and Lebanese nuns and priests in parochial schools, so here they naturally followed the same tradition, feeling that a parochial education was somehow their birthright. Here the nuns and priests were Irish (a few were Italian), but my parents' sense of being part of the Catholic community was the same. Unfortunately, the Irish taught us that it was in our best interest to be identified with the larger whole rather than with our own Eastern traditions.

My mother was a bit more suspicious of the Irish nuns than my father was. She had had terrible times in grade school since the nuns singled her out for ridicule because of her olive complexion and dark, curly hair. My siblings and I had heard this story many times and tried hard to be model students to avoid the same fate. Unfortunately, my fourth-grade teacher, Sister Dunstan, felt it was her Catholic duty to ensure that all Arab and Eastern-rite children in her class receive a massive dose of Irish culture, often disguised as Latin Catholicism. I can still remember the horrified look on my mother's face when I came home one day singing all the verses of a number of classic Irish tunes like "Gallway Bay" and "Oh, Danny Boy." From a religious perspective, we learned nothing of our Eastern-rite Catholic heritage; indeed, we were being weaned away from it and hence from the community. Like many Lebanese Maronites living in Brooklyn, I learned to be more comfortable in a Latin Church setting than in my own tradition.

More often than not in grammar school and high school I was seen as an exotic animal. At the Jesuit prep school I attended in Brooklyn, even the priests were not sure what a Maronite was. They thought the word was "Marianite," erroneously believing the name had something to do with the Virgin Mary.

Culture, religion, family, and education were very much the cornerstones of my extended family's values. When it came to education, my father was both thoroughly modern and a die-hard traditionalist. The boys in the family were expected to complete college, if not advanced degrees. Neither my father nor any of his brothers had completed college. They were obliged to work right after high school and had established a very successful retail business in Manhattan. But my father was convinced that business acumen would not be enough for his children to compete successfully in modern American society. The future, he insisted, belonged to college graduates.

Surprisingly, he felt the same about my sisters' education. Whereas my uncles and aunts tended to send their daughters out into the work force

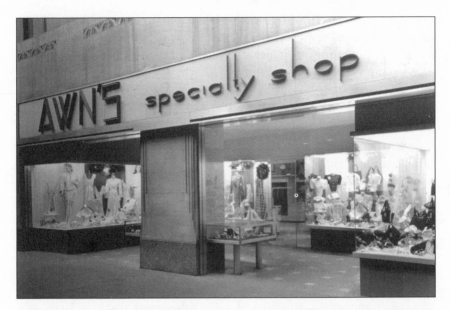

Awn's Specialty Shop, the clothing store owned by the Awn family on Washington Street, was in operation for more than fifty years. Courtesy of Arab American Heritage Association.

after high school, my father insisted that his daughters attend private women's colleges. I do not think, however, that he was quite aware of the consequences of this decision. In his mind, well-educated women would find well-educated, successful husbands. What he did not realize was that college-educated women developed minds of their own and would no longer conform to the patriarchal structure of a traditional Lebanese family. Even to this day, my sisters, both successful professionals, joke with my father that they have rarely seen him take a woman's opinion seriously on any subject. On this, my mother is very quick to agree!

My sisters and I love to remind my father of the time when I was a Cub Scout and needed to help my mother dry dishes in order to earn a merit badge. My father came home late that night from work to see me standing at the sink drying dishes. He asked my mother to step into the next room. "Never again," said he, "will I see my son drying dishes." My mother rolled her eyes and kept her cool. This incident has now become a standing family joke.

After high school I did the unexpected, or as my parents thought, the irrational. I entered a Jesuit seminary, where I continued my education through the Ph.D., was ordained a Maronite Jesuit priest, and eventually as-

sumed a faculty position at Columbia University in 1978 as professor of Islamic religion and comparative religion. While I have been visiting professor at other institutions, I have been at Columbia since I finished my doctorate in 1978.

Obviously, there is more to the story than this bare outline. My almost twenty years in the Jesuits gave me a rare opportunity to pursue in a more substantive way my fascination with the cultural myths of my family, the complexities of religious life in the Middle East, and, for the first time, the serious study of Islam.

As a Jesuit I had originally been slated to complete a degree in Church history, focusing on the minority Christian communities in the Arab world. To do this properly, I obviously needed to know something about Islam. The more I studied the Islamic world, the more I was fascinated by Islamic literature, philosophy, and especially mysticism, known as *Sufism*. *Sufism* was the focus of my doctoral studies at Harvard, and Columbia hired me to teach Islamic religion with a focus on *Sufism*. So you had the somewhat anomalous situation of a Catholic priest teaching Islam at a secular university.

I left the Jesuits in the early eighties for a number of professional and personal reasons, but I am grateful for my extraordinary experiences as a member of that religious order. My career at Columbia has allowed me to pursue seriously my childhood fascination with Arab and Islamic culture and to travel to many different parts of the Islamic world. I am also aware of what a privilege it is to share this culture with talented young men and women from around the country and the world for whom the Arab world and Islam are often one-dimensional clichés.

To grow up an Arab American in New York after the 1967 war is very different from the charmed if myopic period of my childhood and adolescence in the fifties and early sixties. Now the designations Arab and Muslim have more political than cultural connotations, and Islam is seen as a religion of violence, not the religion of great philosophers, poets, scientists, physicians, and statesmen. I am lucky that I was an adult when this sad turn of events occurred. I can imagine how difficult it must be these days to be an Arab Muslim child or adolescent in New York when one is forced frequently to defend one's ethnicity and religion from superficial stereotyping if not outright prejudice.

Through no fault of their own, Arab Christians in America hold many similar prejudices about Muslims. Learning their history from the French, Christian Arabs were taught to distinguish themselves from Muslims by

being told, in fact, that they were not Arabs because the term was thought to be synonymous with Muslim. Our parents believed they migrated here because of persecution. They were being persecuted—not necessarily by Arabs or Muslims or because they were Christians—but by Ottomans who were conscripting them into the military and who saw both their Arabic-speaking Muslim and Christian subjects as disloyal nationalists. But the myths continued; only now, after the passing of the immigrant generation, can Muslim and Christian Arabs join together to discuss their common heritage and history.

I am fortunate to be in a position as an educator to work in some small way against this denigration of Arabs and Muslims by an uninformed press and politicians. Radicalism and political activism in all religious communities have overshadowed the extraordinary cultural heritages of religious societies. We should, however, take heart from the realization that narrow-mindedness and violence in the name of religion is not new but something that has raised its ugly head frequently throughout history in every part of the world. I am reminded of the great scientist/physician of the tenth century, Abû Bakr al-Râzî, known to the Europeans as Rhazes. His medical encyclopedia was translated into Latin and remained in use well into the sixteenth century.

In one of his last writings, al-Râzî attempted to answer conservative religious critics who believed that philosophy and the natural sciences were somehow ungodly or un-Islamic. For al-Râzî, the goal of human existence is not pleasure but the pursuit of knowledge and justice. These are the core ideals for any intellectual. We should never allow ourselves to be deterred from these pursuits because of threats from any group, be it religious or political. The model of the Muslim intellectual, al-Râzî says, is Socrates, who never ceased to pursue wisdom while constantly acknowledging that he really knew nothing. He was even willing to sacrifice his own life for the truth rather than succumbing to the prevailing bigotry of his age.

Al-Râzî, although dead one thousand years, has a lot to say to this Brooklyn boy, and I hope to all of you.

Let us cherish our Arab heritage without overly romanticizing it. Let us not only recognize the serious social and political problems that currently exist in the Arab world but also work seriously to bring about positive change. Finally, let us never lose sight of the extraordinary depth and richness of the culture that we share—a culture that epitomizes the ideals of humanism. Keep in mind the words of the Muslim tradition: For truly God is Beautiful and He loves Beauty.

8

So, Who Are We? Who Am I?

Philip M. Kayal

I chose this title because individual identities normally are derived from group linkages, and the subject under discussion is the emergence or presence in New York City of a collectively shared Arab American ethnicity and identity, if not politic. Personally, I believe group and individual identities are mirrors of each other.

"Who are we and who am I," then, is a great question, a complicated question because identities are always changing. As situations change, so do identities. As the collective identity alters, so does the subjective one. Identity formation, then, is not a singular process with a definitive end point but an evolving social-psychological experience of self-discovery that changes with events, issues, and sociopolitical circumstances surrounding a person.

How we have seen and defined ourselves was at one time a function of forces beyond our control. Now, as we become yet another American interest group, we can at least define for ourselves who we are. This development is also a function of changing external variables like the current emphasis on diversity or multiculturalism.

Answering this query about "who we are" or "who I am," therefore, requires a bit of sociology and an accurate sense of history. This means understanding the broader cultural and structural or institutional contexts we have lived through and now daily live our lives in.

In most of the world, the fate of individuals is tied to the groups that they identify with, either voluntarily or unwillingly.[1] I say "in most of the world" because in the United States the individual reigns supreme and is

assumed to be an entity unto himself or herself. Many Americans eschew collective identities, especially those imposed on them from the outside.

True, America is, for the most part, an open-class and upwardly mobile society where a person can create and recreate himself or herself by effort, whim, or fancy. What may take generations to achieve elsewhere (a change of status, the creation of a national consciousness, or a re-alignment of national loyalties among a people) can happen in America in one's own lifetime; indeed, it is expected to happen as we all Americanize. This is, in fact, the definition of an American: a collection of individuals beholden to no one and responsible only for themselves.

In time, primal linkages are expected to give way to individual self-expression. National loyalties or loyalties to a larger impersonal entity are expected to replace provincial or personal ones. Even the family in the United States is more an association or secondary group than an interpersonal primary group.

Arab Middle Eastern culture, on the other hand, emphasizes collectivity; the family, the village, the tribe, the religion are the primary reference, even more so than the nation. If, in American society, an identity is ultimately a subjective creation where first names take precedence over family names, in Arab society an important if not primary question in locating someone is *ibin mean* or *bint mean* (whose son or daughter)? That is why our story here is so unique. Going from extreme localisms or familial identities to larger groupings and associations is quite an accomplishment. The very idea of a broad Arab American community, never mind identity, is a new phenomenon.

In fact, it emerged atypically after the fact of assimilation for the earlier immigrants. It occurred over decades, involved several ethnic groups, and ultimately transcended religious boundaries. In New York, the place where both individual and collective identities dominate, compete, and coexist with each other at any given moment in time, for a shared Arab ethnic identity to emerge both prejudice and self-denial had to be contained.

For the early wave of immigrants and their descendants, a change in self-consciousness and identity as Americanization proceeded was a political act because a community and ethnic group finally emerged. This process of ethnogenesis occurred simultaneously with alterations in our own individual consciousness. For Syrian-Lebanese in America and in New York, this meant our corporate identity expanded. And most of this expansion occurred in reaction to external or macro variables, like the creation of the

states of Syria and Lebanon, the quality of the welcome that we received here, our integration into religious and educational institutions, and today the defamation of all Arabs, the Palestinian struggle, the civil war in Lebanon, and the relatively recent occupation of the Golan Heights in Syria. Closer to home, it emerged in the context of a highly diversified and stratified city that politicizes group identities at the same time that it rewards the individual who struggles to fit into the national culture and society.

What is true of us is that we did not just become Syrians or Lebanese or Arabs. We did not just automatically become a nationality or even hyphenated Americans. Rather, we went from being Asians to whites (a fascinating story in itself); Melkites, or Maronites, or Orthodox to being Catholics or Antiochians; or from being Aleppians, or Damascenes, or Turks to Syrians, then Lebanese, then Arabs (and for some, Phoenicians). We did this simultaneously while we both Americanized and communalized ourselves. We became an ethnic interest group in a society that denies the legitimacy of ethnic identities.

Indeed, American society legally forbids forced differentiation and separation by ethnicity and race. Ideologically it does the same by social class, and it is hoped, now, by gender. The only form of diversity constitutionally protected, indeed encouraged, is that of religion. How convenient for us, since religion matters a great deal in the Arab East and a great deal in the United States. In both societies, religion is a form of identity and social location. By contrast with the Arab East, however, in America religious affiliations are seen as personal choices with no single religion officially outranking another in power or significance. For Arabs religion is primordial and inherited.

Conveniently avoiding the reality of class, in the "everyday world" we live in most Americans (and American Arabs in particular) see one another in ethnic terms, racial categories, genders, and as members of religions. Indeed, Arab Americans come from a long tradition of rights and privileges being distributed by religious affiliation and family lineage (Millet system).[2] You are what you are because of what your parents are. It was a way of making sense of a pluralistic world and society. This is how most immigrants normally saw the world and this is how the world for the most part is organized. It would be hard to find a New Yorker of any background who would not be doing the same thing today as second nature. The point, however, is that constitutional law tries to level the playing field, stressing individual achievement and freedom as primary. This is even true in religion, for individuals are free to change their religious affiliation, although doing

so is hardly necessary because all religions are seen as equal and, at least ideally, are also considered a private affair and an individual choice. So, if our constitution stresses religious differentiation and freedom over all others, then this factor has to play a role in how we (Arab Americans and others) organize ourselves, as well as in how we see ourselves and are seen by others.

As already indicated, the other variable that affects our identity and our self-esteem is the culture we live in, that is, a Waspish, Anglo-European, Western Christian culture built around rational, secular values that stress the primacy of the individual over the group. Yet, just as our own ethnic identity has changed in the last hundred years, so has the character of the United States. We are living in a highly urbanized and industrialized society that values private enterprise and personal success at the expense of the public good. We are responsible only for ourselves. This is not the prevailing motif of the Arab world, but it is into this world that we all have migrated. Ethnics are always being pulled away from their roots, and this is considered a good thing.

Culturally distinct, religiously misunderstood, institutionally isolated, and socially fragmented, our emergence as a successful ethnic group occurred against all odds. But we were smart, middle class, entrepreneurially effective, self-reliant, communally interdependent, and when we got here at the turn of the century we were generally (and only generally) well-accepted.[3] There was a certain love of us by American Protestants (as Christians coming from the Holy Land), and American racism, while rampant at that time, was mainly directed elsewhere. The virulent anti-Catholicism that had existed during the mid—to late-nineteenth century was slowly abating. These are the macro variables that affected the early Christian Arab immigrant. Oddly enough, these same external factors forced us to rely on ourselves and to develop over time a working identity as Syrians and Lebanese and now, perhaps, as Arabs.

It is my opinion that while the story of Arab immigration here starts with the Syrian Christians, it is not generally understood what these early immigrants were up against when first arriving here. We need to pay attention, therefore, to the social variables that affected their accommodation to American society. Thus a later generation of Arab American scholars, their fellow ethnics, and Americans in general, can understand why it is not so easy for us to be fully identified and involved in what we now call the "Arab American community."

If the America of the early 1900s is not the America of today, then

today's Arab and Muslim immigrants need to appreciate the social circum-
stances that shaped the development of early "Arab American conscious-
ness," if indeed I can even use that term. We need also to understand the
exigencies of both these immigrant flows (the old and the new) and how cir-
cumstances affect political consciousness and behavior.

The early Syrians arrived during the period of "Anglo Conformity,"
when assimilation was the emphasis. The immigration legislation of 1924
effectively put an end to migration from undesirable areas, like the Middle
East. Our small numbers and dispersal throughout the country would pre-
vent us from being politically effective. Today's Muslim Arabs arrive dur-
ing a period of "multiculturalism."

In 1924 Philip Hitti wrote the first story of migration here from the
Middle East.[4] I suspect he would be loath to use the term Arab to describe
the early Christian Syrian immigrants from Mount Lebanon, although he
fought vigorously against the term "Turk" because we were in fact Arabs.
What he did was fit the Christian immigrants who did not see themselves
in terms of nationality into a Western framework so they would be under-
stood by Americans. For a great historian, his book was not great history.
His approach was very political and ideological, and it was probably re-
sponsible for many widely held myths, such as that Syrian Christians came
here because they were being persecuted for the faith and not because they
were bad citizens of the empire, in collusion with the West.

The truth is that they were being persecuted—not by Arabs but by the
Ottomans, as were their Muslim Arab neighbors. Hitti's superficial analy-
sis (designed to make us acceptable to Americans by destroying the immi-
grant stereotypes that fueled the nativist movement) was taken as Gospel
truth although dozens of reasons existed for the migration.[5] Hitti was an as-
similationist and played down conflict; Syrians were presented as apoliti-
cal, middle class, Christian, entrepreneurial, family people. All this was to
get the Dillingham Commission (the Congressional commission examin-
ing immigration policy, whose findings led to the restrictive 1924 immigra-
tion laws) off our backs. His work was followed by my book in 1975[6] and
that of Adele Younis in 1995.[7] (Younis's dissertation should have been pub-
lished long before my own book on the Syrian-Lebanese in America. Her
book appeared after her death in 1991, although her dissertation, upon
which it is based, was completed in 1965.) Titled *The Coming of the Ara-
bic-Speaking People to the United States*,[8] this comprehensive history ded-
icates nearly three chapters to the relationship of American Protestant
missionaries to both the migration here from Syria and the general impres-

sion that Americans had of native Arab peoples—generally a very positive and encouraging view (sometimes condescending), which increasingly soured after the establishment of the state of Israel.[9]

The current, if not historical, negative portrayal of Arabs in the media is the third macro variable that historians should consider when analyzing the development of any ethnic Arab American identity. It is simply not easy to be an Arab or an Arab American. Physically, visually, culturally, religiously (and stereotypically, I might add), we are outsiders. We get bad press no matter what, the Israelis get good press no matter what. We all know that Arab Muslims were the first suspects in the 1995 Oklahoma City bombing.

To understand the early Arab Christian migration here and how their circumstances affect identity formation, we must also look at the experience of the American Catholic Church, since at least half of all Syrian and Lebanese immigrants here were Catholic, most of the others being Orthodox. We need also to understand what happened between and among the Catholic Melkites and Maronites (and between them and Western Catholics). We need likewise to be familiar with the Antiochian Orthodox and their relationship to their fellow ethnics and other Slavic or Greek Orthodox communities.

Suffice it to say that the Irish set the tone for the American Catholic Church, beating out the Germans (who suffered as enemy aliens in two world wars), the Poles (who preferred ethnic churches), and the Italians (who, despite their faithfulness, simply were not churched) for control of the episcopacy. The English-speaking Irish fit in here; they understood the culture, they Americanized (or rather "Irishized") the church and built the bureaucracy or organization that is known as the American Catholic Church. While they saw themselves primarily as Irish Catholic American Democrats, they did not see their church as ethnic (although from a Syrian, Polish, German, and Italian perspective, it most certainly was) because it appeared so American (English-speaking, bureaucratized, rationalized). The Irish made America accept Catholics as a political, social, and religious force. They became Catholic Americans and took their place next to Protestant Americans (and Jews, who likewise had to assimilate, integrate, and organize their diverse religious and ethnic populations) in what was to become known as the "triple melting pot" theory of American society.[10]

What was expected and what suited the Irish was that ethnicity or the ethnic loyalty of other Catholic groups be transferred to their form of rationalized, bureaucratized, nationalized, and desexualized religion. For the

Arab American woman and children with icon, Church of the Virgin Mary, Brooklyn, Palm Sunday, April 7, 2001. Photograph by Mel Rosenthal.

Irish this was no problem because their church was an ethnoreligion, although they did not see it that way. They saw themselves as Americans, although non-Irish Catholics did not always agree. You assimilated, if you were Catholic (certainly in New York or Boston), through the Irish Catholic Church and then you took your place next to other Americans who were Protestant. You can imagine what this assimilationist, de-ethnicizing emphasis did to the Syrian Catholics and their relationship to other Syrians and Arabs. Melkites and Maronites were encouraged to leave their rites and culture behind, thus undermining the basis for a community of culture. We were taught to dissociate from non-Catholics in general and from our cultural traditions in particular.

Similarly, an emphasis on a de-ethnicized religious identity would also affect the Antiochian Orthodox, who only now have begun to incorporate themselves into an American Orthodox Church so as to become yet another melting or transmuting pot.[11] Religion, it is believed, will eventually and should eventually replace ethnicity as the basis for identity and social organization.[12] This structural reality or expectation will impact on Muslim Americans, Hindus, and Buddhists as well. The dilemma is what hap-

pens to immigrant communities that are multi-religious: Will they stay integrated around ethnicity or divide by religious persuasion? Another question is how ethnicity and religion really intersect in the individual psyche to form identity and community. Ethnic and religious causes can overlap and unite a community or they can divide a people and create competitive loyalties.

If our parents arrived here as *roum catholique/orthodox* or as Maronites from Mount Lebanon, but were perceived as Turks or Asians, you can understand how difficult it was for them (or for us) to make sense of themselves and for Americans to understand and accept us. Our Christianity was suspect, and the Latin Irish Catholics simply dismissed us as an incomprehensible religious (actually ethnic) nuisance and forced us to "Americanize," which really was to Latinize. We had a married clergy, icons instead of statues, vernacular liturgies, we blessed ourselves "backwards," did not genuflect, and voted our clergy in or out of our parishes, all of which did not sit well with the Irish and had to go in order for us to be included in their orbit. We were told that we could no longer marry our Eastern Orthodox compatriots, although in Syria, formally or otherwise, you married in the man's religion or rite. The people and clergy understood this. Here, this practice was taboo and grounds for excommunication. Hence a social and religious divide was created between the Syrian Catholics and Orthodox, who frequently married each other in the old country and for ethnic survival reasons would be expected to seek each other out in this country. The Latins were pulling the Catholics into their frame of reference because they wanted a unified singular American Catholic Church and we were standing in their way with our "odd" liturgies and customs.

The Catholic Melkites were drawn into a Latin Catholic orbit (always embraced by the Maronites) and the Orthodox into an American, albeit Protestant, orbit made more pressing by the lack of either Orthodox or Eastern Catholic parochial schools. Catholic Syrians learned Latin (not Greek or Arabic), the Latin mass, and Western spirituality because we had no chance against the enormous resources of the Latin Church. The Orthodox generally used the public school system, which further isolated them from the Catholic Syrians. Some Orthodox were drawn to Protestantism and others became lost when they could not establish their own parishes. Today, of course, the latter situation does not exist. The Orthodox have established a hierarchy, have a flourishing episcopacy and clergy as well as successful Sunday school programs, have Americanized (although being Byzantine in the Western world is not easy), have survived and flourished

against great odds, and are now being drawn into an emerging American Eastern Orthodox camp or melting pot.[13] Like the Melkites and Maronites, a substantial segment of their congregants and clergy are not fully or even partially "Arab."

Somehow, out of this emerged a Syrian American or Syrian-Lebanese community with the structural support of its churches.[14] However, it could only be at best a cultural community, not a political one. Most Syrians were Republicans (but not all) and there were no real community-wide domestic issues until now, save the citizenship/naturalization issue of 1909. And there was no real tradition of political activism. The naturalization issue is significant for several reasons. To win citizenship, the case was made that the Syrians were white and Christians,[15] not dark, African, Asian, or Muslims. The issue was framed in religious and racial terms and that construction continues to this day and probably set the stage for the same differentiation that exists today between Muslim and Christian Arabs.

The Syrian-Lebanese wanted to survive ethnically, not only religiously, and it would be wiser not to be too political, too Arab, or too non-Western and draw attention to the group. They loved their culture and needed to find ways of preserving it here, even if only privately.[16] We told the Americans what they wanted to hear and then did as we pleased. There were cultural groups and church groups who sponsored hugely popular and successful *mahrajans* and conventions throughout the United States, which acted as "marriage markets." The Catholic Syrians, being in the Irish orbit, were simply most at risk and could not remain fully ethnic in such circumstances. A comparable dilemma is being played out today with the arrival of thousands of Arabic-speaking Melkite and Maronite immigrants into an assimilated American Eastern Catholic Church. The Orthodox remained pro-Arab throughout because they fused their culture and religion and were not pressured into Americanization by outsiders. Being fully Byzantine, they were skeptical of the West. The pressure placed on the Maronites and Melkites was to de-ethnicize so an American Catholic Church could emerge. Even where these Eastern-rite Catholic groups remained autonomous, they were seen as temporary institutions—halfway houses on the way to complete absorption into American Catholicism.

The Byzantine rite for the Catholics was Latinized in many cases beyond recognition, making our churches appear more like national parishes or churches than autonomous and independent organizational and theological systems. The Maronites, as far as the Melkites were concerned, were already Latinized in theology, liturgy, and psychology, often claiming the

dubious distinction of being "the Irish of the East." They were more interested in building an independent Lebanese consciousness than being either American or Arab. The Orthodox had comparable problems in that their church was very Byzantine and thus faced all the problems of relocation and integration into a foreign, enemy society. How is the culture of Byzantium (embraced by the Orthodox and now again by the Melkites), for example, going to play itself out in the Big Apple? Oddly enough, this is now the problem facing the revived Melkite church, which got partial ecclesiastical independence from Rome about three decades ago and which has now so reclaimed its roots as to become "too Byzantine" for the assimilated Melkites and not Arab enough for the new immigrants. Either it was too Arab or too Latin and now, perhaps, even too Byzantine.

What, then, could be the basis for community and identity? What would be the content and meaning of ethnicity in a highly stratified and diverse society like ours? It would be an attenuated culture (symbolic ethnicity): the *debke* and *kibbeh* balls, *falafel* and *tabouli*. It would be *mahrajans* and *haflis* and cute Arabic-language phrases. How else could it be? The outmarriage rate for Melkites and Maronites is more than 80 percent and that of the Orthodox is nearly as high.

So the question becomes, Where do we, the descendants of Christian immigrants from Aleppo or Damascus or Beirut, from Turkey or Syria or Lebanon, find our identity? Can we have more than one identity at any one time? To whom or what do we owe our primary loyalty? Are we Catholics or Orthodox or Muslims first? Are we Syrians or Lebanese, and now Jordanians, Egyptians, Palestinians? Are we still Aleppians or Damascenes? Are we only individuals, are we Americans, are we Arabs, or all of the above?

Obviously, the immigrant Christian Arabs have a different take on these questions than do later Arab Muslim immigrants, who often thought that the resistance to forming a community with them was for religious reasons when it might well have been for cultural, ethnic, generational, or political ones. Remembering that our grandparents were leery about being identified as Arabs, how does a singular Arab ethnic group emerge from this variegated past? How do assimilated third—and fourth-generation Syrians, who became fashionably Lebanese in the 1950s after a campaign sponsored by the *Al-Hoda* press, integrate themselves with an immigrant Muslim population that sees Arab culture as its own preserve?

This fusion and consciousness of being Syrian and Lebanese at the same time is no longer the same. When I wrote about the American Syrian-Lebanese in 1970 (and up to the late eighties), I saw them as one continuous

group supported by three social institutions: the Melkite, Maronite, and Orthodox churches. In reality, the Lebanese were more likely to be Maronites (and the Maronites, Lebanese), although there was a large and often disregarded group of Aleppian Maronites and Lebanese Orthodox. Melkites were more likely to be Syrian, although their clergy here was often Lebanese; and the Orthodox, being both Syrian and Lebanese, were more likely to be Arab identified. It was the Maronites who upped the ante!

The Palestinian question in Lebanon, and that of Lebanon's unashamed religious nationalism (making it a "natural" Israeli bedfellow), have totally changed this alliance and ethnic fusion. There is a group of conservative Lebanese American Phalangists who abhor everyone else. They display the same Maronite arrogance about "the Arabs" both here and in Syria, to which they escaped for comfort and protection, yet belittle their hosts.[17]

I believe today you can speak of a distinct Syrian and a distinct Lebanese community, the latter being defined by Maronites as Maronite. I think you can now trace a dissimilar history for both these populations and

Bride, groom, and the groom's mother, who is trying to keep the playing children from colliding with the cake, at Palestinian wedding at Widdi Catering Hall, Bay Ridge, Brooklyn, August 22, 1999. Photograph by Mel Rosenthal.

identify differences in trends and sociopolitical behavior. There is, of course, a group of Syrians and Lebanese who cooperate with one another and work toward common goals under the rubric of Arab. We are the educated, less ideological, and more historically informed third- and fourth-generations. Neither are we single-issue oriented scholars, and as American citizens we support many seemingly divergent positions. Actually, a great deal of talent, energy, and money has left the churches and been shifted to secular, political objectives, much to the horror of the old-time pastors who were loath to support non-church-related activities. True, the churches benefit (as do the mosques now) by positive developments by and media coverage of the secular organizations. They even supply the National Arab American Association, Association of Arab-American University Graduates, American-Arab Anti-Discrimination Committee, and similar organizations with some of their leadership. The churches were the first places we became exposed to our heritage in a positive way. What this means is that the basis for and the structure of the present Arab American community is broader than in the past. No longer is the primary concern cultural preservation via religious affiliation but more realistic concerns like racism, discrimination, and political and judicial issues. There are now large and effective secular, sociopolitical institutions existing side by side with religious ones. Yet, the Brooklyn Syrian-Lebanese community is one of the most difficult to organize because of the divisions indicated above. The problem is magnified today not only by the arrival of thousands of Muslim Arabs into the city but also by the presence of thousands more immigrant Arabic-speaking Christians from Palestine and Jordan and Lebanon who feel uncomfortable in the English-speaking Melkite, Maronite, and Orthodox parishes of Brooklyn.

The problem is not unlike that of the Jewish American community, which also has a broad institutional network seemingly supporting a singular objective, but is, in reality, divided by ideology, generations, and now newer ethnic groups. The emerging Arab American community is not yet institutionally complete,[18] although this is gradually, if grudgingly, changing. Nor are we able to determine where leadership lies, how it is determined, whom it represents, and what the specific goals are. There seems to be a general consensus that the Palestinian question, the problems of the Golan Heights, and the occupation of South Lebanon need to be settled for everyone's sake. But you can be sure that the Maronites and the Palestinians and the Muslim American Arabs see these issues differently.

With this institutional development or expansion, three generations

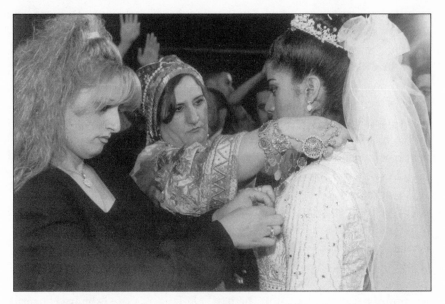

Pinning gold coins on the bride's gown, Palestinian wedding at Widdi Catering Hall, Bay Ridge, Brooklyn, August 22, 1999. Photograph by Mel Rosenthal.

later and for reasons explicated elsewhere in the literature, more of us want to be called or at least are willing to be identified as Arabs.[19] But we know this does not sit well with many, especially among a generation whose historical knowledge about themselves is distorted or misinformed. Communities and identities also need psychosocial and institutional supports. There need to be identifiable and readily available symbols that help us emote and relate to one another. There needs to be face-to-face interaction with similar others, a shared sense of history, and an autonomous economic base, among other things, for a real community to exist. Arabic language use (a true measurement of identity, consciousness, and assimilation) has all but disappeared among the Syrian and Lebanese. Our clothing and lifestyle are typically upper-middle-class American and fashionably New York. Into this pot have poured thousands of Arabic-speaking immigrants in Arab dress (in various degrees and often by gender) mixing in the stores and neighborhoods of the older assimilated Syrians. However, the more difficult conflicts are being played out institutionally, especially in the churches, some of which have reintroduced Arabic into the liturgy after years of dismissing it. Not an easy situation for an American-born

clergy, which is often not even Arab in origin. How do any of us integrate ourselves into the Arab American community politically if even our own clergy are distanced and disinterested in these issues?

To complete the picture, we must examine what is going on structurally among the Eastern Orthodox and Muslim communities. If the Orthodox need to be integrated in a de-ethnicized way with other Orthodox groups to survive, will this not make them less Arab in culture and orientation?[20] Would this situation not make them likely supporters of Orthodox interests rather than ethnic ones? It is difficult sociologically to limit one's social life to religion and/or ethnicity, although it is easier in the first regard because there are more co-religionists than fellow ethnics. Marrying another Catholic may not have been what the Syrians wanted, but it was what was meant to be. The ideal mate for us would be a co-religionist of the same ethnicity and rite, but our small numbers alone precluded this. Clearly, ethnic continuity was damaged by these religious divisions.[21]

One can imagine how this impacts on intergroup relations within the Arab American population and among Muslim Americans. If the structural pressures exist to form a dynamic Muslim American community that encompasses organizationally or institutionally all Muslim nationalities, then Arab Muslims eventually will become primarily (but not only) Muslim Americans sharing their faith unquestionably with Pakistanis, Filipinos, Asians, Africans, etc. Should this very reasonable and historical expectation occur, what would happen to that which we allude to as the "Arab American community?" The situation would be different if all Arabs were Muslims and all Muslims were Arabs, but this is not the case. Islam (like the Orthodox) has to become another melting pot supportive of American society/culture to be accepted as a valid American religion—unless of course ethnic Muslims can invent and sustain their own institutions, somewhat like Syrian Jews do. But this is unlikely for demographic reasons, and because their children will be Americanized and nothing ruins ethnicity like success.

So, are we an ethnic group? If so, how so? What is our corporate title? If it is Arab American, how did this come about? If our parents disdained the appellation Turks, if they were unsure about being Arabs, although in Arabic they would always refer to themselves as "*wlad* Arab," if they preferred more primitive and less Western identities like *Roum* or Maronite, even township and village identities, then how valid and substantial is the new identity of "Arab American" among their descendants?[22] Arabs as an ethnic or racial group never existed in a concrete, institutional way either here

or in the Middle East, yet we act as if it is a real analytical category. It is a new concept—"the Arab nation." It does not work politically anywhere, except perhaps in Egypt, although it is claimed by Iraq, eschewed by the Lebanese, treated ambivalently by the Syrians, and so on.

Arabic is a language. Arab at one time referred to a race; now it is a culture, although people use it differently, often erroneously employing the term Arabic to describe the ethnic group and its food rather than the language. In Bay Ridge, Brooklyn, a new religious group titles itself "the Arabic church." No one seems to know what it means, or who they are. Do Muslims normally see themselves as Arabs or is it vice versa? The French taught the Lebanese that a Christian cannot be an Arab although the Melkite Patriarch issued a statement some time ago arguing that "we are Arabs." His reasoning was language and culture—something any anthropologist would recognize as valid.

In America it has been the custom to identify people by their language. So Italians became Italians here because they spoke Italian. We should have been called Arabs from the beginning, although this would have been a new conceptual development since the term was used variously to describe a race, an ethnic group, and a culture without referring to a singular national identity other than the Arab world (which would have been more accurately titled the Arabic-speaking world).

If Syrian Americans in this country and city took at least two generations to become so and another generation to become Lebanese, it should come as no surprise that we were slow to embrace the title Arab. Part of this re-creation and return to an ethnic identity can be explained by the principle of third-generation interest, in which the grandchildren re-embrace the ethnicity of the grandparents, especially their religions.[23] It was generally believed that children and grandchildren would only be willing to hold onto the religion of the grandparents, but time has shown that many Americans also prefer smaller and more intimate identities like ethnicity. One way of relaxing any tension that may exist between a purely ethnic and a purely religious identity is to simply fuse the two. This is something that assimilationist sociologists never quite understood.

Let me give you a case in point. Originally and in many previous papers, I argued, as did most of my generation, that the Melkite Church should be cosmopolitan, that is, "American." It should divest itself of its ethnic support base and appeal to the broader population as well as the American-born Syrians. "The kids," it was argued, "don't speak Arabic," and therefore the church should use English.[24] This reasoning was based on

the experience of the second generation, which was caught between identities: American or ethnic or hyphenated American. It was assumed that their (our) children would be even more Americanized and not interested in ethnicity, but would keep the faith. No one imagined that one of the reasons the churches had any appeal was that they embraced, preserved, and transmitted ethnicity, albeit in a truncated form.

No one expected the nationwide resurgence in ethnic identity to occur on its own for its own sake, and no one thought that people went to an Eastern-rite church precisely because of its ethnic flavor, because it was socially familiar, historically relevant (our family church), and more intimate. If ethnicity had been completely removed from the Eastern churches, no one would have gone there to worship. There would have been no reason to go. This may be bad theology, but it is good sociology. In a "mass society" like ours, people look for alternate identities and communities, and the Arab churches and mosques can supply them.

The third and fourth generation are also better educated, more willing to learn the facts of their history, more secure in their identities, better traveled, and more likely to see their ethnic past as positive rather than as a hindrance. They are also fair and objective and more likely not to take Zionist views of the history and politics of the Middle East to heart. We know we are good people, generous people, and family people. We are good citizens. There is a radical unfairness to the politics of the Middle East, and as Americans we find it abhorrent that the Israelis get such favored treatment. We hate being demonized, and this tendency has politicized us and brought us into contact with a wider range of informed and educated Arabs than our parents would ever have imagined possible or desirable. We fear discrimination against any Arab Americans because it affects us as well, for we have all experienced it in one way or another.

I became an Arab American simply because it was easier than arguing with ignorant Americans about the intricacies of identity among Middle Easterners. It was easier to identify with the concept and redefine it positively than to argue about its accuracy. I am sure that everyone has his or her own interpretation of what Arab identity means, how and when to use the term, and how to act on this identity. For me it is a political, social identity rather than a historical or personal need to be identified as such. We are, at best, an emerging interest group, drawing membership from a multitude of ethnic groups sharing broadly in a common cultural heritage, determined to protect our rights, and interested in making our voice heard in the cacophony of American politics. We are not really a community, although

we are developing community-wide institutions for the first time in our long history here. Our issues are broad ranging, from civil rights to justice in the Middle East, from foreign-policy inputs to economic reforms at home, and to civil rights issues here and abroad. We have the ability to create and re-create ourselves as the situation permits and requires. We are many things at once and perhaps many things to many people, but we do recognize ourselves.

What is true of us at this point is that we have several identities coexisting with one another that we display to outsiders differently as circumstances permit or require. At any moment, I am primarily a Syrian, Aleppian, Melkite, or Arab. Normally and ideally there is no conflict between them and they often overlap, but each has its own primacy, use, and relevance. We all can be Arabs because some political issues both here and abroad are contextualized as Arab issues and they impact on us directly because they are framed in this context, and so we respond accordingly. As with other groups, a common enemy or common goal can bring us together like nothing else.

Arab New Yorkers in the Late Twentieth Century

9

Inventing and Re-inventing the Arab American Identity

Yvonne Yazbeck Haddad

A rab immigrants living in the United States reflect the political, cul-tural, ideological, and territorial differences of the countries from which they came, as well as the variety of social, political, economic, and psychological forces that have impacted their corporate lives in America. They also bring with them the legacy of debates about and redefinitions of Arab identity that have been shaped throughout the twentieth century and reformulated after the experience of dramatic events, wars, vicissitudes, and tragedies perceived as inflicted on Arab nations and societies. Cur-rently two important factors in the perception of Arabs and the Arab com-munity in the United States are the self-image of the Arab as a victim of American and Israeli interest and the sense that the American press is to-tally biased against Arabs.

For more than a century, immigrants from the Arab world to the United States have been engaged in the process of being and becoming American. This process has been protracted and painful, as various contin-gents of immigrants brought with them their distinctive identities fash-ioned by their own generation in their own countries as a response to prevailing conditions and to expectations set up by the governments of the respective countries from which they came. These identities have also been directly impacted by the vagaries of America's interests, policies, and actions in the Middle East. Once here, immigrants encounter an America in search of its own identity, an America they experience as having a fluid definition of itself as well as fluctuating policies regarding immigrants from the Arab world. Arab American identity is, of course, reshaped and honed by the immigrants themselves as they attempt to understand the

Arab experience of a dominant West through the history of European colo-
nial occupation and subjugation during the first half of the twentieth cen-
tury, American hegemony and intervention in the area since the 1950s, and
what is depicted as the colonial and expansionist policies of Israel in Pales-
tine and the surrounding Arab states.

This identity is also fashioned by the immigrants' local American ex-
periences, the place in which they settle, the treatment they receive in
their new environment, the diversity of the community with which they
associate, their relations with older generations of immigrants, and their
involvement in organized religion and attendance at ethnic or integrated
churches and mosques. Increasingly, this identity also has been profoundly
influenced by American prejudice and hostility towards Arabs and Mus-
lims, both real and perceived.

While it may be convenient for some scholars and observers to attrib-
ute the experience of Arabs in the United States to factors such as igno-
rance of the new culture or the inadvertent response to changing times or
political considerations, many Arabs increasingly see their marginalized
reality as deliberate and specific. In response they are developing a kind of
survival mechanism appropriated as resistance to what is perceived and at
times experienced as a manifestation of Western "anti-Arab" or "anti-
Muslim" sentiment. Thus as they address the same issues that earlier gen-
erations of immigrants encountered, such as what language to teach their
children or how to implant and perpetuate the faith of the forebears, they
are increasingly burdened with the question of whether their children and
grandchildren will be accepted as equal contributing citizens of the United
States, whether they can have a secure future, and whether their values will
be considered a positive force contributing to the reformulation of a multi-
cultural pluralistic America.

There are an estimated three million Americans from Arab countries
in the United States, forming about 1 percent of the population. The Arab
community in North America is noted for its diversity. It includes immi-
grants who chose to move to the United States for economic, political, and
religious considerations as well as émigrés, asylum seekers, and refugees
manifesting a variety of ethnic, racial, linguistic, religious, tribal, and na-
tional identities. Although the percentage of Muslims is increasing among
Arab immigrants, they are still only about one-third of the Arab Christian
majority within the American Arab community. Arabs, likewise, consti-
tute a minority, estimated at 15 percent, within the Muslim community of
the United States. (It is estimated that some 40 percent are African Ameri-

can converts, with the largest immigrant population coming from South Asian Muslim communities.)

A number of different factors go into the consideration of what constitutes Arab American identity. Among them are national origin, ethnicities within nation states, religious affiliation, language and dialect, political affiliation, the composition and experience of various waves of immigration to the United States, temporary versus permanent residence, and differences in American-born generations of immigrants from Arab nations.

National Origin

The Arab immigrants to the United States have brought with them diverse national identities, representing twenty-two different countries that are members of the Arab League. The creation of the nation states, carved by European colonial bureaucrats out of the crumbling Ottoman Empire, led to efforts by the state to create a loyal national constituency out of the diverse groups. While their national constitution might identify them as Arab and the various governments have tried to imbue their nationals with that identity, there are major segments of their populations that have been reluctant to appropriate such an identity. Recent political events have served to exacerbate the differences. The coalition of Arab states, for example, became seriously divided over the Gulf War in 1990–91. The nations of the Arabian peninsula were frustrated by the response of Syrian, Jordanian, Palestinian, Egyptian, and Moroccan populations who thought that Saudi Arabian and American retribution against Saddam Hussein was unjustified and covered dubious motives. The Gulf Arabs questioned the authenticity of the Arabs of the North, dismissing them as merely Arabized peoples who did not understand the threat to the Gulf area by Saddam's military.

Ethnicities Within Each Nation State

The Arab nation states that were carved out of the Ottoman Empire are constituted of a variety of different ethnic communities, some of which were transplanted by the Sultan in an effort to disperse populations deemed a security threat to the dominance of the Empire. As a result these countries are populated by a number of different ethnic groups, such as Chechens and Circassians in Syria and Jordan; Kurds in Syria and Iraq; Assyrians in Syria, Iraq, and Lebanon; and Armenians in Lebanon, Syria, Jordan, Egypt, and Palestine. Immigrants to the United States from these

different groups appear to bring their distinctive ethnic and cultural identities to the mix of what it means to be Arab in America. Some have demonstrated a keen interest in promoting specific ethnic identities.

Diversity in Religious Affiliation

While Arab nationalists consider all citizens of Arab states to be Arab whether they are Muslims, Christians, or Jews, within each of these affiliations are many different sects, denominations, and subsets. Differentiated Christian communities function as remnants of early Christian churches. Among the "Orthodox," for example, are those of Byzantine, Assyrian, Jacobite, Coptic, and Gregorian rites. Each one of these churches has its Catholic Uniate counterpart. More recently Arab countries have seen the establishment of new churches representing Protestant denominations and evangelical or sectarian groups. The Muslim population in the United States is made up of the two major groupings of Sunnis and Shi'ites; the latter includes Ithna Ash'aris (or Ja'faris), Isma'ilis, Zaidis, 'Alawis, and Druze. All of these groups have reconstituted their religious organizations in the United States.

Language and Dialect

While Arabic may seem superficially to be the strongest common bond among Arabs and an initial indicator of ethnic identity, in fact Arabic has so many dialects and regional variations that it is not always at all easy for one Arab to understand another. Most people coming from Arab countries understand Egyptian Arabic because Egyptians have been prime movers in the movie and television industry, but the inverse is not always true. Many Arabs simply cannot communicate with each other because they cannot understand each other's dialects. Differences are especially noticeable between Maghreb (North Africa) and Mashreq (the Levant and the Arab peninsula) as well as Somalia. For all the common language is English.

Political Affiliation

Arab immigrants have also come with a range of political allegiances that they believed held the key to the revitalization of their home countries. Over the last half of the twentieth century various political positions have developed throughout the Arab countries. Some of these positions included

a vision of Arab unity and Arab nationalism, others had regional visions, and still others were limited to the borders of the nation state. Some have been more liberal and progressive, others socialist and Marxist, and still others Islamist. Because the question of identity became paramount as the foundation of nation building, those who emigrated in the 1950s generally had placed their trust in nationalist ideologies grounded in a belief that shared history, language, and culture are sufficient as a basis for community solidarity and national unity. Those who emigrated in the 1960s tended to support Nasserism, or Arab socialism, which had gained popular support in most Arab states by that time. It developed as a reaction to the efforts by the United States and the Soviet Union during the Cold War to enroll the Arabs in their competing coalitions. Arab nationalism and socialism promoted the belief that only by maintaining a nonaligned stance and forging a unity of all Arab nations from the Arab Gulf to the Atlantic Ocean would the Arabs be able to face the challenge of an expansionist Israel planted in their midst. Those who emigrated in the 1980s brought with them a different identity, one that is fashioned by the bitter experience of the Arab-Israeli wars of 1967, 1973, and 1982, as well as the civil war in Lebanon. Consequently, a growing number of Muslim immigrants who came in the 1980s have given up on Arab nationalism and subscribe to some form of Islamic identity, including a small minority who favor "Islamism" as the only way to foster unity and strength to overcome diversity and what is perceived as incessant efforts to undermine Islam and Muslims. At the same time, some Christian immigrants from the Arab world appear to have reverted to identifying themselves as an ethnoreligious group: the Maronites claim that they are Phoenicians, the Copts that they are Pharaonic, and the Assyrians that they are the remnant of Sumeria.

Temporary Residents

Not all Arabs living in the United States are immigrants. Many are here on a temporary basis. They appear to have some influence on immigrants as they interact with them in social, religious, and political affairs. They include migrant laborers who come from different countries, the largest number from Yemen.[1] While some eventually choose to settle in various parts of the United States, most see their identity in terms of their country of origin and live marginal lives in America, saving for their eventual return home.[2] A second marginal group includes émigrés, political and religious refugees who assume a temporary residence in the United States, hesitating to put

down roots as they await a change in the political circumstances in their home countries. In a third group are the hundreds of thousands of students attending various colleges and universities throughout the United States. In many instances, they seek association with resident Arab organizations and attend their religious and cultural activities. Over the last forty years, a significant number have opted not to return to their home countries but to seek employment in the United States. Many participate in the Islamic organizations that are most prominent in university towns throughout the United States. Their number is augmented by itinerant missionaries, members of the pietistic Tableeghi Jamaat (Group of Informers), who come to the United States for what can be categorized as revival meetings to invigorate the faithful as well as to invite outsiders to join the community of believers. Tourists and relatives of immigrants from overseas are also an important source of information about what is acceptable in Arab terms, providing a steady stream of corrective commentary about proper religious and communal identity.

Also active in Arab and Islamic affairs is the large contingent of diplomats to the United States and the United Nations from fifty-six Islamic nations. Two international Islamic organizations, the Muslim World League and the Organization of the Islamic Conference, are recognized by the United Nations as Non-Governmental Organizations. Both have diplomats at the United Nations. The Muslim World League has extensive involvement with Muslim organizations in the United States. Out of its New York office it runs the Council of Masajid in North America, provides Imams from overseas for mosque leadership, and funds Islamic activity in the United States (up to five million dollars a year). Several countries have funded publications that advocate their particular national interests.

Differences in American-born Generations

Sociologists and anthropologists have long talked about the "American" experience in which the second generation is molded to become American and abandon the parents' identity while the third generation begins to look for and feel comfortable with its roots. At first glance, the Arab experience of the United States may be seen as following the same kind of path of integration and assimilation that other immigrants to the United States have trekked. The American expectation is that immigrants would reflect on the benefits and superior values of American society and sooner or later shed their imported identity, holding on to some cultural peculiarities such as

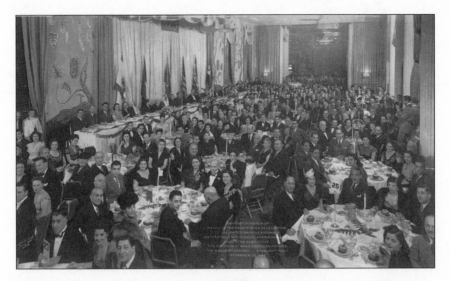

Banquet in honor of heads of the Arab States Delegations to the United Nations Assembly: Egypt, Iraq, Lebanon, Saudi Arabia, and Syria, under the auspices of the Institute of Arab American Affairs, the Waldorf-Astoria, Starlight Roof, November 29, 1946. Courtesy of Aziz Ghannam.

family recipes or ethnic dances while eventually negotiating or inventing a coherent identity that is truly American. In fact, however, the experience of Arab Americans appears to be different as a result both of living in the United States and of the exertion of American power overseas defending its economic and political interests in the Arab world. Negative stereotyping often serves to keep them from integrating. The new immigrants tend to be more ethnically conscious, have more contact with the home country, and in general are more highly protective of their religious identity. The more recent the immigrant, the greater the tendency to ascribe a great deal of the suffering in the Arab world to American policies that are shaped to em-power Israel at the expense of the Arab people. Hence, the process of Amer-icanization is impeded by a profound feeling of an American double standard that dismisses Arab sentiment and rights.

Waves of Immigration

Also impeding the creation of an overarching Arab American ethnicity is the fact that the Arab world has experienced a great deal of stress in the last

part of the twentieth century that has strongly impacted the identity immigrants bring with them. Members of the same family who have emigrated within a decade of each other often have a distinct sense of identity and a perspective on reality quite different from those who came before.

The earliest Arab immigrants were few in number and came to America when racism was paramount and when Anglo conformity was the order of the day. They were predominantly of rural background, hoping to make money and return to live in their homelands. Like the millions of other immigrants who passed through Ellis Island, they followed the patterns of integration and assimilation that were used to refashion them into American citizens. They peddled and opened grocery stores; their children went to public schools and worked in the factories. They enlisted in the American military during the First and Second World Wars and served with distinction. They were eager to belong and in the process interpreted American culture as compatible with Arab concepts of virtue and honor; the Muslims among them emphasized the similarities between Islam and Christianity and the respect Islam has for Jesus and his mother, Mary.

Muslim immigrants who have come after the 1960s, however, have often found the accommodation of the earlier immigrants too high a price to pay, especially since America now defines itself as Protestant, Catholic, or Jewish. No longer either poor or uneducated, as generally was the case with their forebears, recent immigrants increasingly have come to represent the best-educated elite of the Arab world. Doctors, engineers, and computer experts, they were admitted on a preference visa because of their skills and their ability to contribute to developing America's leadership in medicine, technology, and education. They have been influenced by a different socialization process. While they enjoy America's economic opportunities and freedom of religion, association, and speech, they flinch from what they perceive as its concomitant social and spiritual problems. A significant number of these more recently arrived Muslims have no patience for the kind of accommodation and compromise earlier generations of Muslim immigrants made, accusing them of diluting the importance of Islamic traditions, rituals, and distinguishing characteristics. In the process, they have identified rituals and traditions that are designated as the minimum essentials of being a Muslim. They emphasize delimiting difference and distinctiveness as a means of affirming a place for Islam. Their conscious religious observances and their publications place great importance on the manner of prayer and how women dress, walk, and talk. Rather than stressing commonalties with American culture and religion they put the empha-

sis on the differences. Confident that Islam is the perfect way, they promote it as having a solution to America's ills.

Most recently a large number of Arabs who have come to settle in America are refugees from Palestine, Iraq, and Somalia. Unlike the asylum seekers who are fleeing religious or political persecution in Libya, Tunisia, and Algeria, these refugees tend to be from among the poorest echelons with little or no formal education. They are more concerned about survival and the maintenance of traditions than about issues of identity.

It is clear that the immigrant community from the Arab world is diverse. While the various nation states from which they came have attempted since independence to instill a national or Arab national identity in their population, the freedom of association and choice of identity available to the immigrant in the United States has acted as a catalyst for further fragmentation of that identity. By the 1970s many ethnic communities in America were beginning to define themselves in terms of a hyphenated identity: Asian-American, African-American, Hispanic-American, and so on. Many Arabs, faced with a generally negative portrayal in the media, often chose to wear their Arab identity as a badge of honor, referring to themselves as either Arab American or American Arab. Others seized the opportunity to opt out of Arab identity, taking refuge in a more comfortable definition of themselves that was not reviled by the general public.

Arab lobby groups were organized as a consequence of the concern about the prevailing American hostile environment after the 1967 Arab defeat and the community's awareness of the massive ignorance of the American public about the facts of the conflict in the Middle East. Arab Americans were astounded by the one-sided reporting of the American media, which was perceived as totally biased, willingly or inadvertently distorting reality in order to maintain an American public that is totally supportive of the Israeli perspective. The first organization to assume a hyphenated identity and coin the term "Arab-American" was the Association of Arab-American University Graduates (AAUG), which was founded in 1967 by professionals, university professors, lawyers, doctors, and veterans of the Organization of Arab Students (OAS). They came together because of American support for the Israeli invasion of Egypt, Syria, and Jordan in 1967. Initially they flourished, held annual conventions, published a magazine, and gave a voice to frustrated Arab Americans. Problems overseas have always managed to impact and fragment the group, however, impeding efforts to create a united front. The Lebanese civil war (1975–90) began the process as the Lebanese members left the AAUG because they felt that

the leadership sided with the Palestinians and did not take Lebanese senti-
ments into consideration. The Camp David Accords of 1979 led to further
decline and splintering of membership as Egyptians left because the organ-
ization was critical of the agreement. The Iran-Iraq Wars and the Iraqi inva-
sion of Kuwait fractured the group even further.

The concern in the immigrant Arab community was aggravated when
the Nixon administration began the policy of targeting Arab Americans. A
special committee was formed to restrict Arab immigration to the United
States, collect data on the community, and compile dossiers on leaders and
organizations of people of Arab origin who sought permanent residency or
citizenship. This vicious and racially discriminatory campaign against per-
sons of Arab origin offended the dignity and pride of many Arab Americans,
particularly those of Syrian and Lebanese origin who view themselves as
loyal and law-abiding Americans.[3] The National Association of Arab
Americans (NAAA), organized in 1972, was modeled after the pro-Israeli
lobby, the American Israel Public Affairs Committee. Its leadership seeks
to meet with members of Congress and to educate Arab Americans on the
political process. It seeks to engage and inform its constituents through an-
nual conventions.

Utilizing the Freedom of Information Act, the Arab community in the
1970s was able to obtain information that the American administration was
considering preparing two military compounds for the possible detention of
Arabs and Iranians similar to what was done to the Japanese during World
War II.[4] Syrians and Lebanese who were now appropriating Arab identity
were horrified over American policies that would further alienate the im-
migrants and their children, particularly the way that anti-Arab perceptions
were encouraged by such occurrences as the ABSCAM scandal, in which FBI
agents masqueraded as Arabs in order to bribe members of Congress.

The American-Arab Anti-Discrimination Committee (ADC), founded
in 1980 by James Aburezk, former Senator from South Dakota, was mod-
eled after the Anti-Defamation League and aims to fight racism, prejudice,
and discrimination against Arabs. It is currently the largest grassroots Arab
organization, with chapters throughout the United States. ADC has as-
sumed responsibility for such activities as monitoring the content of
screenplays dealing with Arab subjects, seeking apologies from politicians
and newscasters who have used ethnic slurs against Arabs (such as former
secretary of state Henry Kissinger and CBS anchor Dan Rather), filing suits
to stop certain advertisements, and the like.

The Arab American Institute (AAI) was established in 1984 when Jim

Zogby split from Aburezk. It encourages participation in the American po-
litical system, seeking to get Arab Americans to vote and to run for office
and establishing Democratic and Republican clubs such as those active in
Jesse Jackson's run for office in 1988. Zogby, appointed as National
Co-Chair, raised $700,000 for the campaign. Arab Americans generally lack
experience in political participation, fear the consequences of political in-
volvement, and have no experience in coalition building. Other groups
shun them because they are perceived as a liability, often out of fear of an-
tagonizing the Jewish lobby. In 1972, for example, George McGovern
turned down an Arab American endorsement for fear of alienating Jewish
support, and in 1984 Walter Mondale for the same reason rejected a $5,000
contribution from small businessmen in Chicago, as did Joe Kennedy and
Mayor Goode of Philadelphia. More recently, in the New York senatorial
contest Republican candidate Rick Lazio depicted Arab and Muslim contri-
butions to Hillary Clinton's campaign as "blood-money," which led to her
returning the donations.

While a substantial number of the early immigrants intermarried with
Americans, the Islamists are increasingly condemning intermarriage of
Muslim men with non-Muslim women (a practice sanctioned in the
Qur'an). Islamists express concern that such intermarriage keeps the man
away from his religion, his customs, and his society. There is a fear that
instead of leading his wife to his religion, he himself is led into the de-
structive tides of the prevailing environment. If intermarriage does occur
there is usually a concerted effort to convert the non-Muslim wife to
Islam regardless of the fact that the religion and the practice of The
Prophet does not require it. Intermarriage is seen as a loss of the young
people from the community,[5] which may lead to chaos in the lives of the
children who may suffer from the presence of several religions in the same
family.

Some Muslim immigrants come with preconceived convictions that
American culture is shaped by totally different norms than those that un-
dergird Islamic teachings. These convictions are formed by watching
American television programs and B-rated movies that portray America as
a society obsessed by sex and violence. These Muslims see American doc-
trines, values, customs, and traditions as based on European culture rather
than as a homogenization of its constituent immigrant groups. They soon
become aware that the public school system is geared to eradicate immi-
grant culture, and that it has generally been successful in this endeavor
through long school days that incorporate co-educational activities such as

swimming, dancing, acting, hobbies, and trips (which often violate Muslim desires for separation of the sexes).

Islam as defined by the Islamist perspective has created a chasm between those who adhere to the Islamist perspective and those who are more liberal. While both groups agree that the American media is hostile to Arab and Islamic culture and issues and that television programs and film depict Arabs as crazed terrorists, they may not agree on what to do about it.[6] Consequently, parents are unable to force their children to follow the imported culture, in many cases disguised as the Islamic way. They believe that the American school system seduces their children through its celebration of holidays and daily schedules that impede their ability to pray and perform their religious duties. The public-school environment, they say, also exposes them to a variety of ideas as well as to heretical groups that might lead them astray. The Muslim community is also confronted by some in its membership who seek isolation from the American social and political system. The Tableeghi Jamaat of South Asia and the marginal Hizb al-Tahrir group condemn such activity as un-Islamic. They work to maintain the boundaries between what is perceived as a sinful culture and the faithful Muslim community. They seek to eschew any pollution that would accrue through participation in a corrupt system. They believe that any effort to reform America is futile since the whole system is corrupt and grounded in human law that is constantly changing according to public opinion.

The affiliation of these activists with Islamic movements overseas has helped shape both their worldview and their mode of operation. The ideology and field training received from such organizations as the Ikhwan al-Muslimun, Jamat-i Islami, and Hizb al-Tahrir have helped refocus their activities within the North American Muslim community in the hope of recruiting the initial human resources from the immigrant Muslim groups. They have been eager to establish and work within Islamic institutions.[7] Prominent Muslims from overseas are repeatedly invited to address the Muslim communities in the United States at national conventions.[8] Thus in a particular way Islamic activism in the West has been largely a foreign import, a legacy of Muslims who came to the West, some of whom were fleeing their homelands because of their affiliation to Islamic movements. The American context afforded them the opportunity to work for the opposition groups seeking an Islamic alternative to governments overseas.[9]

An important factor defining Arab and Islamic identity in North America has been the vagaries of American foreign policy towards Arab and Islamic countries during the last forty years—policies that continue to

trouble and alienate the majority of Arab American citizens. The dramatic acceleration of interaction between American society and the Arab world does not appear to have a positive influence on American policymakers, who continue to support the state of Israel despite its documented violation of the civil, religious, political, and human rights of its Christian and Muslim citizens. Repeated affirmations by the State Department that the foundations of American policy in the Middle East are based on democracy, human rights, pluralism, and minority rights increasingly are viewed by Arabs as being profoundly hypocritical. While there appears to be a growing tendency in the American media to portray the image of Arab and Muslim as the consummate "other," a terrorist, or more recently as the enemy of all cherished Western values, the Arabs surveying the history and experience of the Muslim community worldwide often see themselves as the victims of discrimination as well as conspiratorial forces of hatred. They trace this victimization from the Crusades and the Reconquista through the age of imperialism and see it reinforced in contemporary events.

While the Israeli occupation of Arab states in 1967 awoke an "Arab consciousness" among some people from the Middle East living in the United States and spurred some of them to create American Arab organizations, others were disenchanted with Arab identity and saw it as divisive. At the same time the revocation of the Asia Exclusion Act resulted in the emigration of a large number of Muslims from South Asia, creating a larger Islamic coalition that could address injustices. Both of these factors served as the impetus for construing identity less in terms of being Arab and more in terms of being Muslim. Two prominent nationalists who reformulated their identity and grounded it in Islam were the late Mohammad T. Mehdi and Isma'il al-Faruqi.

Al-Faruqi was especially interested in the worldwide Muslim leadership potential of the community in the United States. Besides mentoring large numbers of international graduate students at Temple University, he organized intellectual institutions dedicated to the task of Islamizing knowledge. These included the American Association of Muslim Social Scientists, the International Institute of Islamic Thought in Northern Virginia, and the Islamic College in Chicago to provide committed Islamic leadership, not only for the immigrant community but also to the whole world of Islam. His ideas helped create a confident ethos among Muslim intellectuals who maintain the mosque movement that has flourished in North America since the 1970s. They were appropriated by a significant segment of Muslim immigrants who found in them the way to maintain an

exceptional identity that enhanced their strategy of survival in a hostile environment. Al-Faruqi recommended the appropriation of an Islamic ideology that emphasized that Muslims were not to see themselves in the United States as beggars but as active participants in the building of a just society. He saw in the adoption of an Islamic ideology a mechanism for freeing the immigrant from the sense of guilt for achieving some measure of success in the United States. This vision, which ascribes success to God, liberates the immigrant from the need to be exceedingly grateful to America.[10]

There is a growing concern in the Arab American community as well as overseas about American tolerance of negative depictions of Arabs and Muslims. Anti-Arab sentiment is evident in the wake of what Arabs believe is the unbalanced coverage given events overseas by the American press. Media treatment of the TWA hijacking in Lebanon in 1985, the 1993 World Trade Center bombing, and the Aqsa Intifada in Palestine, for example, seemed to bring out deep-seated prejudice in various segments of American society. The media's coverage of the Oklahoma City bombing resulted in acts of retribution against innocent Arab Americans. Some journalists insisted that it demonstrated the modus operandi of Middle Eastern terrorists. After the bombing, President Clinton warned Americans not to blame an ethnic community for individual acts. However, this did not deter him from signing Executive Order No. 12947, which banned contributions to Palestinian charitable institutions by Arab Americans, depriving orphans, widows, and the needy of American financial assistance. It also allowed for seizing the assets of any American citizens who donated funds to non-governmental organizations and civic organizations on the State Department's list of terrorist organizations—including those that support Palestinian relief agencies such as schools, hospitals, orphanages, libraries, women's organizations, and community centers—in the process curtailing Arab civil liberties and human rights.

In the same year, Congress passed the Anti-Terrorism and Effective Death Penalty Acts, which gave the right to the United States, in effect, to try to incarcerate without evidence Arabs residing in America. These actions by the executive and legislative branches of government resulted in airport profiling of suspected terrorists. The model for the profile of a terrorist was therefore not Timothy McVeigh but the Arab. Not only did the executive and legislative branches of the government target Arabs, but the Supreme Court in 1999 in the Los Angeles Eight case validated the denial of First Amendment rights to non-citizens, in this case Palestinian Christians and Muslims.

Two events in the twentieth century appear to have had a profound impact on the formulation of Arab American identity: The 1967 Israeli pre-emptive strike against Egypt, Syria, and Jordan and the Gulf War. While the first brought into existence the American Arab organizations discussed above, who sought to ameliorate the negative image of the Arabs in America and to provide a venue for airing their frustration and for giving accurate information, the Gulf War brought to the fore a new generation of Arab activists who sought to change American policies by operating within the system.

The leaders of the American Arab organizations of the 1970s are aging or have passed on. Sapped by the divisions within their ranks, those who are still active have lost effectiveness over the years and appear not to have prepared a new generation to take over their endeavors. The Gulf War generation, however, has been energized by what is perceived as American hypocrisy and double standard. They challenge the fact that the United States has supported Israel in defying all United Nations resolutions requiring Israel to withdraw from territories it occupied by war while it insisted on Iraqi withdrawal from Kuwait. They are appalled that the United States, which sees itself as the ultimate defender of human rights, is willing to see hundreds of thousands of Iraqi children die of malnutrition due to the American enforced embargo. They question American commitment to religious freedom, since the committee set up by Congress to monitor violations of that freedom condemns only Muslim nations that the American government does not like and is silent about Israeli violations of the human, political, and religious rights of Christians and Muslims living in the Occupied Territories.

Unlike the activists of the 1970s, the new generation is not spending time on establishing umbrella organizations, writing constitutions for these organizations, or running elections for officials or spokespersons. Rather, the activists rely on the Internet to create a network of people committed to justice. They collaborate with existing organizations for human rights, minority rights, and religious rights. These Arab activists are mostly in their twenties and thirties, and they take American values very seriously. They are working to create a better America, one that is not blinded by special interests but that is truly guided by the values it preaches. In the process, they are truly Arab—truly American.

10

The Changing Arab New York Community

Louis Abdellatif Cristillo and Lorraine C. Minnite

For someone who was no stranger to public speaking, the Reverend Khader al-Yateem, the pastor of Brooklyn's Salam Arab Lutheran Church, seemed lost for words. The tall bearded Palestinian in his early thirties stood at the podium, his long white cloak elegantly framing a dark vest and accentuated his already dignified appearance. "I have to confess," he said to the audience of mostly Arab Americans, "your invitation came to me as something of a surprise." Looking out across the crowded ball-room of Widdi Catering Hall, owned by a prominent Palestinian American family in Bay Ridge, Brooklyn, the Reverend Khader spoke earnestly to his hosts: "I'm deeply humbled to be here tonight to share with you this special month. And I thank you for this gesture of reaching out so that our two communities may come closer together for the benefit of all."

Why his surprise? What two communities did he mean? The evening's event was a community *iftar* (breaking of the daylong fast at sunset during *Ramadan*) hosted by one of the busiest Muslim benevolent societies in New York City, the Islamic Society of Bay Ridge, located at Brooklyn's Masjid Musaab bin Omayer. Although the hosts and the majority of guests present that evening were Arab American Muslims, a score of local religious and civic dignitaries were also guests of honor—several rabbis and priests, a congressional representative, a city council member, a state senator, and members of law enforcement and fire departments. But the real novelty of the moment was in the gesture of Brooklyn's Arab Muslims reaching out to their Arab Christian cousins, two separate religious communities having a common language, similar cultural values, and a history of shared joys and sorrows in their native homelands. For both the Rev-

erend Khader and the leadership of the Islamic Society of Bay Ridge, the symbolism of the moment was both powerful and subtle. The Arab New York community is indeed a community of many worlds.

But worlds have a way of changing, and this vignette dramatically underscores the new demographics of Arab New York. For one, Arab Muslim immigrants—once a barely visible minority compared to the Arab Christian majority—are now a fast-growing and increasingly visible presence. The catalyst for this growth was the cancellation in 1965 of a half-century of restrictive immigration laws that precipitated what is being called today the "new immigration." Soon thereafter Arabic-speaking Muslims began emigrating in large numbers from economically or politically troubled regions of North Africa and the Middle East.

Another change is that New York's Arab community is no longer rooted in the original Syrian-Lebanese colonies of Lower Manhattan, Brooklyn Heights, and South Brooklyn (of which Bay Ridge is an extension).[1] Instead, the newest "pioneers" are homesteading into other neighborhoods and boroughs, and in the process they are crisscrossing the boundaries of class, race, ethnicity, and religion in ways that older pioneers might never have imagined likely to happen.

In this essay, then, we offer some preliminary remarks about the changing urban geography of the Arab New York community. We focus on the directions Arab Muslims are taking today within the broader context of community building among the ethnically diverse and ever-increasing Muslim population of New York City. Our discussion will be a synthesis of findings from fieldwork conducted for the Muslim Communities in New York City Project, a three-year study of the Muslim community of New York City, and from recent work on the social history of Arab Americans.[2]

The Muslim Communities in New York City Project[3]

The overarching goal of our three-year study was to assemble the first-ever sociological baseline on Islam and Muslims in New York City. The project aims at providing multiple perspectives on how and to what extent Muslims—indigenous and foreign-born, individually and collectively—accommodate American culture and society while forging a distinctive religious identity. The first task of the study was to identify the spatial patterns and physical markers of the city's diverse Muslim communities.

Our research team of seven men and three women canvassed nearly every neighborhood in New York City from May 1998 to June 1999.[4] They

B & B Electronics owner, Bay Ridge, Brooklyn, with photographs of himself in Jerusalem before emigration, 1998. Photograph by Mel Rosenthal.

visited and collected data on some 1,780 "Muslim sites," secular and religious establishments alike, enabling our project to map out the communal patterns of Muslim New York. While walking the city streets, the researchers kept field notes to describe the urban ecology of the sites and to summarize casual conversations they had with shop owners, store patrons, neighborhood residents, and the like. When the neighborhood canvass was complete, our field workers were able to identify more than thirty-five ethnic/national categories for both indigenous and foreign-born Muslims at 80 percent of the sites visited. Of these, some 649 sites were associated with a dozen different Arabic-speaking nationalities—Algerian, Egyptian, Iraqi, Jordanian, Lebanese, Moroccan, Palestinian, Saudi, Sudanese, Syrian, Tunisian, and Yemeni.

Arab Muslims in the Mosaic of New York City's Muslim Communities

The 600,000 or so Muslims in New York City today represent an astonishing assortment of people from different ethnic, racial, class, and sectarian backgrounds. In all of this diversity, people sometimes make the mistake of

confusing the terms *Muslim* and *Arab*. Undeniably, Islam and the Arabic language are intertwined spiritually, historically, and ritually, yet many people are surprised to learn that most Muslims worldwide are in fact not Arab, nor do they speak Arabic. The same is true for New York City's growing Muslim communities.

Of New York's indigenous Muslims, most are African American, but in recent years there has been a noticeable increase in the number of Latino and European American converts.[5] The city's foreign-born Muslims—arriving in ever-increasing numbers since the late 1960s—hail mostly from the non-Arabic regions of the Muslim world. They originate from Southwest Asia—from Pakistan, Bangladesh, India, Afghanistan, and Iran. Others arrive from the Balkans—mostly from Albania, Bosnia, and Kosovo. Still others come from West Africa—notably from Ghana, Senegal, Niger, and Sierra Leone.

More visible than ever before, New York City's Muslims are very much in the groove of the religious and secular rhythms of the city. They have more than one hundred mosques in which to pray,[6] can purchase *halal* meat at more than twenty butcher shops, use litigation over the right to wear religiously mandated garments or beards in the workplace, and have successfully lobbied the city to suspend parking rules on Islamic holidays. In less visible contexts, however, Muslim New Yorkers occupy just about every rung and niche of the city's secular economy, from cabbies to corporate lawyers, from sidewalk food vendors to restaurateurs of haute cuisine, from parking lot attendants to pediatricians, from law enforcement officers to social workers.

Greater visibility, however, has its consequences, which are sometimes not so pleasant. Many Muslims in New York City, like members of other minority groups, find their aspirations for self-affirmation put on the defensive by ignorance or prejudices deeply entrenched in the larger society. The most widespread and pernicious example of this is the stereotyping of Muslims—Arab Muslims, especially—as religious fanatics and terrorists. But the days of this sort of intolerable "political incorrectness" may be numbered. For as with other minority groups in New York City, the expanding population of Muslims is propelling religious leaders, Islamic centers, and activist groups into the arenas of civic and political engagement.

The Changing Urban Geography of Arab Muslims in New York City

Estimates of the size of the Arab Muslim population in New York City vary widely. The 1990 U.S. Census counted 136,053 New Yorkers claiming Arab

ancestry.[7] Exactly how many of New York City's estimated 600,000 Muslims are Arab or of Arab ancestry is practically impossible to determine.[8] Our own best guess, however, is that the number is most likely toward the higher end of the range of about 40,800 to 74,400 people.[9] Whatever the actual number is, the distribution of the 649 Arab Muslim sites that we canvassed suggests new trends in community building that are breaking with earlier patterns.[10]

Predictably, Brooklyn garnered the largest number of Arab Muslim sites of any of the boroughs canvassed, 245 out of 649 sites or 38 percent of the total (see illustration 23). Although the Atlantic Avenue section of Brooklyn Heights has long reigned as the mecca of Arab American residence and business, our research findings suggest that things are changing. South of Atlantic Avenue, Muslim immigrants from Palestine, Lebanon, Yemen, and Egypt have made Bay Ridge the second most prominent Arab American community in New York City. At the same time, our data show a widening distribution of Arab Muslim sites, mostly small businesses, in other Brooklyn neighborhoods, particularly in Prospect Heights, Sunset Park, East Flatbush, Crown Heights, and Brownsville.

Following close on the heels of Brooklyn, the Bronx had the second largest number of sites at 227 or 35 percent of the total (see illustration 24). Clusters of sites, typically small businesses such as corner delis and convenience stores, dot many of the neighborhoods along the business corridors of Jerome Avenue and the Grand Concourse. This large swath of neighborhoods includes Mott Haven, Melrose, Mount Eden, Mount Hope, University Heights, Fordham, and Norwood. Not coincidentally, a string of one-half dozen community mosques, mostly South Asian, West Indian (Guyana and Trinidad-Tobago), and West African, also lie along this corridor. Other Bronx neighborhoods such as East Tremont, Williamsbridge, and Parkchester appear to be attracting Arab immigrants. One interesting finding about the Bronx hints at who are the newest "pioneers" of Arab New York City: three in four of the Arab sites (172 of 227 sites) were delis or convenience stores commonly referred to as "bodegas" run by Yemeni immigrants.

Our data for Arab Muslim sites in Manhattan also revealed some interesting patterns (see illustration 25). About one-half of its 128 Arab Muslim sites were in the uptown neighborhoods of Harlem, Hamilton Heights, and East Harlem. Another one-third of the sites were located in the downtown areas of Chelsea, Union Square, SoHo, and the East Village. The majority of sites were delis, ethnic restaurants, or clothing stores that were being run by Yemenis, Egyptians, Moroccans, and Lebanese. Again, the Yemenis

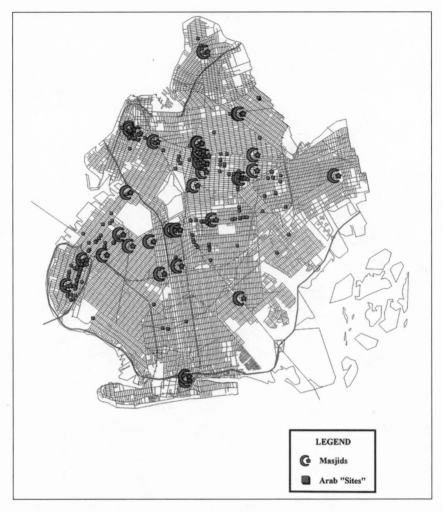

Brooklyn Arab Muslim sites. Courtesy of the Muslim Communities in New York City Project, Columbia University.

seem to have staked a claim to a particular niche, owning some 87 percent of the delis run by Arab Muslims. No doubt due to relatively high rents and real-estate prices, there is a noticeable decoupling of ethnic residential and commercial worlds, making the patterns of Muslim visibility distinctly different in Manhattan as compared to the Bronx, Brooklyn, and Queens.

Because the borough of Queens is home to New York City's largest en-

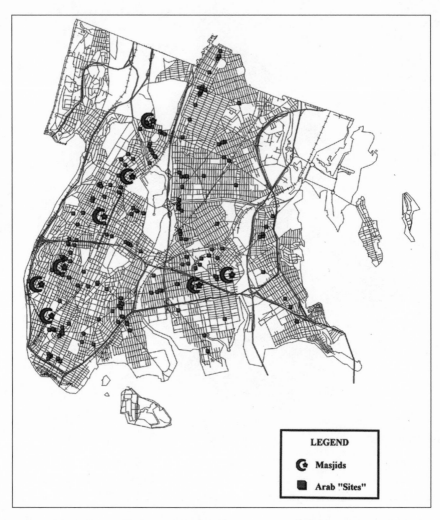

Bronx Arab Muslim sites. Courtesy of the Muslim Communities in New York City Project, Columbia University.

claves of South Asian Muslims who reside mainly in Flushing and Jamaica, it was not too surprising that our canvassing in Queens netted only forty-nine sites for Arab Muslims (just 8 percent of the total for all boroughs; see map on page 133). What is interesting, however, is that more than one-half of these sites were situated in just two neighborhoods, Astoria and Long Island City. The sites canvassed were mainly convenience stores and restau-

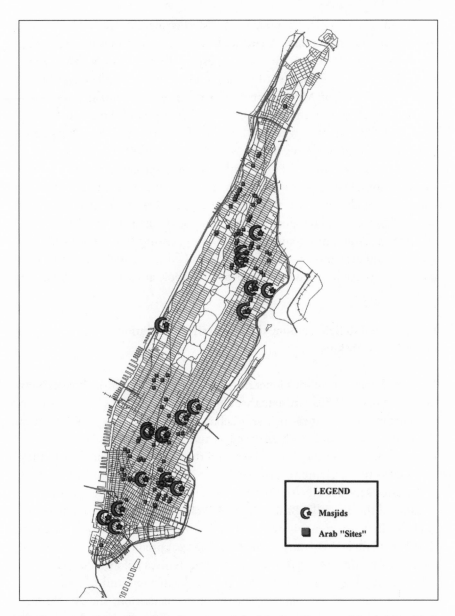

Manhattan Arab Muslim sites. Courtesy of the Muslim Communities in New York City Project, Columbia University.

rants run by Yemenis, Egyptians, and Moroccans. Astoria in particular, from what our researchers heard and observed, is attracting increasing numbers of North African immigrants, especially from Morocco and Algeria. If this trend continues, Astoria may well become the largest concentration of North African Muslims in New York City, if it is not already.

This overview of emerging communal patterns of Arab Muslims in New York City offers a suggestive glimpse of how the Arab New York community is indeed changing. But New York City is, after all, a city of immigrants.[11] Arab Muslims, like any other immigrant community, face the inherent complexities of assimilation and the risk of losing things that anchor cultural identity. Two of the weightiest anchors for immigrants are, of course, language and religion, and many of today's newest Arab New Yorkers, like the Arab immigrants of more than a century ago, are struggling to preserve and disseminate their language and faith. To appreciate how this struggle is unfolding today, a retrospective look at earlier pathmakers is helpful.

Language and Religion among the Pioneering Generation of Arab New Yorkers

Modern chroniclers of the pioneering Arab immigrants who arrived in New York City in the 1880s estimate that about 90 percent were Christians from the Ottoman-ruled areas of Syria-Lebanon and Palestine.[12] Washington Street in Lower Manhattan emerged as the first Arab New York enclave. Many Arab-owned retail businesses, and the corps of peddlers whom they supplied with merchandise, prospered thanks to burgeoning urban markets in America's industrial cities of the Northeast and Midwest. Soon after the opening of the Brooklyn Bridge in 1883, Arab wage-earners and prosperous Arab families began moving across the East River into Brooklyn, which by then had a vibrant economy as the fourth largest producer of manufactured goods in America. Many of these new Brooklynites belonged to the Antiochian Orthodox, Maronite, or Melkite Christian communities.

Throughout this pioneering phase of acculturation, the Arabic language in both its colloquial and standard literary forms helped to sustain the ethnic and religious vitality of the Arab Christian settlers. Literary Arabic flourished in local Arabic newspapers such as *Al-Hoda, Al-Islah*, and *Al-Ayyam*, and by the writings and lectures of such literary giants of the Arab Renaissance in America as Ameen Rihani, Kahlil Gibran, and Mikhail Naimy. Priests from the homelands of Syria-Lebanon were recruited to

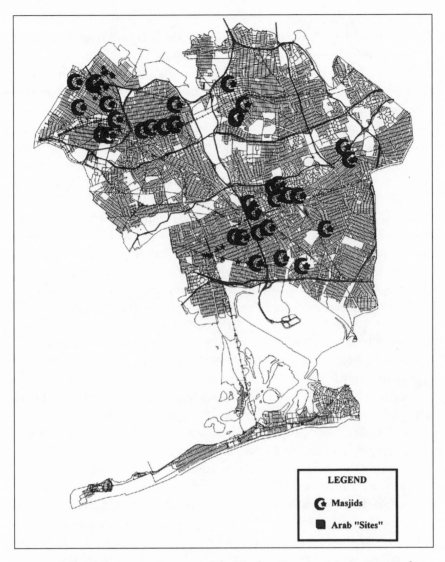

Queens Arab Muslim sites. Courtesy of the Muslim Communities in New York City Project, Columbia University.

minister to the Arabic-speaking parishes that were developing in Manhattan and Brooklyn. This pioneering phase, however, effectively ended in 1924 with the enactment of the National Origins Act.

Gradually, the complex pressures of assimilation chipped away at both the religious and secular usage of Arabic from one generation to the next. American Catholic and Protestant churches in Manhattan and Brooklyn opened their doors to their Arab co-religionists, but the accommodation meant a liturgy in Latin or English, not in Arabic (or Syriac for adherents of the Maronite tradition). Even the Antiochian Orthodox Church saw the necessity of accommodating its own parishioners by promoting the use of an English liturgy.

A far more negative influence on Arabic resulted as each new generation of Arab American children entered the classrooms of New York City's public schools, and nowhere was this more evident than in the gradual fading away of the Arab American press between the two world wars. The few locally published Arabic newspapers or literary journals still in circulation by the 1950s metamorphosed from Arabic only, to Arabic/English, and finally to English only. In short, for both the Christian majority and the Muslim minority in New York City, the gradual assimilation from the margins to the mainstream of society pushed Arabic from the center to the periphery of community life.

As for the minority of the city's Arab Muslims between the 1880s and the 1960s, very little is known. The 1920s and 1930s did see the emergence of several alternative Islamic movements such as the Moorish Science Temple, originating in Newark, and the *Ahmadiyya*, a Muslim reformist and evangelical movement based in India. These movements, appearing at a time when an ideology of pan-Africanism was spreading among blacks in America, Europe, and colonial Africa, appealed less to Arab immigrants than they did to working-class African Americans who felt estranged from local Christian churches. Even the State Street Mosque in Brooklyn, founded in the late 1920s by Sheik al-Haj Daoud Ahmed (reputedly a Moroccan immigrant by way of the West Indies), ministered mostly to African American converts until the late 1960s ushered in the new Arab immigration.

Overall, the relative invisibility of the Arab Muslim minority in New York City between 1880 and 1965 was probably as much a consequence of small numbers as it was of their sharing a common language and similar folkways with members of the larger Arab Christian enclaves in Lower Manhattan and Brooklyn.

Language and Religion among the New Pioneers

Nowadays the lack of visibility is hardly an issue, for the newest Arab Muslim pathmakers in New York City are part of a larger social phenomenon—the rapid growth of a remarkably diverse multiethnic presence of Muslims and Islamic institutions throughout much of urban America.[13] Our team of researchers visited more than eighty businesses providing *halal* food products, such as meats, poultry, processed foods, beverages, and other sundries. And whether they need an item for the bookshelf or the wardrobe, New York City's Muslims can shop at more than twenty-five stores that specialize in religious books, tapes, videos, prayer rugs, fragrances, incense, homeopathic medicines, articles of clothing, and other religious accoutrements. Unquestionably, however, the mosque, or *masjid*, outweighs all other institutions as the most visible symbol of Muslim community life, providing the institutional structure and social momentum for preserving and reproducing language and faith.

Just as the earlier generations of Arab Christian immigrants estab-

Making pastries at International Gourmet Delight, Bay Ridge, Brooklyn, 1998. Photograph by Mel Rosenthal.

lished parishes and churches in Manhattan and Brooklyn such as the Church of the Virgin Mary (Melkite), Saint Nicholas (Antiochian Orthodox), and Our Lady of Lebanon (Maronite), today's Arab Muslims have founded mosques and Islamic centers. In the late seventies there were at best one-half dozen mosques, but by June of 1999 our team of researchers identified twenty-eight mosques in Queens, twenty-seven in Brooklyn, twenty in the Bronx, seventeen in Manhattan, and eight in Staten Island.[14] This means that on average nearly as many mosques were founded in New York City every year for the last twenty years as were founded in the previous century, and this vigorous "brick and mortar" phase of community building shows no sign of slowing down.[15]

Emerging Properties of Mosque-Centered Communities

Several neighborhoods in Brooklyn with heavy concentrations of Arab Americans, particularly Egyptian, Lebanese, Palestinian, and Yemeni New Yorkers, are home to a growing number of mosque-centered communities. These include Masjid al-Farouq on Atlantic Avenue in Brooklyn Heights, Masjid Musaab bin Omayer in Bay Ridge, and the Brooklyn Islamic Center in Bensonhurst. How does a mosque get started? And how is an Islamic center different from a mosque? Our research suggests the following development process for the founding of a mosque like Masjid Musaab bin Omayer and ways that changes occur as its community base grows.

Phase One: A small network of friends and their families from the same home country agree to use a single room in one of their homes as a *masalla* or place of communal prayer. Typically, this network becomes the core of a future board of trustees for a mosque.

Phase Two: If the core group includes or expands to include business entrepreneurs or middle-class professionals, sufficient financial resources and know-how are pooled to buy or lease a storefront or basement and convert it into a small neighborhood *masjid*. At first, hiring and supporting a full-time Imam may not be feasible. In this case, the five daily prayers are held at the *masjid*, but on Fridays the regular congregants attend weekly congregational prayer at a larger mosque elsewhere.

Phase Three: The core group of founders forms a board of trustees and applies for incorporation for tax-exempt status as a religious institution; a permanent Imam is sought; and modest projects for non-formal religious studies and Qur'anic instruction are implemented. The Friday prayer and *khutba* (sermon) is now offered, increasing the mosque's appeal and status.

Phase Four: As the Muslim population in the neighborhood grows, local fund-raising begins to support a part-time staff to provide more formal instruction in Islamic studies and Arabic on weekends for children and young adults. Scholars (sheiks or Imams) from other mosques or from abroad are invited to present lectures and seminars. The stage is now set for the mosque's transition from a mosque to a full-fledged markaz, or Islamic community center.

Phase Five: Local fund-raising and regular sadaqa (charitable donations) and zakat (a kind of tithe or mandatory alms given to the needy, especially at the end of Ramadan) help support a full-time staff.[16] Closely supervised by the board of trustees, special committees oversee the delivery of social services that may include any of the following: literacy instruction, day care, food and clothing distribution to the needy, temporary housing for new immigrants, health-care networking, family counseling, marriage and divorce services, funeral services, organized da'wa projects (educational outreach for the propagation of Islam to both "wayward" Muslims and non-Muslims), summer school and summer camp, civic outreach to local community boards and law enforcement, and interfaith dialogue.

Phase Six: The biggest enterprise that the leaders of every Islamic center dream of, although few actually realize it, is the founding of a full-time Muslim day school. This is an enormous undertaking because of the fiscal, material, and special human resources needed to ensure its success and maintenance. Once established, however, a private day school tends to operate independently from direct influence of the founding mosque because the boards of trustees of most mosques generally lack expertise in the field of education and school administration. Nonetheless, all schools depend on mosque-sponsored fund-raising to supplement their annual budgets and to keep tuition fees affordable.

Our canvassing research suggests that approximately 12 percent of New York City's mosques have gone through all stages from a simple one-room masalla to a full-fledged Islamic community center and private day school. Our own guess is that probably three-quarters of all mosques offer the Friday congregational prayer and provide some kind of informal religious instruction. But no matter what stage of its development, a mosque's top priority is religious education for children and young adults. Unfortunately, only a small fraction of school-age children can attend private schools; the burden of tuition is a factor, but the main problem is classroom space. All private day schools have enormous waiting lists that are backlogged as much as two years.

Today, there are about twelve full-time Islamic day schools in New York City. All are certified by the New York City Board of Education and combine courses in religious studies and Arabic with the standard core curriculum of the city's public schools. Half offer elementary grades only, one school goes from kindergarten through eighth grade, and five offer all grades through twelfth. Although student enrollment often mirrors the dominant ethnic group of the local mosques, the racial and ethnic composition of students and teachers in every private day school is generally far more diverse than that of the mosque congregations themselves.

One interesting development is that the New York City public-school system recognizes the large numbers of Arabic-speaking students in some of its districts. A high school in Brooklyn with a large enrollment of Arabic-speaking pupils, for example, offers bilingual Arabic/English instruction to help children of new immigrants adjust. Additionally, the New York State Board of Regents, the state's educational oversight agency, has pilot-tested an Arabic language exam so that students may soon be able to take Arabic and fulfill their high school foreign language requirement towards their Regents Diploma.

Conclusion

Today's Arab New Yorkers are indeed a community of many worlds. The post-1965 wave of immigration to New York City has transformed both the urban geography and the cultural landscape of an Arab American community that was once predominantly Syrian-Lebanese and Christian. Today, large numbers of first- and second-generation Arab Muslims from North Africa and the Middle East are recasting the social, cultural, and religious features of the community. Mosques and Islamic centers, religious and secular businesses, and an emerging private-school movement are creating communal infrastructures throughout the city that are preserving and spreading the Arabic language and Islamic culture to present and future generations.

Most significantly, these newest New Yorkers are part of the growing presence of Muslims—Arab and non-Arab, indigenous and foreign-born—in the public square of American life and society. This fact raises pressing questions and challenges for New York City's Arab Muslim community, especially in relation to the cultural politics of race and ethnicity in American society. How do Arab Muslims perceive and prioritize their identities? As Arab Muslims, or as Arab Americans? As Muslim Americans, or as

American Muslims? How are they negotiating the cultural and historical disparities between themselves and the larger communities of African American Muslims and South Asian Muslims? How are they contesting the double-edged negative stereotyping of Arab and Muslim that paints them as anti-American religious fanatics?

Clearly, Arab New Yorkers today, both Muslim and Christian, face a world of complex challenges. Grappling with such challenges will require forms of civic and political engagement that many of the newest immigrants were unaccustomed to in their homelands. But with a new generation of Arab American pathmakers of vision like the Reverend Khader Al-Yateem of the Salam Arab Lutheran Church and the leadership of Masjid Musaab bin Omayer, the Arab New York community seems poised to meet the challenges head on.

11

Arab Families in New York Public Schools

Paula Hajar

I have lived in New York for a very long time, but I grew up in Boston.
Boston had its own Syrian-Lebanese enclaves, one of which stretched for
several miles along its own Washington Street, in a section of the city
called West Roxbury. Looking at a class picture not long ago, I counted nine
Arab Americans in my class of thirty second-graders. This was in the
1950s.

One day three new girls appeared on the school playground during re-
cess. Someone told me they had just arrived from Syria. It was winter, and
they were dressed in coats that were made completely of fur. When I heard
the oldest call to her sisters, *"Ta'a li houn,"* I froze. How dared she? I
thought. No one speaks Arabic in school! That moment was the first time
I was aware of a message I must have been absorbing since kindergarten:
Arabic (and for that matter everything else that was not English) was not
allowed.

In all of my schooling—through high school, through college, through
my teaching years in private schools in New York City until I returned to
graduate school in the mid-1980s—invisibility was the most consistent
feature of being Arab American. Because I had spent so much of my life in
schools, schools seemed to be implicated.

In graduate school I began to write papers about Arab identity, includ-
ing an ethnography of a little Arabic Sunday school in Cambridge and an
ethics paper on a 1983 case in which a Palestinian girl asked to hang the
Palestinian flag in her high school's hall of flags and met with resistance.
When it came time to crystallize a dissertation topic for a doctorate in edu-
cation, one of my readers insisted that the study focus on a problem of edu-

cational practice. Serendipitously, at that point I received a call from a Lebanese American friend. A Syrian American friend of hers, the PTA president at the local elementary school, had called her on behalf of the school's guidance counselor. The guidance counselor was looking for someone to lead a support group for Arab immigrant mothers. This was the first time I had heard of the new concentrations of Arab children in New York schools. A week later I visited the school, the principal, the guidance counselor who had made the request, and a teacher who was teaching English to five Arab mothers that day. I learned that the school people were dismayed at some of the Arabs' family practices and that they would welcome a study of the situation.

Over the course of the next year, I visited other schools with high concentrations of Arab children and eventually added a second school to my study. Studying two schools rather than one afforded a better chance of protecting the identity of the informants. Having a double site also turned out to be important because of the schools' differences. These differences became the core of one set of findings.

The study was ethnographic. The dissertation asked questions about the relationship between Arab parents in the two schools and the American teachers who educated their children. It became a study on perspectives, on how people perceived cultural differences, and on how each group presented itself in relation to the other.

At the end I will ask, why is this important? When I wrote this study I believed that schools were significant arenas for clarifying identity and relationships, and I felt strongly that they could foster or quash a child's self-esteem. The enforced silence that I had experienced in school seemed to have been harmful. As an educator, I thought schools had certain obligations. Seven years later, as I review this study from the perspective of an administrator in a suburban public-school system, I am not so sure. I want to use this opportunity not only to tell what I found but also to raise the question, "What do we want from the schools around the issue of ethnic identity?"

Background to the Study

I began conducting my research in the early 1990s; at that time the number of Arabs in the two schools I studied had, within the previous few years, increased dramatically. By that point about a sixth of the student population was Arab, and Arab students comprised 40 percent of the total number of

ESL (English as a Second Language) students. The year I did my study, one school was introducing its first bilingual Arabic class, for eighteen Arabic-speaking second-graders. The other school had tried to introduce a bilingual class for Arab kindergarteners at the beginning of the school year, but that class had folded due to lack of support from the parents.

My sample was composed of fifteen families across the two schools: fifteen mothers and two fathers from Syria, Lebanon, and Palestine. They included Sunni and Shiite Muslims, Christians of various sects, and one Druse couple. Twelve of the seventeen had been in the United States for five years or less.

The sample also included twenty-five to thirty school personnel including teachers, principals, PTA presidents, and others who served the children of the families in the sample. Two of the teachers were Egyptian.

The purpose of the study was not to develop a generalization about the experience of all Arab immigrant families with regard to the American public-school system, but rather to study the experience of a few and from that investigation to raise some questions about the experience of the many.

Methods

Data were gathered from observations and long, in-depth, open-ended interviews. The teachers were interviewed twice, the second time to verify opinions given in the first interview and to ask questions that may have arisen with other informants in subsequent interviews. I was particularly interested in the stories, anecdotes, and examples my informants gave to illustrate their viewpoints. I was less interested in the factual truth than in how people constructed and interpreted reality. I listened to the stories using a number of borrowed and invented formats and analyzed them to get at the total worldview of the speaker.

The interviews, although open-ended, were structured around three questions: First, what information did each person in the sample have about members of the opposite group, and how was that information obtained? Second, what was the nature of their day-to-day communication and what was its content? And third, how did each define and then deal with cultural differences, particularly in the ways that had an impact on the education and socialization of the children?

The Pivotal Role of School Understanding

In the course of doing the fieldwork, I discovered the importance of factors that had not been part of my initial focus. The first of these was the pivotal role played by a school's organizational scheme in shaping perspectives on cultural differences and in shaping the ways they are played out in the classroom.

In some ways, the two schools were quite similar. Both were resource rich, both had active PTAs, and both had relatively high scores on New York State's standardized tests. Children who attended were from a mix of ethnicities, although most were white or considered white. Scarcely one mile apart, the schools served basically the same socioeconomic and ethnic mix of students.

However, what was starkly different were the two schools' policies and practices toward organizing students, policies which had a major impact on the integration of immigrant children into the school community. These policies were a direct reflection of the personal philosophies of the two principals.

The principal at one school abhorred sorting and segregating of any kind. If he could have his way, he would not have allowed into his school any classes for gifted and talented children or any bilingual classes. It was a source of pride to him that all his other classes, at least, were of children with mixed ability levels. According to his design, each consisted of one-third children performing on grade level, one-third children performing above grade level, and one-third children with limited English proficiency (also known as LEPs).

By contrast, the other school had a tracking system. Children were grouped into three academic tiers, with the top class being for the so-called gifted and talented, the second tier for those who were performing above grade level, and the third tier for those who were on grade level or below.

As for the students with limited English proficiency, that year the school had begun an experiment. In kindergarten through second grades, they were segregated into their own classes. The rationale for separating them from the others, according to the principal, was to allow them "to concentrate on learning English." In addition, he said, they would have the opportunity to be "re-socialized" to American mores and values.

As played out, the results of these two organizational schemas were almost diametrically opposed to the two school leaders' original intentions.

Iraqi Muslim girl in ESL class, 1995. Photograph by Mel Rosenthal.

In the school where there were heterogeneous classes, the teachers were so unhappy with the extremes in language proficiency within their classes that they tended to complain to the administration a lot about the hard work such mixed classes involved. The principal turned a deaf ear to their requests to have, as he put it, fewer of "them" in their classes, so the teachers often resorted to referring the Arab children to special education. In fact, they referred these children for evaluation at a rate at least double that of their presence on the rolls. The year before, even though Arabs were one-sixth of the total school population, they represented one-third of the referrals made by classroom teachers for testing for special education. (It followed that one way in which parents were judged was by how they cooperated with or resisted the special-education referral.)

For the most part, teachers in this school did not celebrate culture or think a child's cultural identity was important to recognize. They had a complex rationale for why ignoring culture made for a better learning environment. Among the reasons offered were that they did not want to embarrass the children or put them in the spotlight, that they did not want to veer away from nonacademic matters, that cognitively the children were not ready for such identifications at such a young age, and so forth. "It doesn't matter what they are—children are children," was a refrain I heard often from teachers in this school.

Not surprisingly, children in this school seemed hesitant about their identities. One Palestinian first-grader, the son of one of my participants, insisted to his mother that he hated to speak Arabic, and he had forgotten it anyway. Another Palestinian boy begged his mother not to speak Arabic on the street. When I visited the classes, the Arab children seemed somewhat lost and sometimes listless.

The principal, for his part, insisted that the teachers were not trying hard enough to reach the students they were complaining about—that they were not using a wide enough repertoire of teaching strategies and were making the special-education referrals so as to narrow the range of abilities they had to address in their classes. "That [addressing the children's needs] is their job," he said. "[The teachers] are not being professional." He had come to the point, he said, where he refused to have conversations with them about it.

At the other school, where Arab children were segregated into classes with other immigrant children of similar limited English proficiency in order to "learn English and become American," the picture and the practices were quite different. First, there was not the issue of special-education

referrals that existed at the other school; teachers referred only a handful of Arab children to special education. Moreover, while the principal may have intended that the classes would "re-socialize" the children and their families to American ways, these teachers, highly enthusiastic about biculturalism, were quite consciously undermining the principal's intent by stressing the beauties of holding onto one's original culture and of knowing and speaking another language. They emphasized to the children that the United States was a place where people kept both their old and their new cultures.

In contrast to the children at the first school, the children at the second school were animated, outgoing, and expressive.

As for parent reaction to these situations and parent involvement, again striking contrasts emerged:

The parents whose children were in the school with the heterogeneous classes were satisfied that their children were not being deprived of anything the Americans had.

The parents at the other school were much less satisfied. In fact they were furious. Despite their appreciation of the teachers' efforts and sensitivity, they felt their children were being discriminated against by virtue of their segregation with other immigrant children. "We didn't bring our kids to live with Koreans, or Russians, with ethnic groups," complained one father. "We brought them to live with Americans, to gain the American habits and standards." Precisely because they were so dissatisfied, some of those parents spent a lot of time in their children's classes, volunteering to help in art, teaching French to first-graders, acting as translators for newcomers, volunteering with the class play.

According to their own report, they also complained a lot to the administrators, asking for extra books to help their children get ahead and begging that their children be allowed to graduate out into the mainstream. All felt their requests had been ignored.

When I asked the principal what the Arab parents' response had been to the LEP classes, he said, "We have had no objections, and the reason primarily is we've been able to convince parents that by grouping the foreign-language children together as foreign-language kids, we can provide them with a more intensive course of study, with teachers who are better trained to meet their individual needs." And, he added, in contrast to the Russian parents who, he said, were aggressive about getting their kids into the mainstream and were always asking for extra help, the Arabs were compliant and complacent.

What I took away from these findings, in addition to the discrepancy in reportage, was that what seems like a noble idea at the start can have unpleasant by-products, and vice versa: what can seem like an educationally deleterious scheme at its conception can have some positive fallout, at least in the short run. In any case, any administrative scheme, noble or mean-spirited, can easily be undermined by the people in the front line: the teachers.

What They Did Not Know

The second surprising finding was how little the teachers cared to know about their Arab students. When it came to having information about the Middle East or Arabs, school people were deeply ambivalent.

I learned of this early on. Initially I planned to limit my study to the Lebanese. I soon discovered, however, that many school people had no idea of their students' countries of origin; they would know which families spoke Arabic but not whether they were Palestinian, Lebanese, Egyptian, Yemeni, or Iraqi. The teachers felt they had little use for such particulars— despite the fact that at the time the *Intifada* was still raging, the Lebanese civil war still being fought, the Gulf War was an ongoing trauma, and children were arriving from these places every other week.

In fact, there was an actual resistance to knowing; it was as if ignorance was a protection against prejudice. Comments like "All children are the same" and "I don't ask where they come from," or "I wouldn't know where she's from—let me look at her file" were not uncommon and often a point of pride.

In addition to not knowing what countries particular children were from, most school personnel could not have made any distinctions between one Arab country's living conditions, customs, or culture and those of another country. One teacher commented that it was no wonder the Lebanese women were overwhelmed by the freedom American women had, coming as they did from a country "where women couldn't even walk in the streets, let alone have jobs." Some were ignorant about the variety of religions practiced by Arabs, associating all Arabs with Islam, which they also knew little about. Some learned of *Ramadan* only when a child fainted; one administrator in June of the year I did the study was shocked to be told that *Ramadan* lasted thirty days. He had thought it was three.

They also knew nothing at all about the educational systems children

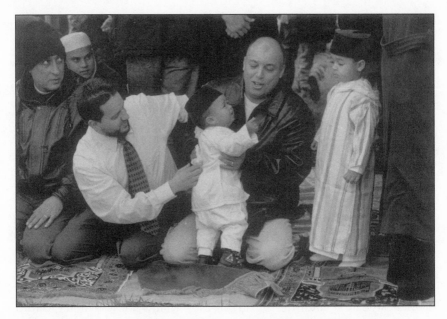

Muslim children at prayer time during *Eid al-Fitr* at the end of *Ramadan*, Bay Ridge, Brooklyn, January 7, 2000. Photograph by Mel Rosenthal.

and parents were coming from, and in the absence of that knowledge often assumed there was no education.

This not knowing and not wanting to know was just one part, although a particularly important part, of the school people's response to Arabs. For reasons having to do with their own ethnic experiences as well as with the demands and concerns of their current professions, school people's responses put them into three distinct groups, and it was this tripartite grouping that comprised the third surprising finding.

Tolerators, Embracers, and Critics

The first group consisted of those who were simply tolerant of different ethnic groups, for whom ethnicity made little difference (or so they claimed). These were the ones most likely to be proud of their lack of knowledge of such details as religious and national background.

One teacher commented, "I think we're supposed to blend them in. I don't even like to isolate anyone. It's just expected that we're all different people, we all have different backgrounds, we all have different religious

holidays. We're all different in different ways, and there's nothing wrong with that."

Another said, "It doesn't bother me what they are . . . I mean, I look at it as a child. To me he's not Arabic, Italian, or Chinese. It's a child. He could have a language problem. No matter what he is, he would be treated equally!"

The principal and most of the teachers at the heterogeneously organized school were such "tolerators." In fact eight of my sample of twenty-five school people were tolerators.

Another group was composed of "embracers," or those who actually found cultural differences, if not delightful, at least interesting, and who were able to see strengths in life practices quite different from their own— or were able to make a connection between their own values and cultural traditions and those of the Arabs. Said one, "When we learned first and last names, Ilham came up and showed me how to write her name in Arabic. And I said, 'Isn't that wonderful.' And Ilham just beamed. I said, 'Isn't that fabulous? I wish I knew how to write my name in another language.' "

Another teacher said, "I don't want to make a big deal out of it, but I think it's very important. Right from the beginning I want them to know who they are and who everyone else is in the class." This teacher talked of allowing a child to pray in class when his uncle died. The experience "personalized Ali for me. When kids share at this level they're more than just Ali from my reading group who's from an Arabic country. They become children who have a culture, who have beliefs. I felt very close to him, I feel an emotional tie with him."

It must be added that embracers knew they were in the minority. They tended to work undercover: to eat lunch in their rooms, to be the least vocal, to keep to themselves. While most people had embracing moments, there were only five (out of twenty-five) true embracers among the American school staff. All of the teachers in the LEP classes in the tracked school were embracers.

Twelve—fully half the sample—were "critics." These were the people who seemed to be skating along on stereotypes and anger. One critic commented, "Kids that are coming from Lebanon, from the time that they're very, very young understand that they're growing up in a country that is war-torn. You cannot expect a child to behave in the same way as a child that grows up in a culture here. This is not a battleground. New York is not a battleground. We've had many kids from Lebanon, from Beirut, who were very aggressive by nature, and whose fathers brought them up to be aggres-

sive, so it's sometimes very difficult to get them to understand that they are no longer in a war-torn country."

Because the speaker was the only one to give such a negative report, I tend to think that he had an axe to grind; or that sheer cultural difference colored his view. But regardless of the source of such perceptions, there were notable cultural differences between the American school personnel and the Arab parents. In other papers presented herein, we read about the fundamental cultural differences between Arabs and Westerners of the early twentieth century. I want to testify that, while most of my sample of Arab parents was not from an educated elite, they shared the views of the writers that Michael Suleiman described in his paper. They suffered from what Thomas Friedman referred to in his *New York Times* op-ed piece of January 28, 2000, "One Country, Two Worlds—Egypt: Between Nile and Net," as "systemic misunderstanding"—which arises when the frameworks of two people are so fundamentally different that they cannot be corrected just by providing more information. I think, in the case of the teachers and the Arab parents, there was a fundamental disagreement about what constituted the well-lived life.

Arab/American Cultural Differences

One deep cultural difference had to do with the value Arabs put on control and limits and the value Americans put on independence and freedom, especially freedom of choice. The tension between these two values was articulated in the examples and anecdotes people gave in their interviews, and was played out in school in many ways.

For example, school people criticized Arab parents' use of corporal punishment. They said that the Arab children were so accustomed to being hit by their parents and by teachers in Arabic school that if they misbehaved, anything less than corporal punishment did not impress them. Teachers reported that sometimes when they told a parent of a child's misbehavior the parent's response was to spank or physically punish the child in ways the teacher could not condone. The result was that some teachers withheld information about the child's misbehavior to protect him or her.

Critics berated the Arab mothers for not getting involved in the life of the school, for keeping to themselves and not mixing with American women.

Critics were irritated by the structure of Arab family life, specifically, the stark division of labor that flew in the face of the current American

ideal of sharing everything: the bread winning, the raising of children, the washing of dishes, and the cleaning. To the critics the division of roles spelled inequity, and the women clearly got the short end.

Included in this issue of gender inequity was the issue of girls' education. Teachers claimed that many Arab parents did not put as much weight on the education of their daughters as that of their sons. They did not encourage their girls to continue on in school; inevitably they faced futures of an early marriage and many children. Teachers felt the girls were not being given a chance to find out who they were and what they wanted to do with their lives, to develop their talents and their individualism. They had no choices in a society in which free choice is practically sacred. This apparent lack of choice was a source of great distress for the teachers, in particular for those who had themselves grown up in traditional families that held similar attitudes. Teachers expressed a certain feeling of sadness with regard to the girls, whom they considered bright and talented, and there was a certain hardening of attitudes toward their parents, whom they wanted to persuade to change or get out of their children's way.

As is usual in situations in which there are two sides to a story, the two sides stressed and ignored different factors. At my request, the Arab parents addressed the issues that the American school people raised, but they also raised their own set of concerns.

With regard to punishments, the parents were concerned with the mildness of the consequences when a child acted out of turn or did not do homework and were distressed if misbehavior was ignored. They were universally elated if teachers punished their children for misbehavior.

One father was pleased when he heard his son had been given time out in the lunchroom: "He hit a wall," he said of the punishment the boy's rowdiness elicited from the teacher. Caring about children meant setting limits. Arabs used all sorts of metaphors about shaping the character of children. "It's like wrapping a young tree," said one father about the importance of inculcating values in the pre-teen years. "After that they will grow straight." "One good spanking and you'll have your kid for life," said one mother.

Control was interpreted as strength; both principals received the compliment, "He's controlling the school." They also valued the teacher who told them what was going on. "She tells me; she's good," was a compliment that parents gave to teachers who worked with them. When a teacher was more concerned with "being a friend to my child" rather than keeping the child in line or making demands on him or her, parents were distressed.

Muhaideen Batah, graduating from Empire State College. A photography
major who had been a carpenter in Nazarus, Palestine, he is now a successful
photographer and lecturer on Palestinian and Islamic issues. New York City, 1999.
Photograph by Mel Rosenthal.

They did, however, appreciate the American way of teaching to many dif-
ferent abilities and not just attending to the academically gifted, which was
often the case in their own countries.

What they were equally and almost universally concerned with was
the lack of challenge in the academic work. Said one father, whose kids had
arrived in New York bilingual in French and Arabic the year before, "Any-
thing they do here, just to write A-B-C and the teachers say 'good job.' They

think the children are coming from nothing. My children lost a whole year in their first year here—only they learned some English."

While teachers were concerned with developing in their students an awareness of choices and the capacity to live independently, Arab parents were worrying over their exposure to just such values.

Parents were concerned by what they perceived as the looseness of family bonds. They were terrified, for example, that their children would get the idea from the Americans that when they turned eighteen they could move away from their families. They were dismayed at the social freedom in general and particularly the ease with which Americans got in and out of marriage. ("They marry to divorce and divorce to marry!" said one man.) ("We spend twenty years solving our problems," said several women.) They deplored the morals of the young American girl. ("Every day she is with a different guy!") They claimed to feel secure and valued as mothers and wives—this role was central to their identity—and it was the relative tenuousness of these roles in American culture that inhibited a few of them from having friendships with American women. Whether they were dealing with reality or a stereotype, the life of the American women was too frightening to most of the Arab women. "The American woman doesn't walk the way the Arab woman walks," was how one mother put it.

In general, they felt that America was much less safe than any of their old countries, where people tended to know each other and to take care of each other and each other's children and the stranger. "Here society is not with you," said one mother, an architect from Damascus. "There I could perhaps let my child be more free [to come and go] because I know that everyone is thinking the same way." It was for this reason that the Arabs spoke of taking or sending their children back to their countries to stay a while during the crucial teen years to "learn how to live." What was meant by "learning how to live" had to do with a sense of the importance of relationships. As Phil Kayal noted in his paper, with Americans enveloped in the self (self-discovery and self-development), freedom, and independence, human interactions seemed dry and impoverished compared to what they had grown up with, where people were enmeshed in each other's lives and were eager to help each other. One father put it this way: "Here you find that families get dispersed, and you end up living in a house, [where] you are alone, [and] you're afraid somebody will break in. If you live in a housing area where everybody around is family, friends, you get more peace. But this society here, I find people are poor."

A friend of mine once commented that what Americans do not appreciate, in their habitual portrayal of Arabs as terrorists, is that Arab family values are much stronger than those of Americans. What struck me as I went around and around the schools for six months was how slender that valuing was for many of the American school people there. Strength for them was not patience and steadfastness, but rather assertiveness, rebellion, breaking out of the mold. One teacher got excited when an Arab mother told her she was divorcing her husband. She said, "The woman told me, 'He was a bum! I threw him out.' I was so excited! She was acting just like an *American* woman."

Conclusion

What is inevitable? I think that if the families stay in this country (some in my sample did not, or they sent their children back to the home country) they will change culturally. Inevitably, limits will give way to the cult of individual choice and freedom. The children eventually will want to be more independent and not as close to their parents as Arabs traditionally are. Encouraged by teachers and American girl friends, Arab girls will begin to see their lot darkly. Families will begin to be more autonomous, more self-sufficient, and also less available to the moment, than they were in the old country. And parents will begin to share roles more, if for no other reason than that is the prevailing wind here.

As for the schools and teachers, they will have a strong influence on this transition and will energize it. In the process they will influence the child's attitude toward his or her own culture in a way that is more subtle but nonetheless problematic.

When I first worked on this problem, I was sure I knew how I wanted to shape this influence. In fact, at the end of my dissertation, I listed a dozen recommendations for teachers and schools. Among them were "Support school people in getting information about Arabs" and "Reframe cultural difference." Yet today, as an overworked administrator worried about students struggling to attain the new state standards, I see that such recommendations are a veritable luxury, the product of a more leisurely era. At the same time, I know I was imprinted with an experience that made me forever hesitant about identifying my ethnicity. I often wonder whether and how my life would have been (and would today be) different had Arab identity been reflected in schools in those days. Similarly, I wonder at the cost of the hesitancy I saw in some of the children in my study, who were

afraid to identify themselves as Arab, who were waiting for a signal from their teachers that it was all right to do so.

Vivian Paley, a veteran teacher, is helpful on this point. The author of *White Teacher*, she wrote that after years of acting as if differences "didn't matter" in her kindergarten classes, she realized that by avoiding talk about those differences she was reinforcing in the children the notion that there was something they should be ashamed of. She wrote, "Anything a child feels is different about himself, which cannot be referred to spontaneously, casually, naturally and uncritically by the teacher can become a cause for anxiety and an obstacle to learning."[1]

Was it an obstacle to my learning? Was it an obstacle to the learning of the children in my study?

Perhaps. In the end, one also has to ask whether the time we must spend compensating for that withholding of permission *to be Arab*, even as we are doing today, has not been as productive and as deepening, or more so, than if our ethnicity, and the different values we associate with it, had been more in the public embrace.

12

The Syrian Jews of Brooklyn

Walter P. Zenner

For the most part, studies of Arabs in North America, on the one hand, and Middle Eastern Jews on this continent, on the other, have excluded consideration of the relationship between those two sets of compatriots. Notable exceptions have been the anthology of Arab American poetry prepared by Gregory Orfalea and Sharif Elmusa (1988), the Arab American bibliographies prepared by Philip Kayal (Younis 1995), and the book on the early immigration of Arabs to the United States by Adele Younis (1995).[1] In reading Younis's book, in fact, I discovered that we had consulted with the same Lebanese Jewish interviewee and had each gleaned somewhat different viewpoints from him.

Terms of Identity

The term "Arab" as we currently use it is like most other national and ethnic labels, a product of both historic experiences and contemporary realities. As I apply this term, unless otherwise indicated, it will mean people who are speakers of Arabic or fairly recent descendants of people who were Arabic speakers in Southwest Asia and North Africa. It is roughly equivalent to the Arabic terms *ibn al-'Arab, bint al-'Arab* (son/daughter of Arabs), or the plurals *awlaad* or *abna al-'Arab.* This is true of these people whether or not they identify with an "Arab nation" in a political sense. Such people may also have more than one national or ethnic label applied to them. Both religious and racial labels are here subsumed as "ethnic labels." By this usage there is no contradiction between being Jewish, Arab, Christian, black, white, and so on. The terms do not imply racial origin, religious af-

filiation, or political orientation with regard to pan-Arabism or any other nationalist ideology.

My usage is compatible with the "ancestry question" used in the United States Census in 1980 and 1990. On those censuses, the census takers were asked to interrogate individuals to answer the question, "What is this person's ancestry?" The question is open-ended and individuals may have multiple ancestries. Individuals who have more than one ancestry were asked to list as many they could, such as "German Irish." The census also tried to distinguish between American Indian, West Indian, and Asian Indian, as well as between Cape Verdean and Portuguese, and Canadian and French Canadian. Religious identities, which are of importance here, were excluded, however—an exclusion of which individual Jews generally approve and sociologists of Jewry deplore. In tabulating the census, various specific local identities, such as Sicilian, Neapolitan, and Lombard, are subsumed under "Italian." Similarly, Egyptian, Yemeni, Iraqi, and Syrian would all be considered "Arab."

Before I proceed, it should be clear that Syrian Jews are not the only Jews from Arab lands in the New York metropolitan area or in North America. There are also Jews who lived in or whose recent ancestors came from Iraq, Yemen, Lebanon, Egypt, and Northwest Africa. Many of those from Lebanon and Egypt are of Syrian descent and live among the Syrian Jews of Flatbush. Others are scattered throughout the metropolitan area.[2]

Demographic Features

The Syrian Jewish community derives from the immigration from Syria that began in earnest in the late nineteenth and early twentieth centuries. Most of the Syrian Jews in the New York metropolitan area are descended from immigrants who arrived between 1900 and 1924, primarily from Aleppo in northern Syria, with a minority from Damascus. There are also individuals who are secondary immigrants with some Syrian ancestry who came via Palestine/Israel, Egypt, Lebanon, and Latin America. While the Syrian Jewish community is concentrated in New York City and vicinity, there have been Syrian Jews in the United States who lived elsewhere and who are referred to as "out-of-towners." The community is concentrated in the Flatbush and Gravesend neighborhoods of Brooklyn and in Deal and nearby towns in Monmouth County, New Jersey. Like their Christian counterparts, by now the overwhelming majority of New York Syrians

speak English. Since 1992 there has been an influx of immigrants from Syria, mainly Damascus, who are speakers of Arabic.

When I began my study in 1958, I always wondered how many Syrian Jews there were. Because religious identity is not recorded in the census and country of origin generally was not enumerated for second—or third-generation immigrants, I was never able to get a good estimate of their numbers. Guesstimates, however, exist. Estimates of the size of the community in the New York metropolitan area are between 20,000 and 70,000, with many suggesting that the number is 40,000. Recently I asked my colleagues in the Sociology Department and the Center for Social and Demographic Analysis at State University of New York at Albany to try to find Syrian Jews. With the help of his students, colleague John Logan has begun an exploration using data from the 1990 census.

Since Syrian Jews are a small group, they are easily lost in a variety of census tracts. John and I decided to start by examining tracts where we suspected they would be concentrated, namely the 11223 and 11230 zip codes. We began to look for "Arabs" in this predominantly Jewish area. While in most tracts the percentages of Arabs are small—less than 3 percent—in others they vary from 10 to 49 percent. Arabs in this country have long been reluctant to identify themselves as such for fear of discrimination and are hesitant about revealing any other personal information common to census reports. The most heavily Arab of these tracts are where they would be expected to be—along Ocean Parkway between Avenue O and Avenue X. The greatest number of Christian Arabs from Syria and Lebanon live in the 11209 zip code area.

There were two other findings. As of the 1990 census, the number of Arab Jews in these tracts was 11,610, much lower than the usual guesstimates; but we do not know what this means. Also significant is the fact that this number is more than one-fifth of the total census Arab population for New York City, which is 51,577. Although likely much higher in number given the presence of so many new Muslim Arab immigrants and as-similated fourth-generation Syrian-Lebanese, this means that a high percentage of self-identified Arabs in New York includes a community of ardent Orthodox Jews and Zionists. Logan and I are also, at this time, looking into the number of Arabs in Deal, New Jersey, and investigating what other ancestries are represented in the areas under consideration. In zip codes 07740 and 07723, there were 1,441 people claiming Arabian heritage. Most were concentrated in three census tracts. This is well below the usual

estimate, but is a fairly high percentage of the Arabs in the New York metropolitan area.

Syrian Jews generally do not describe themselves as "Arabs" or even as "Jewish Arabs." Those who do are more likely to be individuals who are separated from the Brooklyn community, which is the larger group. They have also differentiated themselves from other Jews. In the past they distinguished between themselves, the Syrians, and Jews or Yiddish people, sometimes abbreviated as "S-Ys" for Syrian Jews and "J-dub" (JW) for (Ashkenazic) Jews. They sometimes refer to themselves as "Sephardim" or Jews from the Iberian Peninsula. Historically, this identification is partially accurate, in that many Jews in Syria were descended from Spanish Jewry, and some bore surnames such as Lopez, Laniado, and Picciotto (possibly Peixotto). This appellation is in line with the recent identification of most non-Ashkenazic Jews as Sephardi and the use of Sephardic ritual practices by many Mediterranean Jewish communities. The community center of the Syrian Jews on Ocean Parkway in Flatbush is called the Sephardic Community Center.

A General Description of the Syrian Jewish Community

Jews from Syria, like their co-residents, began their immigration to the United States at the end of the nineteenth century. The majority of Syrian Jews in New York City arrived before the imposition of the quota system in 1924, and most came from Aleppo and its hinterland in northern Syria. A minority of those who came were from Damascus or arrived via other places such as Lebanon, Egypt, and Latin America, places which were also destinations for Jews from Syria. The motivation for emigration from Syria was primarily economic. The desire of men to escape conscription into the Ottoman army after 1909 and the terrible conditions in the Near East that resulted from World War I were additional factors. The Jewish emigration can thus be seen as part of a larger emigration by people of all religious faiths from Syrian lands. It differed only in the immediate origins. While the majority of Christian and Muslim immigrants to the United States in that period came from the Lebanese countryside, the Jews came from urban areas.

Once in the United States, the Syrian Jews, like many of their co-ethnics and co-religionists from Europe, became peddlers. Syrian Jews specialized in the sale of household linens, especially in resort areas throughout

the United States. Some Syrian Jews became importers of linen and lace, while others went into the manufacture of infant wear including christening clothes. There were contacts with Syrian Christian wholesalers as well. Through the Great Depression most were peddlers, but the community prospered from World War II onward. More and more Syrian Jews opened shops. Originally they sold linen, lace, and infant wear, but later they branched out into selling cameras and electronic goods, especially in tourist areas like Times Square. After World War II, the importation of electronic goods became a major niche. Syrian Jews also opened discount stores in the New York metropolitan area.

While many families established residences in resort towns and elsewhere, New York City became the main center of Syrian Jewry in the United States. Many who had sojourned in resort communities eventually moved to New York City.

Originally, the Sephardic Jewish immigrants from the Balkans, Turkey, and Syria lived on Broome and Allen Streets on the Lower East Side. All had some problems gaining from Ashkenazic Jews the recognition that they, too, were Jews. Still, they evidently preferred to live with other Jews rather than with compatriots of other religions from their home countries. Most of the early immigrants were single young men, but in the 1920s many sent for wives from Syria. Also in that period, the Syrian Jews left Broome and Allen Streets for the Sea Beach-Bensonhurst-Mapleton Park area of Brooklyn and established homes and synagogues there. In this neighborhood they again lived among Ashkenazic Jews and Italians, although most other Sephardic Jews lived elsewhere as did most of the Syrian-Lebanese Jews.

From the 1950s onward more and more Syrian Jews moved from the Bensonhurst area to Flatbush-Gravesend, along Ocean Parkway. Most families purchased two-family or single-family houses. The main Syrian Jewish resort in the 1950s was Bradley Beach, near Asbury Park in New Jersey. Even though Bradley Beach was a Jewish resort area, it marked the separation of Syrians from their Brooklyn neighbors, who did not usually vacation in New Jersey. With greater affluence in the 1960s, Deal and its environs became their summer place to go. Many also established permanent residences there.

There are Syrian Jews in the New York metropolitan region who do not live in Brooklyn's Bensonhurst and Flatbush neighborhoods or in Deal, New Jersey. Other areas of residence include Westchester and Manhattan. Some who choose to live in these areas are individuals who are dissatisfied with the community in some way. Others have married Ashkenazic

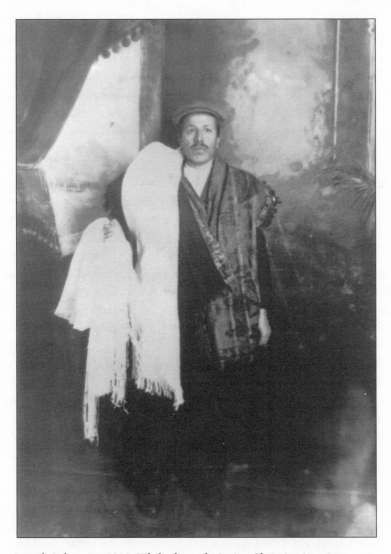

Joseph Sultan, ca. 1910. While the early Syrian Christian immigrants settled in the Washington Street area on the Lower West Side, the Syrian Jewish newcomers joined their co-religionists on the Lower East Side. Joseph Sultan earned his living as a peddler, like many other early immigrants from Syria. Courtesy of the Sephardic Heritage Department of the Sephardic Community Center, Brooklyn.

women. A rabbi who serves one of those communities described his congregation as Syrian men who want to live in Brooklyn married to Ashkenazic women who do not want to be there in any way.

There are at least seventeen Syrian synagogues in Brooklyn, as well as several in Deal and Bradley Beach. There are also several Sephardic prayer quorums (minyanim) in other parts of the metropolitan area, which have a Syrian majority. The synagogues are all Orthodox and follow Syrian liturgy, including the order and wording of prayers and music. Syrian Jews vary widely in their observance of Judaism, but conformity to Orthodox Judaism is quite common and attendance at Sabbath services is relatively high, even though many keep their stores open on the Sabbath.

Most Syrian children went to public school through the 1950s. They were known for underachievement in the academic realm comparable to their Italian, but not Ashkenazi, neighbors. Young women often left school early so they could get married while in their late teens, usually to men in their late twenties who were established in business. Most young men went into business directly after high school. Higher education was seen as a waste of time, a view that has been only partially modified over the past half century. Syrian Jews will still ask young men who want to be doctors why they will waste time and money instead of going into business, which is much more lucrative.

In the past four decades, more and more Syrian children have gone to Orthodox Jewish day schools, both Sephardic and Ashkenazic. Indeed, one established Ashkenazic day school, the Yeshivah of Flatbush, has had more and more Syrian students and may now have a predominantly Sephardic student body. There are also Syrian Sephardic schools. A newer set of schools is the ultra-Orthodox Aterest Torah schools, established in the 1980s by a Jerusalem-born Aleppian rabbi.

According to Kayal and Kayal (1975), the intermarriage rate of Syrian-Lebanese Christians would approach 80 percent by the 1980s, while the intermarriage rate of American Jews today with Gentiles in general is probably more than 50 percent.[3] While Syrian Jews have a substantial intermarriage rate with Ashkenazic Jews, the community has severely curbed marriages with Gentiles, even with converts to Judaism. The rabbis of the community periodically have reissued a ban, excommunicating individuals who intermarry. This ban was originally promulgated in Argentina and is one of the most stringent of such bans, since even most ultra-Orthodox recognize marriages with converts. Rabbis will send warnings even to Syr-

ian Jews living outside of New York City if they hear that they are dating Gentiles.

Much of the social life of Syrian Jews in Brooklyn and Deal revolves around celebrations. Large parties and receptions typically mark rites of passage, including weddings, circumcisions, and bar mitzvahs. Because of a relatively high birth rate and the density of Syrian Jews living in small neighborhoods in New York City and New Jersey, such celebrations are frequent. The affluence of the community encourages quite conspicuous consumption at such celebrations. Large numbers of people are invited. Fund-raising events such as Chinese (or silent) auctions for the synagogues and other institutions are also occasions for socializing. Such happenings maintain social interaction within the community.

Retention of Arab Culture

So far, the description of this community is not too different from that of other semi-Orthodox and Orthodox Jewish groups in New York City. In fact, if one were to visit Syrian Jews in the New York metropolitan area one would find that they dress like others, speak English with a New York accent, and eat foods that for the most part resemble those of their neighbors. But there are ways in which they have in the past and continue today to maintain aspects of their Middle Eastern heritage.

Middle Eastern Jewish Customs

One area, which is a clear marker between Sephardic and Middle Eastern Jews on the one hand and Ashkenazic Jews on the other, are naming practices. Ashkenazic Jews do not name children after living relatives. Those Ashkenazic Jews who do so, such as the Ochs-Sulzburger family in which sons were named for their fathers, are engaging in cultural assimilation. Generally, children continue to receive names that are equivalents of the names of dead relatives, usually grandparents and great-grandparents. Among Sephardic Jews, including the Syrians, grandparents expect the grandchildren to receive their names in a certain order, whether the relatives are living or dead. The first son would be named for the paternal grandfather, the second for the maternal grandfather, the oldest daughter for the paternal grandmother, and so on. This pattern continues to this day,

and the question of maintaining it becomes a bone of contention in mixed marriages of Sephardic and Ashkenazic Jews in Brooklyn and elsewhere.

Passover Dietary Restrictions

Ashkenazic and Sephardic Jews observe most of the same dietary laws. In Brooklyn most restaurants and food shops serving Syrian Jews are *glatt kosher,* or stringently kosher. One area where there is a sharp divergence is over what can be eaten on Passover. While all agree that foods made with yeast and wheat flour (except for matzoh, or unleavened bread) are prohibited, there is a class of foods over which there is disagreement. These foods are called *kitniyot.* Generally this term refers to legumes, such as beans, peas, and peanuts. Ashkenazic Jews are not allowed to eat these foods, while many Sephardic communities—the Syrian Jews among them—permit their consumption during Passover. Dishes made with rice are served during Passover, which is another important marker. While not manufactured either in the United States or Israel, the native matzoh of Syrian Jews is a kind of pita bread, unlike the crackers or wafers that most of us identify as matzoh today.

Food in General

The cuisine of Syrian Jewry is a Middle Eastern style of cooking resembling that of Syrian and Lebanese Arabs, Armenians, and Turks. The staples traditionally were bulgur wheat and rice, as well as lamb and yogurt. This cuisine is easily distinguished from both American cooking and from what we think of as "Jewish food" in the United States. The latter is an Americanized version of kosher East European food. Both these styles of food preparation have obviously influenced Syrian Jews in the United States as well as elsewhere. One can see such influences in the cookbooks such as one prepared by the Sisterhood of the Deal Synagogue.[4]

On many occasions, however, Syrian Jews will eat Middle Eastern foods. Some of these foods continue to be made in home kitchens, while others are bought from the food stores on Kings Highway in Flatbush or Norwood Avenue in Deal that cater to Syrian Jews. *Baqlawa, lahimajin,* and various kinds of *kibbeh* are among the foods that can be found in these stores.

References to Middle Eastern Heritage

Among American-born third- and fourth-generation Aleppan Jews, such references are probably rare. In the 1940s and 1950s, there were ways in which Syrian Jews would allude to their Arab background. For instance, until recently people distinguished those who came from poor backgrounds by referring to them as coming from Bahsita, the neighborhood in the old city of Aleppo where poorer Jews had lived prior to emigration. They might distinguish them from people from Jamaliya, the middle-class suburb of Aleppo.

During World War II, young Syrian Jewish women published a bulletin for the community and its servicemen. The first four issues of this newsletter contained a column called "Syrio-Syncrasies," written by Fred Laniado,

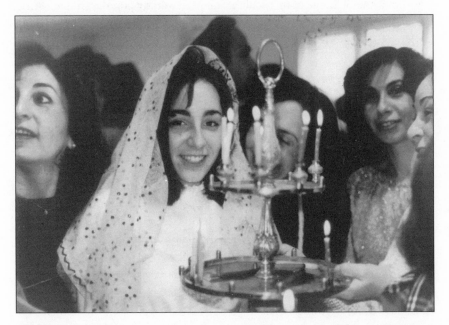

Vicki Levy carrying Seniyeh, 1980s. The candlelight tray (Seniyeh) is circulated at a Bris ceremony to honor a community member and for good luck. Money is placed on the tray and auctioned off. The proceeds from the auction go to a charitable cause in the community, and the winner keeps the offerings on the tray. Courtesy of the Sephardic Heritage Department of the Sephardic Community Center, Brooklyn.

also known as "Don Frederico." Two of these columns contain pseudodefi-
nitions, such as "Syrian singer—One who is implored to sing but who is
completely drowned out once he opens his mouth." The last two columns
repeat stories about *Joha*, the typical Middle Eastern fool/trickster. Al-
though this column was dropped without explanation, it gives us an idea of
how the second generation combined American humor with some memo-
ries of traditional Arab culture.

Liturgical and Ceremonial Music

The most Arab of cultural forms for Syrian Jews in Brooklyn is paradoxi-
cally one of the most Jewish. The Syrian Jewish community has preserved
Arab music for use with Hebrew songs and prayers. We should recognize
that, as people who participate in American culture, the Brooklyn Syrian
Jews have a wide range of musical tastes. Many enjoy popular music, while
some also appreciate classical music. At ceremonies like bar mitzvahs and
weddings there will often be a disk jockey or orchestra playing the more
popular forms of music alongside specifically Jewish and Arab musical
genres.

The liturgical music of the Aleppan synagogue follows Arabic musical
modes called *maqamaat*. One particular mode, *sikah*, is used for most Sab-
bath services and for the Torah reading. But the modes are used for the
lengthy Sabbath morning service at particular times. The musical mode is
related to the expression of particular emotions, and these are related to the
theme of the Torah portion on a particular week. (Among Jews, the Torah is
read in a yearly cycle beginning with Genesis after the autumn Jewish fes-
tivals and ending with Deuteronomy during these same festivals the fol-
lowing year.) Thus, the Arabic musical tradition is preserved and taught to
new generations through the synagogue service.

The songs, also called *pizmonim*, are sung mainly on joyous occasions
(called *simhot* in Hebrew), such as circumcisions, weddings, and bar mitz-
vahs. The tunes are mostly based on the melodies of Arabic (and formerly
Turkish) popular songs, such as those written by Umm Kalthum or Abdel-
Wahab. These also follow the Arabic *maqamaat*. There are some *piz-
monim* that are based on other melodies. A particularly piquant one, with
the melody of "O Tannenbaum" or "O, Maryland," is used in Public School
66, in a Syrian Jewish Brooklyn community, as the school's anthem. The
lyrics are written in Hebrew. A similar genre is petitionary prayers called
baqashot, which are sung at various times in the synagogue.

While the Sabbath service is a capella, musical instruments may be used for weddings and bar mitzvahs. Non-Jewish Arab musicians are sometimes hired to play on these occasions, which are in essence affirmations of Jewishness.

Arab and Jewish: The Identity of Those Outside the Community

Most Americans have only a rudimentary and often false knowledge of their origins, whether they are white Protestants, African Americans, Native Americans, Germans, Poles, Jews, or Arabs. Whether one thinks one's ancestors were aristocrats with a heraldic shield or horse thieves or peasants or peddlers, we rarely have any idea of how they got here. Even when we take courses in high school or college, we learn only the bare outlines of our family's history. The few hours spent in such ethnic institutions as Hebrew school or Arabic school help, but only partially, in placing us in the world. At the same time, most of us see various peoples as being rooted. We have a notion of who are the Germans, the Poles, the Arabs, or the Jews.

It is more difficult to place oneself in an apparently anomalous category. Most people familiar with the ethnic landscape of New York City think of Jews as people who came from Eastern Europe, follow the Jewish religion, and were formerly Yiddish speakers. But what in fact is a "Syrian Jew?" One who knows the Hebrew prayers by heart but does not understand a word of Yiddish or know how to eat gefilte fish.[5] Until recently in Jewish schools that Syrian Jews attended, less was taught about their Syrian background than about that of Ashkenazic Jews. That has begun to change, especially at the Yeshivah of Flatbush. In addition, Syrian Jews themselves have begun making efforts to correct this lack of information by establishing the Sephardic Archives at the Sephardic Community Center in Brooklyn and by setting up a website that communicates information about their history. In any case, those living and participating in the community and its institutions have fewer questions about who and what they are than do those on the margins of the community.

Among the authors represented in Diane Matza's anthology of Sephardic American writing, four are of Syrian ancestry, either full or partial. Jack Marshall, one of the authors included, is also represented by poems in *Grape Leaves*, an anthology of Arab American writing.[6] Three of the four authors in Matza's book (Linda Ashear, Marshall, and Stanley Sultan) grew up in the Brooklyn Syrian Jewish community, while one (Herbert Hadad) did not. None live in the community today. One finds considerable

self-consciousness about their heritages in their writing. The poems by Ashear in the collection deal as much with her Ashkenazic heritage as with her Syrian Sephardic background, and those poems do not deal with the issue of "arabness."

The other three authors do deal with arabness in various ways. Sultan's novel *Rabbi, A Tale of the Waning Year*, which is excerpted in the collection, is set in Brooklyn in 1948. One selection shows how friends of the young protagonist and grandson of the title character, Jason, do not understand how one can be both Jew and *"ay-rab."* These friends also call him "Hindu" because of his exotic ancestry. As a whole, however, the novel does not dwell on the issue of arabness but rather fits into the genre of novels that show the alienation of Jewish youth from their immigrant heritage and the revolt against their elders' orthodoxy and hypocrisy.

Jack Marshall's poetry, both in this collection and elsewhere, explores his struggle with his parental culture and his personal synthesis of Jewish themes with those derived from a Middle Eastern past. He shows hostility toward the orthodoxy of Brooklyn and Deal Judaism, but he includes a portrait of the European Jewish poet Paul Celan (1986). On the other hand, he also writes poems "after Rumi," showing the influence of that *Sufi* poet on his writing. One of his books of poetry is titled *Arabian Nights* (1986). The question of being "Jewish and Arab" is most self-conscious in the writing of Herbert Hadad. Like Linda Ashear, Hadad's mother was Ashkenazic and his father was born in the Middle East. The youngest of the four writers included, Hadad was born in Manhattan, not Brooklyn, and was raised in New England. In an essay called "Arab and Jewish," he ruminates about his mixed heritage and his early school friendship with an Arab girl. The struggle to break away from the constraining features of what has been called "Aleppo-in-Flatbush," which is reflected in the work of Sultan and Marshall, is absent here.

Conclusion

Stressing the "Arab" characteristics of a group of Jews, I have transgressed one of the "lines in the sand" drawn by the Arab-Israeli conflict. While I do not subscribe to the current fad of banishing all discussion of historical essences, I do agree that we should deal with Jewish populations as parts of the societies in which they lived and were socially integrated for centuries.

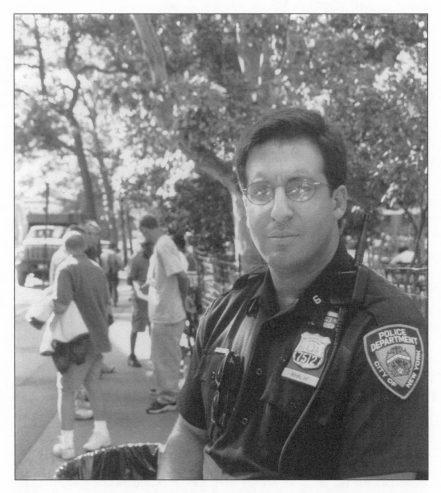

Police officer of Yemenite Jewish heritage, in Washington Square Park, two weeks before his promotion to sergeant. August 2001. Photograph by Mel Rosenthal.

Without denying the existence of past, present, and future conflicts and differences between Jews and their non-Jewish neighbors, we should affirm commonalties when they exist. Certainly Jews from the Arab lands who live in New York City cherish many of their roots in those lands and have preserved some of them while living alongside their former compatriots. Thus it is most fitting for them to be included among the Arab New Yorkers.

13

NY-MASJID

The Mosques of New York

Jerrilynn Dodds

O f course, the architecture of the mosque has no meaning," Imam
Osman of the Islamic Center of New York once told me quite delib-
erately. "In prayer all external concerns must vanish." This position,
which I have heard dozens of times from Imams and *Shura* council mem-
bers in mosques in New York City, lies, I think, at the heart of any study of
mosque architecture in the diaspora. The separation of the act of worship
from the material creation of the mosque is a fact, it would seem, that
needs to be reasserted in particular in New York, a place that does not take
that separation for granted.

In New York's newest immigrant communities, and even in its most
established ones, Muslim prayer halls are often staggeringly simple—al-
most negligently austere. Whether the austerity of these places of prayer is
rooted initially in economic exigency or in religious ideology, the meaning
given to this formal restraint is political. Resistance to a conventional Eu-
ropean American poetics of architecture constitutes a kind of assertion of
the immutability of Islam under siege in New York's vast cacophony of ma-
terial visual noise.

On the other hand, the Islamic Center of New York is not an embattled
storefront mosque, serving a new immigrant community with limited fi-
nancial means. It is the most opulent commission for any religious build-
ing in Manhattan in the past half century, one whose formal aspect grew
from considerable collaboration. When I asked the Imam how he could rec-
oncile his statement with such a building, he answered, "This building was

conceived to receive visitors . . . We are in America now, where people are interested in judging people through their architecture. This is not really our way. But I think that this can be seen as a new era for the mosque. Since this is America, the mosque should be made in an architectural language that Americans understand. But that has nothing to do with Islam." He added without prompting, "The dome, it has no meaning for us."

A prominent representative of the center's principal patron told me pointedly, "One of the only things we really stipulated that we wanted was the dome. We just thought there ought to be a dome; that here the dome was the form by which Islam might immediately be recognized."

As a building, the mosque of the Islamic Center of New York was intended to conform to local cultural conditions. Islam, after all, does not have a single reductive artistic or architectural style. Muslims are part of their local cultures, and they build in as many architectural styles as the divergent places they settle. But the Islamic Center, according to the testimony of those who financed it, was in particular intended to meet the gaze of non-Muslims. So the use of the dome was calculated to be a sign, a marker informed by Western tradition.

Indeed, the dome has become the favored expression of diaspora mosques, a fact that distinguished architect Gulzar Haidir has articulated. But are these all images configured for the non-Muslim gaze, outward looking, without particular meaning for the mosques' primary patrons? To find the answers, I think it is necessary to explore not only the newly built mosques of mature, established communities, but also mosques that might be argued to represent the interests of American and immigrant Muslims at different social and economic stages in their community histories.

The musings I will present here are the result of a collaborative project aimed at documenting and interpreting the mosques that a number of New York City Muslim communities have built. The project's goal is to reveal the ways in which these buildings reflect and create identities for Muslims within a dense and diverse urban fabric, and to explore the texture and creativity that grow from the tensions that are born in a complex urban environment.

Begun in 1993 with the distinguished photographer Edward Grazda, the project's lifeblood was the intrepid team of architecture students from the City College School of Architecture who document, interview, and explore their own place in a world of changing identities: Khidir Abd'Allah, Layla Bahabani, Khader Humied, Numreen Qureshi, and Justin Weiner. These onetime students, now professionals, ought to be viewed as this

fieldwork's authors, along with Ed and me; the changing ideas that are lightly reflected upon in this talk are the process of our working through, as a team, our experiences in New York.

There is only one foundation of the scale of the Islamic Center. Of the estimated one hundred or more mosques in the five boroughs of New York City, no more than one-half dozen can be said to have been designed from the outset as mosques. The rest are storefront buildings, lofts, stores, or warehouses that have been converted to mosques to serve communities that are the result of the impressive diaspora of the past two decades from dozens of Islamic countries to the United States. New York is the port of entry for the overwhelming majority of these new immigrants, but New York also houses one of the most active indigenous African American Muslim communities, which has been constructing its own mosques since the 1970s.

There is no central administration to coordinate or oversee the mosques of New York, no hierarchy among mosques, no central advisory or governing council. The buildings range, in cost and scale, from the Islamic Center to nameless mosques carved out of brownstones and warehouses. They embrace a breathtaking ethnic, social, and economic diversity.

The congregations of mosques in New York City tend to reflect neighborhood demographics and the second language in which the *khutba* is given. The building of any mosque is accomplished by a lay group, the *Shura*, a council of congregation members responsible for the financing and virtually all practical and organizational concerns surrounding the mosque and its decoration. The clergy are on the whole expected to isolate themselves from such material issues, although their participation varies with each community.

Historians and sociologists of New York have charted the settlement histories of various new religious minorities—early German Protestants, Catholics, and Jews in particular—histories that usually begin with an initial place of prayer established in a storefront or reused architectural space. Economic exigency suggests that all of these spaces be makeshift and even austere at the outset. What is interesting for this study, however, is the extent to which many of New York's new Muslim communities draw power and a sense of identity from that initial position. Imams and community members who are asked about architectural space and ornamentation usually respond that austerity is purposeful; for them, an overt concern with the physical and formal character of architecture is positioned with a con-

sumerist ethic that is perceived as a kind of colonization, a form of internal cultural invasion.

Even quite established communities like Masjid al-Farouq, or Masjid al-Falah, have both clergy and communities that have spoken to me of architectural austerity as part of Islamic identity. At times architectural style can be linked with ethnic identity; in the Ali Pasha mosque—the Bosnian mosque in Astoria—or the Turkish Fatih Cami in Brooklyn, prosperity and assimilation were marked by the purchase of a larger building, which is remodeled with an eye towards architectural tradition as a link to ethnic history. Although the message is one of separate identity, the language is one of fairly seductive architectural decoration, speaking of the complexity and multiplicity of identities within Islam rather than dwelling on the immutability and visual inscrutability of the embattled Islam of the earlier, simpler mosques.

But in many growing communities in New York City something very different is happening. At Masjid al-Bidin in the Richmond Hills section of Queens, a single-family home became the initial mosque to serve this community of recent Guyanese immigrants. In the course of about a decade, the adjacent house was purchased and a permit obtained to expand the first building. Three separate enlargements occurred in the course of sixteen years as the Guyanese community became a growing and prosperous presence in Richmond Hills.

In an interview with *Shura* council members, I asked why they had included the domes. Were they meant to evoke the swell domes of Guyana in New York? They told me together, "really, this architecture does not concern us. It has nothing to do with the past; it does not reflect any idea or decision. It was the choice of the man who paid for the renovation. That's really all it is."

On one of a number of subsequent visits to Masjid al-Bidin sometime later, the head of the *Shura* stopped me after prayer and said in passing, "We have been thinking about your question about the dome. We have been thinking, and we have decided that it means the Dome of the Rock, or Medina."

Like the *Kaaba*, the Dome of the Rock and Medina are the buildings that appear in posters that adorn almost every mosque in New York. They are the only floats in the Muslim Day Parade: evocations of a community that must be represented by spaces and ideas rather than by people and narratives. There is no doubt that, for the Masjid al-Bidin congregation, the as-

sociation of the dome with these buildings whose history belongs to all Muslims was an afterthought, a response to my question. But their response was also part of a repossession, a re-invention of this dome, and so serves New York Muslims "whose links," the community leader Dawd Assad has said, "supersede national identities." In New York any dome can be re-coded through the Dome of the Rock if need be; re-coded with an invented tradition. Their use is not the result of a naïve insertion into a Western urban landscape or an obsequious pandering for the European American gaze. Rather it is an empowered, creative response to an internal need to develop a language of forms that expresses the shared experience of economic or political exile in America, the marking out of a new kind of identity for a community while it weaves itself into the fold of New York's urban fabric, economically and socially.

Now, I want to throw a wrench into the works by evoking a second kind of architectural experience, a second meaning and interpretation for

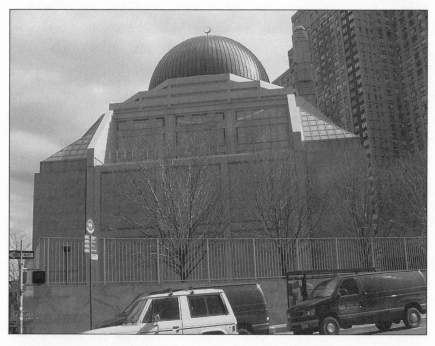

Islamic Cultural Center of New York, Manhattan. Photograph by Kathleen Benson.

the dome: Masjid Malcolm Shabazz, on the corner of Lenox Avenue and 116th Street in Manhattan. This traditional Sunni Muslim mosque with an international community is a particular point of pride for the Muslims of Harlem. Indeed the Malcolm Shabazz mosque, constructed in its present form in 1965 and adopted by the Sunni community in the early seventies (no longer Nation of Islam), is the center of a lively *umma*, which supports a private parochial school, the Sister Clara Muhammad School, a bookstore, restaurants, and a number of community and social services for the children and the sick and elderly of the neighborhood. Leaders of the mosque, among whom is its principal Imam, Izak-el M. Pasha, also have been instrumental in developing an international marketplace in a vacant lot located across the street from the mosque. The project has contributed to the economic revitalization of the area, and plans are under way to initiate the construction of public housing and housing for the elderly in the same intersection where the mosque itself is found.

There is a strong feeling in the community that the presence of the distinctive mosque building in what is a torn and wounded urban context is part of the mosque's healing role. "Sometimes a real down-and-out type will come down Lenox Avenue," Assistant Imam Kareem of the Masjid Malcolm Shabazz said one Friday before *Juma*, "dragging his feet, his shoulders hunched; maybe he's got a bottle in a paper bag . . . but then he'll catch sight of our mosque, and he'll remember how much pride the Muslims have in this neighborhood, and you'll see him straighten right up; for a block or two he'll walk tall as he passes the Masjid." For community members, this broad silver dome interrupts the conventional rectilinear skyline of Lenox Avenue and suggests hope in a neighborhood that has, in the past, been rent with the architectural witness of urban despair: empty lots and abandoned and deteriorating buildings.

At Masjid Malcolm Shabazz, the dome comes to represent the separate identity of this community of Muslims within their neighborhood. Architectural anomaly becomes a declaration of the congregation's capacity to heal the very urban fabric. But the prayer hall of the masjid pulls back into the more restrained world we are accustomed to seeing in New York mosques. Luminous and austere, the open prayer hall's only adornment can be found in the tiny pastel mosaic patterns that cover the elegant fragile columns that support its ceiling. And, as far as the prayer hall is concerned, Imam Kareem shares in the discourse of disassociation and restraint with other New York Imams: "In New York, there are too many distractions,"

he intones. "Distractions from the street, distractions in the subway, there are newspapers and billboards; the room in which we pray can only have light and love. There can be nothing here to distract our minds from God."

On the other hand, the *umma* of Masjid Malcolm Shabazz have unabashedly involved the rhetorical power of their building exterior in the project of social reform. For them, it is part of their mandate to the *umma* as Muslims to provide hope and pride to members of their community.

Masjid Malcolm Shabazz occupies a three-story corner building constructed in brick and faced with panels that frame two floors of large, arched windows. Its plump, carnivalesque, onion-shaped dome occupies its roof with a certain amount of authority, despite its cheesy materials and anomalous character in the neighborhood. It is in fact the incongruence of the dome and arches that give them power: they are potent reminders of the presence of Muslims in the neighborhood, Muslims as a divergence from a hopeless norm, from a rectilinear street wall more often than not pocked with the cavernous windows of abandoned housing stock.

As much as this might be the case, Imam Kareem is not content with the masjid's dome. He explains that "it reflects what people used to think Islam was about. They have more to do with an old-fashioned American interpretation of Islamic architecture or with Ottoman architecture than with Islam in general. It has served us well, but we are thinking that in our next mosque we might turn to West African Islamic forms; to an architecture that better reflects the background of many in our community." He showed me a drawing of a pavilion-like structure with multiple supports . . . and with no dome.

At Masjid Malcolm Shabazz an American Orientalist dome—as reductive an evocation of "the dome as other" as the palace domes of Michael Eisner's Agrabad in the film *Aladdin*—was exploited as a subverted image of marginality, just as early African American Muslims subverted the conventional image of black inferiority until it became a point of pride. In time the community rejects the reductive image of "otherness" quite specifically in favor of architectural forms that can articulate a more particular and less polarized identity.

At Masjid al-Bidin, a dome initially drawn as part of traditional forms from a Guyanese homeland is reinvented in time, so that it comes to represent a new common identity for immigrant American Muslims.

Indeed, makeshift, ad hoc versions of the dome are rapidly becoming the marker for mosques in the five boroughs, regardless of the ethnicity of the community. At Gawsiah Jame Masjid in Astoria, a silhouetted dome

Masjid Baitul Mukarram, Astoria, Queens. Courtesy of School of Architecture, The City College of the City University of New York.

cut out of plywood marks the door of a mosque housed in a small commercial building, and the Masjid Baitul Mukarram in Queens is signaled only by a dome and minaret painted on the alley wall that serves as its entrance. Even Masjid al-Farouq's bare loft windows bristle with little contact-paper domes, which mark the direction of the *qibla*.

That the dome has no single meaning in the architecture of New York's Muslim community is clear for most of us, but what we are finding, I think, is something a little more complex. The only sporadically relenting, cavernous rectilinearity of New York's skyline, New York's street wall, creates a context that imbues any dome with enormous meaning and power. In New York's urban and epistemological skyline, the dome quivers like the difference between us; be its meanings traditional allusion, common identity, or Orientalist reduction, the dome, it seems, must be worked through in the New World marriage of Muslims and New York.

14

Arab Americans

Their Arts and New York City, 1970–2000

Inea Bushnaq

When Fairouz, the popular Lebanese singer with the crystalline voice, came to New York, she filled Carnegie Hall to the brim. Her fans, speaking in a multitude of Arabic dialects, lent a rare lilt to the buzz of conversation at intermission. The aisles were crowded with dark suits and shiny elegances with miniskirts and jeans. There were the Brooklyn-accented and the hip, the American-born and the recent arrivals. The new-comers stood out in the orchestra, grouped as they might have been on a Friday outing back home: the men to one side and the head-scarfed women with babies in their arms and bottle-clutching toddlers trailing behind. Yet when the audience clamored for an encore it spoke with one voice: *"Al Quds Al, Quds"* for the song, "Jerusalem." It was 1971 and the disastrous June 1967 War was on every Arab mind.

At the time it seemed that any Arab cultural event organized or at-tended by New York Arabs was linked to the upheavals in the home coun-tries. Whether in Widdi's neon-lit catering hall in Brooklyn or in the hush of a Park Avenue living room, recitals of music and readings of poetry were held to benefit the victims of politics in the West Bank, Lebanon, and else-where. Artists donated their talent and activists stirred the listeners.

Like other immigrant communities, Arabs in the United States are mindful of those they left behind. The newspapers of the earlier immigrant generations, *Al-Hoda, Miraat-al-Gharb*, and the *Syrian World*, repeatedly carried appeals for help, especially during the great famine in Lebanon of World War I. The second-wave immigrants, however, who arrived in New

York after the easing of quotas in 1965, were concerned with more than simple charity. The world they came from was quite different from the backwaters of the Ottoman Empire that their predecessors had left at the turn of the twentieth century. Two world wars had changed the map. French and British colonial rule had come and gone and in its wake a dozen new countries had been redrawn, each with its own national anthem, flag, and airline. The United States was now the ascendant Western power in the region and it had welcomed the establishment of a Zionist state, an alien culture on Palestinian land, against the will of its inhabitants and despite the combined opposition of the newly independent Arab nations. The allure of America continued to be economic opportunity. But it was also the search for a haven from the violent turbulence of postcolonial nationalist experiments that helped many of the second-wave immigrants find their way to New York. And here it is possible to say out loud what in most countries would be stifled by the censor.

One such refugee was the Palestinian-born poet Rashid Hussein. As a teenager he found himself a citizen of Israel when his home village was included within the boundaries of the new state. While still a schoolboy he was in demand to recite his poems at protest demonstrations by Arabs in Israel. Eventually he published two collections of poetry and he translated Hebrew poetry *(Hayyim Bialik)* into Arabic and Arab folksongs into Hebrew. A teacher and a journalist, he strove for Palestinian rights in Israel. Arabs outside Israel criticized him for working within the enemy state and the Israelis banned his poetry, closed jobs to him, and put him in jail. He came to the United States and, following the 1967 war, chose self-exile in New York.

Hussein was able to make a modest living working at various literary jobs and he devoted himself to the cause of Palestine. He read poetry and spoke out on college campuses and was a vivid presence at Arab gatherings. His words are the mourning of the displaced person:

> Tent number fifty on the left, that is my present
> But it is too crammed to contain a future
> And, "Forget," they say
> But how can I!
> Teach the night to forget to bring
> dreams showing me my village
> teach the winds to forget to carry me
> the aroma of apricots in my fields

and teach the sky too to forget to rain.
Only then may I forget my country.[1]

A gentle soul who once delayed moving to new quarters until the pi-
geon on his windowsill had safely hatched her eggs, Rashid Hussein was ill
at ease in this vast and fast-paced city. Tragically, his life was cut short at
the age of forty in a fire in his New York apartment. Remembering him
with a poem, Abdeen Jabara noted:

In the small room
in which you died
Was a map of the Arab states
Across which you wrote
Mamnu' al tafkir
"Thinking Prohibited."[2]

If the arts were a means for New York Arabs to convey to an audience
beyond their own community their view of events in the Arab world, the
news in the headlines would sometimes prompt interest in the Arab arts in
non-Arab New York. For example, when he was asked what had inspired a
six-week Arab film festival, "The Centennial of Arab Cinema," in the fall
of 1996, Richard Pena, director of the Film Society of Lincoln Center, said
that it was the Oklahoma bombing. The attacks against Arab Americans
and the unjustified suspicions and anti-Arab sentiments in the aftermath of
the explosion had made him eager to demonstrate Arab cultural achieve-
ments to an insufficiently informed public.

In 1976 PEN New York held a conference on "Near East Society in Lit-
erature," which featured leading writers and poets from Israel and from sev-
eral Arab countries. One would not guess from the sedate title that the
Near East was in turmoil—civil war raging in Lebanon, Palestinians stag-
ing guerrilla actions to draw attention to their cause, and the dust barely
settled after the Yom Kippur War. However, PEN did get involved as one of
the sponsors when the Arab American Cultural Foundation gave a poetry
reading in aid of children in Lebanon in 1982, the year of the Sabra and
Shatila massacres. It was a star-studded affair hosted by Representative
John Conyers and with Liv Ullman, Colleen Dewhurst, Noam Chomsky,
Richard Falk, Edward Said, and William Styron listed on the program.
Among those whose work was read were June Jordan, whose poem "Mov-
ing Towards Home" gave the event its title; Ethel Adnan of Lebanon; Pales-

tinian Mahmud Darwish; Israeli Yehuda Amichai; and Arab Americans
Samuel Hazo, Gregory Orfalea, and Naomi Shihab Nye.

Perhaps it is the poets, after all, who can tell a story best—even a polit-
ical story. Three Arab American poets who live in New York, born decades
apart, have documented the experience of being Arab in America at various
times. D. H. Melhem was born in Brooklyn to Lebanese immigrant parents.
A writer and teacher of writing, she has published several books of poetry
and studies of Gwendolyn Brooks and other black writers. In an elegiac col-
lection, *Rest in Love* (second edition 1978), written after her mother's
death, she describes her mother's arrival in New York shortly before the
1924 immigration law closed the gates on what were considered less desir-
able populations:

> There, by the rail, my mother at seventeen
> pale, her thin white arm
> raised, as in salute
> to a seagull
> trailing the ship *Homeric*,
> September, nineteen twenty-two.
> Black dress flutters
> behind her,
> a silken whispering
> about her knees covered
> with black hose
> above black shoes
> mourning
> the year-hardened mystery of her father
> who disappeared en route
> to a Turkish town.

In the same volume, using her mother's voice, Melhem's maternal
aunts advise their niece:

> *say french :*
> who knows what lebanese is?
> or syrian (serbian? siberian?) . . .
> but
> immigration officials
> and neighbors

employers
perplexed by exotics
non-anglo-saxon
non-westeuropean-nontoxic
attest
the best are
types here
longer
the immigration official
said to me,
syrian?
What's
that?
(and sallow
with a menacing
guttural tongue)
your teacher accused
arabic spoken
at home:
"you have an accent"
though fearing strangers
and the foreign school
I went
showed myself
clean educated
stopped her . . .
people don't mean
to be mean
nevertheless
better say
french

Elsewhere Melhem has exhorted poets "to wield their poems like cedar branches, bury discrimination and injustice in grape leaves and olive boughs,"[3] and to let art and life triumph over such a burial. She has addressed hunger in Ethiopia and war in Lebanon. In her collection, *Notes on 94th Street* (1972), there is a poem whose title reads, "lamentation after jeremiah to exorcise high rental / high rise building scheduled for construction with public funds."

Born in Detroit almost a quarter of a century after D. H. Melhem, Lawrence Joseph is now a New Yorker and teaches law at St. John's University. Like Melhem, he records a distinct divide between the indoor and outdoor lives of his youth:

> Lebanon is everywhere
> in the house: in the kitchen
> of steaming pots, leg of lamb
> in the oven, plates of kousa
> hushwee rolled in cabbage, . . .
> Lebanon of mountains and sea,
> of pine and almond trees
> of cedars in the service
> of Solomon, Lebanon
> of Babylonians, Phoenicians, Arabs, Turks
> and Byzantines, of the one-eyed
> monk, Saint Maron,
> in whose rite I am baptized; . . .
> . . . Lebanon
> of grandpa giving me my first coin
> secretly, secretly
> holding my face in his hands,
> kissing me and promising me
> the whole world.
> And,
> Outside the house my practice
> is not to respond to remarks
> about my nose or the color of my skin.
> "Sand nigger," I'm called
> and the name fits: I am
> the light-skinned nigger
> with black eyes and the look
> difficult to figure—a look
> of indifference, a look to kill—
> a Levantine nigger . . .
> who waves his hands, nice enough
> to pass, Lebanese enough
> to be against his brother,
> with his brother against his cousin,

with cousin and brother
against the stranger.

A far cry from the accommodating tone of D. H. Melhem's mentors,
but then, Lebanon of the present day had also been in the house evoked
above:

At dinner, a cousin
describes his niece's head
severed with bullets, in Beirut,
in civil war. "More than
an eye for an eye," he demands,
breaks down and cries.

And Joseph had himself seen violence close up, his home city in flames
during race riots and his own father shot. The excerpts do not do justice to
the long and tightly woven poem "Sand Nigger" (from the book *Curricu-
lum Vitae*, 1988), which needs to be read as a whole. A critic reviewing
Joseph's 1993 work, *Before Our Eyes*, has pointed out that "the rift between
our public and private realms is where Joseph thrives."[4] The poems, many
of them set in familiar corners of Manhattan, mention,

Through a transparent eye, the need sometimes
to see everything simultaneously
—strange need to confront everyone
with equal respect.[5]

Bright color and shifting surprises of language also suggest a kaleidoscope
as the viewing tool. Among the prizes recognizing Lawrence Joseph's writ-
ing was the 1984 National Endowment for the Arts Poetry Award.

The young D. H. Melhem and Lawrence Joseph, both American-born
children of first-wave Lebanese immigrants, crossed into xenophobic terri-
tory when they ventured beyond their doorstep. In contrast, a new voice,
urban, gritty, out of Brooklyn's post-1965 immigrant community, sounds
very much at home in the street. Suheir Hammad, daughter of Palestinian
refugees, who grew up in Sunset Park, was twenty-three years old when her
first book of poems was published in 1996. The title, *born Palestinian, born
Black*, refers to the June Jordan poem mentioned earlier.

When D. H. Melhem remembers the warmth of her grandmother's

kitchen in a prose poem, for some thirty lines the child that she was watches grandmother and mother at the white enamel kitchen table knead and chop and roll and stuff dozens of intricate Lebanese dishes. She tastes mouthfuls of dough and stuffing as she listens for a familiar word or name to drop from the flow of Arabic between the two older women. An idyllic childhood memory even as the adult Melhem concludes, "And I bear witness to a daily translation / of two women's lives into pots and pans."[6] Suheir Hammad, almost fifty years younger, asks, "Why couldn't we just eat pancakes and bacon like everybody else? We had to have olives at every meal and pita bread with everything. I know now that I always loved that food. It's just hard to be different all the time." This in a memoir dedicated to her eighteen-year-old self and her sisters, *Drops of This Story.* (1996) The book opens, "I told her to chop it all off . . . I wasn't going back. I wanted to live, to write. Cutting my hair was an extra measure to make sure I wouldn't lose whatever nerve I had left in me. I wanted to revolutionize." Hammad's work is a process of self-definition, a struggle for personal freedom.

In *born Palestinian, born Black* she writes with heat about Palestine, women, and all who are forced to battle for their rights. Her poem "Ismi" (Arabic for "my name") spells out how far Hammad is from ever saying "french":

please
learn to pronounce
the name of my spirit
the spirit of my name
correctly
and don't complain
it's too throaty
too deep
too guttural
begin it in your gut
let it tickle the back of your throat
warm under tongue
let it perfume your breath
smooth your lips
and release it
round my hips
clearly

The New York that Suheir Hammad has known is worlds away from that of the 1920s. Black has come to be recognized as beautiful and the melting pot has given way to the multicultural mosaic. By the 1970s two institutions were established in New York whose focus was diversity. One was the Ethnic Folk Arts Center with the stated aim, "to affirm the value and importance of cultural diversity as an essential component of our identity." The other, the Alternative Museum, offered gallery and performance space for international arts.

Meanwhile, with the lifting of restrictions on Arab immigration in 1965, large numbers of Egyptians, Palestinians, Jordanians, and Yemenis were arriving in New York and creating distinct communities with their characteristic food, music, and traditions. In the years that followed, three national organizations were founded, the Association of Arab-American University Graduates, the American-Arab Anti-Discrimination Committee, and the Arab American Institute, which together succeeded in giving a voice to the Arab population in the United States and a new, inclusive identity of Arab American. A community that had favored a low profile sought to be heard and recognized as part of the larger society.

"A Concert of Classical Arab Music" at the Alternative Museum in March 1982 featured a young violinist and *oud* (plucked lute) player, Simon Shaheen. Born in Galilee to a musically gifted family, Shaheen came to New York in 1980 to continue his musical studies at the Manhattan School of Music and went on to study musicology and music education at Columbia University. Within two years of arriving in New York he had formed the Near Eastern Music Ensemble: gifted musicians originating from different parts of the Arab world using traditional Arab instruments like the *oud*, the *nay* (a reed flute), the *qanoon* (a large zither-like instrument), and a variety of *tablas* and percussion instruments. He has made five recordings and composed music for the soundtracks of the films *Malcolm X* and *Sheltering Sky*. In 1994 the National Endowment for the Arts awarded him a National Heritage Fellowship.

It is not surprising, then, that Simon Shaheen should have been the first name mentioned when the Ethnic Folk Arts Center was exploring staging a festival of traditional Arab music and dance. Over the years the center had produced festivals devoted to different minorities in the city and in 1993 consulted Stanley Rashid, whose family's business, Rashid Sales Company, had been synonymous with Arab music in America since the 1930s. With Simon Shaheen as artistic director and Stanley Rashid and Paula Hajar as co-chairs of a team of Arab New Yorkers, the Ethnic Folk

Arts Center developed the first Mahrajan-al-Fan, Arabic for "festival of the arts."

In another essay in this volume, Stanley Rashid describes the original *mahrajans* of the 1940s and 1950s, which musicologist Anne Rasmussen has defined as "cultural intersections where music, dance, language, food, stories, and families come together."[7] By using the same word for Mahrajan-al-Fan, the new festival intends to revive the spirit of the bygone celebrations. However, the addition of *al-fan*, "the arts," indicates that the purpose is not just to entertain. Indeed, the Near Eastern Music Ensemble's mission has been to foster an understanding and appreciation of Arabic music forms. Along with performers, every Mahrajan-al-Fan has had lectures, panel discussions, and demonstrations by eminent ethnomusicologists. Participants have included Philip Schuyler, who writes on the music of Morocco and Yemen; Virginia Danielson, whose field is the music and songs of Egypt; Robert Browning, a founder of the Alternative Museum and later of the World Music Institute; and Lebanese-born Ali Jihad Racy, UCLA professor, composer, and performer of Arabic music. Combining scholarship with virtuosity, Simon Shaheen and the ensemble are probably preserving a standard of musicianship no longer easily found in the Arab world, especially after the death two years ago of the Iraqi master *oudist* Munir Bashir.

The first Mahrajan-al-Fan took place at the Brooklyn Museum on a perfect September Sunday in 1994. Student volunteers acted as hosts to nearly 1,500 people. The *New York Times* carried a detailed review of the music by Jon Pareles, noting the "nuanced virtuosity" of the Near Eastern Music Ensemble and describing the concert as one that "invited outsiders to hear music that merges intricacy with fire." The accompanying photograph of Egyptian dancer Husni spinning in a dervish dance and all but airborne by his flying skirts expressed the mood of the whole day.

In an art usually passed on through apprenticeship, it is traditional to acknowledge the masters. In that spirit, *Mahrajan-al-Fan* paid tribute to the veteran musicians who had delighted previous generations in the United States: Tony Abdel Ahad, Hanan, Eddie "The Sheikh" Kochak, and Hakki Obadia. As for the younger musicians, they played hour after hour spurred by the response of their listeners. The range of music was from the strictly classical—*qasidas*, ancient poetry set to music (sung by Syrian Youssef Kassab and Algerian Ruba Hayek) and *taqsim*, solo and counterpoint improvisation that is a test of Arab musicality—to Yemeni songs performed by Abdul Wahab Kawkabani accompanying himself on the *oud* and

Lebanese songs by Naji Youssef ornamented with drawn-out vocal improvisations. By close of the day, the music had turned to village tunes and folk rhythms and the audience in the courtyard was on its feet clapping and dancing its own improvisations.

In addition to music and dance, there was storytelling for the children and, for the adults, poetry. D. H. Melhem and Lawrence Joseph read from their work and were joined by David Williams, Lamea Abbas Amara, Mohja Kahf, and Yousseff Abdul Samad. On the film screen in the auditorium, abstract artist Samia Halaby projected bursts of color in motion, "kinetic" computer art. More traditionally, brightly embroidered peasant costumes from the collection of Hannan and Farah Munayyer, founders of the Palestinian Heritage Foundation, were modeled in a musical enactment of a Palestinian village wedding.

The main complaint was that too many programs had been scheduled simultaneously and the organizers were ready to try again the following year. The second Mahrajan al-Fan, again at the Brooklyn Museum, was spread over two days and presented many of the same musicians and poets with new guests Naomi Shihab Nye and Samuel Hazo, who recited his poems without a text to great effect. Special attention was paid to the children: hands-on workshops in traditional crafts and, at story time, Naomi Shihab Nye reading her book *Sitti's Secrets* (1994) while the illustrator, Nancy Carpenter, held up her original drawings.

There have been four festivals so far, in 1994, 1995, 1996, and 1998, with the Arab American organizers taking over from the Ethnic Folk Arts Center. By the third and fourth Mahrajan al-Fan, which now was divided into an evening concert in Manhattan followed by a full day in Brooklyn, artists were being flown in from the West Coast and the Middle East. Guests included Marcel Khalife from Lebanon, Sabah Fakhri from Syria, Indian Vishua Mohan Bhatt, Sudanese Hamza El Din, Moroccan Hassan Hakmoun, and Ali Jihad Racy. The new format reached a more diverse audience. A lyrical performance of the thousand-year-old epic of unrequited love, *Majnun Layla*, brought tears to the eyes even of a row of West Point cadets.

Mahrajan-al-Fan has been the most elaborate cultural event produced by New York's Arab community in many decades. Families came from New Jersey, Connecticut, and Maine. It was evident that the festival was regarded as an opportunity to promote a sense of heritage in the American-born young. The Arab Network of America, an affiliate of the Middle East Broadcasting Company, filmed the 1995 festival for viewers in Europe and

the Middle East. Non-Arab fans of good Arab music attended in increasing numbers from festival to festival. And the local politicians took note. In the printed programs of the later festivals there are letters of congratulations from Mayor Rudolph Giuliani; the Brooklyn borough president, Howard Golden; and New York City Council Member Kenneth Fisher. In 1995 Councilman Fisher arranged for a reception honoring the Arab community at City Hall—a first. In the ornate council chamber a plaque was presented and the Mahrajan-al-Fan saluted "for its contribution to the New York City mosaic," as gold-framed portraits of former city elders looked on.

Mahrajan-al-Fan, bringing together leading musicians, scholars, poets, and performers before a mixed public of all ages, is a step towards realizing a dream that Simon Shaheen has long had of creating a permanent institute of Arab arts in this city. "Our goal is to perform great music and to have a music school . . . a venue for new compositions . . . appealing to musicians, to the children, and to the general public," he has said in an interview.[8] There would also be room for poetry and dance performances and for art exhibitions. The 1990s saw the formation of a number of Arab American groups in New York, each interested in a particular art form and all wishing for a permanent cultural center. This would serve as a social gathering place and reinforce the feeling of community.

In 1994 a group of Arab New Yorkers participated in a major exhibition of women's art from the Arab world at the National Museum of Women in the Arts in Washington, D.C. Rather than disband after the show the group took the name of Arab Women Artists with the aim of presenting the work of contemporary Arab and Arab American artists. For three and one-half years Arab Women Artists produced events regularly that were related to the visual arts. They presented photographers, painters, a sculptor, jewelry designers, experimental filmmakers, and computer artists. The scale was modest—a following of forty to fifty people swelling to a couple hundred on occasion—meeting in artists' lofts, the Anarchy Café, and eventually at a SoHo performance space.

In 1997 Iraqi-born restaurant owner Salam al-Rawi assembled a committee of energetic young people who called themselves Diwan, Arabic for "assembly." Al-Rawi missed the lively, sociable atmosphere of the coffeehouses back home and hoped to replicate the ambience in New York with the addition of poetry, music, and discussion to the menu. Diwan organized intermittent afternoon or evening programs in one of al-Rawi's restaurants, including storytelling, films, book parties, Arab music, and one evening a

demonstration of how to build an *oud*. As of spring 2000, Diwan has a permanent address in the basement of a new restaurant in the East Village. The whitewalled space, suitable for hanging exhibitions, opens onto an Arab-style courtyard with a fountain in the middle.

In 1998 a New York Chapter was formed of the Radius of Arab-American Writers Inc. (RAWI), a national association started in 1996. RAWI (the acronym means "bard" in Arabic) meets on the last Saturday of every month, currently at the Cornelia Street Café in Greenwich Village. Many of the poets mentioned earlier have read their work at RAWI. New works in progress can be heard there, along with guest speakers from other communities.

Since 1998 Alwan (colors), NYC has been running a film program that shows new films by Arab directors bi-weekly at the Cantor Film Center of New York University. Following the screenings, filmmakers frequently are present to discuss their work. New Yorkers are able to see films here that cannot be shown in their country of origin because of censorship.

To date the only Arab American community and cultural center in New York is a virtual one. That is what Mazin Abu-Ghazalah had in mind when he created the website Café Arabica in 1996. It carries cultural and political news, announcements of events, interviews, profiles, book reviews, classified ads, job offers, travel tips, and a *souk*, which, like the peddlers of old, brings a selection of wares, from books to foodstuffs, delivering them all from desktop to desktop.

The longest-standing organization in New York to present Arab arts has been the Islamic Heritage Society, founded in 1971. Initiated by wives of Muslim representatives at the United Nations to raise funds for building the Islamic Center now at 96th Street, it went on to offer monthly cultural and social programs for Muslims living in New York and for interested non-Muslims. It has continued to raise funds and provide humanitarian aid to disaster areas like Gaza, Bosnia, Chechnya, and Cairo and Turkey during the earthquakes. It has been consistently generous in support of other organizations in the city, furthering the appreciation of Islamic culture.

Outlasting all of the above, the Israeli-Palestinian conflict endures. Thirty years later, New York's Arab musicians and poets are still occupied, whether at Widdi's in Brooklyn, or in Manhattan raising funds for Palestine. But the determination remains to keep the Mahrajan al-Fan on New York's cultural calendar. *Inshallah* (Arabic for "God willing").

15

Hollywood's Muslim Arabs

Jack G. Shaheen

>*"The Arab people have always had the roughest and most uncomprehending deal from Hollywood, but with the death of the Cold War the stereotype has been granted even more prominence. In* The Mummy *[1999], I could hardly believe what I was watching. . . . So, here's a party game for any producers with a Middle East setting in mind; try replacing one Semitic group with another—Jews instead of Arabs—and THEN listen for the laugh."*
>> —Anthony Lane, *New Yorker*, May 10, 1999, pp. 104–5.

>*"Regrettably, some Americans are still 'imprisoned because of their prejudices.' I know that Arab Americans still feel the sting of being stereotyped in false ways. The saddest encounter of course [was] the heartbreaking experience of Oklahoma City."*
>> —President Bill Clinton, Arab American Institute, Washington, D.C., May 7, 1998.

>*"We are all diminished when a person is subject to discrimination."*
>> —Janet Reno, attorney general, American-Arab Anti-Discrimination conference, June 11, 1998.

For more than two decades, I have been studying the manner in which purveyors of popular culture project Muslim Arabs and the effect their images have on individuals. Examples here are drawn from more than eight hundred feature films and hundreds of television newscasts, documen-

taries, and entertainment shows, ranging from animated cartoons to soap operas to movies of the week. Not included, although in themselves an extremely important topic of study, are print and broadcast news stories, editorial and op-ed pages, editorial cartoons, children's books, comic books, textbooks, print advertisements, toys, and games. My underlying thesis is that stereotypes can lower self-esteem, injure innocents, impact policies, and encourage divisiveness by accentuating our differences at the expense of those human qualities that tie us together.

In 1982 I began soliciting information about Muslim Arab images from a number of television producers, writers, and network executives. I still recall the rationale for stereotyping offered by James Baerg, director of program practices for CBS-TV in New York City: "I think," he remarked, "the Arab stereotype is attractive to a number of people. It is an easy thing to do. It is the thing that is going to be most readily accepted by a large number of the audience. It is the same thing as throwing in sex and violence when an episode is slow." [1]

Not much has changed since then. Research verifies that lurid and insidious depictions of Arabs as alien, violent strangers, intent upon battling non-believers throughout the world, are staple fare. Such erroneous characterizations more accurately reflect the bias of Western reporters and image-makers than they do the realities of Arab and Muslim people in the modern world.

On the silver screen the Muslim Arab continues to surface as the threatening cultural "other." Fear of this "strange" faith keeps some people huddled in emotional isolation. As Professor John Esposito says, "Fear of the Green Menace [green being the color of Islam] may well replace that of the Red Menace of world communism. . . . Islam is often equated with holy war and hatred, fanaticism and violence, intolerance and the oppression of women." [2] Esposito asserts that narratives about the Muslim world all too often assume that there is a monolithic Islam out there somewhere, as if all Muslims believe, think, and feel alike.

Research reveals that the stereotypical Muslim Arab presented to Americans resembles Iran's Ayatollah Khomeini, Libya's Moammar Gadhafi, or Iraq's Saddam Hussein: Muslims and Arabs in this country, who overwhelmingly do not identify with these political leaders, believe that their fellow Americans assume they do. Explains thirty-year-old Shahed Abdullah, a native Californian, "You think Muslim, you think Saddam Hussein, you think Ayatollah." [3]

Through immigration, conversion, and birth, Muslims are this nation's

fastest-growing religious group. Regrettably, the approximately five to eight million Muslims who live in the United States are confronted with a barrage of stereotypes that unfairly show them as a global menace, producers of biological weapons, zealots who issue *fatwas* or burn Uncle Sam in effigy. The majority of Muslims are not Arabs, and of course not all Arabs are Muslims. Yet Hollywood's image-makers often project Muslims and Arabs as one and the same. In reality, Muslims are an integral part of the American mainstream, individuals who contribute to their respective communities as teachers, doctors, homemakers, lawyers, and artists. They respect traditions, are committed to education, faith, family, and free enterprise. Indeed, the community is generally a peace-loving quilt of cultures: 25 percent are of South Asian descent, Arabs represent another 12 percent, and nearly half are converts, mainly African Americans.

This mix of ethnic, racial, and cultural backgrounds offers a broad range of Muslim viewpoints. As Professor Sulayman Nyang of Howard University explains, "Muslims can be compared to Catholics. They are as different from each other as Mexican American Catholics in Southern California are from Polish and Italian Catholics in Chicago or Philadelphia."[4] Muslims are a diverse group: the "seen one, seen 'em all" cliché does not apply. Writes Steven Barboza in *American Jihad*, "There are more than 200,000 Muslim businesses [in the United States], 165 Islamic schools, 425 Muslim associations, 85 Islamic publications, and 1,500 mosques" spread from Georgia to Alaska.[5] Many Muslims hold prominent positions in business and public service. They appreciate the religious freedom in America, freedom not always available in the lands they left. Nevertheless, although Muslim Americans are an integral part of the American landscape, enriching the communities in which they live, the United States is seldom referred to as a "Judeo-Christian-Muslim" nation.

In a recent national survey cited by John Dart of the *Los Angeles Times*, the Americans polled viewed Christians in general, Jews, and, on balance, Mormons, as good influences on United States society, but more than 30 percent regarded Muslims as having a "negative influence."[6] Muslims maintain that they are perceived as a negative influence for political reasons, out of ignorance, and because producers of entertainment profit from vilifying them. As a result, image-makers tend to focus on a violent and extreme minority. On television and in feature films one sees Arabs primarily as bearded fanatics out to seduce blond, Western heroines. Chanting "Death to the great Satan," they appear as the enemy, as anti-Jewish, anti-Christian terrorists out to destroy the United States and Israel.

Motion Pictures

It seems that most people have difficulty distinguishing between a tiny minority of persons who may be objectionable and the ethnic strain from which they spring. "The popular caricature of the average Arab is as mythical as the old portrait of the Jew," writes columnist Sydney Harris. "He is robed and turbaned, sinister and dangerous, engaged mainly in hijacking airlines and blowing up public buildings."[7] "If the Italians have their Mafia, all Italians are suspect; if the Jews have financiers, all Jews are part of an international conspiracy; if the Arabs have fanatics, all Arabs are violent," says Harris. "In the world today, more than ever, barriers of this kind must be broken, for we are all more alike than we are different."[8]

Virtually since its inception, the Hollywood film and television industry has promoted prejudicial attitudes toward numerous groups: viewers have seen the Asian as "sneaky," the black as "Sambo," the Italian as the "Mafioso," the Irishman as the "drunk," the Jew as "greedy," the Indian as the "savage," and the Hispanic as "greasy." In the year 2000, however, such offensive labeling is no longer tolerated. Now "it appears that we're down to one group, the Arabs," writes columnist Jay Stone. "When was the last time you saw an Arab character in a movie who was anything but one of the three B's (billionaire, bomber, belly dancer)?"[9] "One group should not be singled out as enemies of all that is good and decent and American," adds Stone. "Where are the movies about Arabs and Muslims who are just ordinary people? It is time for Hollywood to end this undeclared war."[10] Sam Keen, author of *Faces of the Enemy* (1986), shows how Arabs are still vilified: "You can hit an Arab free; they're free enemies, free villains—where you couldn't do it to a Jew or you can't do it to a black anymore."[11]

As President John Kennedy said, "The great enemy of truth is very often not the lie, deliberate, contrived and dishonest, but the myth, persistent, persuasive and realistic."[12] For more than a century movies have created myths. Ever since the camera began to crank, the unkempt Muslim Arab has appeared as an uncivilized character, the outsider in need of a shower and a shave, starkly contrasting in behavior and appearance with the white Western protagonist. Beginning with Universal's *The Rage of Paris* (1921), in which the heroine's husband "is killed in a sandstorm by an Arab," Hollywood's studios have needlessly maligned Arabs. Motion pictures such as *The Sheik* (1921) and *Son of the Sheik* (1926), which starred the popular Rudolph Valentino as Sheik Ahmed, displayed Muslim Arabs

as brutal slavers and promiscuous desert sheiks. Of course, Valentino, as the hero, cannot really be an Arab:

> Diana, the heroine: "His [Ahmed's] hand is so large for an Arab."
> Ahmed's French friend: "He is not an Arab. His father was an Englishman, his mother, a Spaniard."

Emulating the 1920s desert sheik theme—Arabs reject their own women, preferring to kidnap and seduce fair Western heroines—are silent Arabian shorts: *Whistling Lions* (1922), *Maid in Morocco* (1925), and *Two Arabian Sights* (1927). The shorts, which run about fifteen minutes, were screened in movie theaters along with full-length feature films.

All three shorts show sex-starved Arabs intent on adding to their harems—"a new favorite." Enter the American protagonists. They outwit and bring down unkempt, lecherous sheiks. In *Lions*, for example, the American hero rescues his sweetheart from the clutches of "Alla-Gha-Zam's" a pint-sized Egyptian sheik; the Arab owns "5,000 camels" and gobs of wives. In *Morocco*, the American's newly wedded bride is kidnaped by seedy Arabs. Before rescuing her, the groom punches out scores of saber-wielding guards. Next, he floors "Ben Hammered, the Mighty Caliph of GINFEZ; [he] has two hundred wives [whom he tags the 'Thundering Herd']—and is looking for more."

In *Sights*, "Hassan Ben Homemuch, a sheik of the desert [who] was very fond of wives, but not his own, moves to smooch Lotta Gelt . . . who ran a boxing gymnasium at home [in America]." When Hassan tries to romance Lotta, she decks him with a single punch. Hollywood's sexy sheik of the 1920s became the oily sheik of the 1970s and 1980s; concurrently, the industry's *bedouin* bandit of the 1920s became the "fundamentalist" bomber who prays before killing innocents. The cinema's sheiks are uncultured and ruthless, attempting to procure media conglomerates *(Network*, 1977), destroy the world's economy *(Rollover*, 1981), kidnap Western women *(Jewel of the Nile*, 1985), direct nuclear weapons at Israel and the United States *(Frantic*, 1988), and influence foreign policies *(American Ninja 4: The Annihilation*, 1991).[13] Then and now, Arab characters are carefully crafted to alarm viewers. Films project the diverse Islamic world as populated with fanatic *mullahs*, billionaire sheiks, terrorist bombers, backward *bedouin*, and noisy bargainers. Women surface either as gun toters, as mute, bumbling subservients, or as veiled belly dancers bouncing volup-

tuously in palaces and erotically oscillating in slave markets. More recently, image-makers are offering other caricatures of Muslim women: covered in black from head to toe, they appear as uneducated, unattractive, and enslaved beings. Solely attending men, they follow several paces behind abusive sheiks, their heads lowered.

Mindlessly adopted and casually adapted, these rigid and repetitive portraits narrow our vision and blur reality. On screen, the Muslim Arab lacks a humane face. He or she lives in a mythical kingdom of endless desert dotted with oil wells, tents, run-down mosques, palaces, goats, and camels. These caricatures serve to belittle the hospitality of Arabs and Muslims, their rich culture, and their history. Functioning as visual lesson plans, movies, like books, last forever. No sooner do Hollywood's features leave the movie theaters than they are available in video stores and broadcast on TV. From 1986 to 2000, I tracked feature films telecast on cable and network channels in St. Louis, Missouri, and Hilton Head Island, South Carolina. Each week, fifteen to twenty movies mocking or denigrating Arab Muslims were telecast. In numerous films such as *Navy SEALs* (1990), *Killing Streets* (1991), *The Human Shield* (1992), *The Son of the Pink Panther* (1993), *Bloodfist V: Human Target* (1994), *True Lies* (1994), and *The Siege* (1998), viewers could see American adolescents, intelligence agents, military personnel, policemen, even Inspector Clouseau's son massacring obnoxious Arab Muslims.

Unsightly Arab Muslims and prejudicial dialogue about them appear in more than two hundred movies that otherwise have nothing at all to do with Arabs or the Middle East. In films such as *Reds* (1981), *Cloak and Dagger* (1984), *Power* (1986), *Puppet Master II* (1990), *The Bonfire of the Vanities* (1990), *American Samurai* (1992), and *Point of No Return* (1993), Muslim caricatures appear like phantoms. Libyans, especially, are a favorite target. In films like *Back to the Future* (1985), *Broadcast News* (1987), and *Patriot Games* (1992), Libyan "bastards" shelter Irish villains, bomb United States military installations in Italy, and shoot a heroic American scientist in a mall parking lot. *The American President* (1995), an otherwise agreeable romantic comedy about a widowed president falling for a lovely environmental lobbyist, mentions Libyans as bombers of a United States weapons system. In this case, at least, writer Aaron Sorkin softens the anti-Libyan dialogue by expressing sympathy for the Arab janitor and other innocents about to be annihilated.

Universal Studios' *The Mummy* (1999), an eighty million dollar remake of the 1932 Boris Karloff classic, displays hostile, sneaky, and lecherous

Egyptians. A dirty Egyptian jailer, tagged "a stinky fellow," moves to proposition the heroine. Opening frames reveal Egypt, "a messed-up country;" here the Western protagonist and his legionnaire squad gun down scores of attacking *bedouin.* Assisting Imhotep, the revived attacking mummy, are gobs of saber-wielding mummies and an Egyptian mob; carrying torches, they resemble zombies. In the end, the protagonist brings down all the bandage-wrapped curs, dispatching Imhotep back into his sarcophagus.

Motion pictures such as *Not Without My Daughter* (1990) show the Muslim Iranian male as a religious hypocrite. Like the Muslim Arab (most Americans do not realize that Iranians are not Arabs), the Muslim Iranian is a liar who abuses Islam and kidnaps his American wife and daughter. Not only does he imprison and abuse his wife in Iran, he seems to do so in the name of Islam, as when he slaps her face, boasting, "I'm a Muslim!" After breaking an oath sworn on the *Qur'an,* he brags, "Islam is the greatest gift I can give my daughter." When he departs the mosque followed by his relatives, the camera cuts to a poster of a grim Ayatollah Khomeini. The editing implies that the offensive actions of Muslims, in this case Muslim Iranians, toward American women are connected with the behavior of Iran's late Ayatollah.

Hollywood characterizes Palestinians not as victims or stateless refugees suffering under Israeli occupation, but as religious fanatics, threatening our freedom, economy, and culture. Producers selectively frame the Palestinian as a demonic creature without compassion for men, women, or children. Palestinian Muslim images reflect a combination of past stereotypes, such as those that depicted Hispanics as "wet backs," Jews as insurgents, blacks as sexual predators, Asians as sneaky, and American Indians as "savages." The "Palestinian equals terrorist" narrative initially surfaced in 1960, in Otto Preminger's *Exodus.* In the 1980s ten features, including *The Ambassador* (1984), *The Delta Force* (1986), *Wanted Dead or Alive* (1987), and *Ministry of Vengeance* (1989) put into effect images showing the Palestinian Muslim as Enemy Number One. Feature films tag him as "scumbag," "son of a bitch," "the Gucci Terrorist," "a fly in a piece of shit," "animal," "bastard," "f—in' pig," and "stateless savage" who "massacres children." The slurs are not rebuked by other characters.[14] Several made-for-television movies also paint the Palestinian as a despicable being, including *Hostage Flight* (1985), *Terrorist on Trial* (1988), *Voyage of Terror* (1990), and Cinemax's April 1998 documentary, *Suicide Bombers: Secrets of the Shaheed.*

Two 1990s box-office hits, *True Lies* (1994) and *Executive Decision*

(1996), also portray Palestinian Muslims as screaming, murderous "terrorists" killing American innocents, including a priest. In *Lies,* Muslims ignite an atom bomb off the Florida coast. Avi Nesher, a former Israeli commando working in the Hollywood film industry, was "incensed by the sick humor of a [*Lies*] scene in which an Uzi tossed down a flight of stairs inadvertently mows down a roomful of Arabs." Nesher told *Jerusalem Report* correspondent Sheli Teitelbaum, "You were supposed to laugh? I fought Arabs and I had Arab friends, but this was completely dehumanizing a group."[15]

In *Decision,* Muslim Palestinians hijack a passenger jet, terrorize the passengers, kill a flight attendant, and prepare to unload enough lethal nerve gas to kill millions in Washington, D.C., and along the East Coast. Throughout, Islam is equated with violence. Holding the Holy Qur'an in one hand and a bomb in the other, a Palestinian Muslim enters the swank diningroom of London's Marriott Hotel and blows up innocent couples. Four days after the film was released, employees of a Denver radio station burst into a mosque and began heckling worshipers while the station broadcast their antics.

In Twentieth-Century Fox's 1998 feature, *The Siege,* Denzel Washington and Annette Benning portray FBI and CIA agents who track down and kill Palestinian Muslim terrorists. The film displays Arab immigrants—assisted by Arab American auto mechanics, university students, and even a college teacher—killing more than 700 innocent New Yorkers. *The Siege* not only reinforces historically damaging stereotypes but also advances a dangerously generalized portrayal of Arabs as well as Arab Americans as rabidly anti-American.

Paramount's *Rules of Engagement* (2000), one of the most blatant anti-Arab movies in the history of cinema, encourages viewers to despise Muslim Arabs. Opening frames show U.S. Marines killing eighty-three Yemeni civilians—men, women, even children. The shooting scenes imply that the Marine colonel (Samuel Jackson, Jr.) who orders his men to gun down the Yemeni is at fault, that his Marines slaughtered innocent, unarmed Yemeni. But the film's conclusion justifies the Marine colonel's decision to open fire and kill all the Yemeni. A flashback reveals gun-toting Yemeni, even boys and girls, shooting at the Marines. Especially troubling to this writer is that *Rules of Engagement* was produced in cooperation with the Department of Defense and the U.S. Marine Corps. Also, the screenplay is based on a story by former Secretary of the Navy James Webb.

Even the Walt Disney Company, a self-professed family-friendly mega-company, is guilty of the vilification of Arabs and Muslims. Since 1992 Disney has released seven features with harmful caricatures. In December 1995 Touchstone Pictures, a subsidiary of Disney, issued a remake of Edward Streeter's 1948 book, *Father of the Bride*. In Disney's *Father of the Bride, Part II*, a sequel to the 1991 Steve Martin remake, disagreeable Mideast Americans are introduced for the first time. (In the original 1950 Spencer Tracy-Elizabeth Taylor film and all the earlier *Father of the Bride* movies, Muslims and Mideast Americans do not appear at all.) Steve Martin and Diane Keaton appear as the happily married George and Nina Banks; they have everything, including a wonderful "Brady Bunch" home. When George convinces Nina to sell the house, a crass Arab family, the Habibs, is introduced. The rich and unkempt Mr. Habib (Eugene Levy) smokes, needs a shave, and talks with a heavy accent. When Mrs. Habib attempts to speak, her husband barks mumbo-jumbo, a mix of Farsi and Arabic, at her. Cowering like a scolded puppy, Mrs. Habib becomes mute, perpetuating Hollywood's image of the Arab woman as a submissive nonentity. Habib is portrayed as sloppy, mean, and tight-fisted. After he purchases the house he demands that the Banks be out in ten days, crushing his cigarette on the immaculate walkway. The message is clear: there goes the neighborhood. Interestingly, no one working on *Bride II* denounced the stereotyping, nor did protests emanate from members of the Screen Writers, Actors, or Directors Guilds of America.

Disney continues to demean Arabs in *Aladdin* (1992), the second-most successful animated picture ever made, earning $217 million at domestic box offices. Two sensitivity meetings were held between other Arab Americans and myself with Disney executives in Los Angeles. Weeks after the July 1993 meeting, Disney deleted two offensive lines from *Aladdin*'s opening song before releasing the *Aladdin* video. That was all. The line, "It's barbaric, but hey, it's home," remains. The storyteller is portrayed as a shifty, disreputable Arab; dastardly saber-wielding villains still try to cut off the hands of maidens; and a wicked vizier still slices a few throats. For generations, these scenes will teach children that Aladdin's home is indeed "barbaric." [16] A *New York Times* editorial complained that "To characterize an entire region with this sort of tongue-in-cheek bigotry, especially in a movie aimed at children, [itself] borders on the barbaric." [17] Professor Joanne Brown of Drake University agrees that *Aladdin* is racist. The villains display "dark-hooded eyes and large hooked noses," writes Brown.

"Perhaps I am sensitive to this business of noses because I am Jewish." Brown explains how she would feel if Disney studios created a cartoon based on a Jewish folk tale that portrayed all Jews as Shylocks.[18]

Following the *Aladdin* discussions, Disney executives promised not to demean Arabs in the future. Surprisingly, the studio opted not to honor its commitment and went ahead to feature hook-nosed, buck-toothed Arab "desert skunks" in their home-video release of *Aladdin*'s sequel, *The Return of Jafar* (1994). *Jafar* sold ten million copies to rank among the twenty top-selling videos. That same year, Disney also produced *In the Army Now*, in which "Glendale reservists" deride Arab cuisine, clobber desert Arabs, and encourage the United States Air Force to "blow the hell out of them." Americans of Middle Eastern heritage are again targeted in a Disney children's film called *Kazaam* (1996), starring Shaquille O'Neal, in which Malik, Hassan, and El-Baz, three dark-complexioned Muslim villains needing shaves and speaking with heavy accents, covet "all the money in the world." Sloppy Malik gobbles "goat's eyes" like a pig swallowing corn. He punches good-guy Americans and tosses Max, a twelve-year-old boy, down a shaft, presumably to his death.

In 1997 Disney subsidiaries Miramax and Hollywood Pictures released *Operation Condor* and *G.I. Jane*. Set in the Arabian Desert, *Condor* displays Jackie Chan battling scores of evil Arabs such as a money-grubbing innkeeper and *bedouin* white slavers. Chan also contests with two hook-nosed Arabs, "Soldiers of the Faith," who speak fractured English and wear checkered headdresses that look like tablecloths pinched from a pizza parlor. The duo mock Islam by spouting such lines as, "We will never give up the struggle for the holy battle," and, "Praise Allah for delivering you [Chan] to us again." Watching the film, I wondered why the talented Chan, whose thirty films are box-office hits here and abroad, would vilify anyone, especially since Asian performers are still trying to erase the Fu Manchu images. In *G.I. Jane*, viewers cheer as Demi Moore, a macho Navy SEAL officer, "guts it out" and kills Arabs. The Arabs surface only at the end, when the SEALs move to retrieve a United States nuclear-powered satellite containing weapons-grade plutonium off the Libyan coast. The camera reveals courageous Moore saving her drill sergeant's life, then blasting pursuing Arabs. Since 1986 Hollywood studios have released twenty-two films showing our military units and agents killing Arabs.

The time is long overdue for Hollywood to end its undeclared war on Arabs. The industry should cease uniformly projecting Muslim Arabs as having a monopoly on terrorism. Producers should portray them as fairly as

they do others—no better, no worse. As *New York Times* columnist Russell Baker notes, Arabs are the "last people except Episcopalians whom Hollywood feels free to offend en masse." [19]

Television

From 1950 until today only one Arab American and one Arab Christian immigrant have appeared as characters in a television series. The first was Uncle Tanoose, the Lebanese patriarch portrayed by Hans Conreid in *The Danny Thomas Show* (1953–1971). Tanoose occasionally appeared while on visits to his relatives in the United States. The second was Corporal Maxwell Klinger, an Arab American soldier in *M*A*S*H* (1972–1983), played by Jamie Farr, who tries to get himself discharged by wearing women's clothing. Characters modeled on such public figures as consumer advocate and presidential candidate Ralph Nader, heart surgeon Dr. Michael DeBakey, UPI's White House correspondent Helen Thomas, or radio's Top-40 celebrity Casey Kasem never appear. This absence is wounding. There was not a single 2000–2001 series featuring an Arab American character. Surely, image-makers know what happens to young people when someone in authority portrays their society as one in which they have no public presence. Such an experience, writes Adrienne Rich, can generate "a moment of psychic dis-equilibrium, as if you looked in a mirror and saw nothing."

Since 1974, when I began to document images on entertainment shows, the rogues have often been Arab Muslims. A selective overview of more than 200 programs, including network newscasts, documentaries, comedies, soap operas, children's cartoons, dramas, and movies of the week, yielded the following results. Fanatical Muslim Arabs surface in several mid-1980s television movies such as *Hostage Flight* (NBC, 1985), *Sword of Gideon* (HBO, 1986), *Under Siege* (NBC, 1986), *The Taking of Flight 847* (NBC, 1988), *Terrorist on Trial: The United States vs. Salim Ajami* (CBS, 1988), and *Hostages* (HBO, 1993). These TV movies are now repeatedly rebroadcast on both cable and network systems.

In *Hostage Flight*, the protagonist says, "These [Arab Muslim] bastards shot those people in cold blood. They think it's open season on Americans." In *Under Siege*, the United States secretary of state tells the ambassador of a Muslim nation, "People in your country are barbarians." The FBI director in this film also scrutinizes the large Arab American community in Dearborn, Michigan, for terrorists who have blown up shopping malls

and threatened the White House, telling his African American colleague, "Those people are different from us. It's a whole different ball game. I mean the East and the Middle East. Those people have their own mentality. They have their own notion of what's right and what's wrong, what's worth living for and dying for. But we insist on dealing with them as if they're the same as us. We'd better wake up." In *Terrorist on Trial*, a Palestinian Muslim boasts that he ordered the deaths of American women and children and advocates the use of nuclear weapons, saying, "We will strike at them in their home country as well as overseas. Long live Palestine!"

What is so disturbing about these television movies is that they effectively show all Arabs, Muslims, and Arab Americans as being at war with the United States. Accomplished Arab American actors are obliged to play terrorists and to demean their heritage. Nicholas Kadi, for example, a competent character actor, makes his living playing Arab Muslim *kuffiyeh*-clad terrorists. In 1990 Kadi lamented on the news show *48 Hours* that he seldom speaks in films. Instead of talking, directors tell him to impart "a lot of threatening looks, threatening gestures, threatening actions. Every time we [he and others playing heavies] said 'America,' we'd [be directed to] spit." Says Kadi, "There are other kinds of Arabs in the world besides terrorists. I'd like to think that some day there will be an [normal] Arab role out there."[20] Kadi has played stereotypical roles in films such as *Navy SEALs* (1990) and in TV shows such as "Scimitar," a 1995 NBC *JAG* episode. In "Scimitar" the Iraqi-born Kadi impersonates a Saddam-like colonel holding Meg, an innocent United States Army officer, hostage. The lusting Kadi tries to force himself on the attractive blonde. One screen myth maintains that Arabs consider "date rape" to be "an acceptable social practice." The camera dwells on the drooling Kadi wielding a Damascus scimitar slowly to remove Meg's uniform. The rape is thwarted just in time and Kadi is killed.

The demonization of Muslim Arabs is reminiscent of the demonization of American Indians. As commentator Pat Buchanan pointed out at the annual American-Arab Anti-Discrimination conference in Washington, D.C., on June 13, 1998, "The Arabs I see in Hollywood movies are like the movies I used to see with the cavalry and Indians." Clad in strange garb, Arabs are obliged to speak garbled English and to crave blond heroines. Just as screen protagonists call Indians "savages," they call Arabs "terrorists." The closing frames of "Scimitar" show an Iraqi helicopter pursuing Americans. When the chopper goes down in flames, the Marines cheer, "Yahoo. It's just like *Stagecoach* with John Wayne." Puzzled by the reference to

Wayne, a motion-picture idol, Meg asks the Marine: "John Wayne was killed by Iraqis?" He replies, "No, Indians!" In the Gulf War movie *Hot Shots Part Deux!* (1994), United States soldiers prepare for an Iraqi attack. Warns one G.I., "Indians on the warpath."

A November 1996 segment of *FX: The Series* depicts Rashid Hamadi as a stereotypical Arab drug addict who runs over and kills in cold blood a New York City police officer. But when policemen move to apprehend him, Hamadi boasts, "I have diplomatic immunity. You can't arrest me." In the end, Hamadi is caught smuggling counterfeit bills into New York City; his "Lebanese" and "Iranian" friends in Beirut fabricated the plates. Final scenes show policemen seizing Hamadi, that "piece of garbage" and "slimeball bastard."[21] In 1998 two *Soldier of Fortune* segments, "Surgical Strike" and "Top Event," surfaced on the UPN television network. Produced by Rhysher Entertainment, the "Strike" episode depicts Arab Muslim "bastards" blowing up a passenger plane, killing all 230 on board. And in Rhysher's "Event," Arab terrorists move to release three truckloads of poison gas "in the name of Allah," killing thousands of Los Angeles residents. When asked who she works for, the female militant barks, "I work only for Allah." On September 22, 1999, only several weeks prior to the 1999 American-arranged peace talks between Syria and Israel, NBC-TV's highly acclaimed new series, *The West Wing,* made its debut. Producers of the two-part fictional program, titled, "Proportionate Response," target real people, depicting Syrians as terrorists. In the scenario, Syrians shoot down an unarmed United States aircraft carrying fifty-eight passengers, including the American president's friend, an African American physician. Angry, the president wants to retaliate; he seriously contemplates the "carpet bombing of Damascus" and "creating thousands of [Syrian] civilian casualties." In the end, the president's aides convince him to relent; he reluctantly agrees only to "cripple Syria's intelligence and their surface-to-air capabilities." It should be noted that Syria has never been involved in any way in such an incident. Only three unarmed planes have been downed by surface-to-air missiles: the United States downing of an Iranian airliner; the Soviet Union's downing of a Korean airliner; and Israel's downing of a Libyan airliner.

On the *Jon Stewart Show,* United States soldier puppets kill white-robed Arab puppets. Waving the American flag, one soldier boasts, "I killed many of them!" Says another, "I decapitated quite a few of them myself." Stewart's audience applauds.[22] In *Twisted Puppet Theater,* Ali, the Muslim puppet sporting a black beard and turban, shouts, "There is only one God

and Mohammed is his prophet!" Then he turns and shoots dead Kukla, the good clown puppet.[23] From December 1991 through early 1992, MTV featured *Just Say Julie* segments, sandwiched between music videos, showing Julie addressing unsavory Moroccan buffoons as "scum" and the "creep with the fez." In one segment the two "fiendish" Arabs armed with explosives moved to blow up the television channel.

Cartoons

During the past three decades I have viewed and studied scores of American cartoons denigrating the Arab, starting with the 1926 animated short, "Felix the Cat Shatters the Sheik." Ub Iwerks's 1934 Popeye cartoon "Insultin' the Sultan" features a fat, lecherous sheik with seventy-five wives. Intent on adding a Western woman to his harem, the "exalted" potentate abducts Olive, Popeye's sweetheart, and whisks her off to Algeria. Popeye-the-legionnaire to the rescue. He brings down gobs of bearded Arab guards, then floors the sheik's mammoth wrestler—"a monster." Fast forward to a 1938 Porky Pig cartoon, "Porky in Egypt." Here, Arab Muslims in prayer suddenly become Amos 'n' Andy shooting craps, and a sexy harem maiden removes her veil, revealing an ugly face. Children's favorite cartoon characters such as Bugs Bunny, Woody Woodpecker, Daffy Duck, Superman, and Batman have ridiculed and trounced Arabs.[24] Since 1975 more than sixty comparable cartoons have surfaced on television, depicting Arabs as swine, rats, dogs, magpies, vultures, and monkeys.

Writers give cartoon Arabs names like "Sheikh Ha-Mean-ie," "Ali Boo-Boo," "The Phoney Pharaoh," "Ali Baba, the Mad Dog of the Desert, and His Dirty Sleeves," "Hassan the Assassin," "The Desert Rat," "Desert Rat Hordes," "Ali Oop," "Ali Mode," and "Arab Duck." While monitoring cartoons on November 23, 1996, I saw "Well-Worn Daffy" on the Nickelodeon channel. Wearing a white *kuffiyeh* and armed with a shotgun, Daffy shoots at three winsome Mexican mice. The mice call Daffy, among other things, "Arab Duck!" Adult viewers may be able to separate fact from animal, but for many children the animated world of cartoons consists of good people versus bad people, the latter often Arabs.

Effects on Children

Viewing such cartoons brings back memories of earlier portrayals of stupid African Americans, savage American Indians, "dirty" Latinos, buck-

toothed "Japs," and hook-nosed Shylocks in burnooses. Jewish mothers in Europe of the 1930s and the 1940s, as well as African, Indian, Hispanic, and Japanese mothers in the United States during this period, tried to shield their children from such imagery, but hateful portraits cannot help but promote bigotry toward them. America's Muslim Arab parents are increasingly aware of these dangers and work to counteract or eliminate them. Citing scores of old motion pictures being telecast on cable systems, along with cartoons, reruns of television dramas and sitcoms, plus newly created TV programs and TV movies of the week, they fear that stereotyping has become more pervasive than ever. Conversely, image-makers are now giving children of other ethnic origins positive role models to identify with. Characters appear on the screen that make children feel good about themselves: American Indians, African Americans, Hispanics, Asians, Jews, Italians, Polynesians, Irish, English, Poles, East Indians, Scots—just about every racial and ethnic group on the planet, except the Arabs.

According to the American-Arab Anti-Discrimination Committee (ADC), many parents have complained that, as a result of the pervasive stereotype, their children have become ashamed of their religion and heritage. Some children have asked their parents to change their Arab names to something more American sounding. A Texas teen told his sister, "I lied about where our parents had come from." Especially alarming is the number of incidents targeting youngsters. After the 1993 World Trade Center bombing, several children of Arab descent in New York were told to "go back where you came from." They went home from school in tears, writes *New York Times'* Melinda Henneberger. "Classmates told them they were responsible for the attack. Muslim girls were taunted; schoolmates pulled off their head scarves."[25] At a suburban Muslim day care center in Texas the driver of a passing car shouted, "Here's a bomb for you, lady!" and threw a soda can at a teacher and her students.

The *Anti-Arab-American Discrimination Hate Crimes* document, published by the ADC in November 1994, and the Council on American-Islamic Relations'(CAIR) 1996 manual, *A Rush to Judgment: A Special Report on Anti-Muslim Stereotyping,* report many similar incidents. During the heartbreaking experience of Oklahoma City, Suhair al-Mosawia, a Muslim woman seven months pregnant, lost her baby after teens pursued her, hammering her home with rocks. Following Muslim custom, she gave the stillborn a name, Salam, Arabic for "peace." One Oklahoma City resident suggested putting Arab Americans in internment camps.[26] In a *Cleveland Plain Dealer* op-ed essay, Palestinian activist Hamzi Moghrabi

reported that "in Detroit, home of the largest Arab American population outside the Middle East, business owners, including the editor [Osama A. Siblani] of the *Arab American News*, were subjected to bomb threats" and trash was thrown at mosques.[27]

Media Images and Prejudicial Responses

Media images, points out media critic Jerry Mander, "can cause people to do what they might otherwise never have thought to do."[28] Following the April 1995 Oklahoma City tragedy, speculative reporting combined with decades of stereotyping encouraged more than 300 hate crimes against America's Arabs and Muslims. Abuses took place even as Muslims mourned the disaster, along with other Oklahomans.[29] Mohammed Nimer of CAIR told reporter Laurie Goodstein, "Most of these incidents have been completely unprovoked. . . . just mere encounters with a person who looks like a Muslim, or a person praying, have prompted bias and violence. That is alarming."[30]

In Brooklyn, the police department reported that after the Oklahoma City bombing numerous Arab American businesses received hostile calls and death threats. One caller said, "We're going to put a bomb in your business and kill your family." A San Francisco mosque received thirty-five bomb threats. In Toledo, Ohio, the St. Francis de Sales High School yearbook, the *1995 Accolade*, printed in bold capital letters, "KILL ALL THE CAMEL JOCKEYS!" The remark was part of a 500-word essay by a student. Officials immediately issued apologies, however, and the high school president, Reverend Ronald Olezewski, wrote to parents and friends saying that the "insensitive reference" should never have been either written or published. "We apologize," he said. "Please presume ignorance rather than malice and be assured that all at this institution of learning will learn from the wrong."[31]

The day of the Oklahoma City explosion, Abraham Ahmed, a United States citizen of Jordanian origin, boarded a plane in Oklahoma City en route to visit his family in Jordan. Two hours after the bombing, it was reported that Ahmed was a suspect. Immediately, some people in Oklahoma City began dumping trash on his lawn; others spat on his wife. While Ahmed was in Chicago waiting to make connections, FBI authorities escorted him into a room and interrogated him for six hours. Missing his flight, Ahmed arrived late in London. There he suffered a humiliating strip-

search. After five more hours of interrogation, the handcuffed Ahmed was sent back to Washington, D.C., for another day of questioning. More than a year after he was cleared, Ahmed, who has lived in Oklahoma City for fourteen years, still receives suspicious stares from neighbors. He plans to move back to Jordan.

Hateful words and images have their impact on public opinion and policies. There is a dangerous and cumulative effect when repulsive screen images remain unchallenged. The negative images are sometimes perceived as *real* portrayals of Muslim culture, which come back to afflict Americans of Arab heritage as well as non-Arab Muslims in their dealings with law enforcement or judicial officials. For example, in January 1997 a judge in Dearborn, Michigan, was asked to rule whether an attorney could show *Not Without My Daughter* to a jury deciding on a child-custody case between an Arab American father and a European American mother. Incredibly, the judge allowed this defamatory film portraying an Iranian man as a child abuser and child kidnapper to be introduced in court, influencing the judicial proceeding.[32]

The Arab Muslim image parallels the image of the Jew in Nazi-inspired German movies such as *Robert and Bertram* (1939), *Die Rothschild Aktien von Waterloo* (*The Rothschilds' Shares in Waterloo*, 1940), *Der Ewige Jude* (*The Eternal Jew*, 1940), and *Jud Süss* (1940). Resembling the hook-nosed screen Arab wearing burnooses and *thobes*, screen Jews also dressed differently than the films' protagonists, wearing *yarmulkes* and black robes. They, too, appeared as unkempt money-grubbing caricatures who sought world domination, worshiped a different God, killed innocents, and lusted after blond virgins.[33] The simultaneous barrage of stereotypical films, editorial cartoons, radio programs, and newspaper essays helped make Jews scapegoats for many of Germany's problems.[34] Concerned that misperceptions might hinder genuine peace in the Middle East, *Newsweek* columnist Meg Greenfield wrote, "Actually what I see coming is more like a reversion, a flight back to the generalized, hostile attitudes towards Arabs and/or Muslims as a collectivity that prevailed both as government policy and as public prejudice for so many years." Although progress has been real, Greenfield remains concerned about the kind of blanket, indiscriminate anti-Arab sentiment so often expressed in public. "If anything," she writes, "we should be seeking to sharpen and refine our involvement with those Arabs who are themselves enemies and targets of the violent, hate-filled elements in the region. We should be making more distinctions and discriminating judgments among them, not fewer."[35]

Why Vilify People?

No single factor leads to stereotyping. Undeniably ignorance, the hand-maiden of bigotry, continues to be a contributing factor. Most image-makers do not have the religious, cultural, or language background to understand Islam. To my knowledge, not one university, including those with Middle East and Near East centers, offers courses focusing on Arab and Muslim images in popular culture; and no university actively seeks to recruit faculty members to address this issue, even though comparable subjects are offered for other ethnic groups. In classroom discussions and research works, all too few scholars are documenting and discussing media images of Arabs and Muslims. It may take decades of education before misinformation is depleted.

One of the reasons why America's Arabs are not yet able to define themselves may be because none belongs to America's "media elite." There are no Arab or Muslim communications giants comparable to Disney's Michael Eisner, Fox's Rupert Murdoch, or Time-Warner's Ted Turner. Few work as broadcasters, reporters, or filmmakers. Until Arabs and Muslims achieve some influence, their voices will not be heard. As producer Gilbert Cates says, "It's axiomatic. The more power you have, the louder your voice is heard."[36]

Inflexibility and indifference impact the stereotyping. Many Muslim and Arab leaders are reluctant to become involved. Although scores of films and television shows denigrating the Arab are purchased, rented, and screened throughout the Western as well as the Muslim and Arab worlds, Muslim information officials and media syndicators often appear to be apathetic. Until recently they have made little or no attempt to meet with image-makers to discuss those images ridiculing them and their neighbors.

Politics and fear are other reasons for the stereotypes. In spite of many noteworthy accomplishments, American Arabs and Muslims do not yet have sufficient political clout to effect fundamental change. The efforts initiated by various groups, such as the American Muslim Public Affairs Council, the Council on American-Islamic Relations (CAIR), the American-Arab Anti-Discrimination Committee (ADC, an organization with 25,000 members and seventy-five campus and city chapters), however, have resulted in limited apologies, minor edits, and some altered scenarios.

On June 11, 1998, Attorney General Janet Reno told Americans of Arab heritage attending an ADC conference that stereotypes should never influence policy or public opinion. Yet, when this writer asked CNN's Peter Ar-

nett whether stereotyping had any impact on United States Middle East policies, he said, "The media elite follow United States policy," adding that those responsible for shaping policies are influenced in part by the stereotypical pictures in their heads.

Conclusion

Openness to change is an American tradition. There are numerous ways for image-makers to humanize the Arab Muslim. They could reveal in television shows, documentaries, and motion pictures the telling effects of hate crimes brought about by stereotyping. They could show the impact of such prejudices on children, especially how some are taunted during the Muslim holy month of *Ramadan*, the time of purification and abstention. Although *Ramadan* has "a special meaning for Muslim children, their fasting makes them stand out in school," writes AP's Katherine Roth. Some children are distressed, saying, "they often have to contend with anti-Muslim slurs."[37]

Although harmful caricatures may not disappear soon, those professionals engaged in addressing negative portraits merit recognition. In early March 1998, this writer and Dr. Hala Maksoud, president of the American-Arab Anti-Discrimination Committee, informed Dr. Rosalyn Weinman, NBC-TV's executive vice president of broadcast standards and current policy, that the network's soap series, *Days of Our Lives*, was impugning Arab Muslims. Dr. Weinman followed up immediately on our concerns. For weeks prior to our conversation the soap had displayed a kidnapped blond United States heroine held hostage in the "harem" of the Sultan's desert palace. Her kidnapper, a bearded black-clad Arab, warned that unless she pleased the Sultan, her head would be "chopped off by an Arabian axe, one of those long, curvy sharp swords." Not only did Dr. Weinman issue an apology, NBC promptly dropped all images and references to Arabs from the soap's plot, and as of March 27 the heroine's captors began appearing as generic villains.

During Jay Leno's appearance on CNN's "Larry King Live" he was asked whether he ever apologized to anyone he had made fun of. Leno replied that he had. "I said something about Iran or something. And I said instead of chopping the arm off, they were doing it surgically, or something [like that] now, to criminals. I made some jokes about it and I heard from some Arab Americans. And I called them up and I apologized, admitting that Arab Americans sometimes get a bad rap. When you are wrong, you do apologize. And in that case I was wrong. And I have no problem with that."

Although Leno mistakenly assumes Iran to be an Arab country, his insights and candor are refreshing.[38]

In ABC-TV's May 4, 1995, *Nightline* segment, "Muslims in America," host Ted Koppel remarked that "Muslims are the stereotyped religion in the United States" and that Muslims are "often the first we think of when there's a terrorist incident." Koppel displayed coverage of the Oklahoma City bombing containing the speculative statements made by several network correspondents about the connection to Middle East terrorism. His interviews and footage humanized Muslims: like other American Arabs, he reported, those living in Cedar Rapids, Iowa, "home of the oldest mosque in America," were "made to feel like aliens when the bomb went off in Oklahoma City." And on April 18, 1997, Koppel hosted a telling religious segment titled "The Hajj," focusing on producer-writer Michael Wolfe's pilgrimage to Mecca. This landmark production, narrated by Wolfe, a Muslim, is one of the most watched segments in *Nightline*'s history. Commenting on the success of "The Hajj," Wolfe says, "I wanted to put front and center a very different view from the distortion that generally attends images of the Muslim world." And March 12, 2000, on PBS-TV's *Religion and Ethics*, reporter Anisa Mehdi documented Abdul Alim Mubarak's pilgrimage to Mecca. Throughout Mehdi's in-depth feature, Mubarak, an African American Muslim from New Jersey, addresses the peaceful and devout nature of Islam.

Some welcome exceptions to caricatures of Arabs in Hollywood features are beginning to appear. Party Pictures' 1995 *Party Girl* represents a first: Mustafa, a Muslim Lebanese schoolteacher, is the romantic lead. Selling *falafel* to earn his way through college, Mustafa wins the American heroine's heart and helps her become a responsible person. Independent producer Michal Goldman's 1996 documentary film on singer Umm Kulthum, one of the most important figures in Arab popular culture *(Umm Kulthum: The Voice of Egypt)*, was enthusiastically received during the Arab Film Festival at New York City's Lincoln Center on October 9, 1996. Fox's 1996 *Independence Day*, a movie depicting earthlings about to be exterminated by space aliens, shows the world's armies, including both Israeli and Arab combat units, preparing to repel an alien attack. Following a quick shot of scrambling Israeli soldiers and the Israeli flag, actor Sayed Bayedra appears as an Arab pilot. Speaking Arabic, Bayedra rushes to his plane to stop the invaders. Coincidentally, during the summer of 1980 when I was interviewing executives and producers for my book *The TV Arab*, writer Jack Guss told me that perhaps the best way to contest the stereotype

would be to show outer-space aliens attacking earth. This way, said Guss, even Arabs and Israelis could be together, fighting off the invaders.[39]

Two other 1996 features, Paramount's *Escape from Los Angeles* and New Line's *The Long Kiss Goodnight*, briefly display Muslim Arabs as victims of prejudice. The films may solicit mild sympathy for Arabs and Muslims, and although not yet an established trend, the images mark the beginning of a much-needed change. In the 1998 feature *A Perfect Murder*, a remake of the 1954 thriller *Dial M For Murder*, actor David Suchet appears as a bright, soft-spoken Arab American New York City detective, Mohamed "Mo" Karaman. Concluding frames show Mo, sympathetic to the heroine's ordeals, saying in Arabic, *"Allah ma'a kum"* (May God be with you). In English, the heroine replies, "And you, as well."

Also, in 1999 Disney Studios and Warner Bros. humanized Muslim Arabs in two telling motion pictures, *The Thirteenth Warrior*, based on Michael Crichton's book, *Eaters of the Dead*, and *The Three Kings*.

Set ten centuries ago, Crichton's *Warrior* stars Anthony Banderas as Ahmed Ibn Fahdlan, a devout, highly cultured Arab Muslim champion. Ahmed travels to an unnamed northern land and helps Nordic warriors defeat "a terror that must not be named." Explains Banderas, "This Arab guy I play gets caught by cruel Vikings, and their cultures clash completely. But they have a mission to carry out, and that starts pulling them together." Throughout this recommended film, the Vikings tag Ahmed "friend" and "little brother." No clash of civilizations here; Arab and Aryan surface as friends.[40]

Written and directed by David O. Russell, *The Three Kings* takes place in the Iraqi desert immediately after the 1991 Gulf War. The telling scenario focuses on four American soldiers and their friendly, respectful relations with courageous Iraqi rebels intent on overthrowing Saddam Hussein. In this anti-war drama, Iraqi and American lives are, for the most part, given equal value. One empathizes with war victims, American and Arab. American soldiers are injured; one is killed. Saddam's followers are shot. Yet, United States bombs cripple an Iraqi officer's wife; another bomb destroys a building; falling masonry crushes an Iraqi boy in his bed. No faceless or nameless Arabs here; instead, Iraqis are individualized, projected with dignity.

Former Disney Chairman Jeffrey Katzenberg has said, "Each of us in Hollywood has the opportunity to assume individual responsibility for creating films that elevate rather than denigrate, that shed light rather than dwell in darkness, that aim for the common highest denominator rather

than the lowest." [41] On December 6, 1996, Katzenberg, one of three executives in charge of DreamWorks entertainment, solicited opinions from Arab and Muslim American specialists about DreamWorks' animated feature, the *Prince of Egypt*. The four-hour session included a presentation of a rough cut of the film, followed by a candid question-and-answer session.

Regional and national Muslim organizations and agencies are beginning to pay more attention to the ways in which Arabs, Muslims, and Islam are portrayed in the public media. For example, the Council on American-Islamic Relations (CAIR) successfully lobbied Paramount Pictures for two years to drop Arab Muslim villains from their new film, *The Sum of All Fears* (2001). Director Phil Robinson told CAIR that, unlike Tom Clancy's best-selling novel on which the movie is based, *The Sum of All Fears* will have "European Neo-Nazis" as the villains (not Arab Muslims) who detonate a nuclear device at Denver's Super Bowl. In his letter to CAIR, Robinson wrote, "I hope you will be reassured that I have no intention of portraying negative images of Muslims or Arabs, and I wish you the best in your continuing efforts to combat discrimination." [42]

Professionals with Muslim and Arab agencies point out instances of prejudicial depiction and are working with non-Muslims in schools and other public arenas to help provide a more balanced—and more accurate—picture of persons who have for so long been misrepresented and maligned in the news and in various forms of entertainment media. It seems reasonable to hope that as they become more vigilant, and as the American public is gradually made aware of the hurt that is caused by such unfortunate misrepresentations as have been visible throughout the past hundred years, Arabs and Muslims may enjoy at least relative immunity from prejudicial portrayal and see themselves depicted at least as fairly as are members of other minority groups in America.

16

Lebanese Women

The Beirut–New York Connection

Evelyn Shakir

In the fall of 1999 I was fortunate to be a Fulbright fellow in Lebanon (the first posted to that country in more than twenty years). Mine was a combination teaching-research fellowship, which meant that I taught one course to third-year English majors at the Lebanese University and was free to pursue a research and writing project of my own choosing. Because of my interest in Arab women's experience in the United States, and with this symposium in mind, I decided to look for and interview Lebanese women who had lived for a stretch of time in New York City and then, for whatever reason, had chosen to return to Lebanon.

In approaching these women I had a couple of related questions in mind. I wondered how strong a presence New York continues to be for them—sometimes decades after the fact—and what role, if any, it plays in the allegories of their lives. What I discovered is that, even for women who returned to Lebanon nearly thirty years ago, New York remains so closely identified with their sense of themselves that to be away from it is to suffer periodic bouts of homesickness (sometimes even love sickness). If nothing else, New York remains an important feature of the mental landscape these women inhabit, a landmark against which they measure themselves and their lives.

I interviewed six women who can be grouped by age into two categories. Three are (at a guess) fifty or older, with grown children. The other three are in their thirties or early-to-mid forties, one unmarried and the other two with small children. Ordinary enough. But it is important to say

from the start that the women I interviewed are not representative of Lebanese women as a whole (although they probably are typical of a certain Lebanese sub-culture). Certainly, they are unlike the early immigrants to New York, male and female. But they are different, too, from many more recent immigrants. Different, if nothing else, in class and education. Therefore, their experience of New York should not be taken as typical because it was, of course, determined by what they brought with them—by who they were to begin with.

All the women come from relatively privileged backgrounds: that is, from families that were, at the least, solidly middle class. Their parents, often professionals themselves, valued education for their daughters as well as for their sons, tended to be cosmopolitan in outlook, and were, with one exception, Christian. Furthermore, even the one Druse woman I interviewed comes from a family that is oriented to the West. (Her father is married to an American and maintains an apartment in New York's Greenwich Village.) Given these circumstances, it is no surprise that all the women speak both French and English fluently, that five out of six hold at least a bachelor's degree, and that they all have or have had full-time careers. One is a retired school administrator; the others are an economist, a secondary-school teacher, a fashion designer, a choreographer, and a filmmaker.

At some point, as I have indicated, all these women found themselves in New York City, their sojourns ranging from two to fifteen years. One came here as a young bride, another was married not long after her arrival (to someone she knew from home), and a third left her husband behind in Beirut. The other women were single when they came and remained so throughout their years in New York. With only one clear exception, then, the women came here on their own, mostly to study but in one case to take a job. For those who arrived between 1975 and 1990, as most did, the Lebanese civil war was, as you might expect, a contributing factor. But only one woman pinpointed it as the decisive factor.

Christine had lived in Beirut through the early years of the civil war and the Israeli invasion of 1982. Awful years. "But," she told me, "you reach a point, you function very normally even in the midst of shelling. You get upset, but for stupid reasons, like not having enough water to do the dishes, instead of being upset by the fact that half your balcony just dropped into the street." The feeling that finally takes over, she said, is defiance. She remembered, for instance, one day when Beirut was shelled from all directions—the sea, the sky, the mountains—for eighteen hours straight. At the end of twelve hours, she decided "the hell with this, I'm going to walk

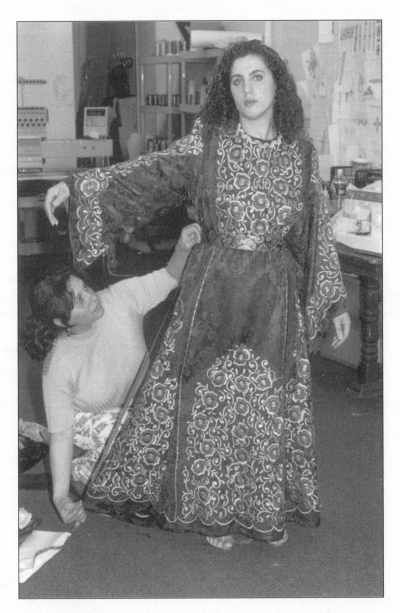

A fitting at Four Golden Needles dress shop, Bay Ridge, Brooklyn, 1999.
The shop, which has since closed, was owned by a Palestinian; the
woman being fitted is Lebanese; the dressmaker is Egyptian. Photograph
by Mel Rosenthal.

on the Corniche [an avenue that hugs the coastline]," and she put on a red dress and went out. Along the way she met militiamen, most of them drunk or high on drugs. They offered her coffee.

Clearly, Christine had endured a great deal, but the massacres at Sabra and Shatila refugee camps, perpetrated by a Christian militia, were the last straw. She decided, "I didn't want anybody doing something like this and claiming that they were doing it for my sake. That's when I packed up and left."

What was New York like for Christine and the others? Implicit in what I have already said is that they all found much here to like. Of course, they had reservations or qualifications, but the general tenor of their remarks was that New York had done well by them, offering advantages not available, they were convinced, anywhere else in the world. It is significant, by the way, that most of the women drew a clear distinction between New York and the rest of the United States (a view shared by many Americans). They thought of the city as something else entirely that just happened to be located in this country. In it but not of it. This decoupling enabled these women, I think, to claim the city as their own, whatever their views about the United States. In fact they were able to think of themselves, at least at moments, as New Yorkers in exile, even if self-imposed exile.

The three older women, I found, were especially starry-eyed about the city. "I loved it," they would say to me. "I have a passion for it." On a brief return visit last year, Nouhad (the economist) did not try to see any of her old friends. "I wanted to be alone with New York," she told me. "Believe me, it's a love story." She sounded like a woman who has an extramarital fling (in this case, with a city) but goes back to her husband (in this case, Lebanon) for the sake of the children. (Which is exactly why she did return. Her husband—the flesh and blood one she had acquired—thought it would be best for their children to be raised "at home.")

At first I was skeptical. I suspected these women were rhapsodizing about New York just to be polite, telling me what they thought I wanted to hear. Here I was, asking about New York, and perhaps I had a vested interest in it. So I would tell them, "I'm not from New York, I'm from Boston," thinking that would free them up to be more frank. Instead, *that* was when their politeness came into play. "Boston's nice, too," they assured me.

Why this romance with New York? For Nouhad and her contemporary Paula, the city remains fresh and brilliant in memory largely because of its association with their salad days, when they were young students, young brides, and young mothers. Young and at the same time free from the kind

of surveillance they would have lived under at home and free, too, of certain ritual responsibilities. Instead of attending obligatory family functions, for instance, they developed New York-style rituals of their own. "It was a rite," said Paula (who had spent her New York days completing a degree in archaeology and later teaching French to adults). Every Saturday evening, late, her husband would put his jacket on over his pajamas, and go down to the street to buy the Sunday *Times*. "And he'd buy us a chocolate bar this big," she said, "and we would sit together on the floor, each one with the section of the paper we liked. That is something I cannot forget. We didn't need anything more."

Nouhad told me how she and her husband might, on the spur of the moment, dash down to a concert at Lincoln Center or Carnegie Hall, or, after studying well into the evening, hop a bus to 42nd Street, walk for a while, then wind up browsing happily at Doubleday's bookstore. Other women fondly remembered outdoor theater, coffeehouses, museums, the Speakers' Corner in Central Park, and public broadcasting station Channel 13. The women I interviewed might not have had money to spare, but they were young, energetic, and prepared by background and education to take advantage of the cultural richness the city offers. "New York is like a big cake to a hungry person," Jana (one of the younger women) told me. Or, in another of her phrases, "a discovery place—it helps you keep the child in you."

And then there was the ethnic diversity of the city, a feature especially significant to women coming from a country that, during the years most of them were in New York, was tearing itself apart in sectarian violence. Not that New York or any American city offered a perfect model of ethnic and racial harmony. But at least the population was not engaged in armed warfare. Furthermore, the ethnic patchwork of New York made the city feel more welcoming. Christine explained her reason for deciding to come to the United States rather than to France. "In Europe," she said, "I would always be a foreigner. In New York, there was a possibility of belonging." In other words, there was no one model, ethnic or otherwise, that she would have to conform to. Paula put it this way: "I was very tempted to stay in New York because [in doing that] I didn't feel I'd be leaving my country, because New York was everything at the same time." Katey, who managed the New York office of an American school in Beirut, also found New Yorkers "receptive to diversity." It was comforting, too, that people she met on the job or through her service to the YWCA were sympathetic to her story of Lebanon and its sufferings. "New Yorkers read the paper daily," she said.

"They are more international." Even a comparatively uneducated black handyman she met knew of Lebanon from his Bible.

Equally important to the women, New York was a kind of academy. It modeled styles and ways of living, some of which they tried to emulate or reproduce in Lebanon. Paula, for instance, carried even her furniture back with her or, more accurately, had it shipped. Not so much out of sentiment or nostalgia, but because it epitomized the simplicity and functionality she had learned to prize and found congenial to her own nature. "You learn that things have an aim; you look for something comfortable, something sturdy, something of good quality. That's what New York taught me. It's very sober, New York." When she spoke of simplicity, she meant also the way people deal with one another. "In New York, you are more yourself. Simple, truthful, but not less sophisticated. You are very sophisticated but you express it simply."

Simplicity was a word I heard over and over—comments on New Yorkers' simplicity of manner and on the city's relative freedom from the artifice and social convention that the women had found stifling in Lebanon. For Paula, as a woman simplicity had a special meaning. In Lebanon, she said, women worry too much about what others will think, they put on veils (metaphorically speaking), they try to conform to a particular female image. Their makeup, their dress become standardized. "And more sexy," I suggested to her. Yes, she said, and told me about a young woman she knows who came back to Lebanon after living for some years in Texas. In Beirut, she took one look around and then shortened her skirts by ten centimeters.

As students or apprentices in New York, these women also learned both skills and attitudes that would sustain them in their careers. Nouhad, who had been a graduate student at Columbia, told me how sobering it was to realize she was competing with formidable students from all over the world and to see their mental discipline and realize that she had to match it in order to succeed. "That is the lesson of America," she told me. "Hard work! That is what Columbia teaches you. I will never forget that; it has molded me forever."

Of course, for the three women in fashion or the arts, New York was an ideal incubator, a hospitable environment where they could meet and learn from others in their field and feel that they were in their natural element. According to Christine (the filmmaker), "The experience I had living in New York City is definitely the infrastructure to any work I do—the way I conceive it, the way I put it together, the way I reflect upon it. New York enriched me incredibly. Because of its own very powerful movement, it

moves you as well, allows you to go forward. Once you've lived there long enough, this energy inhabits you, and I'm always scared that it will fade away."

Why, then, did the women return to Lebanon? Nouhad, as I have already indicated, was following her husband's lead. Paula, also young at the time, was doing the same. A sense of duty compelled her husband, a doctor, to return to Lebanon in the middle of the war. Left to their own devices, Paula and Nouhad probably would not have returned so soon, perhaps would not have returned at all.

Katey, who lived in New York for twelve years and "loved every minute of it," resettled in Beirut at quite a different stage in her life, the moment when she retired. Even though her Beirut-based husband had died by then and her only child lives permanently in the United States, she was propelled back to Lebanon by a homing instinct, a fear perhaps of being adrift in a far city where she no longer had a rational role to fill. Or maybe by a sense that dusk was falling—time to leave the playground and come into the house. As even Paula said to me, "I love New York, but to be old and alone there is too much!"

It was career that brought Jana back to Lebanon. After studying dance and choreography in New York, she decided to channel her energies into the creation and analysis of ethnographic performance and, for the sake of that work, needed to be close to her cultural roots. But for the other two women I interviewed, the decision to return to Lebanon was not an obvious one. At the time they made that U-turn, both were single and launched on careers that had a far better chance of flourishing in New York than in Beirut. And yet they found themselves heading east, a step that each, in her own way, continues to second-guess. It is this ambivalence that makes their stories especially interesting and instructive.

After arriving in New York in 1984, Loulwa attended the Parsons School of Design in Manhattan and then served apprenticeships in a couple of fashion houses. But then she began yearning for warmth, she said, literally a warm climate, but also the warm relationships between people that she remembered from Lebanon, especially during the war years. "There was a bonding among the people that was very beautiful," she said. "A sense of closeness and caring because we were all under danger." New York, on the other hand, seemed to condemn her to a "machinelike existence, very far from the way we [Lebanese] think, the way we live. It's very impersonal; it's very cold." She agreed that New York was "the happening city." But "why all this running and running," she asked herself, "when

you can have your little place in the sun?" Then, too, in 1989, the year of her decision, civil fighting (about to end although Loulwa did not know it) was still tearing Lebanon apart, and she was convinced that she should do something to help her homeland. Still, it was a difficult decision, because, as Loulwa confessed, she is an ambitious person and she knew that in terms of money, success, and new professional horizons, she would be infinitely better off in New York.

For Christine, too, the decision to return did not come easily. In leaving Lebanon, she had decisively turned her back on the country. Her intention was to work and establish residency so that she (the granddaughter of an Irish American woman) could apply for American citizenship. She took film courses at Hunter College, lived in Greenwich Village, became part of a local and international film community, and produced a couple of prizewinning films. She also got involved in the larger New York community, teaching and working with women inmates on Riker's Island.

In all, Christine lived in New York for fifteen years and for the first several was so disillusioned with Lebanon that she avoided any reference to her origins. But then one summer she found herself in Romania, making a film on the plight of street children, and that was when it happened. She thought, "Here I am working with these Romanian kids and, in the meantime, I'm trying to completely obliterate any relationship I have with a country that's in as much of a mess. Why don't I go see what's going on there?" So she returned to Lebanon. Not to stay—she kept her New York apartment—but (with partial backing from the BBC) to make a film about Lebanon.

What kind of life awaited these women in Lebanon? One or two settled in with relative ease. "I didn't find any difficulty living in America," said Katey, "and I didn't find any difficulty coming back home." But for those who returned in wartime, initially it was difficult. Jana found the limitations on her freedom of movement so intolerable—the fear of militias fighting in the streets or robbing passersby—that she actually returned for a while to New York. Paula, whose husband was busy at the hospital, was often home alone with her children, whom she was afraid to allow out on the streets. Instead, she turned her living room into a tennis court, she said, to try to keep them amused indoors. When the shelling was bad, her family retreated into a basement shelter, sometimes for days at a time. There are still bullet holes in her balcony.

Outside the house it was not just the fighting that threatened her. Because of the religious conservatism that held sway for a period during the

war, she was also afraid to appear on the streets unless dressed in long skirt and long sleeves. She was afraid to speak a foreign language—English or French—where she might be overheard. And she asked her friends to call her "Um Afif" in public because her own name, Paula, sounded too Western.

The readjustment to Beirut was also difficult for reasons unrelated to the war. Paula, who had left for New York as a bride, had not known what it would be like to be a married woman in Lebanon, the expectations, the restraints on her freedom, the things she would be expected to do and do well. Especially by her mother-in-law, who once told some people, "What are you going to visit her for? She can't even make coffee."

As I have said, Christine returned to Lebanon to make her film (an allegory about the war) and then leave. But production took more time (and money) than she had expected—not the six months she had calculated, but a year and a half. All the while she was getting more and more attached to Lebanon. When the film was finally finished, she said to herself, "Okay, it's time to go back." But she could not do it. That was about five years ago, and in the interim she has married and had three children. Her husband would like to move to the United States, but she keeps saying, "Not yet."

Loulwa also came back with a plan: to open her own shop and workroom. Mindful of Gandhi's lesson about weaving one's own garments, she wanted to help foster a homegrown industry and to encourage women to wear with pride affordable fashions produced in their own land. Hers was not to be the isolated world of wealthy Lebanese women "dressing up, completely oblivious to what was going on around them, wearing Christian Dior outfits to lunch while bombs fell." To reinforce her commitment to the reality of the place she lived in, she mounted her first fashion show at the ruins of the bombed-out, rat-infested St. George Hotel. Loud music blasting from speakers kept the rats at bay; hundreds of candles made in the mountains illuminated the darkness. The show, attended by 900 people, was a huge success, receiving international coverage in papers such as the *Washington Post* and the *Boston Globe*. Since then Loulwa has steadily built up her business, holds shows twice a year, and designs costumes for the theater.

For Loulwa and Christine the debate goes on, whether or not to return to New York. "It's always in my mind," said Loulwa. True, she remembers the things she did not like about New York—the rat race, the autocratic way bosses treated workers, the racism. (When she went blond, people treated her more nicely.) But she sees things in Lebanon that also profoundly disturb her, above all the refusal to face up to history, to examine

the war and how it happened, to engage in intersectarian dialogue that might help prevent its recurrence. People just want to forget about the war, she said. They are tired and they need to think about surviving. As for the sense of connection with others, she wonders how deep it goes. "They're nice to you," she said, "but if you were really in trouble, I don't know how much they would help you."

On the other hand, Loulwa has also found that there is such a thing as too much community, having people lay too much claim to you. "Here," she said, "people don't respect your privacy because they consider they're part of your life and they have the right." "Do you mean family?" I asked. "Family," she said, "people on the street, the concierge of your building, the grocer where you buy your cigarettes. They have this feeling that you owe them something, that you owe them explanations."

Of her return to Lebanon, Christine said, "It was a very bad career move. I'm in a place where cinema doesn't really exist. It's terrible, it's very lonely. I spend my time at my computer, sending e-mails, hoping to receive as many as possible from my friends [overseas]." For the film she's currently making, she works closely with someone in New York, "bouncing around ideas because I don't really have anybody here." There is no space in Lebanon, she said, for an artist to survive. As long as you have money, you're respected—even people who sold arms during the war or exported drugs. But as an experimental cinematographer, she is a fish out of water. If she goes to the minister of culture with an idea for a film, he says, "What we really want is to show how beautiful Lebanon is."

As Christine balances Beirut against New York, she remembers the solitude and absence of a stable community in New York, as well as the hectic pace. And she recalls how giving birth to her first child also discouraged her from going back. "I wanted this kid to have a sense of its roots," she said, "to be familiar with the sounds in the street, the sound of the music coming out of the car, with the language, the light, with whatever this is. And now I'm not so sure any more." Now she worries about other lessons her daughter may learn in Lebanon—about judging people according to how much money they have and women according to their appearance.

You end up needing both places, she explained, and she hopes to establish a way of life where she can move back and forth between them. "I need New York for my work," she said, "and for my spiritual survival. People who have lived in New York always need to go back to get that energy." ("That adrenaline," said Nouhad.)

In the personal iconography of the women I interviewed (most notably

Loulwa and Christine but the others as well), it is clear that New York represents unlimited potential for growth and achievement in their personal lives and in their careers. Here they find what is new and exciting in their field, inspiration for their work, colleagues who share their passions, and personal liberty. The siren song of New York speaks to the side of them that aspires to individual excellence. But it leaves them hungry for home, for belonging, for feeling oneself in the service of something larger and more important. Thus, it competes with a kind of idealism. And with a stubborn refusal to give up on Lebanon, a country that has been manhandled and self abused and yet lays claim to them in ways it is difficult to resist.

Despite the relative ease with which they move between continents and cultures, being Lebanese remains central to these women's sense of themselves. But they are Lebanese of a particular ilk. Five out of six, whether believers or not, are Christian by background, and generally not the more common Eastern-rite Christian, but Protestant. That identity links them with earlier generations who, at the turn of the twentieth century or earlier, came under the influence of American missionaries, especially through the medium of the American University of Beirut. They are the ones whose forbears not only studied at mission schools but also actually converted. For these women, as well as for the one Druse among them, an affinity with the West going back for generations helps define who they are. (Not that any one of them repudiates her Arab identity or is a religious isolationist. Quite the contrary.)

But identity continues to evolve, often in unexpected ways. These women have lived abroad, specifically in New York City, and then returned to their own country. That circumstance also defines them, sets them apart, engenders a sense of kinship with others who have done the same. It is at least slightly ironic that, in returning to Lebanon in search of community, some of them found it not where they expected but among their fellow sojourners. According to Christine, her loneliness in Lebanon is eased primarily by the company of other returned émigrés. They are her emotional support. "They're more open," she told me, "they're more aware of the global village phenomenon. People who stayed here don't know that you can be Lebanese but that doesn't mean you're not part of the rest of the world." Loulwa sounded a similar note. Saddened by parochial tendencies she has seen in Lebanon, she has found a new way of thinking about herself and where she belongs. "I'm a citizen of the world," she said. "I can live in New York and feel that I am part of New York. I can live anywhere else in the world and feel that I belong."

Something else unites all the women I interviewed and helps determine their sense of themselves. They are all residents not just of Beirut but of its headland, Ras Beirut. And even of a particular neighborhood, Hamra, which fans out from the American University of Beirut and stretches almost to the Lebanese American University. In Hamra, you have the sea at your feet. You stroll along the Corniche and buy roasted corn from a vendor or Turkish coffee from a man with an urn. You attend concerts and art shows and lectures at the two American universities. You live in a place of narrow streets and congested traffic, a place that is crammed with book shops, cafés, greengrocers, banks, food stalls, pastry shops, video stores, cyber cafés, and shops that sell chocolates and nuts, antiques or jewelry, clothing and shoes, shoes, shoes! "Just go around this block," said Katey, "and everything you can think of you can buy." "As chaotic and bustling as New York," said Christine. "I like that about it."

Hamra is also cosmopolitan, multisectarian, and progressive, thanks in large part to the American University of Beirut, its traditions, and the people it has attracted from around the world. "In Hamra," said Jana, "they accept all people, they try to give them space." It is on account of this openness that the women I spoke to say they will never live anywhere else in the city. They are proud of Hamra; it is central to their identity. And it is as close to New York as they are ever likely to come in Lebanon. "It's tolerant," Loulwa told me, "it's this melting pot of people and acceptance of the other. Paris is not like that, London is not like that. Only New York." Christine put it very directly: "I don't want to live in a ghetto. I want to live with all kinds of people or I don't want to live here at all. I believe in this definition of Lebanon."

For three months last fall, I lived in Hamra. I had already decided it was a village, even before I heard it described that way. We read about six degrees of separation. In Hamra it is two degrees. I never met a person there who did not know at least one other person whom I also knew. In Hamra people live within walking distance of one another, they stop and chat, they come by without calling. In short, they have time. Or else they make it. Maybe not so much as they used to, but more than in New York or even Boston. In Hamra the florist can tell you if the person you are looking for lives in the apartment building across the street because he knows all the people in that building; they are his neighbors. And in Hamra people still tell you where they live not by street name and number, but by the names of buildings, which are generally family names. Hearing those names, native Beirutis can and do trot out the whole history of the family. Hamra is a

place where a dress designer—I am thinking, of course, of Loulwa—back from a dinner where her hostess has admired her elegant velvet stole, sets about making one as a gift for her. Where I (usually shy about intruding) feel comfortable enough to drop in on her workroom. The Turkish coffee appears, first thing, and the designer, who has settled down for a chat, looks up from our conversation, smiles—one would have to say lovingly—at the young woman with the brass tray in her hands and says, "Thank you, *habibti* [my dear]."

Nothing is careless. Every gesture is a brushstroke in the creation of her identity and, *'nshallah* (God willing), in the re-creation of Beirut.

17

Being Arab American in New York

A Personal Story

Abdeen Jabara

My experience with the Arab community in New York City far pre-dated my move to the city in 1994. My father had immigrated in 1906 from what was then the Syrian province of the Ottoman Empire and is now Lebanon. He landed at Ellis Island and then made his way to a small town in the northern part of Michigan's lower peninsula where there were other young men from his village in the western Bekaa Valley who were building a railroad bed across the state.

In 1923 he married and settled in another small northern Michigan town with his new wife, who had came to the United States as a three-year-old with her parents from the same region in Lebanon that my father was from.

While growing up in this small northern Michigan town in the 1940s where our family owned and operated a grocery store, I first came into contact with the Arab settlement in Brooklyn. From time to time my parents would order different ingredients for "Arabic food" from Sahadi's or Malko Brothers on Atlantic Avenue in Brooklyn. I remember well the cartons arriving and the excitement that we had opening them to get the spices and grains, the *tahini* and *halawah*, which were not available to us except from cities in downstate Michigan.

The other memories I have of our family contact with New York were the occasional orders my father made for long-playing Arab records from Rashid Sales in Brooklyn. I distinctly remember the flat brown boxes arriving and my dad removing the records that had been carefully packed be-

tween layers of paper so that they would not break. My dad loved Arab music, and while I did not much understand it, I remember how he would put the records on and his eyes would glisten with all the memories of the "old country."

Occasionally, someone would come to visit and would leave behind an Arabic-language newspaper that was published in New York.

All of this is to say that very early on, despite our isolation from any Arab community and the fact that we rarely traveled away from our home town, I had a sense that New York City was a lively and copious center of Arab American life. It was in this small town, under the impact of my father's strong ethnic identity, that my own solid identification with our origins took root.

Before moving to New York in 1994, I had visited it on numerous occasions, once during my university student days and subsequently in connection either with legal work or as head of several different Arab American organizations. These visits did not allow me to understand the Arab American community that I would come to know after my move here. In fact, I think these short visits generally gave me a negative feeling about the city. I found it impersonal, dirty, difficult to get around, and expensive. The members of the Arab community that I would come into contact with during these visits were either professionals or staff members at the United Nations. As president of the American-Arab Anti-Discrimination Committee, I was continuously frustrated at the difficulties we had in establishing a strong, cohesive, functioning chapter in the city.

Since my relocation to New York, I have, I believe, been on a constant voyage of discovery of its Arab American community. It has been a voyage of surprises, delights, and, yes, disappointment.

Because I came to New York, in part, to work on a case that involved the immigrant Muslim Egyptian community in the city, it was this group that I got to know initially. It was a community that had some fairly intense publicity—first as a result of the arrest and prosecution of one of its members in the killing of Rabbi Mier Kahane and subsequently in the trial of Sheik Omar Abdel Rahman on charges of seditious conspiracy in the 1993 World Trade Center bombing. While I had come to New York to serve as co-counsel in representing Dr. Abdel Rahman in his eight-month trial, I had not been present when El Sayed Nosair was initially tried for the murder of Kahane. In that trial Nosair was represented by attorneys William Kunstler and Michael Warren. During the Nosair trial I was living in Washington, D.C. From time to time I would read some fleeting accounts of the

allegations and trial but had little if any sense of what was transpiring in New York regarding a core group of Egyptians who were opposed to the government of Egypt. I was also not aware of the size of the Egyptian community in New York, which I have since learned has mushroomed over the past two decades.

When I practiced law in Detroit in the seventies and eighties, many of my clients were drawn from the very large Yemeni population in the area. Most of them were employed in the automobile industry in Dearborn, Detroit, and Hamtramck or as scullions and busboys in the restaurants of metropolitan Detroit. I knew that there was a sizable Yemeni community in New York, but I did not realize the extent to which they had found an economic niche in operating newsstands, tobacco and lottery shops, and grocery stores. Many were the small shops I would enter in Manhattan to find that the proprietor or employee was Yemeni. An almost telltale sign of the ethnicity of the owners is the presence of Arabic-language newspapers and magazines in the stands on the sidewalk in front of the shops. Because I live and work in Manhattan and there is no specific Arabic-speaking residential area in that borough, my interaction with these blue-collar Arab Americans has been of a limited nature.

One of the major discoveries that I made in New York was that it is a series of smaller neighborhoods, which people tend to relate to as their community or village as against the city as a whole. Arising out of these various neighborhoods are different interest groups whose members may be drawn from the larger community. I am constantly meeting people on both the "neighborhood" and "interest group" level of the city in different functions and forums.

Perhaps the greatest and most personally satisfying discovery that I have made in New York as regards Arab Americans has been the community of active and committed musicians, writers, poets, and artists that I found. Of course I had no right to be surprised at the existence of such a community since this is the cultural capital of the world and it historically had been the center of Arab American literary life, but I was. I cannot recollect exactly when it was that I first heard about the Radius of Arab-American Writers, Inc. (RAWI), on whose board I then sat. I do remember, when I sent in a check to join and receive its newsletter, how totally thrilled I was to see a group of culturally active people who felt that they shared a bond based upon some loosely defined Arab/third-world identity. Part of this discovery was encapsulated in the indefatigable work of Barbara Nimri Aziz, who, in her own indomitable way, helped marshal the talents

and energies to make RAWI a reality on the New York and national Arab American scene. Coupled with her weekly radio program, *Radio Tahrir*, on WBAI and organizing symposia at NYU on the American attack on the Sudanese pharmaceutical plant al-Shifa after the 1998 bombing of the U.S. Embassies in Kenya and Tanzania, she has made and continues to make an imprint on the cultural and political presence of the Arab American community in New York.

Perhaps the pinnacle of my cultural discovery was attending Simon Shaheen's Mahrajan-al-Fan for two successive years and hearing poets like D. H. Melhem and Suheir Hammad read poetry that spoke to me. Hammad in her *born Palestinian, born Black* has drawn upon an Arab American experience of growing up in the urban environment of race and class and daily struggle to emerge in a defiant yet beautiful sense of self.

Certain individual Arab Americans in New York stand out for their contributions, and one of those I knew, sadly, passed away a few years ago. Although he was a one-person operation, Mohammad T. Mehdi was an incredible fighter for Arab causes and he always sought to do it through the channels provided by society at large: the media and the courts. He was a remarkable person who always exhibited a great deal of humor. Because of his total commitment and principled stances, he was beaten by Jewish Defense League thugs and driven into poverty. Despite all this he exuded optimism and a sense of indefatigable will against the powers that be. To him the United States Constitution with its First Amendment guarantees was the way in which American Arabs and American Muslims could make their voices heard over the powerful behind-the-scenes forces. While he was not honored in his lifetime, his success in having the Crescent and the Star erected in Grand Central Station at Christmas was his crowning achievement.[1] I remember how the media remarked at the time that the fact that it was displayed reflected the religious and ethnic changes that were happening in New York.

My experience of Arab American New Yorkers has provided a continual series of vignettes and discoveries. One of those vignettes was the free postcard advertising a jazz club on Lafayette Street in Greenwich Village that featured drawings of the four most famous Arab female singers—Umm Kulthum, Fairouz, Asmahan, and Warda—each with their names written in Arabic. Admittedly, the name of the jazz club is Fez at the Time Café, but only an Arab who could read the names could really understand what the card meant. I am sure, however, that there is a story behind the issuing of this postcard. I, of course, took as many as they would allow and sent them

to my friends. Another such vignette was the discovery of a store in the Chelsea Market that sold Moroccan imports, which organized a cooking class on a Sunday morning. I signed up for the two-hour lesson with excitement. When we needed utensils or ingredients, all the chef, Hamid Idrissi, did was dash to the nearby greengrocer or butcher or kitchen-supply outlet.

And then there are the movie festivals of Arab films and the marvelous shows of Arabic calligraphy that the Metropolitan Museum has had, the latest of which was sponsored by a Turkish bank. The World Music Institute's wonderful presentations of various dance and music groups from the Middle East and North Africa are an annual affair that I always look forward to.

Many years ago I was in Los Angeles and someone took me to a small café to hear an *oud* player. The musician, of whom I had never heard, was named Hamza el-Din, and he sang in both Arabic and Nubian. It was wonderful, and I was totally mesmerized by his lilting song and the beauty of his *oud* playing. Over the years he became famous with a loyal national and international audience. I was certain to purchase each of his new CD's when they were issued. How wonderful it was to rediscover him and his music live here in New York City. Of course, this was not just Arab music but a major contribution to world culture.

Whenever I take a cab in New York I have made it a habit to read the name of the cabby since most of them are immigrants from third-world countries. By the names I can generally tell what country the driver is from and I often engage him in conversation. I have been told that fully 40 percent of the cab drivers are from South Asia—Pakistan, India, and Bangladesh. Another percentage are Arabs—principally Moroccan and Egyptian. The percentage of the entire cab driver population who are Muslim can be deduced from the paucity of cabs on the street during the major Muslim holiday of *Eid al-Fitr* at the end of *Ramadan*. These cab drivers form just a segment of the overworked and exploited third-world work force in the city, and it is always interesting to me to hear their stories. While there are a number of Arabs who drive cabs in several other American cities, I have never experienced it as much as I have in New York for the simple reason that travel in this city by cab is such a way of life. This, of course, is in addition to the huge number of Arab immigrants who drive car-service vehicles for trips to the airports and elsewhere.

One other fact about the Arab presence in New York that I did not learn about until I moved here was the number of Arabs who were on the *Titanic* when it embarked on its fateful voyage from England in April 1912 headed

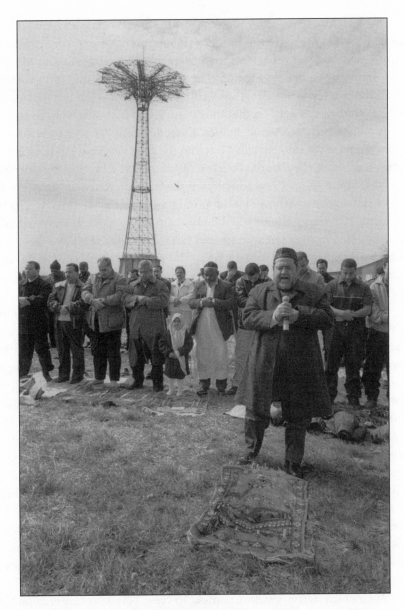

At Astroland Amusement Park, Coney Island, men observe the call to prayer, March 27, 1999. The occasion is *Eid al-Fitr*, the three-day festival of fast-breaking. Photograph by Mel Rosenthal.

toward New York City. There were, according to one of the accounts of the trip, 154 Syrians on board the *Titanic,* all but four of whom were traveling in third class. At least thirteen of them were from the village of Kafr Mishki in Lebanon's western Bekaa region. The village of Kafr Mishki is just across the al-Misk valley from my father's village in the Bekaa. Only thirty-eight of those Arab passengers on the *Titanic* survived. The survivors had such family names as Assaf, Ayoub, Boulos, Kassem, Naimie, Moubarek, Butros, Wehbi, Yared, Saad, and Yazbek. Given all the attention that has been given to the sinking of the *Titanic* because of the recent film, one might only hope that some serious investigation of the Arab presence on that ship as part of the ongoing pattern of Arab immigration to this country might be conducted. Certainly the movie did not, I am told, report it, and certainly those huddled masses with weathered Lebanese village features were not dining under chandeliers or dancing to the sound of some ship orchestra. They were part of the ongoing story, of the saga of Arab immigration to the new land.

I recall that when I first came to New York City I attempted to get involved in organizing the Arab community. I compiled a mailing list of a sizable number of Arab American professionals to whom I sent an invitation to a Christmas party, a kind of social get-together. There was a surprisingly good turnout, and from all reports everyone had an enjoyable time. Several more of these events were organized with the idea that at each one there would be a presentation on some subject as it relates to the Arabs or the professional expertise that some of the persons attending possessed. After three or four such parties, held in different people's apartments, these get-togethers came to a halt because we simply lacked the organizational infrastructure and the facility through which to sustain the effort. Which brings me to my last observation. New York is so large, and there are so many demands on one's time, both in work and in the social setting, that it is almost impossible to organize an ongoing successful Arab American presence unless one has a small core group of individuals who are prepared to carry the brunt of the work.

Much of my activity before coming to New York was centered on the political life of Arab Americans and United States involvement in the Middle East in a fashion that I saw as being inimical to the interests of the Arab and Palestinian peoples. Indeed, most of my professional life from the time of the June 1967 war had been involved in organizing in the Arab American community in one way or another. As a member of the AAUG, Palestine Human Rights Campaign (PHRC), and ADC I attended conferences, spoke

Adele Jane Kiamie Najib was about fourteen years old when she traveled from her village in what is now Lebanon to Cherbourg, France, to board the *Titanic* on her way to join her parents in the Bronx, New York. She later married a man named Kiamie and had two children, Mitchell and Leila. She died of malignant melanoma in 1924, when in her late twenties, and is buried in Mt. Olivet Cemetery in Queens, New York. This photograph was taken in the Throgs Neck section of the Bronx, New York, not long before her death. Of the 2,223 passengers and crew who sailed on the maiden voyage of the *Titanic*, an estimated 154 were Syrian; of the 706 survivors, 38 were Syrian. Courtesy of Thomas Dahdouh, grandson of Adele Kiamie Najib.

on campuses, and generally attempted to put my legal training to use in helping the Arab American community confront the myriad attacks and harassment to which it was subjected. Indeed, it was partially because of this lifelong involvement that I found myself in New York to help defend one of the most outcast of clients in a highly charged atmosphere. Little did I understand that this case would be only the introduction to what would become a relentless onslaught by the courts, the authorities, the politicians, and the media against persons who were Muslim Arabs. Only a few months after the trial of Shiekh Abdel Rahman ended, a paralegal in the case, Nasser Ahmed, who I had come to know and respect, was arrested on alleged immigration law violations. He was denied the right to political asylum or the withholding of deportation on the basis of evidence that neither he nor his attorneys were allowed to see. His case was the first of more than two dozen such cases, in which the Immigration Service and Justice Department were selectively using secret evidence to detain and deport Arabs. This case took up much of my time until November 1999, when Attorney General Janet Reno refused to block his release from detention as ordered by the immigration judge.

I bring up this case because of the experience I had trying to mobilize support for Nasser and his release in the New York Arab community and against the use of secret evidence by the government to imprison and deport him back to certain torture. I must say that my experience was a very sad one as, in the several demonstrations we called on Nasser's behalf and in the teach-ins that we organized, I found that there was an overwhelming level of fear in the Arab American community about being identified with anything remotely oppositional to the United States government. This perhaps is to be expected from any first-generation blue-collar immigrants, but I found that this was true also of the established, educated, and articulate. They had little or no sense that there was a larger Arab community beyond the one with which they personally identified. They also had little sense that the United States Constitution was meant to apply to them and that, if they did not fight for their rights and the rights of other Arab Americans, they could not expect much sympathy when they were targeted because of their ethnic background.

There are probably a myriad of reasons besides the one that I cited—fear—for this reluctance to get involved in the major pressing criminal-justice issues in an era in which "Muslim" and "terrorist" have become synonymous. People are busy in their own lives. New York is a huge metropolis where the levers of change and involvement are not so readily dis-

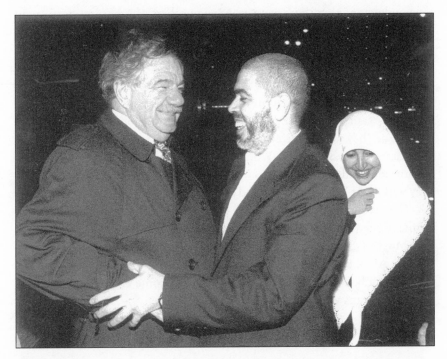

Abdeen Jabara (left) greets his client Nasser Ahmed after his release from the
Metropolitan Correction Center in New York on November 29, 1999, as Ahmed's
wife, Salwa Elbyadai, looks on. Ahmed, who was jailed for more than three years
on the basis of secret evidence, was freed after immigration officials gave up a last-
ditch legal challenge to his release. AP Photo/Robert Mecea.

cernable. And certainly the media has not been a friendly one. I recall dis-
tinctly that the first major positive story that was published on the Nasser
Ahmed case, besides a column by Anthony Lewis, was done by a reporter
who came specifically from Detroit to do a story for the *Detroit Free Press.*
The only real exception to this prevailing media attitude has been an Arab
American who is a staff writer for a Long Island newspaper. A few years ago,
when New York City Council President Peter Vallone made the obligatory
politician's trip to Israel, he was taken to a hill in Jerusalem where the Is-
raelis were about to build a new settlement. He uttered some words of sup-
port, which were picked up by the New York papers. Immediately, a group
of us got together to meet with Vallone to protest his words of support.
While he did not apologize for the comment, it seemed clear to me that Val-

lone understood that there were growing numbers of Arab Americans who were dismayed by his acceptance of illegal and discriminatory Israeli settlement building and would act accordingly. These meetings were reported in the media and we felt that we had contributed to the consciousness raising of Vallone. I think that this is one thing that sooner or later the New York Arab American community will have to address: It must establish a political organization with a staffed center that can coordinate and monitor matters as they affect this community. I believe that people will see that they can make a difference. When the institutions in the larger society—government and the media—see an organized effort that has a mass base, they will be, at least, more guarded and perhaps even responsive.

The demographics of New York City, according to the statistics of the ethnic background of its newcomers, are changing rapidly. The third-world and Muslim components of the population have grown by leaps and bounds. All of these newcomers cannot but have a real impact on both the culture and body politic of the city. And with some energy and thought, Arab Americans will be part of that impact.

Afterword

Kathleen Benson

The last session of the February 2000 conference was an audience sharing opportunity moderated by Michael Hindi, codirector of foreign student services at New School University. A number of audience members took the microphone to express their feelings about the conference and about being Arab in New York City. One of the most eloquent speakers was a young woman named Tala Manassah, whose remarks are reprinted here. A resident of New York City who attends the University of Chicago, she has titled the written version of her words "From Rage to Interlocution."

Tala J. Manassah

I am a native New Yorker. For nearly all of my eighteen years I have inhaled the unmistakable stench that makes New York, New York. The pulsating energy of the greatest metropolis in the world has pushed and pulled, tugged and grabbed at me since I was tiny. For all intents and purposes, I am a New Yorker. I can tell you anything, from where to find the best hot dogs in the city (Gray's Papaya on West 72nd Street) to where to find the most expansive collection of old thimbles (Laxo's on Prince Street). The winding streets of Little Italy and Greenwich Village don't faze me, nor does that underground maze—urban limousine—known as the subway system. The city is my home. My fondest memories, the most important events of my life, have happened here.

But I am not just a New Yorker. For as long as I can remember, my imagination has been held by a land of legends some 8,000 miles away. The almost yearly trips to the Middle East, to Palestine, have shaped my think-

ing and have established my obsessions. Even here, in our Upper East Side home, the sounds and smells and sights and tastes of our Arab heritage surround my sister Nigh and me. A typical Sunday morning in our house involves waking up to the strong smell of my mother's Turkish coffee coupled with the toasty smell of *menaeesh*.

In our home Dad is the DJ and Fairouz is our favorite singer. These days my college roommate has learned to request particular songs. At first, though, she'd object to Arab music; "I can't understand what she's saying," was her standard complaint. After a while, I think she realized that complaining was useless, since I would simply take her hands and start dancing with her. Now she is as big a fan as anyone I know. But going to college wasn't all peachy. Having attended a very small high school since I was eleven, it was rare that I'd have to explain "what I am."

Now, the question "What are you?" puzzles me. I know exactly what the questioners want to know—they mean to ask, "What is your ethnic background?" But something about the wording "What are you" is particularly invasive. So I usually give frustrating answers when asked the question in that way. "I am a voracious reader" or "I am a vegetarian" are two of my favorite responses. People usually catch on that I am being obnoxious and will rephrase the question more precisely. Finally, "What is your ethnic background?" Because of the typical response, which I'll get to in a moment, I've turned this into something of a game for myself. "Guess. What do I look like to you?" Most of the time they will guess French, sometimes Russian—I've even gotten Argentinean. But I'm still waiting for the person who surprises me and guesses right.

Yet it's not so much that people guess wrong that bothers me. More than anything else, it is the response I get once the other person has exhausted all of his or her guesses. "Palestinian," I say. Jaws drop. "But you're so white, your eyes are green, you're not wearing that thing on your head!" These are the good responses. I've gotten, "Does your father beat you?" "Do you know how to make a bomb?" "Do you hate Jews?" And, as a five-year-old, "You're one of those rag heads?!" These kinds of reactions used to bother me. But bother is an understatement. Enrage is perhaps adequate.

Somewhere along the way I realized that, while maintaining the passion that rage encompasses is healthy, keeping that hatred inside of me is not. I still hate ignorance, and I think that is okay. My mother told me something some years ago, which I believe to be the most sage advice I've ever received. "Don't hate," she said, "because hate in your heart will consume you, too."

Now when people ask, "Where did you get green eyes from?" I smile, somewhat smugly, and just say, "I bought them, thanks." Perhaps more telling, though, is this: I will never forget being in a discussion group with a very prominent pro-Israeli filmmaker last year. Specifically, I'll never forget the look on his face when, after he had finished proselytizing to a group of young people about the State of Israel as a nation for the "unwanted, for the victims," I stood up and said, "It is exactly that culture of victimization that is the problem with the State of Israel. For when we see ourselves as victims, we forget that we can also victimize others. We forget that we have the capacity to inflict pain on other people." So I refuse to see myself as a victim. For it is not every person who has the honor of saying that their family's lineage goes back two thousand years.

Kathleen Benson

Tala may be an example of the principle of third-generation interest to which Philip Kayal referred in his essay, "So Who Am I? Who Are We?" She is certainly an example of the determination of young New Yorkers of Arab heritage to fight the stereotypes to which Arab New Yorkers and Arab Americans in general have been subjected for too long and to celebrate their rich historical and cultural heritage. Through this book and the museum exhibition in the spring of 2002, the Museum of the City of New York hopes to introduce both New Yorkers and others to the diverse communities of old and new Arabs in New York who are making their own mark on this city of immigrants.

Notes
Glossary
Bibliography
Index

Notes

2. The Syrian-Lebanese Community of South Ferry from Its Origin to 1977

1. Lucius Hopkins Miller, *A Study of the Syrian Population of Greater New York* (New York, 1904), 10–13.

2. W. Bengough, "The Syrian Colony," *Harper's Weekly*, 3 Aug. 1895, 746.

3. U.S. Bureau of the Census, *Twelfth Census of the United States*, (Washington, D.C., 1900).

4. *New York State Census*, 1905.

5. Miller, *Syrian Population of Greater New York*, 15. The population of South Brooklyn was housed largely between 42nd Street and 73rd Street and between 4th Avenue and 6th Avenue.

6. Ibid., 15.

7. Nagib T. Abdou, *Dr. Abdou's Travels in America and Commercial Directory of the Arabic Speaking World* (New York, 1910), 155, 163; Catherine Glover, "Syrians in the Brooklyn Colony Quickly Adopt American Customs," *Brooklyn Daily Eagle*, 10 Feb. 1907, 1.

8. Miller, *Syrian Population of Greater New York*, 13.

9. Philip K. Hitti, *Syrians in America* (New York, 1924), 67; "History of South Ferry," *Brooklyn Daily Eagle*, 8 Aug. 1886 (Brooklyn Historical Society Scrapbooks, vol. 3, p. 9).

10. Herman Rinke, "New York Subways: Fifty Years of Millions!" *Electric Railroads* 23 (Oct. 1954): 2.

11. Miller, *Syrian Population of Greater New York*, 15; Glover, "Syrians in the Brooklyn Colony," 1.

12. Philip M. Kayal and Joseph M. Kayal, *The Syrian-Lebanese in America: A Study in Religion and Assimilation* (Boston, 1975), 153.

13. John K. Sharp, *History of the Diocese of Brooklyn* (New York, 1954), 2:84.

14. Miller, *Syrian Population of Greater New York*, 22–23.

15. Hitti, *Syrians in America*, 107; Reverend Thomas Zain, interview by Mary Ann Haick DiNapoli, St. Nicholas Antiochian Orthodox Cathedral, Brooklyn, N.Y., Jan. 2000.

16. Glover, "Syrians in the Brooklyn Colony," 1.

17. Miller, *Syrian Population of Greater New York*, 25.

18. Ibid., 26.

19. Louise Seymour Houghton, "Syrians in the United States," pt. 3 *Survey*, 2 Sept. 1911, 794.

20. Habib I. Katibah, *Arabic Speaking Americans* (New York, 1946), 26; New York Telephone Company, *Brooklyn, Queens, and Staten Island Directory* (New York, 1924), 699.

21. Maurice E. McLoughlin, "Syrian Settlers in Brooklyn Have Developed Many Talented Citizens in Various Fields," *Brooklyn Daily Eagle,* 22 May 1932, sec. 1, A17.

22. Kayal and Kayal, *Syrian-Lebanese,* 85; Glover, "Syrians in the Brooklyn Colony," 1; Winifred Gregory, ed. *American Newspapers, 1821–1936* (New York, 1937), 467, 471, 472; Abdou, *Dr. Abdou's Travels,* 329.

23. *Al-Hoda, 1868–1968* (New York, 1968), 125.

24. Miller, *Syrian Population of Greater New York,* 14.

25. *Al-Hoda,* 3 Feb. 1903; *Al Mohajer,* 19 Dec. 1903.

26. Miller, *Syrian Population of Greater New York,* 14.

27. *Twelfth Census of the United States.*

28. Miller, *Syrian Population of Greater New York,* 14, 28.

29. Ibid., 30.

30. Ibid., 10.

31. *New York State Census,* 1905.

32. Kayal and Kayal, *Syrian-Lebanese,* 101.

33. Monroe Berger, "America's Syrian Community," *Commentary,* Apr. 1958, 315; The Syrian Society of the City of New York, *First Annual Report* (New York, 1893), 7.

34. Miller, *Syrian Population of Greater New York,* 14.

35. *New York State Census,* 1905.

36. Miller, *Syrian Population of Greater New York,* 30–31.

37. Abdou, *Dr. Abdou's Travels,* 156; S. A. Mokarzel and H. F. Otash, *The Syrian Business Directory* (New York, 1908–09, 31, 33.

38. Abdou, *Dr. Abdou's Travels,* 156, 322; Mokarzel and Otash, *Syrian Business Directory,* 31, 34.

39. Abdou, *Dr. Abdou's Travels,* 156, 567; Mokarzel and Otash, *Syrian Business Directory,* 33, 155.

40. Miller, *Syrian Population of Greater New York,* 14.

41. Abdou, *Dr. Abdou's Travels,* 156; Mokarzel and Otash, *Syrian Business Directory,* 31.

42. Miller, *Syrian Population of Greater New York,* 14.

43. Abdou, *Dr. Abdou's Travels,* 156; Mokarzel and Otash, *Syrian Business Directory,* 31.

44. Katibah, *Arabic Speaking Americans,* 23; Adele Younis, "The Growth of Arabic-Speaking Settlements in the United States," *Arab-Americans: Studies in Assimilation,* ed. Elaine Hagopian and Ann Paden (Wilmette, Ill., 1969), 106.

45. Abdou, *Dr. Abdou's Travels,* 156, 157.

46. Ibid., 156; Mokarzel and Otash, *Syrian Business Directory,* 34.

47. Houghton, "Syrians in the United States," pt. 4 *Survey,* 7 Oct. 1911, 964.

48. Kabil A. Bishara, *The Origin of the Modern Syrian* (New York, 1914), 17; Abdou, *Dr. Abdou's Travels,* 1.

49. Houghton, *Survey,* Sept. 1911, 796, 798; the newspaper article referred to appeared around the time of Houghton's series of articles.

50. Kayal and Kayal, *Syrian-Lebanese,* 74.

51. Houghton, "Syrians in the United States," pt. 1 *Survey,* 1 July 1911, 492.

52. *New York State Census,* 1915.

53. "New York by Races" *New York Times*, 18 Dec. 1921, sec. 7, p. 7.

54. Rinke, "New York Subways," 7.

55. Kayal and Kayal, *Syrian-Lebanese*, 68.

56. Sharp, *Diocese of Brooklyn*, 2:84–85; Zain interview.

57. American Association of Foreign Language Newspapers, Inc., *The Foreign Language Market in America* (New York, 1923), D:28.

58. Ibid., D:35; "Mohammedans Have Paper Here," *Brooklyn*, 25 Aug. 1923, 11.

59. Editorial, *The Syrian Review* (Dec. 1917): 3.

60. Katibah, *Arabic Speaking Americans*, 27; *The Syrian American Directory Almanac 1930* (New York, 1929), 122–23; Philip K. Hitti, *Educational Guide for Syrian Students in the United States*, (New York, 1921), 34.

61. "Syrians Offer to Fight," *New York Times*, 27 Apr. 1914, 4.

62. Hitti, *Educational Guide*, 103.

63. Houghton, "Syrians in the United States," pt. 2 *Survey*, 5 Aug. 1911.

64. Ibid., 655.

65. Katibah, *Arabic Speaking Americans*, 7–8.

66. *New York State Census*, 1915.

67. *Al-Hoda*, 22 Dec. 1921, 21 May 1918.

68. Habib I. Katibah, "Syrians," in *One America*, ed. Francis J. Brown and Joseph Slabey Roucek (New York, 1945), 292.

69. McLoughlin, "Syrian Settlers," A17; Guy Hickok, "Around the World in Brooklyn," *Brooklyn Daily Eagle*, 27 Jan. 1935, A10.

70. Ruth Karpt, "Street of the Arabs," *New York Times*, 11 Aug. 1946, sec. 6, p. 47; "Two Loaves for 8! No, Two Loaves for 5! No, Two Loaves for 6," *Syrian World*, Dec. 1933, 6.

71. *New York State Census*, 1925.

72. *Syrian American Directory*, 135–232.

73. Kayal and Kayal, *Syrian-Lebanese*, 87; Margaret Mara, "Living in Brooklyn: Syrians Contribute to the Borough Mosaic," *Brooklyn Daily Eagle*, 29 June 1949, 19.

74. Mara, "Syrians Contribute," 19.

75. Hitti, *Syrians in America*, 100.

76. "Immigrants in Politics," *Syrian World*, Feb. 1929, p. 42; "Spirit of the Syrian Press: Paper Urges Syrians to Vote," *Syrian World*, Dec. 1926, 68.

77. "Immigrants in Politics," 42.

78. "National Origins Immigrant Plan in Effect; Law Curtails Entrants and Changes Quotas," *New York Times*, 1 July 1929, 3.

79. Joseph W. Ferris, "Restrictions of Immigration," *Syrian World*, Feb. 1929, 4.

80. "About Syria and Syrians: Dagher Night A Great Success," *Syrian World*, Feb. 1931, 53.

81. "Fusion Victory Elates Dagher," *Syrian World*, 10 Nov. 1933, 1.

82. *New York State Census*, 1925.

83. Abdo A. Elkholy, "The Arab-Americans: Nationalism and Traditional Preservations," in *Arab-Americans: Studies in Assimilation*, ed. Elaine Hagopian and Ann Paden (Wilmette, Ill., 1969), 7.

84. *Syrian American Directory*, 116–18.

85. Ibid., 117; Katibah, *Arabic Speaking Americans*, 8.

86. *Syrian American Directory*, 110–11, 123–25.

87. Ibid., 111–12.

88. Ibid., 112–15.

89. *Syrian World*, Sept. 1926; *Syrian American Directory*, 119; McLoughlin, "Syrian Settlers," A17.

90. *Syrian American Directory*, 116, 121, 119.

91. Elkholy, "Nationalism and Traditional Preservations," 7.

92. Jane Corby, "Syrians in Brooklyn Lure Multitudes by Celebrated Cookery," *Brooklyn Daily Eagle*, 31 Oct. 1948, 23.

93. Kenneth T. Jackson, ed., *The Encyclopedia of New York City* (New Haven, Conn., 1995); s.v. "Muslims" by Marc Ferris, 793.

94. Harmon H. Goldstone and Martha Dalrymple, *History Preserved: A Guide to New York City Landmarks and Historic Districts* (New York, 1974), 425–26. The Congregational Church of the Pilgrims merged with Plymouth Church in 1934. The Plymouth Church of the Pilgrims is now on Orange Street.

95. Sharp, *Diocese of Brooklyn*, 2:85.

96. *Syrian American Directory*, 107; Reverend Paul Schneirla, interview by Mary Ann Haick DiNapoli, St. Mary's Orthodox Church, Brooklyn, N.Y., 20 Sept. 1977.

97. Hitti, *Syrians in America*, 111, 108, 134; "Clinton Street Church Deal," *Brooklyn Daily Eagle*, 17 Mar. 1954, sec. 2, p. 1.

98. Hitti, *Syrians in America*, 110.

99. *Syrian American Directory*, 122–23.

100. McLoughlin, "Syrian Settlers," A17.

101. Ibid., A17; *Syrian American Directory*, 122–23.

102. Peter Haley, "Babaganouj, Baklava, and Belly-Dancers," *Phoenix*, 5 May 1977, 39.

103. Hickok, "Around the World in Brooklyn," 10; Hitti, *Syrians in America*, 100.

104. "News of Societies, New York," *Syrian World*, Mar. 1929, 55.

105. "News of Societies, New York," *Syrian World*, Feb. 1929, p. 56.

106. "About Syria and Syrians: Concert in New York by Fedora Kurban," *Syrian World*, June 1929, 52.

107. "About Syria and Syrians: Al-Hoda Moves to Brooklyn," *Syrian World*, Sept. 1930, 58.

108. "*Al-Hoda* Moves," 52; Hitti, *Syrians in America*, 135; Kayal and Kayal, *Syrian-Lebanese*, 85.

109. "*Al-Hoda* Moves," 52.

110. "Notes and Comments: The End of an Experiment," *Syrian World*, Oct. 1927, 49.

111. *Syrian American Directory*, 119.

112. *Syrian World*, July 1926, 58; "Syrian Editor on the *Brooklyn Eagle*," *Syrian World*, Oct. 1926, 57.

113. "Little Syria," *Downtown Brooklyn*, Aug. 1974, 4.

114. "New Radio Series Arranged," *Syrian World*, 15 Dec. 1933, 8; "J. S. Sponsors Program," *Syrian World*, 20 Dec. 1934, 3; "Syrian World to have Regular Broadcasts," *Syrian World*, 9 Mar. 1935, 1; "Arabic Radio Programs," *Syrian World*, 30 June 1933, 3.

115. Reverend W. A. Mansur, "Problems of Syrian Youth in America, I," *Syrian World*, Dec. 1927, 9.

116. "Children of America," *Syrian World*, Mar. 1929, 15.

117. "Spirit of the Syrian Press: The Position of the Emigrant," *Syrian World*, Feb. 1928, 48.

118. Caroline Zachary Institute of Human Development and the Common Council for American Unity, *Around the World in New York* (New York, 1950), 16.

119. Frances Diane Robotti, *Key to New York: Empire City* (New York, 1964), 29–30.

120. Margaret Mara, "Living in Brooklyn: For Delicacies, Try the 'Casbah,' " *Brooklyn Daily Eagle*, 30 Oct. 1960, sec. 2, p. 19.

121. "Syrian Young Men Oppose Cobble Hill Rehabilitation," *New York Times*, 2 Oct. 1962, 35.

122. Emily Arbeeny, "Lifelong Cobble Hill Resident: 'Landmarks, You Done Me Wrong,' " *Phoenix*, 23 June 1977, 7.

123. Kayal and Kayal, *Syrian-Lebanese*, 197; Protestant Council of the City of New York, *Bay Ridge, Bensonhurst, Borough Park, Sunset Park: Four Communities in Southwest Brooklyn* (Chicago, 1955), 18; Community Council of Greater New York, *Brooklyn Communities* (1959), xxxix, 69; Jim Mannix, "Ye Olde Timers: Syrian Thoughts," *Home Reporter and Sunset News*, 17 Mar. 1972, sec. 2, p. 28.

124. "Little Syria"; John L. Hess, "Mideast Tension Afflicting the Arab Communities Here," *New York Times*, 7 Oct. 1972, 35; Monica Surfaro, "An Exciting Urban Bazaar," *Phoenix*, 25 Sept. 1975, 15.

125. "Little Syria," 4.

126. Haley, "Babaganouj," 39.

127. "Clinton Street Church Deal," sec. 2, p. 1.

128. "Cobble Hill Church Building to be Made Into Arabic Music Hall," *Phoenix*, 30 Jan. 1975, 4.

129. "Maronite Diocese is Moving to Brooklyn," *The Tablet*, 11 Aug. 1977, 6.

130. Haley, "Babaganouj," 39.

131. *Around the World in New York*, 103.

132. Ibid., 95.

133. Ibid., 17.

134. William Debs, interview by Mary Ann Haick DiNapoli, Brooklyn, N.Y., Jan. 2000.

135. Linda Charlton, "End Comes to *Al-Hoda*, Arab Paper," *New York Times*, 21 Sept. 1971, 39; Hess, "Mideast Tension," 35.

136. "Truman Gets Arab Plea," *New York Times*, 4 Oct. 1951, 10.

137. "U.S. Praised on Lebanon," *New York Times*, 27 July 1958, 7.

138. Hess, "Mideast Tension," 35.

139. Editorial, *New Lebanese American Journal*, 16 Oct. 1975, 2.

140. Mike Homsey, "Letters to the Editor: Reader Says Arab is Beautiful," *Home Reporter and Sunset News*, 2 Nov. 1973, sec. 2, p. 88.

141. Kayal and Kayal, *Syrian-Lebanese*, 81.

142. Ibid., 122.

143. Ibid., 125, 139.

144. Ibid., 21, 201.

145. Ibid., 115.

146. Ibid., 191.

147. Ibid., 106.

148. Ibid., 106.

149. Ibid., 133.

150. Ibid., 84.

151. Ibid., 120, 171.

152. Elkholy, "Nationalism and Traditional Preservations," 12.

153. Mary Bosworth Treudley, "The Ethnic Group as a Collectivity," *Social Forces,* Mar. 1953, 261 (quoted in Kayal and Kayal, *Syrian-Lebanese,* 172).

3. Impressions of New York City by Early Arab Immigrants

1. Salloum A. Mokarzel, *Tarikh al-tijara al-Suriyya fi al-mahajir al-Amirkiyya (The History of Trade of Syrian Immigrants in the Americas)* (New York, 1920). In Arabic.

2. While Henry Chapman Ford, the author of *Anna Ascends,* got the idea for writing a play about a Syrian (i.e., Arab American) woman after he met and became friends with an Arab family in Washington, D.C., and whereas the star of his play was modeled after an Arab woman (Anna Ayyobb) he met in Boston, the play itself takes place in New York City. See Henry Chapman Ford, "Why I Wrote a Syrian Play," *Syrian World,* July 1927, 33–34.

3. Mikhail Naimy, *Sab'oun: Hikayet 'umr (Seventy: Story of a Lifetime),* vol. 1, 1889–1911 (Beirut, 1967), 60. In Arabic.

4. F. M. Al Akl, *Until Summer Comes* (Springfield, Mass., 1945), 9.

5. Solomon D. David, *Transfigured: The Autobiography of Solomon D. David, MD,* as told to J. Robert Moffett (New Braunfels, Tex., 1979), 17.

6. Abraham Mitrie Rihbany, *A Far Journey* (Boston, 1914), 143–45; see also Al Akl, *Until Summer Comes,* 247.

7. Salom Rizk, *Syrian Yankee* (Garden City, N.Y., 1943), 70.

8. Ibid., 71–72.

9. Mikhail As'ad Rustum, *al-Ghareeb fi al-gharb (The Stranger in the West)* (New York, 1895), 15–16. In Arabic. See also George Hamid, *Circus* (New York, 1959), 45.

10. Rizk, *Syrian Yankee,* 119.

11. Abdou, *Dr. Abdou's Travels,* 614; see also, "Three American Wonders Seen by a Tourist on a New York Street in a Twenty-Minute Period," *al-Jami'ah,* 15 July 1906, 62–63. In Arabic. The three "wonders" were electrical engraving on stone; a piece of land measuring eighteen by eighteen feet at a New York street corner, which was sold for $750,000, a huge amount at the time; the use of a human standing like a statue as an advertisement for the cigar he smoked. A third early observer of the New York scene was Philip Hitti, who noted Americans' "good will toward all and passion for work" (see "She Thought I Was an 'Assyrian,' " *World Outlook,* June 1918, 14).

12. Faud Sarruf, *Mashahid al-'alam al-jadid (Views of the New World)* (Cairo, Egypt, 1925), 8. In Arabic.

13. Ibid., 19.

14. Ibid., 27.

15. Ibid., 30, 34.

16. Ahmed Zaki Abu-Shady, *Min al-Sama' (From Heaven)* (New York, 1949), 151–53. In Arabic.

17. Khalil Sakakini, *Katha ana ya dunia (Thus Am I, Oh World)* (Jerusalem, 1955), 14. In Arabic.

18. Sakakini, *Ma tayassar (What Is Available)* (Jerusalem, 1943), 95. In Arabic. Sakakini's observations were originally made in a 1918 article in *al-Sufur* (Egypt), under the title "The Way Americans Live." In Arabic.

19. Sakakini, "Some Observations after My Departure from Syria to America," *al-Jami'ah,* 21 Mar. 1908, 4. In Arabic.

20. Sakakini, "Some Observations after My Departure from Syria to America," *al-Jami'ah*, 28 Mar. 1908, 6. In Arabic.

21. Ralph A. Felton, "A Sociological Study of the Syrians in Greater New York" (master's thesis, Columbia Univ., 1912), 30–31.

22. Niqula Haddad, "A Painful Sight in New York," *al-Jami'ah*, June 1908, 113–18. In Arabic.

23. Ibid., 117.

24. Haddad, "A School for the World on Brooklyn Bridge," *al-Jami'ah*, Oct. 1908, 233–44. In Arabic.

25. Ibid., 235.

26. Ibid., 235.

27. See Nadeem N. Naimy, *Mikhail Naimy: An Introduction* (Beirut, 1967).

28. A suggestion that Naimy should live in the Arab quarter of Brooklyn did not appeal to him at all because he greatly valued his privacy and a life of seclusion. Mikhail Naimy, *Seventy*, vol. 2, 1911–1932, p. 66.

29. Ibid., 8, 10.

30. Ibid., 13.

31. Ibid., 27.

32. Ibid., 65.

33. Mikhail Naimy, "Two Scenes out of Many," *al-Sa'ih*, 19 July 1923, 5. In Arabic.

34. Rihbany, *A Far Journey*, 202–04.

35. Nasib Arida, *al-Arwah al-ha'irah (Bewildered Souls)* (New York, 1946), 269–73. In Arabic.

36. Ibid., 270.

37. Ibid., 271.

38. Ibid., 272–73.

39. See Geoffrey Nash, *The Arab Writers in English: Arab Themes in a Metropolitan Language, 1908–1958* (Brighton, Eng., 1998); see also the extensive information about Ameen Rihani and his works on the following website: http://www.ameenrihani.org.

40. Ameen Rihani, "On the Roofs of New York," in *Rihaniyyat (Rihani Writings)* (Beirut, 1922), vol. 1, pp. 63–67. In Arabic.

41. Ibid., 66.

42. Rihani, "On Brooklyn Bridge," in *Rihaniyyat (Rihani Writings)*(Beirut, 1922), vol. 1, pp. 56–62. In Arabic.

43. Ibid., 58.

44. "New York," *al-Samir*, 1 Dec. 1929, 721–22. In Arabic.

45. Ibid., 722.

46. It is worth noting here that Sarruf also had much praise for the Arab American press and for the great progress achieved by the Arab community in New York City and in the United States generally. Sarruf, *Mashahid al-'alam al-jadid (Views of the New World)*, 72–86.

47. Ibid., 150–61.

48. Philip Hitti, "America in the Eyes of an Easterner," *al-Hilal*, 31, nos. 3, 4, 5, 6, 7, 8, 9 (Dec. 1922; Jan., Feb., Mar., Apr., May, June 1923): 246–55; 371–79; 474–80; 580–88; 715–20; 811–18; 940–44. In Arabic.

49. Hitti, "America in the Eyes of an Easterner," *al-Hilal*, 31, no. 4 (Jan. 1923): 376; see also Hitti, "The American Woman and the Syrian Woman," *al-Mawrid al-Safi*, 6, no. 2 (Mar. 1921): 97–106. In Arabic.

50. Another fervent admirer of the great advances made by women in America was Amir Boqtor. See his "The Wonders of Women's Progress in America," *al-Sayyidat wa-al-rijal*, 6, no. 8 (30 June 1925): 5–7; and "The Contrast between Women's Conditions in the East and Women's Great Progress in America," *al-Sayyidat wa-al-rijal*, 7, no. 1 (Nov. 1925): 5–8. Both articles in Arabic.

51. Farah Antun, "An Easterner's View of the West," *al-Jami'ah*, (Apr., May, June, July 1908): 64–69, 93–96, 105–12, 149–55. In Arabic.

52. Antun, "Observations in America," *al-Jami'ah*, 15 Sept., 15 Oct., 1 Nov. 1906): 208–12, 257–69, 313–17. For another admiring view of America, see Mahmoud Sami, "What I Saw in the United States," *al-Hilal*, 38, no. 4 (1 Feb. 1930): 407–11. In Arabic.

53. Rihbany, *A Far Journey*, 144.

54. For a sample of some of the anguish and psychological pain suffered by the Arabs in New York and in America generally presented in a humorous account, see William Peter Blatty, *Which Way to Mecca, Jack?* (New York, 1960).

55. See, in particular, Rihbany, *The Syrian Christ* (Boston, 1916); *Wise Men from the East and from the West* (Boston, 1922); Rihani, *The Book of Khalid* (New York, 1911); "My East and West," *Asia*, 36, no. 12 (Dec. 1936): 776–78; and "A Common Measure for East and West," *Asia*, 35, no. 3 (Mar. 1935): 173–75. For Rihani, the best possible solution for East-West contrasting contributions was cross-fertilization and mutual understanding. See, in particular, "Where East and West Meet," *The Open Court*, 48, no. 2 (Apr. 1934): 65–76.

5. My Mother's Zither

1. *Grape Leaves: A Century of Arab American Poetry*, edited by Gregory Orfalea and Sharif Elmusa, University of Utah Press, 1988, reprinted by Interlink Publishers in 2001.

8. So, Who Are We? Who Am I?

1. This perspective on the relationship of self to others is commonly referred to as "the sociological imagination." It means seeing the links between private biographies and social circumstances.

2. Cahnman and Werner, "Religion and Nationality," *American Journal of Sociology*, vol. 99:6 (May 1944), 524–29.

3. Philip M. Kayal, ed., *The Coming of the Arabic-Speaking People to the United States*, by Adele L. Younis (New York, 1995).

4. Hitti, *Syrians in America*.

5. Kayal, Philip, "Eastern Orthodox Exogamy and the 'Triple Melting Pot' Theory: Herberg Revisited," St. Vladimir's Theological Quarterly, vol. 25, 1981, 239–57; Saliba, Najib. "Emigration from Syria" in *Arabs in the New World: Studies on Arab-American Communities*, ed. S. Y. Abraham and N. Abraham (Detroit, 1983), 30–43.

6. Kayal and Kayal, *Syrian-Lebanese*.

7. Kayal, *Coming of the Arabic-Speaking People*.

8. I had the honor to edit this fascinating history book with substantial help from Paula Hajar, my friend and colleague.

9. Kayal, *Coming of the Arabic-Speaking People*.

10. Will Herberg, *Protestant, Catholic, Jew: An Essay in American Religious Sociology* (Garden City, N.Y., 1960).

11. Herberg, *Protestant, Catholic, Jew.*

12. Hensen, Marcus, "The Third Generation in America," *Commentary* XIV (November 1952), 492–500.

13. Kayal, 1981.

14. Kayal and Kayal, *Syrian-Lebanese.*

15. Kayal, *Coming of the Arabic-Speaking People.*

16. Treudley, Mary B., "The Ethnic Group as Collectivity," Social Forces, 31 (1953), 262–65.

17. In a trip to Syria in 1993, the author was startled at the number of Lebanese Maronite merchants in Aleppo who actually disdained their Syrian hosts, referring to them as backward and uncultured "hicks" because they were not Western-oriented.

18. Breton, Raymond, "Institutional Completeness of Ethnic Communities and the Personal Relations of Immigrants," *American Journal of Sociology,* vol. 70 (September 1964), 2.

19. Ernest N. McCarus, *The Development of Arab-American Identity* (Ann Arbor, Mich., 1994).

20. Kayal, 1981.

21. I do not believe this situation has changed. I doubt if Muslim Arab Americans of the immigrant generation would prefer or easily accept an Arab Christian spouse or a non-Arab Muslim spouse over an Arab Muslim from the same country and city, etc.

22. McCarus, *Arab-American Identity.*

23. Hensen, 1952.

24. Kayal and Kayal, *Syrian-Lebanese.*

9. Inventing and Re-inventing the Arab American Identity

1. Nabeel Abraham, "Detroit's Yemeni Workers," *MERIP Reports,* 53 (1977): 3–9.

2. Nabeel Abraham, "National and Local Politics: A Study of Political Conflict in the Yemeni Immigrant Community of Detroit, Michigan" (Ph.D. Diss., Univ. of Michigan, 1978).

3. Ayad al-Qazzaz, "The Arab Lobby: Toward an Arab-American Political Identity," *al-Jadid* 14 (Jan. 1997): 10.

4. Hussein Ibish in Curtis Stokes, ed. *Race in the 21st Century* (2001); Hussein Ibish in Joy James, ed., *States of Confinement* (1999).

5. al-Dari, 72.

6. al-Dari, *al-Wujud,* 71.

7. Omar Afzal,"Learn not Copy: Movements Facing Challenges of the West," *The Message,* Mar. 1996, 23.

8. Ibid., 23.

9. Ibid., 23.

10. Isma'il R. Al-Faruqi, "Islamic Ideals in North America," in Earle E. Waugh et al., *The Muslim Community in North America* (Edmonton, 1983), 259–70.

10. The Changing Arab New York Community

1. The Arab immigrants of the 1880s who established the founding colony of Washington Street in Lower Manhattan had all but resettled in Brooklyn by the 1930s; see

Mary Ann Haick, "The Syrian-Lebanese Community of South Ferry, 1900–1977" (master's thesis, Long Island Univ., 1979).

2. The Muslim Communities in New York City Project of Columbia University was honored to participate in a symposium on Arab Americans in New York City hosted by the Museum of the City of New York in early February 2000. Here, we revisit our symposium presentation, titled "The Changing Arab New York Community," and address more specifically emerging issues of Arab Muslim identity and community in New York City.

3. The Muslim Communities in New York City Project was funded by a grant from the Ford Foundation.

4. Eight of the ten researchers were Muslims.

5. See "Olé to Allah: New York's Latino Muslims" <www.latinmuslims.com/history/muslims_aidi.html> by Hisham Aidi, a Ph.D. candidate at Columbia University and a member of our research team.

6. Probably 95 percent of these were established in just the past 25 years.

7. The "Arab" category was used for the first time in the 1990 census and includes all those indicating Egyptian, Iraqi, Jordanian, Lebanese, Moroccan, Palestinian, Syrian, and "other" Arab ancestry in response to the ancestry question on the census questionnaire. The survey researcher, John Zogby, himself an Arab American, has argued that the size of the Arab American population in New York City is considerably higher than the official census would suggest. Zogby estimated that the number of Arab Americans in 1990 in Brooklyn, Queens, and Manhattan alone was closer to 160,000.

8. New York City is thought to be home to one in ten Muslims in the United States. The estimate of 600,000 for the number of Muslims in New York City, then, is ten percent of six million estimated Muslims in the United States.

9. The lower estimate of 40,000 was obtained by multiplying 136,000 by 30 percent, the estimated national percentage of Muslims in the Arab American population as reported by Jack Shaheen (*Arab and Muslim Stereotyping in American Popular Culture* [Washington, D.C., 1997]). The higher number of 74,000 was calculated by multiplying 600,000 (a rough estimate of the Muslim population for New York City) by 12.4 percent (sociologist Fareed Numan's 1990 estimated percentage of Arab/Middle Eastern Muslims in the United States).

10. Our canvassing of Staten Island revealed only one significant Arab Muslim site, a small mosque community of mostly Egyptians.

11. The U.S. Census Bureau projects that about 40 percent of New York City's population is now foreign born.

12. Kayal and Kayal, *Syrian-Lebanese*; Eric J. Hooglund, Introduction to *Crossing the Waters: Arabic-Speaking Immigrants to the United States Before 1940* (Washington, D.C., 1987); Younis, *Coming of the Arabic-Speaking People*.

13. Jonah Blank, writing in *U.S. News and World Report*, notes that "five to six million strong, Muslims in America already outnumber Presbyterians, Episcopalians, and Mormons, and they are more numerous than Quakers, Unitarians, Seventh-day Adventists, Mennonites, Jehovah's Witnesses, and Christian Scientists, combined. Many demographers say Islam has overtaken Judaism as the country's second-most commonly practiced religion; others say it is in the passing lane." See "The Muslim Mainstream," *U.S. News and World Report*, 20 July 1998.

14. Identifying a particular mosque as "Arab," "Turkish," "Pakistani," or by some other specific ethnic category is of questionable value of utility for two reasons. First, Muslims in New York City strongly disapprove of such labels, which they believe under-

mine the concept of the unity and equality of all Muslims in the global Islamic commu-
nity, the *ummah*. Second, it would be exceedingly difficult to find a single mosque in
New York whose board of trustees, Imam, and "congregation" all belong to the same eth-
nic group. Although ethnicity is sometimes a factor in power struggles over governance
and decision making, the multi-ethnic character of most mosques is more the rule than
the exception.

15. Since there is no official registry for New York City mosques, a precise count is
difficult. The Muslim Students Association lists about 115 mosques, but infrequent up-
dates make this number uncertain. Members of our research team heard anecdotal esti-
mates of about 130 mosques.

16. Fund-raising sometimes extends to the home country or to philanthropic organ-
izations or governmental agencies in wealthy Muslim countries such as Saudi Arabia and
the Gulf States.

11. Arab Families in New York Public Schools

1. Vivian Paley, *White Teacher* (Cambridge, Mass., 1979), xv.

12. The Syrian Jews of Brooklyn

1. See Gregory Orfalea and Sharif Elmusa, *Grape Leaves: A Century of Arab-
American Poetry* (Salt Lake City, Utah, 1988); Younis, Selections, *Coming of the Arabic-
Speaking People*; and Younis, "Growth of Arabic-Speaking Settlements."

2. For a study of Yemeni Jews in New York City, see Dina Dahbany-Miraglia, "Amer-
ican Yemenite Jewish Interethnic Strategies," in *Persistence and Flexibility: Anthropo-
logical Perspectives on the American Jewish Experience,* ed. Walter P. Zenner (Albany,
N.Y., 1988), 63–78. Also see Victor D. Sanua, "Contemporary Studies of Sephardic Jews in
the United States," in *Coat of Many Colors: Jewish Subcommunities in the United
States,* ed. Abraham D. Lavender (Westport, Conn., 1977), 280–88.

3. Kayal and Kayal, *Syrian-Lebanese.*

4. Sisterhood of Deal, *Deal Delights* (Deal, N.J., 1980); also see Grace Sason, *Kosher
Syrian Cooking* (Brooklyn, N.Y., 1988) and Claudia Roden, *A Book of Jewish Food* (New
York, 1997).

5. Sephardic Archives, *The Spirit of Aleppo: Syrian Jewish Immigrant Life in New
York, 1890–1939* (Brooklyn, N.Y., 1986).

6. Diane Matza, ed., *Sephardic-American Voices* (1997), 163–67; Orfalea and El-
musa, *Grape Leaves.*

14. Arab Americans: Their Arts and New York City, 1970–2000

1. *The World of Rashid Hussein,* ed. Kamal Boullata and Mirene Ghossein, Associa-
tion of Arab-American University Graduates Monograph 12 (Detroit, Mich., 1999).

2. Ibid.

3. Notes by D. H. Melhem introducing a selection of her poems in *Grape Leaves,* ed.
Orfalea and Elmusa.

4. Alberto Mobilio in *Voice Literary Supplement,* quoted on the cover of Lawrence
Joseph, *Before Our Eyes, Poems* (New York, 1993).

5. "Some Sort of Chronicler I Am" from Joseph, *Before Our Eyes.*

6. "It is warm in Grandmother's kitchen . . ." from D. H. Melhem, *Rest in Love* (New York, 1978).

7. Anne Rasmussen, "Arab Music in the United States: An Historical Overview," in the program book of the first *Mahrajan-al-Fan* (Sept. 1994).

8. *New Routes: The Newsletter of the Ethnic Folk Arts Center* (spring 1994).

15. Hollywood's Muslim Arabs

1. Jack G. Shaheen, *The TV Arab* (Bowling Green, Ohio, 1984), 122; see also Jack G. Shaheen, "American Television: Arabs in Dehumanizing Roles," in *The American Media and the Arabs,* ed. Michael C. Hudson and Ronald G. Wolfe (Washington, D.C., 1980), 39–40.

2. John Esposito, *The Islamic Threat* (New York, 1992), 5.

3. Carla Power, "The New Islam," *Newsweek,* 16 Mar. 1998, 35.

4. Sulayman Nyang's statement from "Campaign Highlights Muslims' Quandary," *Los Angeles Times,* 10 Aug. 1996, B10.

5. Steven Barboza, *American Jihad* (New York, 1993), 9.

6. John Dart, *Deities and Deadlines* (Nashville, Tenn., 1996), 19; "The World Shrinks and Stereotypes Fall," *Detroit Free Press,* 11 Apr. 1986.

7. Jay Stone, "Billionaires, Bombers, and Belly Dancing," *Ottawa Citizen,* 17 Mar. 1996, 1C

8. Ibid.

9. Ibid.

10. Speech to the Association of American Editorial Cartoonists, San Diego, Calif., 15 May 1986; see Sam Keen, *Faces of the Enemy* (Cambridge, Mass., 1986), 29–30.

11. John F. Kennedy, Yale University Commencement Address, 1962.

12. Jack G. Shaheen, "Our Cultural Demon: The 'Ugly' Arab," *Washington Post,* 19 Aug. 1990, C1-C2.

13. Jack G. Shaheen, "Screen Images of Palestinians in the 1980s," in *Stock Characters in American Popular Film,* vol. 1 of *Beyond the Stars,* ed. Paul Loukides and Linda K. Fullers (1990).

14. *Stock Characters in American Popular Film,* 50.

15. *Jerusalem Report* (17 Oct. 1996): 49.

16. Jack G. Shaheen, "There Goes the Neighborhood," *Atlanta Journal/Constitution,* 3 Feb. 1996, 7.

17. "It's Racist, but Hey, It's Disney," editorial, *New York Times,* 14 July 1993.

18. Joanne Brown, "Stereotypes Ruin Fun of *Aladdin,*" *Des Moines Register,* 22 Dec. 1992, 12.

19. Russell Baker, "More Killing, Hollywood Style," *Jacksonville (Wis.) Gazette,* 1 Sept. 1997.

20. Nicholas Kadi on *48 Hours,* CBS-TV (30 Jan. 1991).

21. *FX: The Series,* UPN, channel 9, New York City (29 Nov. 1996).

22. *Jon Stewart Show,* KMOV-TV, St. Louis, Mo. (25 Feb. 1995).

23. *Twisted Puppet Theater,* Showtime (23 July 1995).

24. See my "Cartoons as Commentary" (paper presented at the Chicago Historical Society during the Illinois Humanities Council's Festival, 13 Nov. 1993).

25. Hamzi Moghrabi, "A Rush to Judgment—Again," *Cleveland Plain Dealer,* 23 Apr. 1995, 3C.

26. See Council on American-Islamic Relations, *A Rush to Judgment: A Special Report on Anti-Muslim Stereotyping,* (Washington, D.C., 1996), 9, 10; see also, *The Daily Oklahomian,* 25 Apr. 1955.

27. Moghrabi, "A Rush to Judgment—Again," 3C.

28. Jerry Mander, *Four Arguments for the Elimination of Television* (New York, 1978), 13.

29. See Council on American-Islamic Relations, *A Rush to Judgment.*

30. Laurie Goodstein, "Report Cites Harassment of Bombing," *Washington Post,* 20 Apr. 1996, A3.

31. Marc Briendel, "School Yearbook Scandal Prompts Surprise, Anger," *Hills Publications,* 13 June 1996, 3.

32. American-Arab Anti-Discrimination Committee, *Report on Hate Crimes and Discrimination Against Arab Americans,* (1996–97), 33.

33. David Stewart Hull, *Film in the Third Reich* (Berkeley, Calif., 1969), 157–77.

34. Ibid.

35. Meg Greenfield, "A Mideast Mistake in the Making," *Newsweek,* 29 May 1986, 84.

36. Gilbert Cates cited in "TV Women Portraying New Image," *St. Louis Post-Dispatch,* 26 Jan. 1993, 3D.

37. Katherine Roth, "Muslims Observe Holy Month of Fasting and Prayer," *Island (Hilton Head, S.C.) Packet,* 27 Jan. 1996, 4B.

38. Jay Leno on *Larry King Live,* CNN transcript no. 1652 (24 Jan. 1996).

39. Jack Guss, interview by Jack G. Shaheen, Los Angeles, Calif., 15 July 1980.

40. *Movieline* (June 1998): 50.

41. Katzenberg cited in Shaheen review of *Father of the Bride, Part II.*

42. "CAIR Good News Alert," 26 Jan. 2001.

17. Being Arab American in New York

1. The Crescent and Star symbol is associated with Muslim countries in much the same way as the Stars and Stripes are with the United States.

Glossary

All terms are Arabic language unless otherwise noted.

Abn al-'Arab: Literally, "the children (or descendants) of the Arabs."

Al-Bayan: Literally, "information." Brooklyn-based Muslim paper established in 1914.

Al-Hoda: Literally, "The Guidance." Prominent Arab American newspaper and publishing house. It also published the *Lebanese American Journal* in English.

Al-Jami'ah: Translates as league, union, federation, university, or community, depending on the context.

Allah ma'a kum: Translates as "God be with you."

Al-Majallah Al-Tijariyeh: Literally, "The Business Review." This newspaper reported the business activities of the early Syrian community.

Al-Rabita al-Qalamiyya: Literally, "The Pen Bond" or "Association of the Pen." A literary society founded by Kahlil Gibran and others. Also *Ar Rabitah al Qalamuya.*

Al-Samir: Literally, "The Entertainer." Prominent Arab-American journal. Also *Al Sameer.*

Al Quds, Al Quds: Literally, "The Flower of Cities," i.e., Jerusalem.

Alwan: Literally, "the colors."

Ameraba: A term to describe the fusion or creation of an Arab and American musical sound or beat. Popularized by Eddie Kochak of Brooklyn.

Antiochian Orthodox: When the Christian Church split into Western and Eastern segments in 1054, the Eastern Church become known as the Eastern Orthodox Church. It is variously called the Byzantine or Greek Church because this religion follows the rituals developed around the Byzantine Court. In Syria and Lebanon this Orthodox tradition is called Antiochian. The Church in the West became known as the Roman or Latin Church.

Awlaad: Children or offspring. The plural form of *walad,* child or offspring.

Awlaad Arab: Literally, "Offspring of the Arabs." Used to differentiate first- or second-generation Americans (or others) of Arab heritage from those born in Arab countries.

257

Ay-rab: Arab. Originally the Arabs were desert dwellers and the first to adopt Islam. Today the term refers to those who speak Arabic or identify with the Arab East and is no longer a biological or racial category.

Baqashot: Literally, supplications or requests. Hebrew petitionary prayers sung in the synagogue.

Batlawa: The Arabic word for the popular pastry known as Baklava. It is layers of fillo dough stuffed with walnuts and covered in either honey or sugar syrup.

Bedouin: Generally a term for Arab or Muslim dwellers of the desert.

Bey: Title of courtesy addressed to males.

Bint al-'Arab: Literally, "daughter of Arabs." An Arabic woman.

Bint Mean?: Literally, "daughter of whom?" An inquiry regarding the family roots of an Arab girl.

Dabke, Dabkees: Arab line dance, in which dancers holding hands behind a leader follow him or her in an intricate pattern of steps, stamping rhythms with the feet. Also *debke.*

Da'wa: Calling the people to Islam; an outreach effort.

Diaspora: The dispersed members of an ethnic or national group.

Diwan: An assembly.

Dome of the Rock: One of the holiest spots and mosques of Islam. Located in Jerusalem.

Druse: An Islamic sect, mostly Lebanese and Syrian.

Durbakee: A circular drum held between the legs and played by an open hand.

Eastern-rite Catholics: Orthodox groups in Syria and the Ukraine who are in communion with Rome, or the Western church, are known as Eastern-rite Catholics. Other Eastern-rite but non-Byzantine traditions, like the Maronites, are also Eastern-rite Catholics. Many Catholics think that their Western or Latin tradition is the only Catholic tradition because it is the most numerous and widespread. But the Catholic Christian tradition has both Western and Eastern branches. There are Roman Catholics of the Latin rite and Roman Catholics of the Eastern rite, as well as many Eastern-rite Melkites, Maronites, Copts, Armenians, and Syriacs, to name a few. The leaders of these churches are called Patriarchs, similar to the Pope, who is also the Patriarch of the Latin rite. For Eastern Catholics, the Pope is the first among equals.

Effrenj: Literally, "from Franks" (franji). European or European-style.

Eid: Holiday or holy day.

Eid al-Fitr: Literally, "breaking-the-fast holiday." A major Muslim holy day, the end of Ramadan.

Falafel: A popular Palestinian food made of crushed chickpeas and spices, fried in oil and served in pita or Syrian bread.

Farsi: The early language of Persia or Iran.

Fatwa: A legal statement in Islam, issued by a *mufti* (lawyer expert in religious law) on a specific topic.

Glatt **Kosher:** *Glatt* in Yiddish, literally, "smooth." A Jewish term for the highest level of dietary restrictions.

Habibti: Term of endearment addressing a female, meaning "my love." The masculine is "Habibi."

Hadith: Prophetic tradition; with the Koran, the guide to Islamic life. The narrative relating the deeds and utterances of Prophet Muhammad and his companions.

Hafla, Haflis: A large gathering of people, usually indoors at a hotel, featuring Arabic music, dance, and food; a party.

Hajj: One of the five pillars of Islam—requirements of a Muslim's religious duty, it is a religious pilgrimage or journey to Mecca. The other four are the belief in the one and only God, prayer, fasting, and almsgiving or charity.

Halal: Meat that has met the religious requirements in the butchering process.

Halawah, Halvah: Literally, "something sweet." In America, a confection made of crushed sesame seeds and honey.

Ibin Mean?: Literally, "son of whom?" An inquiry regarding the family roots of an Arab boy.

Ibin al-'Arab: Literally, "son of Arabs." Arabic man.

Iftar: The breaking of the daylong fast at sunset during Ramadan.

Imam: Leader of prayer in a prayer group and head of a mosque.

Imhotep: Ancient Egyptian who lived during the reigns of Djoser and his successors. High Priest of the god Ptah, he was an architect who oversaw the construction of Djoser's Step Pyramid and surrounding complex. The antagonist in the movie *The Mummy* was named after and very loosely based on him.

Intifada: Literally, "shaking off." A modern term referring to the recent Palestinian resistance movement and civil uprising spontaneously generated by young people.

Ismi: Literally, "my name."

Joha: Folkloric character in Arabic storytelling, generally portrayed as a wise fool.

Jihad: The obligation to defend one's faith or beliefs.

Jinnee, Jin: Arab mysticism, or spirits created by God, both good and evil.

Juma, Jumea: Literally "Friday" or "week." From the word for "gathering," Friday being the day appointed for praying as a community.

Kaaba, Ka'ba: From the Arabic for "cube." The cubic structure covered with black cloth within the Great Mosque in Mecca, the Prophet Muhammad's birthplace. It is the focal point of the *Hajj.* According to tradition, Abraham built a shrine on this site.

Kanoon: A sweet-sounding seventy-string instrument unique to Arab music. Also *Qanoon.*

Kawkab Amerika: "Star of America," or "American Star," the first Arabic-language newspaper in the United States.

Khaleek Azab: Literally, "remain a bachelor."

Khutba: An Islamic speech or sermon. Sometimes used to refer to the sermon given during the Friday Congregational Prayer.

Kibbeh: Refers to a type of meat dish popular in Syria and Lebanon. It is lamb with bulgur wheat, onion, and salt, pounded into a dough then baked, fried, or stewed with a stuffing of nuts, meats, and spices.

Kitniyot: Aramaic, literally, "legumes." Refers to special dietary restrictions concerning legumes during Passover. The exact restrictions differ between Sephardic and Ashkenazi traditions.

Kuffiyeh: Checkered head scarf traditionally worn by men; today the black-and-white version has come to represent the Palestinian resistance movement.

Lahimajin: Meat pies made with lamb and spices.

Latinized: The Western Catholic rite tradition. See Romanized.

Levant: From the French *Levant* for the rising of the sun, i.e., east. Generally, a term for the Near East, including Lebanon, Syria, Palestine, and Iraq, and the Arab inhabitants of the region.

Madeiras: Embroidered petit-point table linens from the Portuguese islands of Madeiras.

Melkites: In Syria around 1724, several Antiochian Orthodox bishops and their followers entered into communion with the Roman or Latin Church. They were Byzantine in theology and rituals and became known as Byzantine or Eastern-rite Catholics. They are variously called Melkites or Greek Catholics because they combine their Byzantine or Greek heritage with their Catholic allegiance to Rome.

Maghreb: Literally, "sunset." Refers to northwestern Africa and the Arab inhabitants of the region.

Mahjar: Literally, "emigrant."

Mahrajan: Literally, "festival." A large outdoor Arab picnic akin to a *Hafleh.* Normally held on a fairground over a long holiday weekend complete with food, music, and dance.

Mahrajan al-Fan: Literally, "festival of the Arts."

Maqam, Maqamaat: Arab musical mode. *Maqamaat* is the plural.

Markaz: An Islamic community center without a school.

Maronites: The Catholics of Lebanon and some cities of Syria, especially Aleppo, are known as Maronites. They use the traditions of the early Church at Antioch, not Byzantium. Their rituals closely resemble those of the Western or Roman church. The Maronites claim an unbroken loyalty to and affiliation with the Church of Rome. They have their own hierarchy under a Patriarch who lives in Lebanon.

Masjid: See *Mosque.*

Masalla: An Islamic community center with a private day school.

Matzoh: Hebrew, literally, "unleavened bread." Served during Passover in the Jewish tradition.

Medina: Literally, "city." Generally refers to *Al Medina (al Munawwara)*, "the Radiant City," or *Medina[t]al Nabi*, "City of the Prophet," the city in Saudi Arabia to which Muhammad fled from Mecca in 622 A.D. the year from which the Muslim calendar is dated. It is a stop on the *Hajj* pilgrimage.

Menaeesh: An Arab sandwich made of olive oil and *za'atar* (an herb from the region similar to thyme).

Minyanim: Sephardic prayer quorums.

Miraat al-Gharb: Literally, "The Mirror of the West." Arabic language newspaper founded by Najeeb Diab. Also *Mirrat Al-Gharb*.

Mosque: A Muslim house of prayer or worship.

Mullahs: Iranian religious leaders.

Nay: A reed flute.

Nshallah: Slang for *inshallah* or "God willing."

Oud: an Arab stringed instrument, a forerunner of the guitar.

Phalangists: Christian Lebanese who sided with Israel during its 1982 invasion of Lebanon.

Pizmonim: Hebrew, literally, "songs" or "poetry."

Qasida: An ancient form of poetry written in three parts, one of which was either a panegyric in praise of a patron/ruler or a satire condemning an enemy.

Qibla: The direction in which the believer orients himself or herself for prayer. Prayer is always directed towards the *Kaaba*.

Qur'an: The holy book of Islam, the words received by the Prophet Muhammad, which are the basis of the religion.

Ramadan: Muslim holy month when believers fast; a time of purification and abstention.

Romanized, Latinized: The Church at Rome is also known as the Latin Church. Its rituals are those most Catholics are familiar with. When the Eastern Catholics arrived in the United States with their Byzantine Catholic traditions, they were poorly understood. To fit in and be accepted by their fellow Catholics, many Melkite churches became Latinized or Romanized. For example, they gave up their right to have a married clergy, replaced their icons with statues, introduced the western organ, and often began blessing themselves in the Latin fashion instead of from right to left. Over time, the Melkites in the United States have again emerged with their Byzantine heritage intact while maintaining their communion with Rome. For this reason, they are considered a bridge with the Eastern Orthodox Church.

Roum: Christian Arab term referring to the Byzantine Christians, either Catholic or Orthodox, as in *Roum Catholique* or *Roum Orthodox*.

Sabaq El Kheil: Literally, "playing the horses."

Sabra: One of two towns in Lebanon in which Christian Phalangists killed thousands of Muslims during the 1982 Israeli invasion of Lebanon. The other town was Shatila.

Sadaqa: A charitable donation.

Sahra: A party or gathering in one's home.

Shatila: One of two towns in Lebanon in which Christian Phalangists killed thousands of Muslims during the 1982 Israeli invasion of Lebanon. The other town was Sabra.

Sheikh: A term of respect for an elder; a title for a religious scholar, spiritual master, or the ruler of a sheikdom.

Shura: Islamic consultation.

Sikah: An Arabic-based type of liturgical music used in Sephardic synagogues, especially around the city of Aleppo.

Simhot: Hebrew, joyous occasions.

Souk: A marketplace, usually a long alleyway with sellers lining both sides.

Sufism, Sufi: Islamic mysticism, a mystic.

Ta'a li houn: Come here.

Tablas: Percussion instruments.

Tabouli: A popular Arab salad made of parsley, bulgur, mint, tomatoes, spices, olive oil, onions, and lemon juice.

Tahini: A sesame-seed paste used in Arab cooking, especially dips.

Taqsim: Solo and counterpoint musical improvisation.

Tarboosh: A man's cylindrical red felt hat with a flat top, adapted from the Moroccan fez, during the Ottoman occupation. The fez is not as tall as the *tarboosh.*

Thobes: Traditional Arab clothing, a tunic- or robe-like garment that fits loosely and is worn long, even to ground length.

Umma: A Muslim community.

Ward El Bayda: Literally, "The White Rose," a landmark Egyptian film.

Yarmulke: Yiddish, a skullcap worn by Jewish men.

Yeshiva: Hebrew, literally, "seminary." Also used to denote a Jewish educational facility.

Zakat: A kind of tithe or mandatory alms given to the needy, especially at the end of Ramadan.

Bibliography

Abdou, Nagib T. *Dr. Abdou's Travels in America and Commercial Directory of the Arabic Speaking World.* New York, 1910.

"About Syria and Syrians: *Al-Hoda* Moves to Brooklyn." *Syrian World*, Sept. 1930, 58.

"About Syria and Syrians: Concert in New York by Fedora Kurban." *Syrian World*, June 1929, 52.

"About Syria and Syrians: Dagher Night a Great Success." *Syrian World*, Feb. 1931, 53.

Al-Hoda, 3 Feb. 1903.

Al-Hoda, 21 May 1918.

Al-Hoda, 22 Dec. 1921.

Al-Hoda, 1868–1968. New York, 1968.

Al Mohajer, 19 Dec. 1903.

American Association of Foreign Language Newspapers, Inc. *The Foreign Language Market in America.* New York, 1923.

"Arabic Radio Programs." *Syrian World*, 30 June 1933, 3.

Arbeeny, Emily. "Lifelong Cobble Hill Resident: 'Landmarks, You Done Me Wrong.' " *Phoenix*, 23 June 1977, 7.

Ashear, Linda. Selections. In *Sephardic-American Voices*, edited by Diane Matza, 159–61, 302–5. 1997.

Bengough, W. "The Foreign Element in New York, a Syrian Colony." *Harper's Magazine*, 3 Aug. 1895, 746.

Berger, Monroe. "America's Syrian Community." *Commentary* (Apr. 1958): 314–23.

Bishara, Kalil A. *The Origin of the Modern Syrian.* New York, 1914.

Blank, Jonah. "The Muslim Mainstream." *U.S. News and World Report*, 20 July 1998.

Brown, Francis J., and Joseph Slabey Roucek, eds. *One America.* New York, 1945.

Caroline Zachary Institute of Human Development and the Common Council for American Unity. *Around the World in New York.* New York, 1950.

Charlton, Linda. "End Comes to *Al-Hoda*, Arab Paper." *New York Times*, 21 Sept. 1971, 39.

"Children of America." *Syrian World*, Mar. 1929, 14–17.

"Clinton Street Church Deal." *Brooklyn Daily Eagle*, 17 Mar. 1954, sec. 2, 1.

"Cobble Hill Church Building to be Made into Arabic Music Hall." *Phoenix*, 30 Jan. 1975, 4.

Community Council of Greater New York. *Brooklyn Communities*. 2 vols. 1959.

Corby, Jane. "Syrians in Brooklyn Lure Multitudes by Celebrated Cookery." *Brooklyn Daily Eagle*, 31 Oct. 1948, 23.

Dahbany-Miraglia, Dina. "American Yemenite Jewish Interethnic Strategies." In *Persistence and Flexibility: Anthropological Perspectives on the American Jewish Experience*, edited by Walter P. Zenner (Albany, N.Y.: 1988), 63–78.

———. "An Analysis of Ethnic Identity among Yemenite Jews in the Greater New York Area." Ph.D. diss., Columbia Univ., 1983.

Editorial. *New Lebanese American Journal*, 16 Oct. 1975, 2.

Editorial. *The Syrian Review*, Dec. 1917, 3.

Elkholy, Abdo A. "The Arab-Americans: Nationalism and Traditional Preservations." In *The Arab-Americans*, edited by Elaine C. Hagopian and Ann Padden (Wilmette, Ill.), 3–17. 1969.

Faria, N. Handwritten Memoirs. 1952.

Ferris, Joseph W. "Restrictions of Immigration." *Syrian World*, Feb. 1929, 3–8.

Ferris, Marc. "Muslims." In *The Encyclopedia of New York City*, edited by Kenneth T. Jackson. New Haven, Conn., 1995.

Friedlander, Jonathan. *Arabs in America*. Los Angeles, Calif., 1981. Documentary film.

"Fusion Victory Elates Dagher." *Syrian World*, 10 Nov. 1933, 1.

Glover, Catherine. "Syrians in the Brooklyn Colony Quickly Adopt American Customs." *Brooklyn Daily Eagle*, 10 Feb. 1907, 1.

Goldstone, Harmon H., and Martha Dalrymple. *History Preserved: A Guide to New York City Landmarks and Historic Districts*. New York, 1974.

Gregory, Winifred, ed. *American Newspapers, 1821–1936*. New York, 1937.

Hadad, Herbert, 1997. Selections. In *Sephardic-American Voices*, edited by Diane Matza, 65–67; 308–13.

Hagopian, Elaine, and Ann Paden, eds. *Arab-Americans: Studies in Assimilation*. Wilmette, Ill., 1969.

Haick, Mary Ann. "The Syrian-Lebanese Community of South Ferry, 1900–1977." Master's thesis, Long Island Univ., 1979.

Haley, Peter. "Babaganouj, Baklava, and Belly-Dancers," *Phoenix*, 5 May 1977, 8.

Hess, John L. "Mideast Tension Afflicting the Arab Communities Here." *New York Times*, 7 Oct. 1972, 35.

Hickok, Guy. "Around the World in Brooklyn." *Brooklyn Daily Eagle*, 27 Jan. 1935, 10.

"History of South Ferry," *Brooklyn Daily Eagle,* 8 Aug. 1886. (Long Island Historical Society Scrapbooks, vol 3, p. 9.)

Hitti, Philip K. *Educational Guide for Syrian Students in the United States.* New York, 1921.

———. *Syrians in America.* New York, 1924.

Homsey, Mike. "Letters to the Editor: Reader Says Arab Is Beautiful." *Home Reporter and Sunset News,* 2 Nov. 1973, sec. 2, p. 88.

Hooglund, Eric J., ed. Introduction to *Crossing the Waters: Arabic-Speaking Immigrants to the United States Before 1940.* Washington, D.C., 1987.

Houghton, Louise Seymour. "Syrians in the United States." Pts. 1–3, *Survey* 26 (1 July, 5 Aug., 2 Sept. 1911): 481–95, 647–65, 787–803. Pt. 4, *Survey* 27 (7 Oct. 1911): 957–68.

"Immigrants in Politics." *Syrian World,* Feb. 1929, 42.

"J. S. Sponsors Program." *Syrian World,* 20 Dec. 1934.

Karpt, Ruth. "Street of the Arabs." *New York Times,* 11 Aug. 1946, sec. 6, 47.

Katibah, Habib I. *Arabic Speaking Americans.* New York, 1946.

———. Chapter on Syrians. In *One America,* edited by Francis J. Brown and Joseph S. Roucek. New York, 1945.

Kayal, Philip M., ed. *Coming of the Arabic-Speaking People to the United States.* Staten Island, N.Y., 1987.

Kayal, Philip M., and Joseph M. Kayal. *The Syrian-Lebanese in America: A Study in Religion and Assimilation.* Boston, 1975.

Khalaf, Samir. "The Background and Causes of Lebanese/Syrian Immigration to the United States Before World War I." In *Coming of the Arabic-Speaking People to the United States,* edited by Philip M. Kayal. Staten Island, N.Y., 1987.

Kligman, Mark. "Modes of Prayer: Arabic Maqamaat in the Sabbath Morning Liturgical Music of the Syrian Jews in Brooklyn." Ph.D. diss., New York Univ., 1997.

"Little Syria." *Downtown Brooklyn,* Aug. 1974, 4.

Mannix, Jim. "Ye Olde Timers: Syrian Thoughts." *Home Reporter and Sunset News,* 17 Mar. 1972, sec. 2, 28.

Mansur, W. A. "Problems of Syrian Youth in America, I." *Syrian World,* Dec. 1927, 8–12.

Mara, Margaret. "Living in Brooklyn: For Delicacies, Try the Casbah." *Brooklyn Daily Eagle,* 30 Oct. 1960, sec. 2, 19.

———. "Living in Brooklyn: Syrians Contribute to the Boro Mosaic." *Brooklyn Daily Eagle,* 29 June 1949, 19.

"Maronite Diocese Is Moving to Brooklyn," *The Tablet,* 11 Aug. 1977, 6.

Marshall, Jack. *Arabian Nights: Poems.* Minneapolis, Minn., 1986.

———. Selections. In *Sephardic-American Voices,* edited by Diane Matza, 163–67. 1997.

———. *Sephardic-American Voices: Two Hundred Years of a Literary Legacy.* Hanover, N.H., 1997.

———. *Sesame: Poems.* Minneapolis, Minn., 1993

McLoughlin, Maurice E. "Syrian Settlers in Brooklyn have Developed Many Talented Citizens in Various Fields." *Brooklyn Daily Eagle,* 22 May 1932, sec. A, 17.

Miller, Lucius Hopkins. *Our Syrian Population: A Study of the Syrian Communities of Greater New York.* New York, 1904.

"Mohammedans Have Paper Here." *Brooklyn* (25 Aug. 1923): 11.

Mokarzel, S. A., and H. F. Otash. *The Syrian Business Directory.* New York, 1908–9.

Naff, Alixa. *Becoming American: The Early Immigrant Experience 1880–1950.* Carbondale, Ill., 1985.

"National Origins Immigrant Plan in Effect; Law Curtails Entrants and Changes Quotas." *New York Times,* 1 July 1929, 3.

"New Radio Series Arranged." *Syrian World,* 15 Dec. 1933, 8.

"The New Syrian Society Has a School." *Brooklyn Daily Eagle,* 10 May, 1892.

"New York by Races." *New York Times,* 18 Dec. 1921, sec. 7, 7.

New York State Census. 1905.

New York State Census. 1915.

New York State Census. 1925.

New York Telephone Company. *Brooklyn, Queens, and Staten Island Directory.* New York, 1924.

"News of Societies, New York." *Syrian World,* Feb. 1929, 56.

"News of Societies, New York." *Syrian World,* Mar. 1929, 55.

"Notes and Comments: The End of an Experiment." *Syrian World,* Oct. 1927, 49.

Nu'man, Fareed H. *The Muslim Population in the United States: A Brief Statement.* Washington, D.C., 1992.

Orfalea, Gregory, and Sharif Elmusa. *Grape Leaves: A Century of Arab-American Poetry.* Salt Lake City, Utah, 1988.

Protestant Council of the City of New York. *Bay Ridge, Bensonhurst, Borough Park, Sunset Park: Four Communities in Southwest Brooklyn.* Chicago, 1955.

Rihbany, Abraham Mitry. *A Far Journey.* Boston and New York, 1914.

Rinke, Herman. "New York Subways: Fifty Years of Millions!" *Electric Railroads* 23 (Oct. 1954): 1–8.

Robotti, Frances Diane. *Key to New York: Empire City.* New York, 1964.

Roden, Claudia. *A Book of Jewish Food.* New York, 1997.

Sanua, Victor D. "Contemporary Studies of Sephardic Jews in the United States." In *Coat of Many Colors: Jewish Subcommunities in the United States,* edited by Abraham D. Lavender (Westport, Conn., 1977), 280–88.

Sason, Grace. *Kosher Syrian Cooking.* Brooklyn, N.Y., 1988.

Sephardic Archives. *The Spirit of Aleppo: Syrian Jewish Immigrant Life in New York, 1890–1939.* Brooklyn, N.Y., 1986.

————. *Victory Bulletin.* July 1942-September 1945. Facsimile prepared for an exhibit at the Sephardic Community Center, Brooklyn, N.Y., 1985.

Shaheen, Jack G. *Arab and Muslim Stereotyping in American Popular Culture.* Washington, D.C.: Center for Muslim-Christian Understanding, History and International Affairs, Edmund A. Walsh School of Foreign Service, Georgetown Univ., 1997.

Sharp, John K. *History of the Diocese of Brooklyn,* 2 vols. New York, 1954.

Shelemay, Kay Kaufman. *Let the Jasmine Flow: Song and Remembrance among Syrian Jews in the Americas.* Chicago, 1998.

Sisterhood of Deal. *Deal Delights.* Deal, N.J., 1980.

"Spirit of the Syrian Press: Paper Urges Syrians to Vote." *Syrian World,* Dec. 1926, 68.

"Spirit of the Syrian Press: The Position of the Emigrant." *Syrian World,* Feb. 1928, 48–49.

Suleiman, Michael W. "Early Arab-Americans: The Search for Identity." In *Crossing the Waters: Arabic-Speaking Immigrants to the United States Before 1940,* edited by Eric J. Hooglund. Washington, D.C., 1987.

Sultan, Stanley. *Rabbi: A Tale of the Waning Year.* West Whately, Mass., 1977.

————. Selections from *Rabbi* and other sources. In *Sephardic-American Voices,* edited by Diane Matza, 121–27, 177–220, 1997.

Surfaro, Monica. "An Exciting Urban Bazaar." *Phoenix,* 25 Sept. 1975, 15.

Sutton, Joseph A. D. *Aleppo Chronicles.* Brooklyn, N.Y., 1988.

————. *Magic Carpet: Aleppo in Flatbush.* Brooklyn, N.Y., 1979.

The Syrian American Directory Almanac 1930. New York, 1929.

"Syrian Editor in the *Brooklyn Eagle.*" *Syrian World,* Oct. 1926, 576.

"Syrian Riot in Street, and Many are Hurt." *New York Times,* 24 Oct. 1905.

The Syrian Society of the City of New York. *First Annual Report.* New York, 1893.

Syrian World, July 1926.

Syrian World, Sept. 1926.

"Syrian World to Have Regular Broadcasts." *Syrian World,* 9 Mar. 1935, 1.

"Syrian Young Men Oppose Cobble Hill Rehabilitation." *New York Times,* 2 Oct. 1962, 35.

"Syrians Offer to Fight." *New York Times,* 27 Apr. 1914, 4.

Treudley, Mary Bosworth. "The Ethnic Group as a Collectivity." *Social Forces* (Mar. 1953): 261.

"Truman Gets Arab Plea." *New York Times,* 4 Oct. 1951, 10.

"Two Loaves for 8! No, Two Loaves for 5! No, Two Loaves for 6." *Syrian World,* 1 Dec. 1933, 6.

U.S. Bureau of the Census. *Twelfth Census of the United States.* Washington, D.C., 1900.

"U.S. Praised On Lebanon." *New York Times,* 27 July 1958, 7.

Whitehead, Charles. *Sketch of Antonio Bishallany: A Syrian of Mount Lebanon.* New York, 1863.

Younis, Adele. "The Growth of Arabic-Speaking Settlements in the United States." In *Arab-Americans: Studies in Assimilation,* edited by Elaine Hagopian and Ann Paden. Wilmette, Ill., 1969.

Younis, Adele. Selections. In *The Coming of the Arabic-Speaking People to the United States,* edited by Philip M. Kayal. New York, 1995.

Zenner, Walter P. "Arabic-Speaking Immigrants in North America as Middleman Minorities." *Ethnic and Racial Studies* 5 (1982): 457–77.

———. *A Global Community: The Jews from Aleppo, Syria.* Detroit, Mich., 2000.

Index

Italic page numbers denote illustrations or information in captions to illustrations.